THOM BROWNE.

Viktor & Rolf.

Fashion
Together

Fashion Together

Fashion's Most Extraordinary Duos on the Art of Collaboration

Edited by Lou Stoppard
Foreword by Andrew Bolton

Rizzoli
NEW YORK

New York Paris London Milan

Contents

Foreword by **Andrew Bolton**

1+1=3

Fashion, by its very nature, is collaborative. Even before the birth of the haute couture in the mid-nineteenth century when fashion came to be defined by the artistic expressions of designers rather than by the dictates of individual clients, fashion has always relied on a vast network of specialists for its creation. Anticipating their role in the creative process of these emerging designers, Denis Diderot and Jean Le Rond d'Alembert outlined the work of specialised craftsmen in their pioneering and provocative publication *Encyclopédie, ou Dictionnaire raisonné des sciences, des arts et des métiers* (*Encyclopedia, or Systematic Dictionary of the Sciences, Arts, and Crafts*), published between 1751 and 1772. They included *plissé* (pleating), *dentellerie* (lacework), *maroquinerie* (leatherwork), *broderie* (embroidery), *plumasserie* (featherwork), and *parurier floral* (artificial flowers), all of which continue to be integral to the creation of fashion today.

Typically, these skilled artisans are in service to fashion, executing and realising a designer's creative vision, although their exquisite masteries provide undeniable sources of inspiration for designers. The dynamics between the designers and collaborators featured in this book, however, are quite different from those between these enabling craftsmen on whom designers rely for the unique interpretation of their ideas and concepts. For the most part, these are synergistic partnerships based on shared creative visions that speak of collusion, complicity, and conspiracy. Traditionally, the history of costume is presented as an individual designer's search for self-expression. The symbiotic pairings in this book, however, question this accepted and entrenched image of fashion as the outcome of one person's creative vision and reveal that authorship is often more complex and multifaceted.

Each duo consists of exceptionally talented individuals with unique styles and skills from diverse backgrounds and creative upbringings. They range from partnerships between fashion designers and accessory designers to those between designers and models, stylists, photographers, and filmmakers. Others reveal personal, close-knit relationships based on marriage and lifetime partnerships or friendships. Designers and their so-called muses are also featured, although not in the traditional relationship of active, creative, productive man and docile, passive, submissive woman. On the contrary, she is shown as she always was—not as a stereotypical representation of an idealised woman but as an individual of exceptional talents with a vivid personality and fertile imagination whose creativity is commensurate with that of her collaborator. Together, all these creative relationships present a compelling narrative arc of the contemporary fashion landscape.

Nevertheless, such collaborations are not unique to contemporary fashion practice. From the early twentieth century onwards, fashion has been defined by similar mutually enriching partnerships. Like so many innovations, they have their origins with Paul Poiret, the designer who dominated fashion in the first decade of the twentieth century. Although he is best remembered for

liberating women from the corset, Poiret established the blueprint of the modern fashion industry through his far-reaching and wide-ranging collaborations. His most illustrious creative partnerships were with the artists of his day (Poiret himself was a passionate art collector). He worked with Raoul Dufy on a number of designs for fabrics, perhaps most famously for a coat, which he dubbed "La Perse" (now owned by The Metropolitan Museum of Art), created for his wife and "muse" Denise. As well as with Dufy, Poiret also worked with the graphic artists Paul Iribe and Georges Lepape, most notably on a series of deluxe albums for his elite clients.

Elsa Schiaparelli, who, coincidentally, was a client of Poiret's in the 1920s, inherited his mantle a decade later. Reflecting the dominant artistic discourses of the 1930s, especially Surrealism, she worked with a number of artists including Salvador Dalí, Jean Cocteau, and Alberto Giacometti. But the twentieth century is replete with similar collaborations, many of which anticipate the creative partnerships featured in this book. Gabrielle "Coco" Chanel's collusion with Fulco di Verdura or Halston's with Elsa Peretti has a correlation with Alexander "Lee" McQueen and Shaun Leane; Madame Suzy's alliance with Wallis Simpson, the Duchess of Windsor, has an affinity with Philip Treacy and Isabella Blow; Rudi Gernreich's association with Peggy Moffitt has an analogy with Riccardo Tisci and Mariacarla Boscono; and Yves Saint Laurent's relationship with Loulou de la Falaise has a correspondence with Marc Jacobs and Katie Grand.

What is unique about the nature of creative partnerships in the twenty-first century is their increasing prevalence. As this book illustrates, the number of designers working collaboratively across artistic disciplines is growing exponentially. It also highlights the remarkable range and astonishing diversity of these collaborations. No longer content to align themselves with partners in their own medium, designers are looking outside of fashion for their creative expression, as evidenced by Iris Van Herpen's collaboration with the architect Philip Beesley. Such alliances highlight the immense possibilities of the combined practices of two creative luminaries. They not only expand our understanding of the act of creation but also the nature of artistic identity, creating new and unique authorial models. From concept to realisation, creative partnerships are becoming an essential part of fashion's potential and development. They are not only critical to innovation but also essential to the future of fashion, establishing new paradigms and complex genealogies. As this book testifies, when powerful creative forces unite, 1 + 1 = 3.

Introduction by **Lou Stoppard**

Fashion is often seen as an industry of eccentric personalities—unique, exceptional talents—but it's the collaborations, rather than the individuals, that underpin the industry and inspire this book. A lone genius makes for a great story, but the greatest collections and the greatest photographs rely on the input of many. As designer Jonathan Anderson of J.W. Anderson, whose collaboration with stylist Benjamin Bruno is featured in this book, puts it, "You can be the most genius designer in the world. You can make the most incredible clothing and come up with the most incredible silhouettes, but if you're unable to collaborate, it will never grow."

Collaboration has become something of a buzzword in the last decade. I began this book when designer-high-street hook-ups were booming and luxury brands had increasingly started calling on artists and famous faces to produce one-off collections or products. These were tools that worked to pull in press and cause a splash. But I'm interested in the lasting partnerships—the formative friendships, the unions that exist behind the scenes or the decades-long working relationships that have shaped each participant's vision and life. These relationships are common across the industry, but their complexity has been under-analysed. How is credit shared? How is work divided? Is jealousy or ownership an issue? Is there a recipe for success? These and other questions took me around the world into the studios, haunts, and, on lucky occasions, homes of some of fashion's most intriguing collaborators.

This book serves as a study of collaboration. You can read each interview and draw parallels between the different pairs—perhaps noting the way that the duos behind both Viktor & Rolf and Proenza Schouler talk of operating almost as one mind, making work based on shared experiences and approaching decisions as a pair. For many others, the process is the opposite—a partnership gives them the opportunity to share the workload, utilise individual strengths, and save time. In some pairs, one member serves as a moral support or cheerleader; in others, the dynamic relies on constructive criticism and the prospect of a challenge. Some show an obvious power balance; others seem utterly equal. In some, the spark behind the union is immediately obvious—there is so much in common, a clear harmony—while in others the relationship is unexpected, complex. The dictum that opposites attract holds true in work environments, too.

One challenge in writing this book was working out the pairings. Some relationships were obvious, notably those of the constant partners who always operate as duos, such as Inez van Lamsweerde and Vinoodh Matadin or Mert Alas and Marcus Piggott. But other pairs were harder. Collaborative people tend to be prolific in their collaborations—committed throughout their careers to several other creative minds. In their interview, Nick Knight and Daphne Guinness talk of their relationship as one composed of "orbits" and remark on the web of individuals—Alexander McQueen, Gareth Pugh, John Galliano—who connect them. Constellations of stars seem an apt analogy. Knight

himself could have appeared in this book with any of the former, or indeed with Yohji Yamamoto, with whom he worked in the 1980s on now iconic catalogues and images. McQueen, too, offered many relationships to analyse—such as that with his stylist, Katy England, or his milliner, Philip Treacy, or even the likes of dancer Michael Clark or production designer Joseph Bennett, who were so instrumental in creating his catwalk spectacles. This book deliberately considers a broad spectrum of relationships—that between a designer and jeweller, as is considered in the chapter on McQueen and Shaun Leane, seemed particularly unusual and special. I was drawn to the less tangible, more unexpected partnerships that operate outside of the usual structures of the industry. It is commonplace for a designer to collaborate regularly with one stylist—such are the demands of the catwalk show or advertising campaign. In the cases where a designer and stylist team features here, it is because I felt the pair's working relationship extended beyond the norm. For example, I was intrigued when the much-lauded designer Jonathan Anderson declared of his relationship with Benjamin Bruno, who collaborates with him on his namesake label J.W. Anderson and at Spanish house Loewe, "Ben has the fashion and I have the commerciality." Their interview shows how fashion's professional relationships can evolve into unique, specific partnerships.

Other relationships featured in this book are between milliner and designer, designer and stylist, photographer and photographer, model and designer, and designer and designer. Some of the relationships speak of the success and rewards that can come from approaching someone outside of your industry. Iris Van Herpen's mesmerising, sculptural dresses, created with the help of architect Philip Beesley, have redefined the ways modern fashion can make use of technical innovation. Their partnership shows the benefits of a broad gaze and an open mind. So, too, does the relationship between designer Gareth Pugh and filmmaker Ruth Hogben. Their collaborations have redefined ideas of the best way to showcase fashion, challenging the supremacy of the catwalk show and helping promote and shape the growing medium of fashion film.

In many ways, this is a book about love. Many duos are friends or lovers first and collaborators second. And while some of the pairs in this book have generated huge revenues for businesses and brands, it's rarely money that ties them together. Milliner Philip Treacy, when discussing why his relationship with the late, great stylist Isabella Blow is often cited as an iconic collaboration reasons, "Because it wasn't about anything financial. It was about friendship and love—it was sincere and authentic." Similarly Beesley, when discussing first meeting with Van Herpen, says, "I remember feeling, this could be a kindred spirit. And perhaps there is no greater pleasure than such a thought." These kinds of collaborations never really end. Over time, pairs may part and new opportunities may emerge, but a truly formative union stays with the participants forever, influencing and shaping their creative output indefinitely. These relationships live on both in the annals of fashion history and in the minds, drive, and instinct of those involved. As Leane puts it when speaking of his seventeen-year-long collaboration with McQueen, "I'll make a piece for one of my collections and think, Lee would love that! Then I know it's a winner. He's embedded in me."

Though my interview with Maria Grazia Chiuri and Pierpaolo Piccioli is not present in the final version of this book, I spoke to the pair when they were the star duo behind Valentino. They've since moved on, with Chiuri taking up the role of creative director of Dior in 2016, but the pragmatism they employed when speaking of their relationship—begun when they were introduced by a mutual friend in Rome—stuck with me. "You become known as a duo or a couple when you are in the spotlight. But if you look backstage there are many couples who work together because they have a good relationship and do things well together, and they spend time together for lunch because it's fun, or they share a table," said Chiuri. Though the collaborators in this book are icons now, many did not meet their matches when in power, but instead encountered them while studying, or as unknown hopefuls, eager to find a way into the world of fashion. There are pairs like this across the hardworking fashion world—meeting for a morning coffee, breaking for a shared cigarette, chatting in the studio kitchen.

Some of those featured have a role that is almost impossible to define: they simply inspire. I trod carefully when using the word "muse." As Michèle Lamy discusses in her conversation with her collaborator and partner, Rick Owens, the term suggests a certain passivity. When looking back at the history of the fashion relationship, I was less intrigued by the pairing of a well-dressed woman

on the arm of a designer than by the more dynamic, layered partnerships that have set the tone for today's collaborations—Elsa Schiaparelli and Salvador Dalí, Celia Birtwell and Ossie Clark, Yves Saint Laurent and Pierre Bergé, Helmut Lang and Melanie Ward, to name just a few. This book looks at the partnerships of today among those who, like the forebears mentioned above, have bucked trends and caused the industry to evolve.

The fantasy of the designer in an ivory tower, dreaming up wonderful ideas in isolation, has never been accurate. The difficulties and pressure many designers face are better recognised now, and that sense of a solo creative—feared, adored, and admired—seems outdated. As we go to print, the notion of a "collective" and other such terms for a group or team is gaining popularity. Vetements won the attention of the press when it emerged as a shadowy collective, before lead designer Demna Gvasalia revealed himself. Across the board, emerging talents, such as Marta Marques and Paulo Almeida of rising London label Marques'Almeida, are choosing to work together. Teamwork is now celebrated as a pragmatic way to excel in a tough industry—a more modern way of surviving the big business that is fashion. The late, great Joe Bates, one of the founders of London knitwear label Sibling (which, in an unusual set-up for the time, was formerly run by a trio of collaborators), observed to me early in my career that a trio is a failsafe mechanism, because when disaster strikes, as it inevitably does, "if two are on the floor crying, there's still one standing."

Fashion is about cooperation. The fashion images in this book were the work not of one person, but of a roster of many. The photographer couldn't create his vision without the model, the hair stylist, the make-up artist, the casting director, the stylist, the manicurist, the set designer, and the many other bodies who help a shoot to run smoothly. The clothes featured within those pictures also rely on teamwork—including delegation to those with unique craftsmanship skills and technical knowledge.

The worlds spotlighted in this book show that creativity tends to be pushed forward and enhanced when challenged. Dialogue, discussion, and even confrontation are central to innovation. So, is there a recipe for productive collaboration, as I set out to discover? Of course not. But what drew together each of the duos was trust. Most pairs acknowledged that, more than a shared artistic vision or a common creative sensibility, it's trust that makes for a great relationship. "Relationship" is an apt word. Like happy romantic unions, successful creative partnerships rely on a certain amount of chemistry. The relationship works or it doesn't. And when it does work, it is a joy, pure and simple. Togetherness is nuanced, magical, hard to define, and, when right, beautiful to observe.

Marc Jacobs and **Katie Grand**'s partnership is known and celebrated far beyond fashion thanks to their involvement with a diverse range of cultural icons, many of whom frequently appear in editorial images, campaigns, and catwalk shows crafted by the pair. For over two decades, "super stylist" Grand has helped add drama, theatre, celebrity casting, and an editing eye to Jacobs's already bombastic catwalk shows, and the garments he creates regularly furnish the pages of her popular fashion magazine, *Love*, which she founded in 2009, and her former title, *Pop*, founded in 2000. Grand is female and British, Jacobs is male and American, yet the two share a similar sensibility and understanding of fashion that embraces entertainment personalities, street culture, and playful and deliberate homages to other greats of fashion. Their work is informed heavily by the now, and the idiosyncrasies of the Zeitgeist, while liberally referencing the aesthetics of past eras. The pair first began working together when Jacobs was serving as artistic director of Louis Vuitton, a position he held for sixteen years until 2013. Grand initially worked on the French house's campaigns before eventually starting to style catwalk shows; she styled Louis Vuitton from 2005 until 2013, and has worked since 2012 on shows for Jacobs's eponymous label, which he founded in 1986. Grand continues to work closely on the Marc Jacobs line, while collaborating with other brands and designers including Miu Miu, Bottega Veneta, and Giles Deacon.

Marc Jacobs and Katie Grand

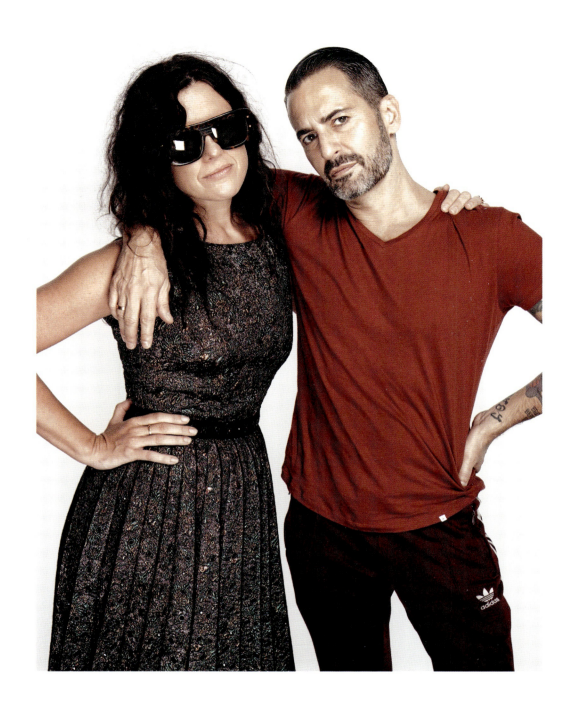

Grand and Jacobs, photographed by their frequent collaborator David Sims
on set during a Marc Jacobs campaign shoot. The image appeared on the
cover of *The Daily Front Row* in September 2015.

Do you remember the first time you met?
Marc Jacobs: I don't. She does. I've been reminded of it, but for some reason I keep forgetting it. She crashed a Louis Vuitton party.
Katie Grand: It was a dinner party at Hôtel Costes. My friend Giles Deacon is really good friends with Peter Copping, who at the time was the head of studio at Louis Vuitton. Giles suggested we go. We turned up thinking it was going to be a drinks party, and, of course, it was a sit-down dinner for about twenty people—just the team. I remember some of Vuitton's employees glaring at us. But then it became a funny tradition that I would be invited after that. They used to do drinks at Le Bristol after, and we'd also always go. I remember, as time went on, sitting next to Marc chatting about fashion and stuff. Back then Keith Warren was head of menswear, and he asked me to work on menswear. So that was how I ended up in the studio.

Marc, do you remember what you thought of Katie during those conversations?
Jacobs: "Energy" would be the key word—it's a good opening note to describe our relationship. Katie brings a burst of energy. That's how I first remember her—her laugh and everything like that.

Tell me how you came to work together at both Louis Vuitton and Marc Jacobs.
Grand: I started working on the Louis Vuitton ads as well—I was asked by Mert [Alas] and Marcus [Piggott]. But at that point, Marc wasn't there on the shoots. The first season I did we were in Switzerland, and it was twenty degrees below zero, and we were up a mountain. It was so cold you couldn't actually hold the camera. Then the model fainted because of lack of oxygen. It was in the days of the Polaroid, so we'd have to fax the image back to the studio for them to check. We were ready to set up the second shot, when the message came back from Marc: "Could you try the first again with a different suit?" I remember we were all like "Argh!" He was sitting in his nice hot office! We wanted to kill him! I've never been so cold in my life. But really it was great. And he was right about the suit. I think it only drives you nuts if someone's not right.

Marc, I've hear that one of the reasons you really love working with Katie is that she reacts to ideas with a lot of joy.
Jacobs: She'll get quite giddy. It does make you feel good about doing something, because the reaction is so genuine and particular, rather than just pensive, or a simple yes or no.

When did you begin to get really close? Did that come when you started working on Marc Jacobs together?
Jacobs: Well, work is my life. It's a huge part of my life. And I think it was when we started doing the two things together—the Marc Jacobs collections and Louis Vuitton collections—and we were spending so much time together. I didn't see anyone as much as I saw Katie. And we were always communicating—in between when we saw each other we were texting, sending photos, sending pictures of fittings.

Grand: Marc doesn't like change at all. He hates changing his staff. He loathes it. I think he kind of fears it. We'd got to this point where I was working with him so closely on Vuitton, and we'd notice that he would use quite a lot of starting points from the Vuitton discussions for his own collections. He was texting me all the way through August. I'd be in Ibiza with Peter Copping, who'd laugh at me and say, "I'm so glad I don't work there anymore!" Marc would just send me everything—all the shoe trials, all the bag trials. Text after text after text saying, "What do you think of this?" I thought, this is getting ridiculous. August is spent answering Marc's texts! I felt like I was working on it, but I wasn't formally working on it. It just got frustrating—probably because I was such a fan of the Marc Jacobs name. I always felt like I was a Marc Jacobs shopper rather than a Vuitton shopper. I was hungover one morning, and he was asking me something, and I texted back, "Why don't you just ask me to do the show?" And then there was silence. I stood in my kitchen thinking, I'm fucked! Have I just lost my job? But it had been brewing in my head for two years. In the end I'm glad I did it, because we got to do both.

Marc, you must rely on that constant communication a lot when the pace of collections is so vigorous?
Jacobs: It does get so stressful. It can feel very, very serious. When you can turn to someone and get, as with Katie, a sense of the delight that she has in something, it's much more important than just hearing someone approve of something. When we're together it's the actual, physical, primitive connection or the visual— the eyebrows raise or the smile or, again, that laughter. There will be times where I'm so tired, like at the last show for Louis Vuitton, and I'll look to her and say, "Katie, is it okay?" and she'll say, "It's more than okay. It's great." I never know. I am so deliriously tired and so stressed that often it's not until a couple of days later that I can look at the video and look at the images and say, "Okay, I was really happy with that."
Grand: Marc can get very down, and then he gets very introverted and you have to be quite tough to deal with that. Because days can go by where you get nothing from him except very short answers. And then, after about four days, it's like everything has been digested in his head and he's ready to react to what you've been saying. But as with most designers, I'm aware that it's their name, it's their money, and they're the ones who come out at the end. Although you are employed to have your opinion, you can't push people too much, because they are very vulnerable. Some aren't. Miuccia Prada's not, and Tomas Maier isn't—they're stalwarts. Whereas others are a lot more vulnerable, and I've learnt over the years that when Marc snaps at me or when he gives nothing, you've just got to keep going. It's a three-week stint, and I'm there with him every day. You can crumble at the end of it. I really like the contrast of working with someone like Tomas Maier, who comes with forty-two looks and the show pretty much put together. He expects me to tweak it, give my opinion,

drop some stuff, switch some stuff in, cast it, work on the hair and make-up with him, and music, and that's it. The clothes are the clothes.

Would you say you are similar people?
Jacobs: I think we like a lot of the same things in fashion. We're both big Prada fans—we think Miuccia's the greatest. Sometimes we wear the same clothes, Katie and I. We have the same Prada fur coat. There's music, there's art. And there's also the contrast—there will be things that she's interested in that I'm not. And because I do value her opinion, that makes me eager to explore something that doesn't interest me because it interests her.
Grand: Our taste is very similar, which is why we can finish each other's sentences. I can pretty much second-guess stuff, especially with the advertising or the layout. I don't have that same second-guess relationship with other people. David Sims, for instance—his PA could phone me about a casting question and I'd say, "I have no idea what he's thinking."

You seem to have a shared interest in pop culture and certain characters or celebrities.
Jacobs: It's that London/New York thing, which is a real genuine love for street culture and youth and club culture and music, whether it's TV pop, film pop, art pop. There's a similarity in energy. Growing up and listening to British music and even watching British comedies, as a New Yorker I tended to get the humour, whereas I think a lot of people in the States, or even in Paris or Milan, wouldn't.
Grand: In our early years at Vuitton, we would be amused or interested by someone that was very famous but not very cool. We'd admire that they were a huge star, but Vuitton was the biggest star in a way, so you could explore irony and play with it. While you were working with photographers like Mert and Marcus, with the clothes made by the Vuitton studio, you knew that you could make, say, Jennifer Lopez look the best she was ever going to look. I'd say Marc is less interested in popular culture than I am. He'll entertain me, but it's not his obsession. He has pretty sophisticated taste. I have no idea what he and some of his colleagues and friends are talking about when they're discussing furniture designers and carpet designers—it's another language to me.

Katie, when you look at Marc's shows do you see your own ideas and obsessions in them?
Grand: There are degrees. Some of my favourite shows that we've worked on are the ones that are very *him*. The Daniel Buren graphic one for Spring/Summer 2013 was my favourite thing we ever did at Vuitton. I actually cried at the end of the show, which was really weird. I've never done that in the history of work. He drew every look. Same with the Marc Jacobs Victorian collection, for Spring/Summer 2014—he drew every look. There are other Vuitton collections that Julie de Libran, who was head of studio at Vuitton, and I worked on much more, so they were weighted more towards us

than him. Julie and I, when left to our own devices, can get quite Prada!

Marc, women seem to be very important to your team. Why? And is part of the reason you enjoy collaborating with Katie because she brings a female perspective?
Jacobs: I think that's important of all the women that I work with. I've always credited women designers as being historically the most important in terms of their contributions to fashion, and I think that's because they don't objectify women in the same way. It just comes down to the fact I'm not a woman, even though I certainly have no problem wearing women's clothes! When women on the team at Marc Jacobs want or desire or covet the thing that I'm working on, that gives it validity. It allows you to believe in things, when otherwise they just seem like a costume, somehow.
Grand: There are certain women he really trusts and values in the studio—Sofia Coppola, Rachel Feinstein, Julie de Libran, Katie Hillier—because he knows that we're all voracious shoppers. He knows how much money we all spend—it's really disgusting, actually! So when we all want the Marc Jacobs stuff, he's really flattered, because he knows how much money we can drop at Prada or Azzedine or Miu Miu.

Marc, would you call Katie a muse?
Jacobs: No, no, no. She is someone I have a dialogue with and that I bounce ideas off. It's not like she's an object or something fictional. She is a very real part of our routine and making the decisions.

Collaboration seems totally in your blood. I'm thinking of the many artist collaborations you did while at Louis Vuitton, such as with Stephen Sprouse and Yayoi Kusama. Have you always been the kind of person who enjoys working with other people?
Jacobs: I do. I'm really at my most effective or useful when I'm on my own, but I don't like being on my own! I always think the best things come from a dialogue when you throw things back and forth. So, when I'm working with other people, I feel there's a kind of real integrity to the work and a fluidity. If I just had to sit in a room by myself and come up with things, they'd be pretty static. It wouldn't have the same life and the energy. I don't mean to put myself down, because obviously I do a lot more than participate, but everyone I work with contributes something special, and I know that without their contributions the results wouldn't be the same. With Katie and me, it's almost like clockwork. There'll be times when I'll be completely freaked out. We'll have had an hour or two hours of sleep, and we'll be going home and coming back and surviving on just a salad—and Katie and I will look at the pictures, and she'll say, "Come on, let's try this," and then this magic occurs.
Grand: Someone like Giles is really happy sketching on his own. He doesn't feel the need to bounce off people. Whereas Marc likes to react against or with things. That starts him thinking. Marc's not done a single interview where he says, "I." It's always "we."

It's really nice that he does push people out like he does. He's happy for his staff to be photographed for magazines or profiled.

Jacobs: It's all of us. When I say "me" I always mean "we"—that group of people that are involved in getting from a blank piece of paper to an idea to a presentation to a product. The clothes, the fashion, the sense of spirit, the music, the light—it just is a collaboration. There's no other way to describe it.

Grand: I think it is appreciation of how hard everyone works for him. In most design studios, you can't work from ten till six or have a life and have children and all the things that normal people have. When you work that intensely with someone, that is your life. He understands that for most of the people around him, he is the be-all and end-all. And the show and the work that we do, we do because we love it. Sure, everyone is paid okay, but I don't think any of us would work that hard for the money.

It seems that your relationship extends far beyond the usual designer/stylist collaboration.

Grand: A weird thing has happened over the years. It used to be that I'd come in and do consultancy days. That would be maybe three, four, five days a season, and then I'd do the big stint at the end, which was two to three weeks, and my thing would be putting clothes together. But now what happens is I work much more with him on the design, and, to be honest, he puts it together at the end. He always always places the bags and the shoes. I don't even flinch now! We have come to design more and more by outfits, so we don't make loads and loads of clothes. When the studio is emptied before the show, and the clothes have gone to the space, there is probably nothing more than a few extra pairs of trousers, knitwear, shoes, a few bags—there's not that racks and racks of clothes thing.

Why do you think your relationship with Marc has lasted so long? Is it because of the friendship?

Grand: Actually, I think there's a definite professional boundary between us, which is sometimes crossed by how demanding he is. But it's not like we go on holiday together—it's not that kind of relationship. And I quite like that there is a bit of a formality to it, which I think surprises people, given that he gives me so much credit.

Marc, the fact that you credit Katie and your team so often runs counter to the way fashion traditionally has utterly fetishized the star designer, the solo creative.

Jacobs: I've often said that anyone who pretends that exists is just lying. It takes so many people to do what we all do. There are the women who sew, the people who make the patterns, the people who cut the patterns, the people who sell, the PR, the photographers, the models. Everyone plays a part, and when it works, it's because everyone's brought something very special.

—

This interview took place over the phone between London and New York, where the Marc Jacobs label is based, on October 16, 2014, with follow-up in person at the *Love* offices in East London on November 13, 2014.

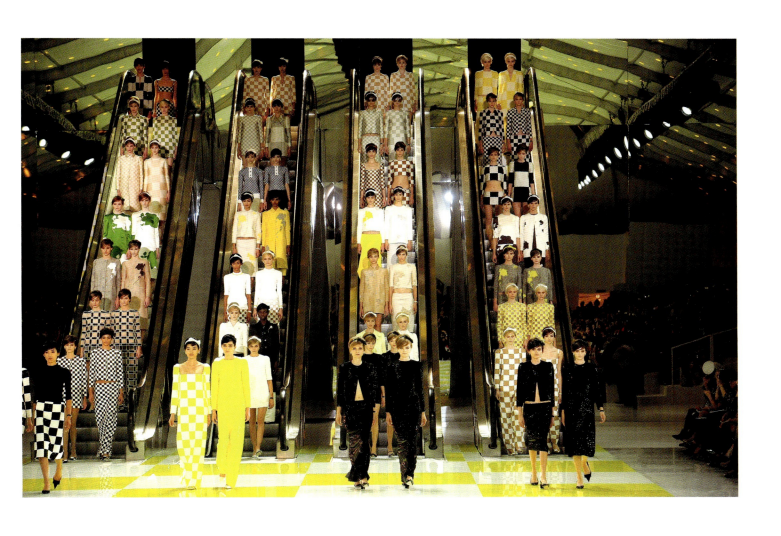

Jacobs's S/S 2013 show for Louis Vuitton, which drew inspiration from Daniel Buren's *Les Deux Plateaux* installation and featured a set created by the artist, moved Grand to tears—a first in her time working on runway shows. Models walked in pairs, descending onto the runway via four escalators, and were clad in checks inspired by the house's famous Damier pattern. Jacobs would present just two more runway shows for the house, F/W 2013 and his swan song, S/S 2014.

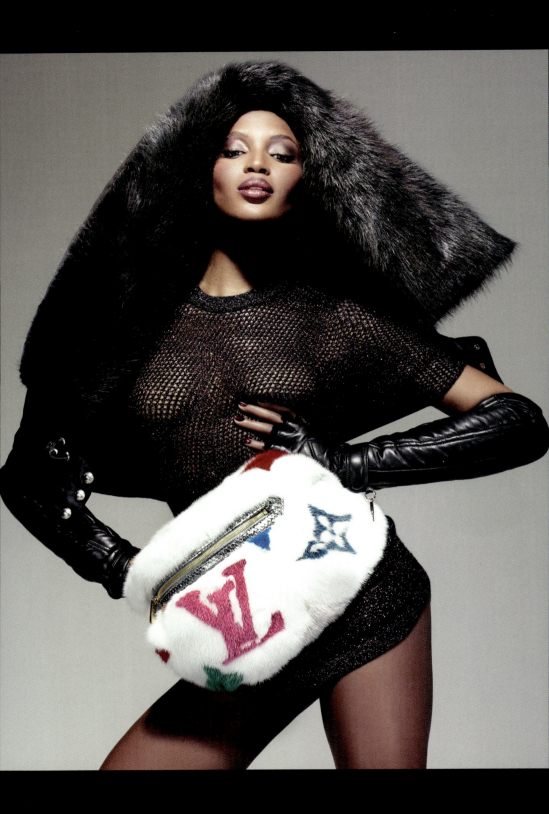

Above and opposite: Naomi Campbell and Kate Moss starred in the Louis Vuitton F/W 2006 campaign, shot by Mert and Marcus and styled by Grand. The leopard print worn by Moss was created for Vuitton by Stephen Sprouse, one of many collaborators recruited by Jacobs to lend their eyes to the house's clothes and accessories. Jacobs's innovative approach to collaboration has inspired countless other designers, including Kim Jones, current artistic director of the Louis Vuitton men's collections, who on page 119 discusses the influence of Jacobs's time at Vuitton on his own collaborative vision for the house. In addition to collaborations with artists, Jacobs's tenure at Vuitton was defined by his association with iconic female actresses, models, musicians, and fashion figures. Jacobs dedicated his final show for Louis Vuitton, S/S 2014, to "the women who inspire me and to the showgirl in every one of them," name-checking Grand and Moss alongside Cher, Grace Coddington, Madonna, and Anna Wintour.

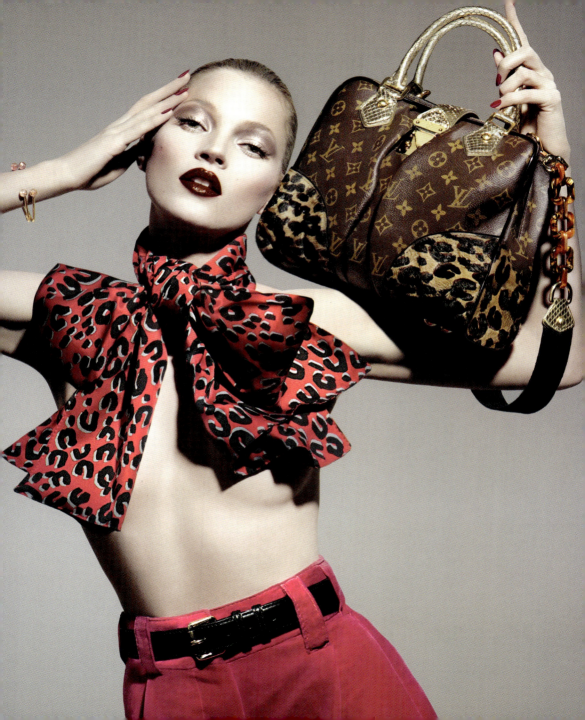

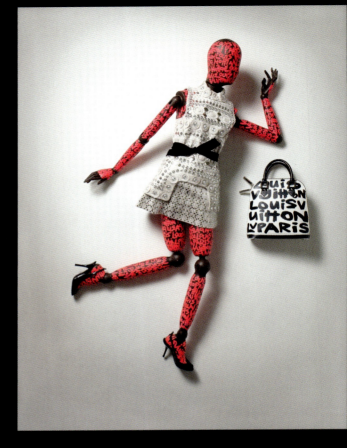

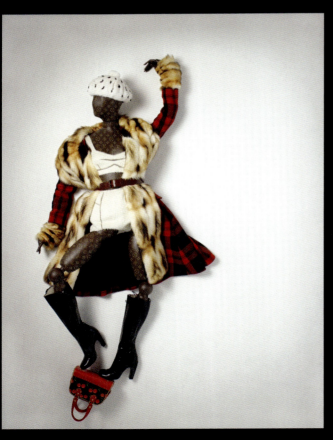

In 2011, Grand curated *The Art of Fashion* at La Triennale in Milan to celebrate thirteen years of ready-to-wear Louis Vuitton. Catalogue images by David Hughes showcase some of the thirty-plus silhouettes put together by Grand using pieces from different seasons. **This page, clockwise from top:** A monogram sequin dress from F/W 2000 matched with a mink scarf from F/W 2004, a Leonor bag from S/S 2004, a cap from S/S 2000, and sandals from S/S 2009. An embroidered wool dress from the Russia-inspired F/W 2001 show, styled with Graffiti Alma bag from S/S 2001, made in collaboration with Stephen Sprouse, and sandals from S/S 2003. A wool mohair underwear set from F/W 2002, worn with an ermine fur hat and skunk fur and wool coat from F/W 2004, a Monogram Cerises Fermoir bag from S/S 2005, made in collaboration with Takashi Murakami, and boots from F/W 2001. **Opposite, top:** A denim and sequin patchwork jacket from S/S 2005, styled with a T-shirt and Bowly bag from S/S 2007, hand-embroidered shorts from Cruise 2007, made in collaboration with Judy Blame, a cap from S/S 2000, a mink bum bag from F/W 2006, made in collaboration with Takashi Murakami, and clogs from S/S 2010. **Opposite, bottom:** The same mannequins were used by Grand and Hughes for a shoot for *Love* magazine to publicise the exhibition. Here, it's styled in a nurse's hat by Stephen Jones for Louis Vuitton from the S/S 2008 collection, a collaboration with Richard Prince, a Liberty print dress from S/S 2007 and shoes from S/S 2001.

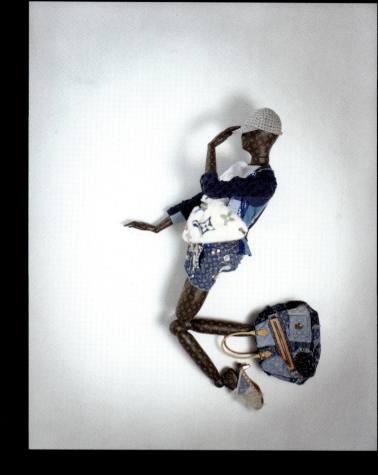
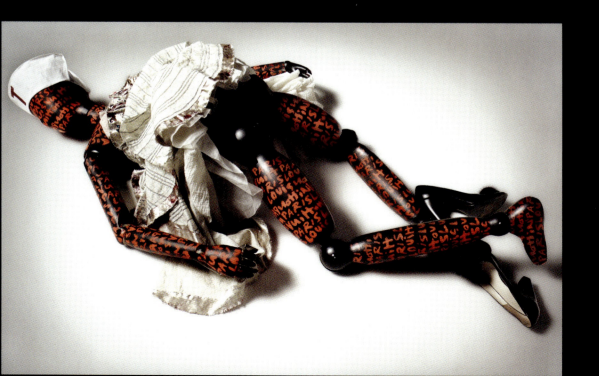

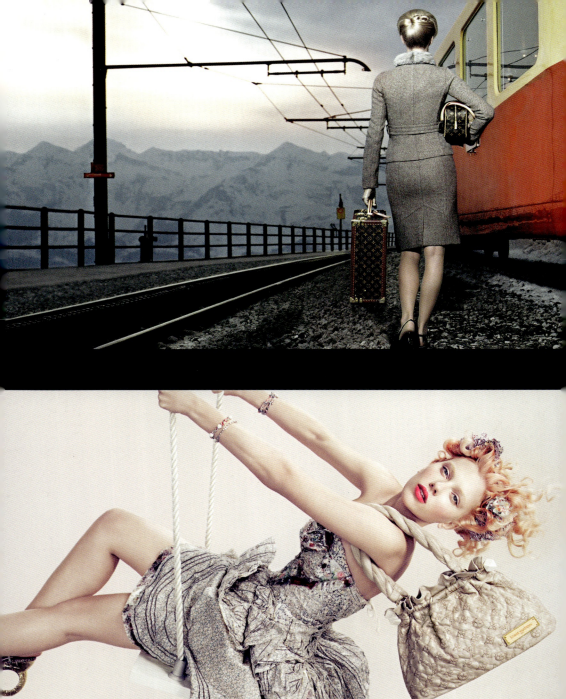

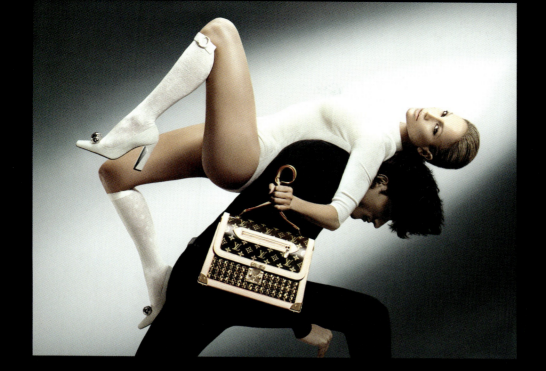

"While you were working with photographers like Mert and Marcus, with the clothes made by the Vuitton studio, you knew that you could make, say, Jennifer Lopez look the best she was ever going to look," comments Grand. Jacobs and Grand's tenure at Vuitton saw numerous famous faces recruited to front the house's campaigns. Grand acknowledges that she is more obsessed with pop culture than Jacobs is, but he "entertains her." All the campaigns on this and the opposite page were shot by Mert and Marcus, whose playful yet glossy imagery for the brand became synonymous with Jacobs and Grand's Louis Vuitton aesthetic. **Opposite, top:** Grand's first campaign for the house: Eva Herzigova, shot in Switzerland for F/W 2002. **Opposite, bottom:** Scarlett Johansson for S/S 2007. **Above:** Jennifer Lopez for F/W 2003. **Below:** Eva Herzigova for S/S 2003. **Following pages:** Angela Lindvall, Claudia Schiffer, Naomi Campbell, Natalia Vodianova, Eva Herzigova, and Stephanie Seymour for Louis Vuitton S/S 2008, also shot by Mert and Marcus.

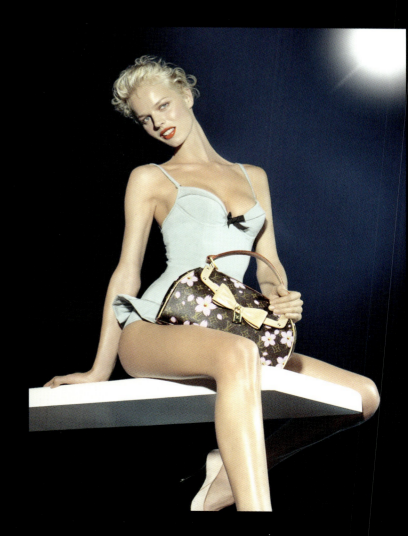

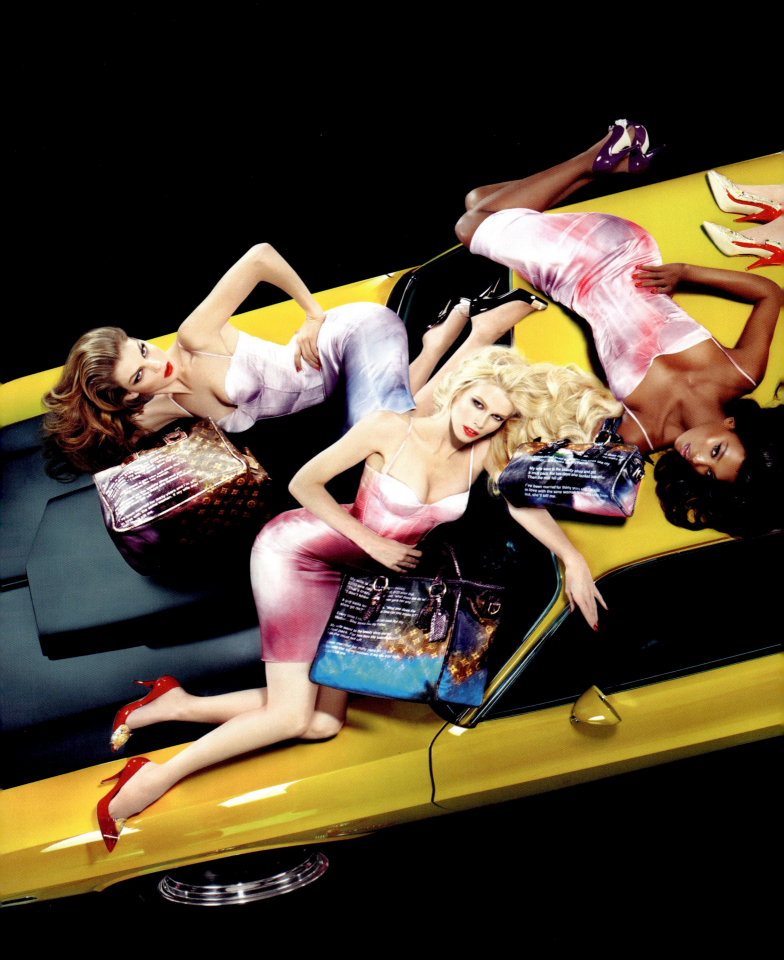

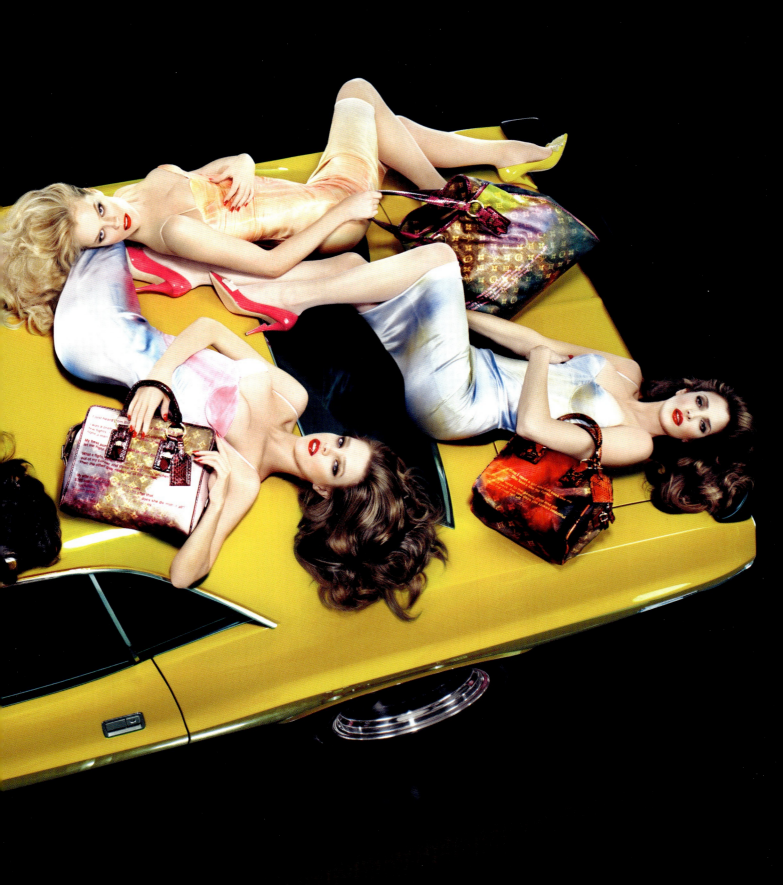

Above: Grand launched style magazine *Love* in 2009. Jacobs has contributed regularly to the title, often providing bespoke clothing. The title's first cover star was singer Beth Ditto, shot by Mert and Marcus. Inside, Ditto (left) appeared in a Louis Vuitton necklace and a feathered skirt made especially for the magazine by Jacobs's Louis Vuitton studio. One of many other pop culture icons to feature in the title was model Kelly Brook (right), who, shot by Mert and Marcus, appeared nude save for a Marc Jacobs stole in issue four.

Below: A gaggle of Jacobs and Grand's famous friends came together for the S/S 2016 Marc Jacobs campaign, shot by David Sims. Featured here are (top, left to right) Shelby Hayes, Karly Loyce, Veronika Vilim, Emily Ratajkowski, (bottom, left to right) Matty Bovan, Sky Ferreira, Sara Choi, Alice Metza, and Jamie Bochert; Bette Midler, Christina Ricci, and Lana Wachowski also took part. Jacobs called the images "a personal diary of people who have and continue to inspire me and open my mind to different ways of seeing and thinking… a celebration of my America." **Right:** The accompanying note, written by Jacobs, refers to a graffiti sweatshirt from the S/S 2016 show, made in collaboration with designer Matty Bovan, a protégée of Grand's, who also appears in the campaign.

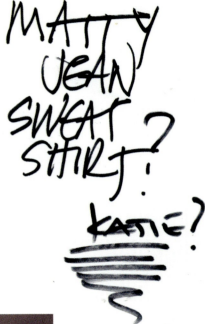

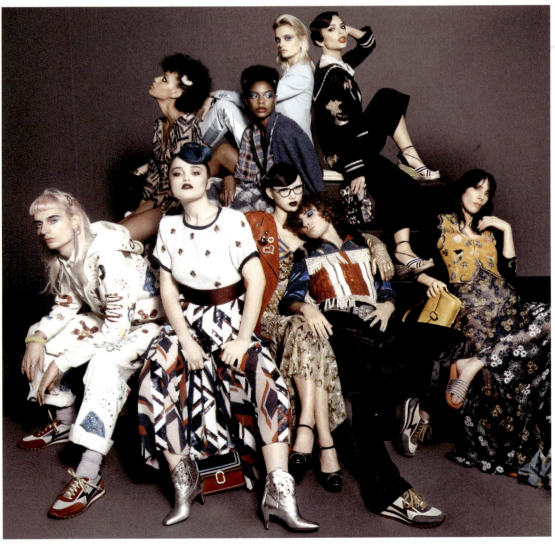

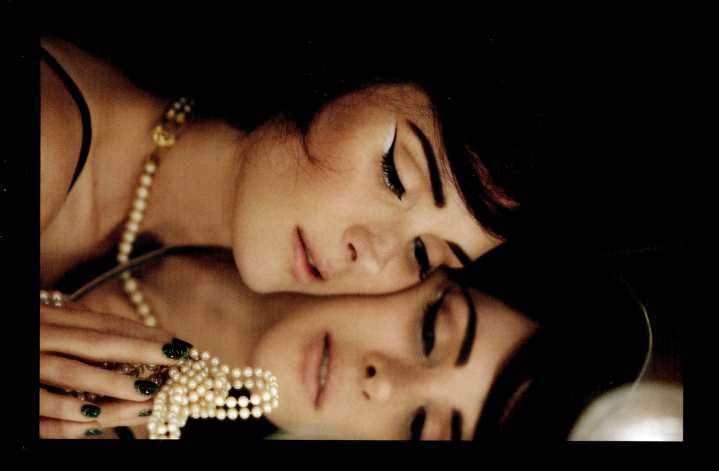

More famous faces: Jacobs's long-time friend actress Winona Ryder
(above) in the Marc Jacobs S/S 2016 beauty campaign, and musician and
actress Miley Cyrus (opposite) in the label's S/S 2014 campaign, both
shot by David Sims and styled by Grand.

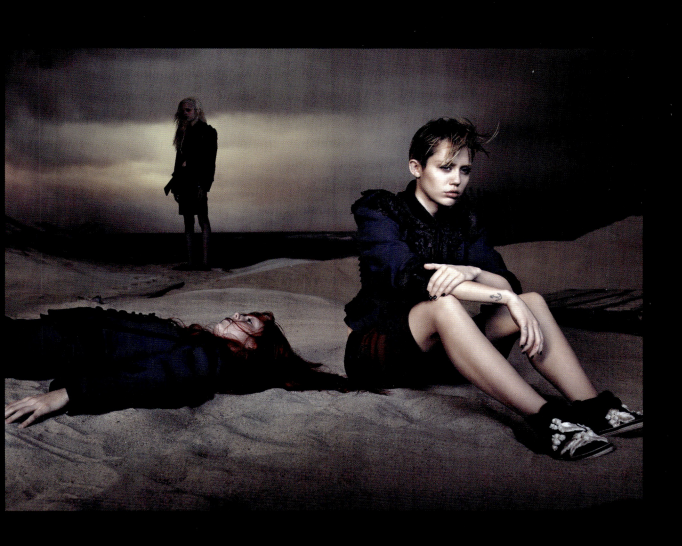

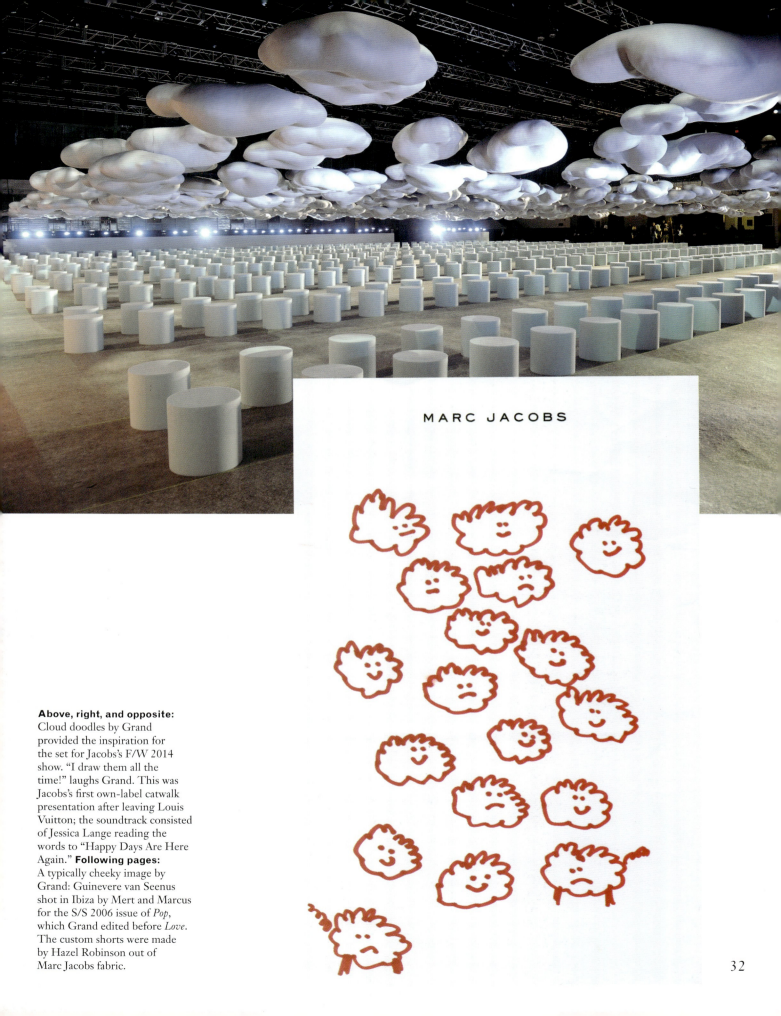

MARC JACOBS

Above, right, and opposite:
Cloud doodles by Grand
provided the inspiration for
the set for Jacobs's F/W 2014
show. "I draw them all the
time!" laughs Grand. This was
Jacobs's first own-label catwalk
presentation after leaving Louis
Vuitton; the soundtrack consisted
of Jessica Lange reading the
words to "Happy Days Are Here
Again." **Following pages:**
A typically cheeky image by
Grand: Guinevere van Seenus
shot in Ibiza by Mert and Marcus
for the S/S 2006 issue of *Pop*,
which Grand edited before *Love*.
The custom shorts were made
by Hazel Robinson out of
Marc Jacobs fabric.

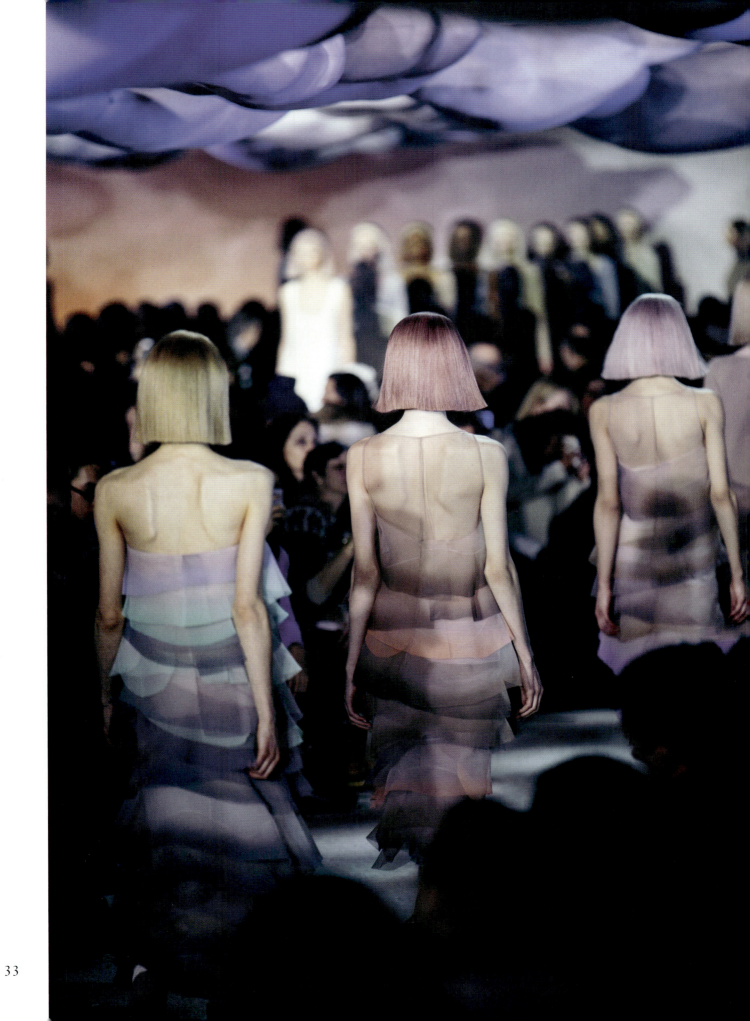

Partners in life and work, **Rick Owens** and **Michèle Lamy** joke that they were brought together by transvestites. Their shared interest in club culture, performance, and fetish runs through much of their output, notably Owens's dynamic, emotive catwalk presentations. The Californian fashion designer met Lamy in 1990 in Los Angeles. Lamy, who is French, gave Owens his first break in fashion, employing him to work on her menswear collections when she ran her own eponymous label. At the same time, she had a French bistro, Café des Artistes. There, the pair regularly socialised with an eclectic mix of artists and performers, which sparked their interest in theatricality. In 1994, Owens started his own label, selling exclusively in Los Angeles. After securing investment for international expansion, Owens relocated to Paris in 2003, setting up home with Lamy in the 7th arrondissement. This space and their physical appearances are indistinguishable from their output—Lamy is famous for blackening her bejewelled fingers with ink and drawing a black line down her forehead, pointing towards her gilded teeth. The pair married in 2006. Today, Owens designs his fashion collections in a solitary way, but he collaborates closely with Lamy on Rick Owens fur and furniture.

Rick Owens and **Michèle Lamy**

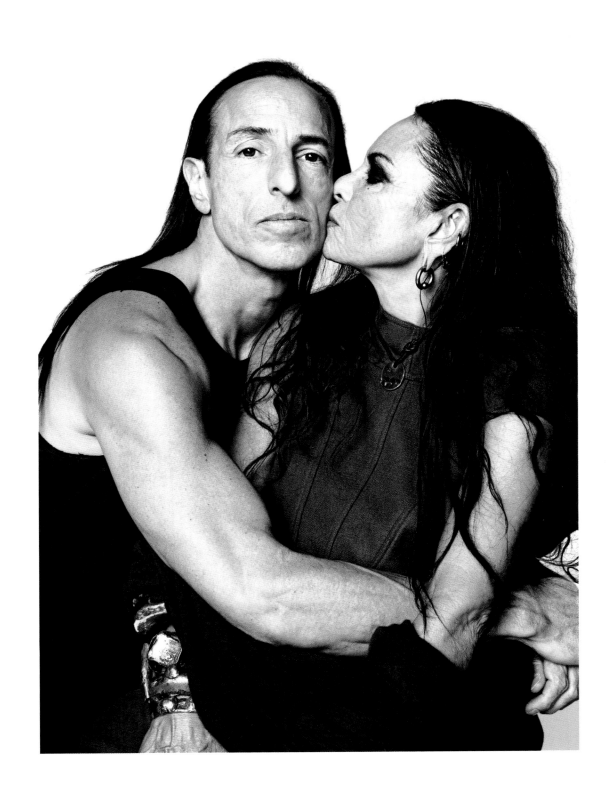

Owens and Lamy, whom he nicknamed "the Hun,"
shot by Danielle Levitt in January 2016.

How do you work together?

Rick Owens: The furniture is the first way we started working together. Although the fur did precede that. But the furniture is where the collaboration is more tangible.

Michèle Lamy: We have been together for nearly thirty years. He is an Olympian and I am a Deleuzian. There are lots of thing that we do together—some of them don't need to be relayed to you! But the furniture is a good place to start when discussing our work together.

Owens: We complement each other. I'm about arriving at the destination from point A to point B with the straightest line. And Michèle is about enjoying the journey.

Lamy: The journey is important because on the way to the destination you can get ideas for something else.

Do you actively try to split things so you have clear remits?

Owens: Absolutely, and we've had to negotiate, because it can get problematic. Take the fur area. I don't really get involved in the studio because, "Too many cooks in the kitchen," and that's Michèle's kitchen. So I talk to Michèle about things—she and I discuss matters, but then she goes to her kitchen and does her thing. And it's the same with the furniture. Well, maybe a little different.

Lamy: I would say that I am the . . .

Owens: The developer?

Lamy: Yes. I always try to make it Rick Owens adjacent.

Owens: We'll consult. And often Michèle will take her pick from something she has seen in the previous season and then she'll develop that. Sometimes without really even talking to me.

Lamy: Even though it's been nearly thirty years, we still struggle.

Owens: It's true! Sometimes there are conflicts, and I do think we should have figured things out by now!

Lamy: At the same time, it feels very alive. The furniture is not my only role. Like I wear neoprene socks, and then if you look at his collection—there are neoprene shoe socks.

Owens: [Laughs] Yes, I'll look at what she does and then knock it off!

Lamy: I just meant to say that there is a bit of balance.

Owens: Clothes are an area I can't share. I have to think very selfishly, and I don't think about anything else apart from my own thoughts. Obviously, you are influenced by everything. But, I have found over the years that I can't take anybody into consideration except myself. I have to think "what do I really want?" or "what do I think is right?" because otherwise I'll just get distracted, and I won't know whose advice is the best advice. I have to go to the beach for a week and not talk to anybody about it. Nobody sees the stuff until just before it gets on the runway, because I can't get distracted. I'm kind of passive, so if somebody raises an eyebrow it can skew things.

Lamy: Talking about collaboration is complicated, when you've lived together for twenty-seven or twenty-eight years. He will never come to me and say, "I'm stuck on T-shirts." It's more innate.

Do you think of yourselves as having the same mind?

Lamy: Not the same mind!

Owens: A little bit, though! Introducing Michèle as my wife always sounded a little awkward to me. I always preferred saying "my better half," because it's charming for one thing. But it's also true. You find a mate who's going to complement the parts of you that are missing, and that's what both of us do, because Michèle left to her own devices would be in a tent in the wilderness.

Lamy: Yes. With lots of stuff!

Owens: She'd be leaving a trail of destruction behind her. Leaving burnt ashes behind her.

Where would you be without Michèle?

Lamy: Your studio.

Owens: I would be in a very chilly, sterile place. I wouldn't be here talking to you. I would be very isolated and very closed off.

You regularly say that you are an introvert and Michèle brings the extroversion. Did you realise how opposite you were when you met each other, or has that developed more and more?

Lamy: He was twenty-five when we met. Imagine!

Owens: No! I was twenty-seven.

Lamy: We are not going to fight about the date. The date doesn't matter.

Owens: You're right.

Lamy: I'm the one who spied or discovered or realised the talent he had.

Michèle, were you running the restaurant when you met?

Lamy: No. I had a clothing company that I had for ten years in L.A. After that I had a restaurant. I've done a lot of things! Don't ask me about all the things I've done or you'll think I'm schizophrenic.

Do you remember the first time you met?

Lamy: I have this friend—he was a stylist. He's still our friend. I asked him to come and work for my company and do some men's clothes. He told me, "I cannot do it alone—I don't know how to do it, but I met this fabulous guy."

Owens: Yes he said, "I can't do it without a pattern maker."

Lamy: I said fine, we will get a pattern maker. And they did a fabulous collection, it was like a revolution. But then Rick came to me and said that my friend could not do anything at all and he wanted to do the collection alone. And like that scene in *Morocco* with Marlene Dietrich with Gary Cooper throwing her shoe, I told my friend to go!

Owens: I betrayed my friend!

Lamy: I feel that I discovered everything! I was super impressed. It killed two birds with one stone. It killed me, and it killed my friend. It was a big shock. We were killed and rebirthed at the same time. So we started again and here we are.

Owens: I simply did what I had to do to get on top! [laughs]

What was your first impression of Michèle when you met her?
Owens: Well, everybody's impression—she's got a little something, right?
Lamy: We were coming from different places, and then we realised what we had in common were our transvestite friends. I had transvestites living in the house!
Owens: It's true—transvestites brought us together.
Lamy: I mean I had a daughter—Scarlett [Rouge]. And my friends would say, "Your life makes it so difficult to find a relationship." But we had the clubs in common.
Owens: Our first date was at Water the Bush, and I almost got killed by some gang member. We went dancing at some gang place. The bar was on Hollywood Boulevard. I remember I had an Evian bottle full of vodka in my pocket. I stumbled on some guy while we were dancing, and he was kind of creepy. And I remember another one of our first dates when—
Lamy: Oh my God—the police.
Owens: It was very romantic! In downtown L.A. there is a river, so there's a way that you can drive down into the river, and it's like a big canal. So we were driving around and drinking beer.
Lamy: Was I?
Owens: Well, you were sipping it. And then the police had their lights on us and we had to put our hands up through the rooftop of the car, and then they found more booze in the car, and they said, "Just get the fuck out of here. It's too dangerous. Just get out." And they let us go!
Lamy: Because they thought I was a lady!

You've said in interviews before that you'd never had a proper relationship before you met Michèle.
Owens: Well, yes. I'd never lived with anybody. I'd never considered myself in love with anybody. Michèle has been married three times.
Lamy: The others were not important. It was a way to travel the world.

How do you separate the work from you as a couple. Or do you not separate it? Do you have to live it all the time?
Lamy: We'd kill ourselves if we were thinking, this is work and this is that. It was not like one wanted to make babies at home and the other wanted something else.

People find it quite hard to describe what someone in your role, Michèle, does. It's interesting that you said "developer" before. People often call you a muse. Do you find that quite annoying?
Lamy: I think they should Google "muse," because people say that a lot. But I think people just say it when they don't know what to say. Etymologically it implies someone who lounges around. That's not what I do. It's better to escape this word.
Owens: But you won't, so you'd better get used to it. Like I had to get used to "Goth." I think it's more

"mate" than "muse." "Mate" suggests you are doing something together.

Michèle, given that you had your label first, are you frustrated when people focus on Rick and then paint you as the mere muse?
Owens: If I were in Michèle's position, I would get irritated. So I assume that sometimes it's annoying.
Lamy: It does not irritate me out in the world. The irritation is with him. Because we have been together for so long, I have the feeling that people think I'm not doing anything or I don't know what I'm doing. But there is always the tribe.

I think when a woman has a complex, indefinable role in a relationship, people can't explain it so they rely on stereotypes—they think of her as a passive muse.
Owens: I don't think anyone would ever think of Michèle as a passive muse. I think that's why she sparks people's interest—because she doesn't fit the typical role of a muse.
Lamy: I can be proud of that. That's why I don't get annoyed that the name is Rick Owens. What does it mean to know each season who decided what? We see the bigger picture.

Did you used to hang out with each other in the restaurant all the time?
Owens: Yes, we were living together by the time the restaurant had started. It was our dining room.
Lamy: The restaurant was our dining room, but it was also a melting pot for our world. That was my little theatre.
Owens: The whole thing has always been about how to have a good time. How can we enjoy our life and have beautiful dinners with the right silverware? It's still about that. A lot of times the clothes are just my poetic fancies on my own, and then sometimes they are more about our life. The furniture is very much what we want to live with. It's our dream environment.

The brilliant fashion journalist Jo-Ann Furniss once said to me that you're like Ralph Lauren, because you're a lifestyle brand.
Owens: She's said that to me, too! It's funny because I was always horrified by Ralph Lauren trying to pretend to be WASPy gentry. I've been repelled by that whole snob fantasy. It's the most pretentious thing. And then I realised—
Lamy: That we are doing the same thing?
Owens: I realised that I'm a fifty-two-year-old man trying to pretend that I'm a sixteen-year-old skate punk and I'm just as fake as Ralph Lauren is. I have my own kind of ideal that I am trying to emulate. Everybody's as fake as Ralph Lauren. I'm just as bad.
Lamy: No, no! He's not just as bad! We have to figure out why this is more authentic, because it is.
Owens: You know why—because it's more tongue-in-cheek. It's more campy. It's a little bit more ironic and it's a little sillier. It doesn't take itself as seriously.

The people who buy your work are so committed to you.
Owens: You're right. You can buy great clothes in
UNIQLO. If I were a young person, that's where I'd
shop. But labels are very much about buying into
a poetic vision and being part of something.

What do you think people see in your vision?
Owens: If I could find it, then I could put it in a
bottle and sell it, which I kind of do! But the recipe is
unknown. That mystery is the magic of fashion.

*It's like a relationship in that sense. You can't work out why
it works.*
Lamy: Yes.
Owens: Well, I can. I mean who else on earth could
possibly be the right person for me? [laughs]

*Do you ever come across a piece in your archive, furniture or
whatever, and find you can't remember whose idea it was? Do
you ever fight about that?*
Lamy: No—because he always thinks that the idea was
his! [laughs] Like the sock shoe! But we are aesthetically
destined.
Owens: Probably. Yes.

—

This interview took place on June 14, 2014, over
brunch at Claridge's hotel in London.

Opposite: Owens and Lamy live together in Paris in the 7th arrondissement. Their house is full of furniture
of their own design, as well as artworks they've collected. The Rick Owens furniture line began out of
necessity for the couple's personal use—the first piece they created was their bed—and then developed into a
significant project on which the designer collaborates closely with Lamy. Here, their pieces sit inside their home
alongside an urn by Georges Hoentschel and a large mural by Scarlett Rouge, Lamy's daughter from a previous
relationship. **Following pages:** Drawings of Owens, Lamy, and other figures by Benoit Barnay, who met
Owens when he worked for him as a model. Lamy took Barnay under her wing and let him stay for a spell in
the house she shares with Owens. As an expression of thanks, Barnay drew for her, and those drawings became
central to Owens's S/S 2015 collection, which featured them embroidered on canvas tunics.

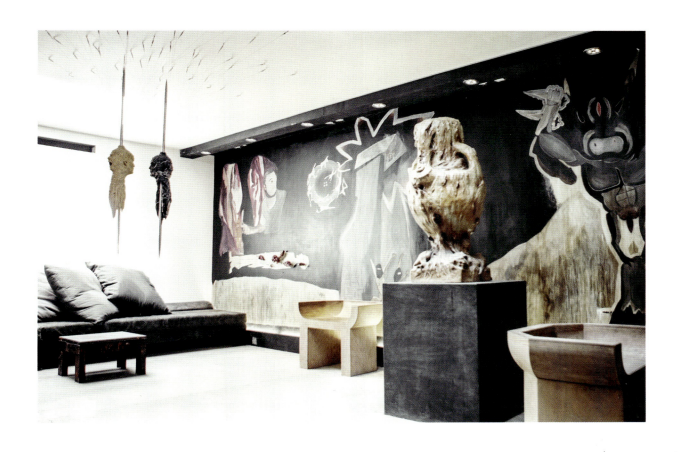

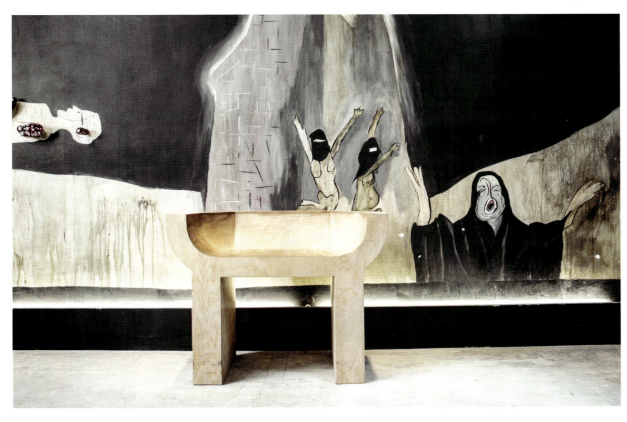

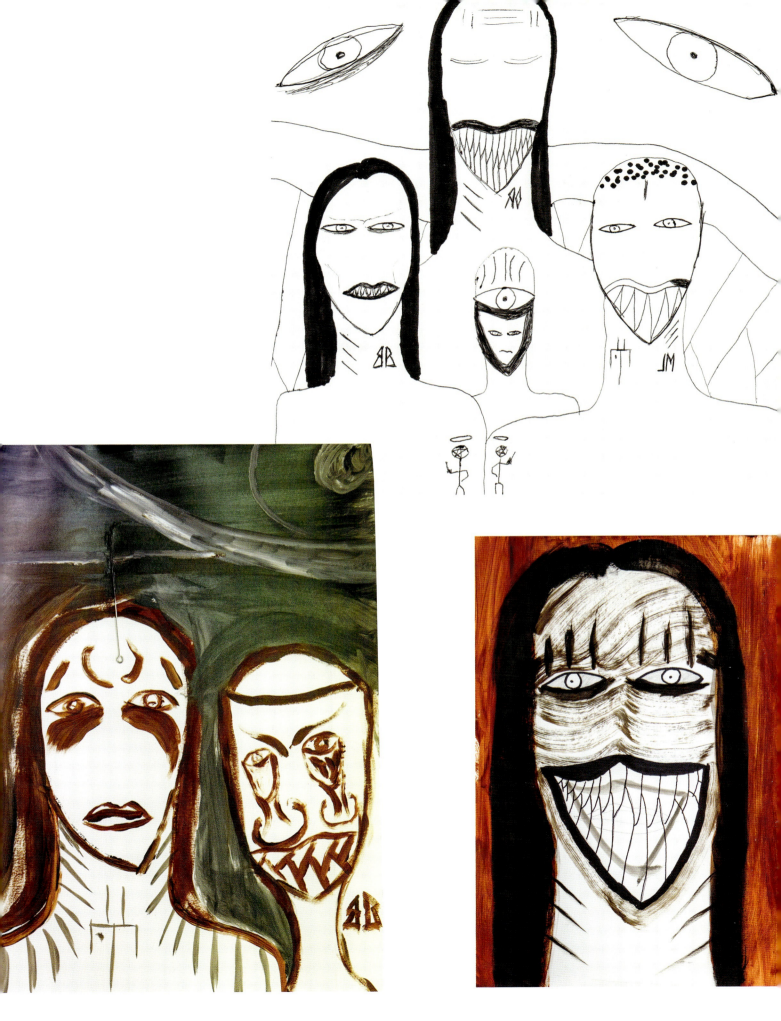

16

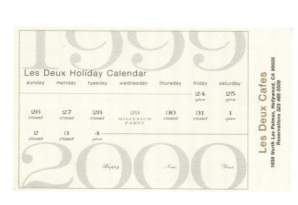

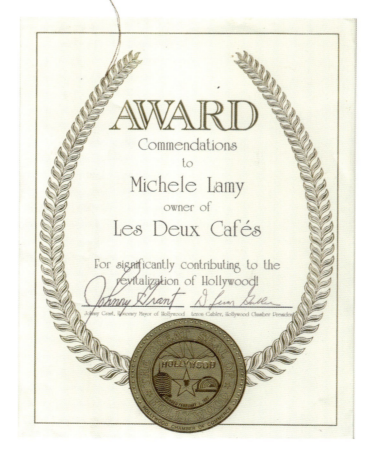

LES DEUX CAFÉS

MICHELE LAMY

..AS PALMAS HOLLYWOOD CALIFORNIA 90028
323 465 0509

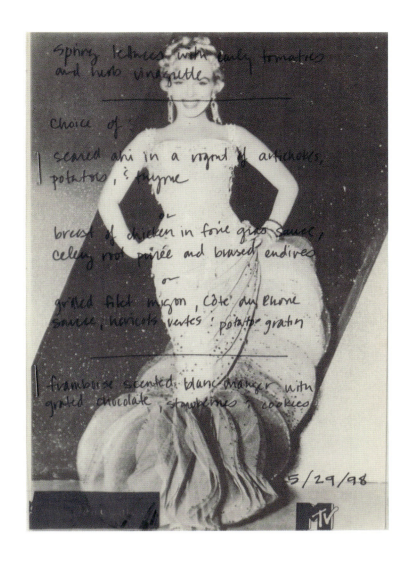

spring lettuces with early tomatoes
and herb vinaigrette

choice of

seared ahi in a ragout of artichokes,
potatoes, & thyme

or

breast of chicken in foie gras sauce,
celery root purée and braised endives

or

grilled filet mignon, côte du rhone
sauce, haricots vertes & potato gratin

framboise scented blanc manger with
grated chocolate, strawberries & cookies

5/29/98

MTV

LES DEUX CAFES
WILL BE CLOSED
ON CHRISTMAS DAY
DECEMBER 25

JOIN US ON DECEMBER 24
FOR A CANDLELIGHT,
OUR FAMILY LIVES TOO FAR
AWAY, LET'S VISIT OUR
FRIENDS AT LES DEUX
AND WAIT FOR
SANTA BY THE FIRE
CHRISTMAS EVE DINNER

RESERVATIONS
323 465-0509

1638 N. LAS PALMAS HOLLYWOOD CALIFORNIA 90028

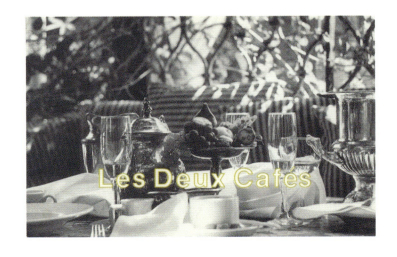

Les Deux Cafés

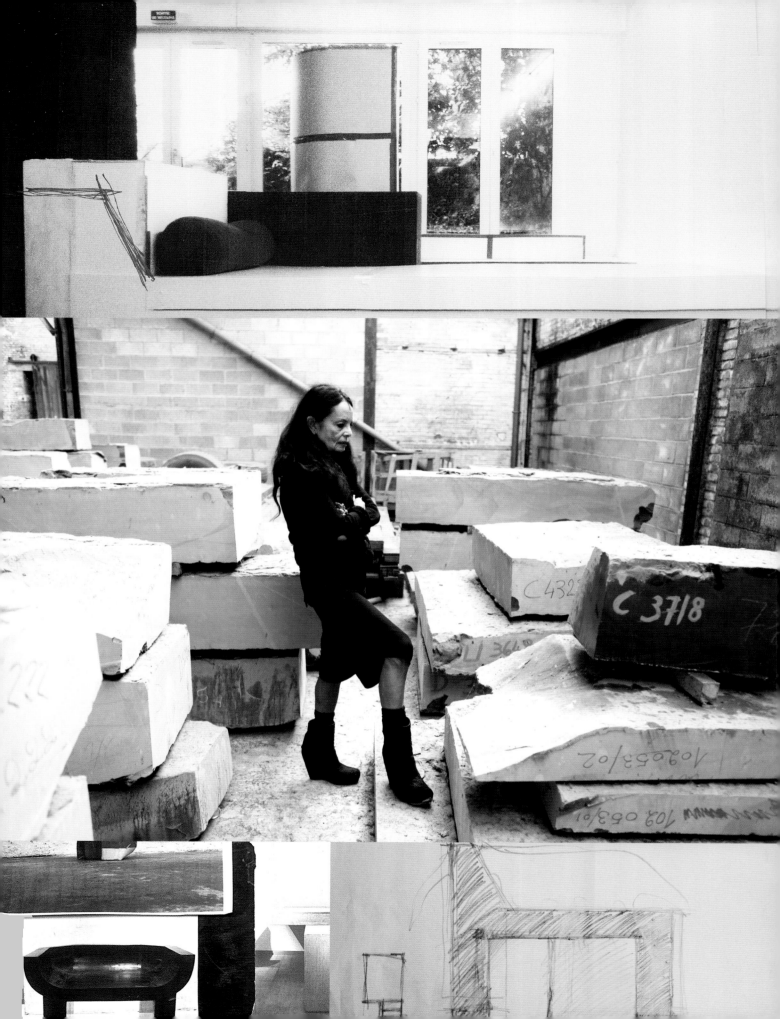

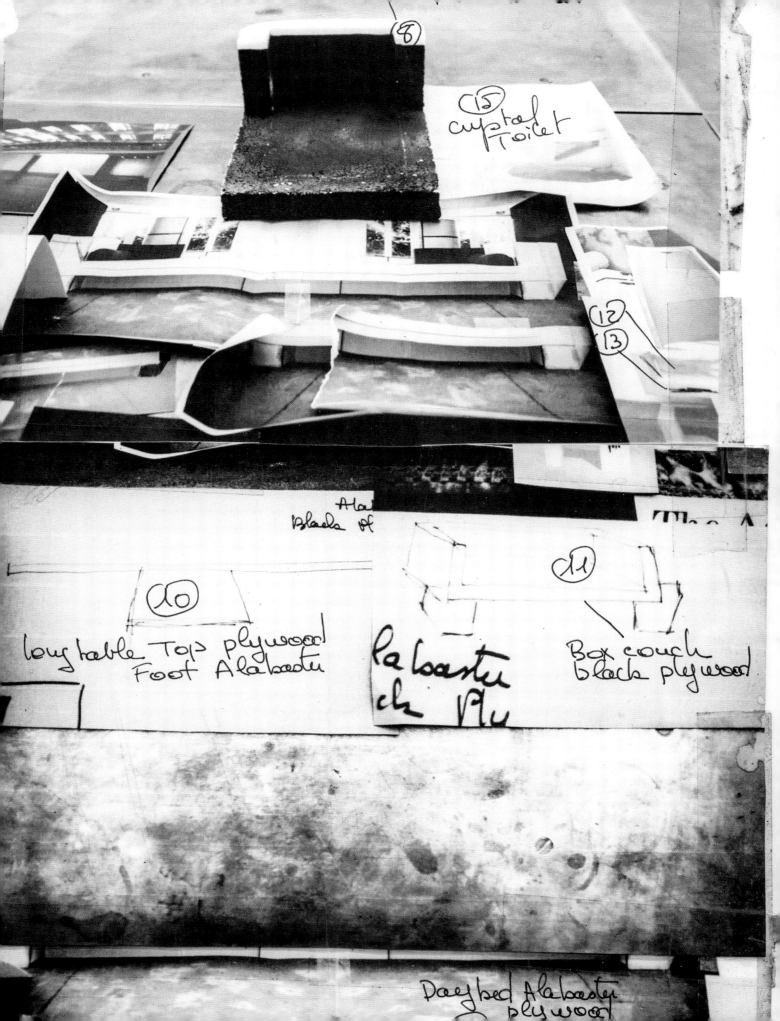

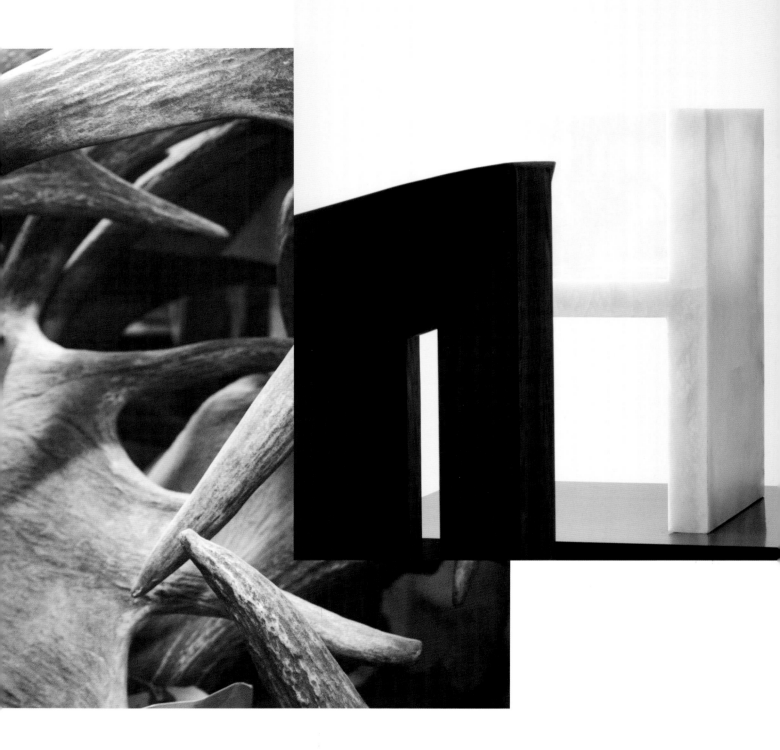

Owens describes his furniture as the place where his collaboration with Lamy is "more tangible," although the pair also work together on his furs. He describes the furniture as Lamy's "baby." **Pages 46–49:** Design sketches for Rick Owens furniture pieces and finished works. **Page 46, middle:** Lamy surveys materials, photographed by Matthieu Bredon-Huger. **Above and opposite:** Moose antlers, regularly used by Lamy and Owens on their signature chairs and stools. **Page 50:** Rick Owens furs. **Page 51:** Owens and Lamy take in the scene in their furniture studio in this image by Adrien Dirand.

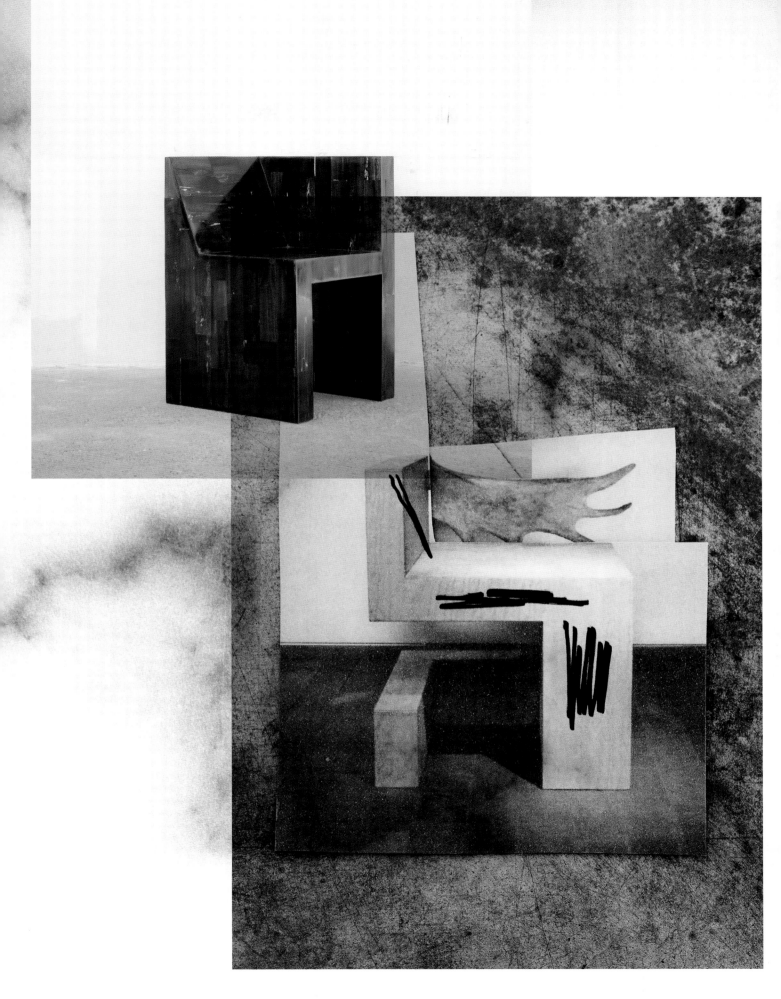

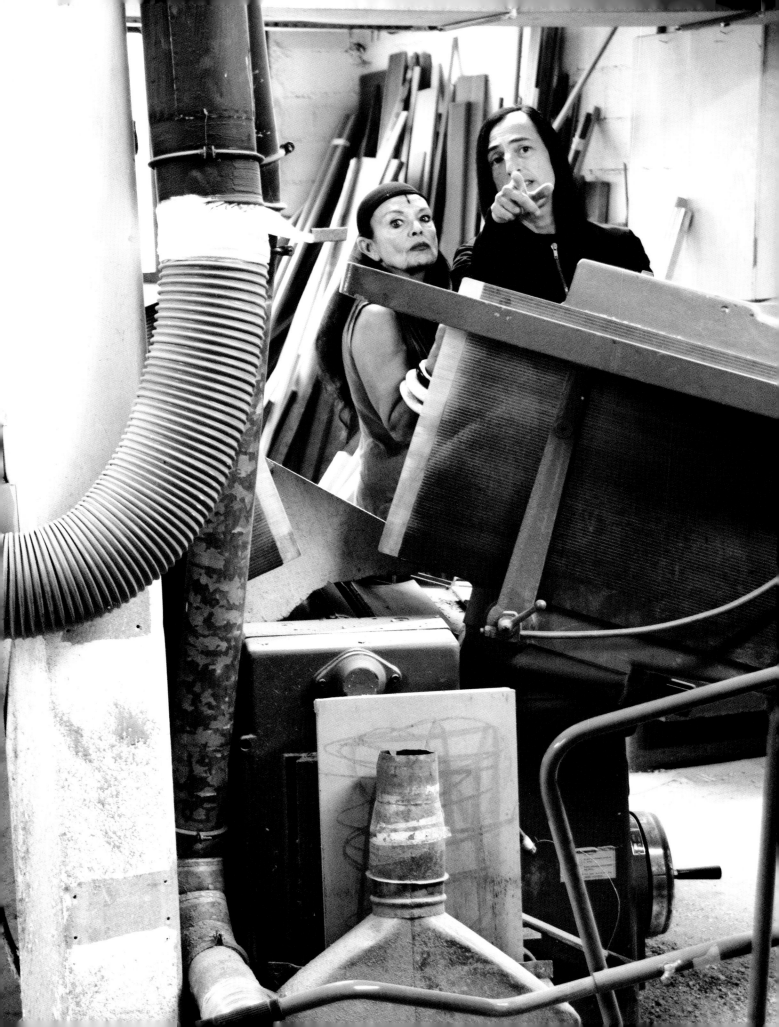

Neither image-maker **Nick Knight** nor style icon **Daphne Guinness** gravitates towards the commercial side of fashion. The former is known for questioning fashion's accepted vision of beauty and, over his nearly forty-year career, for shooting women and men with disabilities; breast cancer survivors with visible scarring; blood-splattered fighters; and models who are fluid in their gender identities. As a patron of fashion, Guinness supports those who defy typical notions of femininity and elegance, championing designers such as Gareth Pugh and Alexander McQueen, individuals with whom Knight also collaborated regularly. Both Knight and Guinness have a distinctly British sensibility, an interest in tradition, and an instinct for how rules and regulations can and should be broken. Their collaborations are well documented on Knight's fashion website, SHOWstudio.com, an experimental not-for-profit platform founded in 2000 to support fashion film and live media. In 2013 the pair united for *Splash!*, an ambitious live-streamed project conducted in collaboration with designer Iris Van Herpen. Knight used high-speed cameras to capture Guinness being splashed with black and clear water and then offered up a carefully chosen still from the footage to Van Herpen to use as the inspiration for one of her signature water dresses. The one-off dress, which looks like water hitting the body, was then displayed at SHOWstudio's London gallery. In 2012 the pair worked on *Visions Couture*, a set of films showcasing haute couture garments and pieces from Guinness's own wardrobe. The works featured singing by Guinness and were displayed in the windows of the flagship Printemps department store in Paris, alongside sculptures of Guinness created using 3-D scanning technology. Many of Knight and Guinness's projects have come from a shared interest in the interplay between science and art and a desire to question and shape the media in which they choose to work.

Nick Knight and **Daphne Guinness**

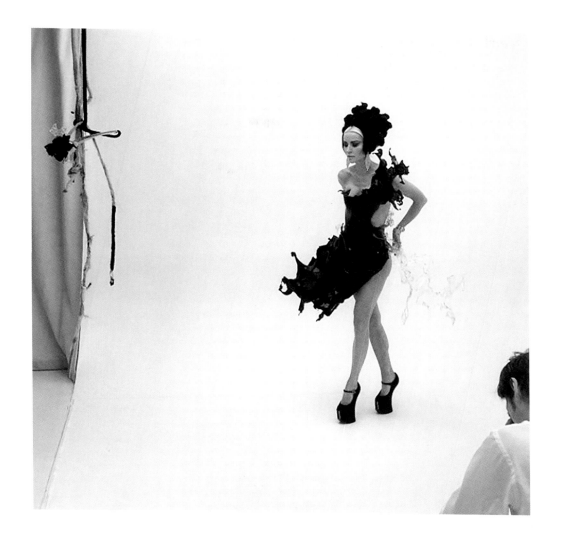

Knight shoots Guinness in a custom dress made by Iris Van Herpen in 2013. The project, titled *Splash!*, was streamed live on SHOWstudio, Knight's fashion platform.

How did you meet?

Nick Knight: I knew of you, Daphne, through Lee—Alexander McQueen. I think the first time I remember actually meeting you was after a Lady Gaga concert. We all went to a Chinese restaurant.

Daphne Guinness: It was her birthday.

Knight: They had a whole floor upstairs. You came with Philip [Treacy].

Guinness: It was just after Lee died.

Knight: But I met you again at a talk that John [Galliano] did with Amanda Harlech and myself and Colin McDowell. John was incredibly shy.

Guinness: He is so, so shy.

Knight: Yes, he wouldn't hold a microphone.

Knight: So it was myself, John, Amanda and Colin. And Colin is big and bombastic. John is shy. So Amanda and I were kind of picking up the slack. Colin would pose a question to John, and he would almost refuse to answer and I'd do it on his behalf.

Guinness: I was sitting there watching with Gareth [Pugh].

You have a lot of friends in common. Why do you think that is?

Knight: It's sort of creative planetary orbits.

Guinness: We all embrace the future.

Would you say that what first drew you together was those shared people, and then when you spoke it became shared interests?

Guinness: Yes. And physics. And music.

Knight: Daphne and I often talk about this—there is a such a disconnect between the arts and the sciences. They get taught and practiced so separately.

Guinness: What I would like to do is sponsor a class of kids who did both in the same class—physics and art together—because they are so connected. Or music and physics.

So, you're united by an interest in the science side of art?

Guinness: Your family come heavily from the science side.

Knight: True. Both my parents were scientists. My father was a psychiatrist, and my mother was a physiotherapist. Her father thought it was inappropriate for her, as a lady, to be a doctor, so she had to be a physiotherapist. But my parents never seemed to get pleasure through science—it came through the arts. My mother became a welder, so she would get bits of metal and weld them together and make interesting sculptures. She scandalised the family by insisting that she didn't want sheets or crockery for a wedding present. She wanted a welding kit.

Guinness: I don't blame her.

Knight: She also used to do abstract oil paintings. And my father, later in life, got involved in the antique trade. He was into pottery. My brother is a chemist.

Daphne, how did you get interested in the sciences?

Guinness: I just read lots and lots of books about quantum physics. I can't subtract or do anything practical like that, but I could do things like inverse flow diagrams.

Many of the projects you have worked on have a scientific aspect, such as the Iris Van Herpen Splash! project. You're also interested in interactives and 3-D scanning.

Guinness: I'd love to do more 3-D scanning. People haven't really crossed the new technologies with fashion. It does seem to be Fashion Week everywhere, but it's not about making things better. It's just redoing stuff.

Is this going to be a long-term collaboration?

Knight: I hope so. There are things I'd like to try with Daphne.

Guinness: There are some amazing technologies, but it's 2015, and we still don't have clothing that properly moulds to our bodies.

Fashion people are quite cautious, aren't they?

Guinness: Fashion has become about superfluous stuff. For example, hats used to be worn because they were needed to keep the head warm.

Knight: Now you get the sense that they are looking for a marketing tool to sell more dresses.

Guinness: I've sat in on those corporate meetings. It's just suits. I do think AIDS had a huge impact in the 1980s and 1990s on designers. It left things very imbalanced, and those who remained became very isolated.

Knight: I grew up during that period. After the war, the pill was invented, so women were no longer afraid to get pregnant. So in the 1960s and 1970s you have sexual freedom. Religion takes on less importance. There is an attitude of wanting a new world—that 1960s enthusiasm for the future. Then AIDS comes along in the 1980s and everyone becomes super cautious.

Fashion commentators often say that everything is getting less individual.

Knight: It has become very homogenous. It is sort of the Starbucks approach. It's about things being easy, convenient, slouchy. Nothing is challenging.

Nick, did Daphne's unique image attract you to her?

Knight: Yes. Actually, I remember when I first met Daphne I was visually fascinated by her. I was sitting and talking, and I remember thinking, "I'm not actually hearing anything. I'm just looking." As a person, she does propose a set of rather astounding visuals.

Do you remember what she was wearing?

Knight: No, because we were at that talk. But the next time, all the jewellery she was wearing struck me. Often she sits or gestures with her hands up around her face, and she had this huge blue ring that matched her eyes, her contacts. I think she had on a blue satin frock coat—unless I'm mixing that up with my Kate Moss/David Bowie *Vogue* shoot.

54

I don't want to say you see her as an "object," because of how that sounds, but is it something like that?
Knight: She is her own art form. She has a strongly defined visual presence.

Daphne, fashion is more than clothes to you, isn't it?
Guinness: I get upset when I think about the way fashion is operating. These big companies manufacturing things in Bangladesh and then selling them for 400 pounds. You just think of those poor people. Why not resuscitate the textile industry in England? I like to know where my clothes are made. That's why I like people like Noritaka [Tatehana] and Deborah Milner.
Knight: People will miss all those craftsmen when they are gone. There are people around right now who are the last to know their craft—once they are gone, so is their knowledge. You can never replace them; you can never get that skill back again. Like the man who makes my shirts, Frank Foster, who made shirts for the Beatles. He is ninety years old. He used to be a boxer in the 1940s.

Many of your projects with each other don't have a commercial end. Does that change them?
Knight: That's a very important point. However much I love Yohji Yamamoto or Lee McQueen or other people I have previously worked with, in the end you are fitting into a system that's about selling clothes. With Daphne, it's just about the joy of creating and the joy of trying things out.

So, it's purely because you want to and you can?
Knight: Obviously, there are times that you do work commercially. Printemps is a big department store, Roger Dubuis is watches. But that's not the reason we started working together, and we will continue to work together whether we are asked to or not. Luckily enough, people asking gives us an excuse, or even funds.

What makes a collaboration great?
Guinness: With Nick, the best thing is that I never know if I'm doing it right or not. I don't even know what "it" is, and I like that.
Knight: That's because you're doing it instinctively. But of course you are doing it right. You are super lovely to photograph. When I look at the camera, and I see the images and the shapes you propose, I hear something. I've said quite a lot that I don't really see things—I hear them. When I look through the camera at you, I can hear the melody, I can see the tune. I do find it very frustrating when we meet, because I think I'd love to take her photograph now, now, now.
Guinness: I've never thought of myself as someone who could appear that way to a photographer. I've thought of myself as small and, in a way, a tomboy.
Knight: You will push yourself to hell and back to get the image.

So, you're saying Daphne is fearless?
Knight: Yes. I know you'll go even further, and push my work even further.
Guinness: And it is the mistakes sometimes…
Knight: They show you the things you can't see.
Guinness: And sometimes they tie the story together.
Knight: Yes! I always say that a mistake is like a chink in the armour that's beautiful. I let things free-fall a little bit, because if you control everything perfectly, you never see those mistakes. And they're not really mistakes—just options you didn't suspect.
Guinness: They are happy accidents.
Knight: Sometimes the accident can be your best work.

You both collaborate a lot. Nick, you've worked with Yohji and Simon Foxton and Lee McQueen, as you said, and Daphne, you've worked with McQueen and Gareth Pugh and Antony Price. Why is collaboration so important to you both?
Guinness: It's family.
Knight: It's a nice thing to be able to see the world through Daphne's imagination or through Lee's imagination. To try to see what they see. It's such a privilege. People talk about teleporting, and I suppose collaboration is the closest thing I've known to that—you're almost entering someone else's body and understanding the world as them. That's why I want to work with so many different people, because trying to understand the world through John Galliano's eyes or through Daphne's eyes or Lee's, or all those people, offers a whole set of experiences that you become privy to, that you're allowed to see. You can see all the reasons that they became the people they are. It's a real honour to work with other people—with those people. I wouldn't want to work in any other way— otherwise it's like talking to yourself.

Do you have any specific goals?
Knight: There are some short-term things, but it's not really like that.
Guinness: I think I'll always be intrigued and inspired to work with Nick.
Knight: Life is extremely exciting and challenging. As soon as we walk out of this room, we'll feel something totally new that will change our minds. Through working more and more you put yourself in the position where that can happen more and more.
Guinness: I like to be pushed. With Nick I've been on a trapeze, I've been naked and splashed with water. So many people just do the beauty shot.

Perhaps when you work together it is harder to predict the result because it is harder to define your relationship. Nick, when you work with, say, Simon Foxton, he is the stylist and you are the photographer. With Daphne, there are no fixed roles.
Knight: That was about falling into a set of roles that are quite clearly defined—Simon is a stylist for a magazine and I'm a photographer for a magazine, so we know that we are working on a series of pictures for

a magazine. Daphne and I work together purely because of a shared set of interests. It's more about finding out about each other.

Guinness: Yes, and about seeing where it goes and what happens.

In fashion, however, most creative relationships are born out of those fixed roles.

Guinness: It's always been very natural between us. Often you feel restricted when you get on a shoot and people have too much of a plan. You can't do anything because they have a storyboard.

Knight: I never storyboard anything.

Guinness: Sometimes when other people are directing you in front of the camera, you almost want to say, "Look, why don't you do it yourself!"

Does it all come back to the unknown? Do you enjoy working together so much because you turn up and have no idea what is going to happen?

Guinness: Exactly.

Knight: We all know that sense of being moved ahead by desire.

—

This interview took place in the centre of Nick Knight's daylight studio in SHOWstudio's offices in London's Belgravia on July 23, 2014.

Above: Objects on Knight's desk at SHOWstudio's headquarters in Belgravia, London, include a sculpture of Guinness that he created using a 3-D scan of her body. The pair share an interest in new technologies and the interplay between science and art. Also on Knight's desk is his iPhone, which he regularly uses in lieu of a traditional camera, and a portrait of Sid Vicious shot by Bob Gruen in 1978. On the wall is another of Knight's sculptures, created using a 3-D scan of Kate Moss.

Opposite: Knight's first ever shoot with Guinness, commissioned to celebrate the glove she's wearing, a collaboration between Guinness and jeweller Shaun Leane. The 18-carat white gold and diamond evening glove, which references armour, took years to make and is titled *Contra Mundum*, meaning "against the world." This and other images appeared in *Telegraph Magazine* in 2011.

56

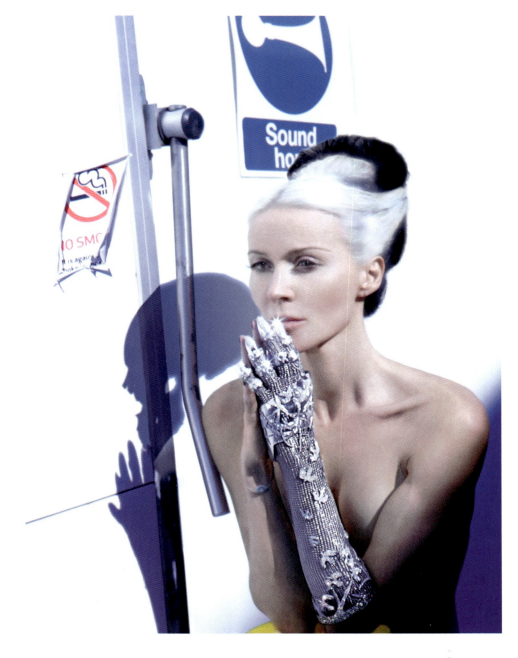

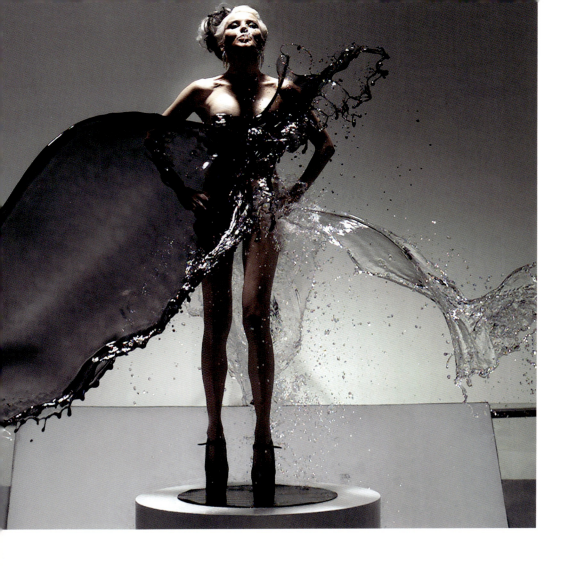

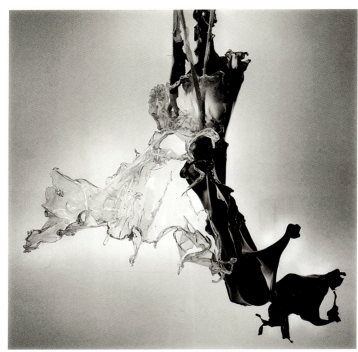

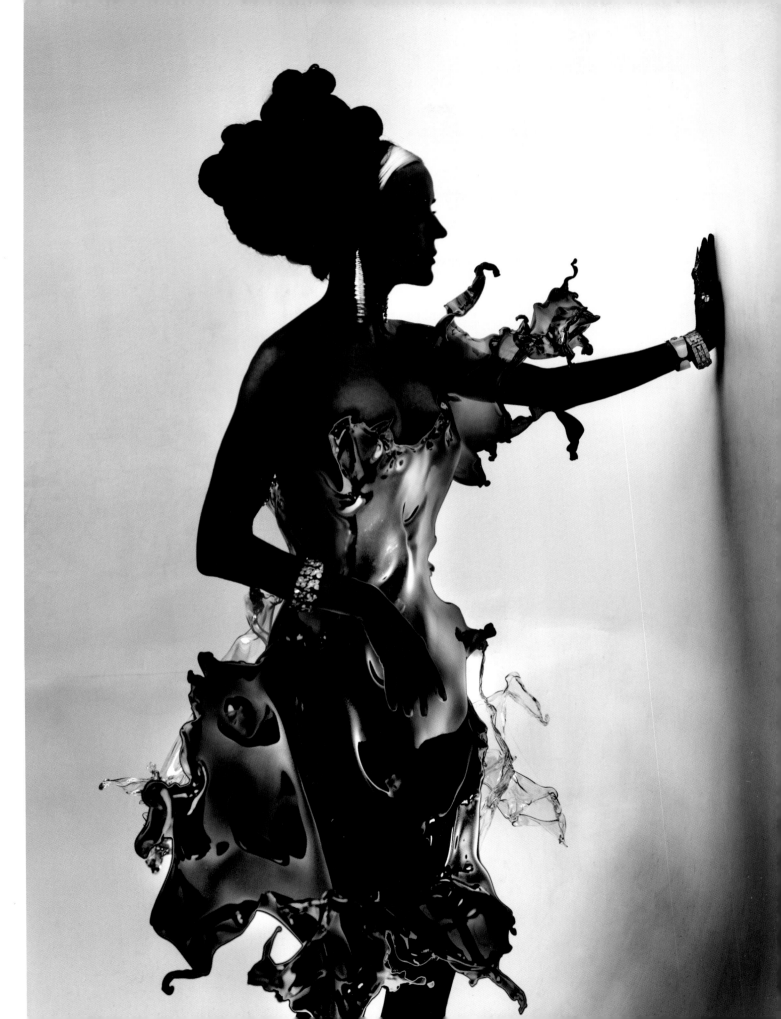

Fatal Flaw.
Love is a sort off Madness .
I imagined Heaven
I have No Art
 In other Lives
 In other Lives
I know your Soul is Sound
 Martyrs Groan
 But I will not Sigh . . .
 Though the Universe Melts away
 I Will Not Sigh
 I Will not Sigh
 x4 Your Fatal Fall
 Your Fatal Fall
 · Your Fatal Flaw
 × Your Fatal Fall

 Your Imagination
 No Imagination

XII Love is a sort of Deadly Nightshade
 It makes your EYES BRIGHT
 Intrigue Defies
 Charmed
 Shifts in Time
 Love Divine
 Love Divine
 Warp Speed !!
 Lightening
 Love Born of the Stars?
 Or
 Hallucination
 x11 Warp Speed .. Lightening
 Your Fatal Fall
 Your Fatal Fall
 Your Fatal Flaw
 You Fatal Fall
 Your Imagination
 No Imagination
 Love is Forgiveness × VII
 In The End × V

Previous pages: Images from *Splash!*, an ambitious 2013 collaboration between Knight, Guinness, and Iris Van Herpen that was streamed live on SHOWstudio. **Page 58, top:** Knight used high-speed cameras to capture Guinness being splashed with black and clear water and then offered up a carefully chosen still from the footage to Van Herpen to use as the inspiration for one of her signature Perspex water dresses. **Page 58, bottom left and right:** The making of the one-off dress. **Page 59:** One of Knight's images of Guinness in the final creation. **Above:** Over her career, Guinness has expressed herself through various media. Music has always been a passion of hers, and in 2013 she launched her debut single, "Fatal Flaw," the lyrics to which appear here in her handwriting. **Opposite:** This image by Knight, shot for *W* magazine in 2011, was used as the cover art for the "Fatal Flaw" vinyl.

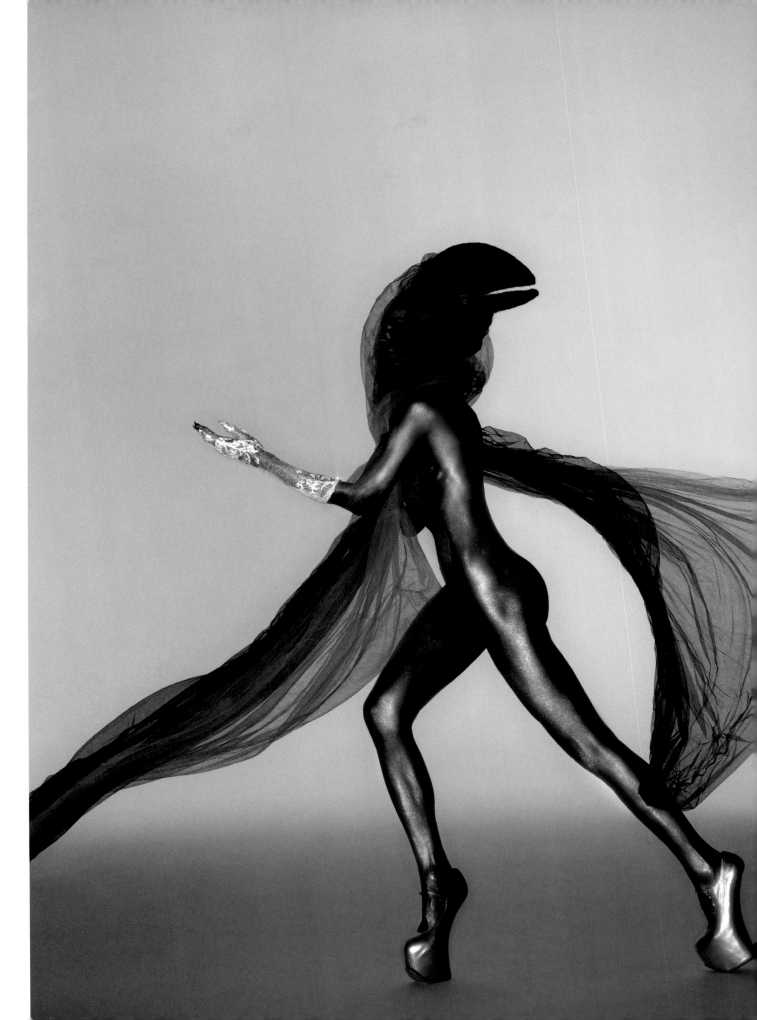

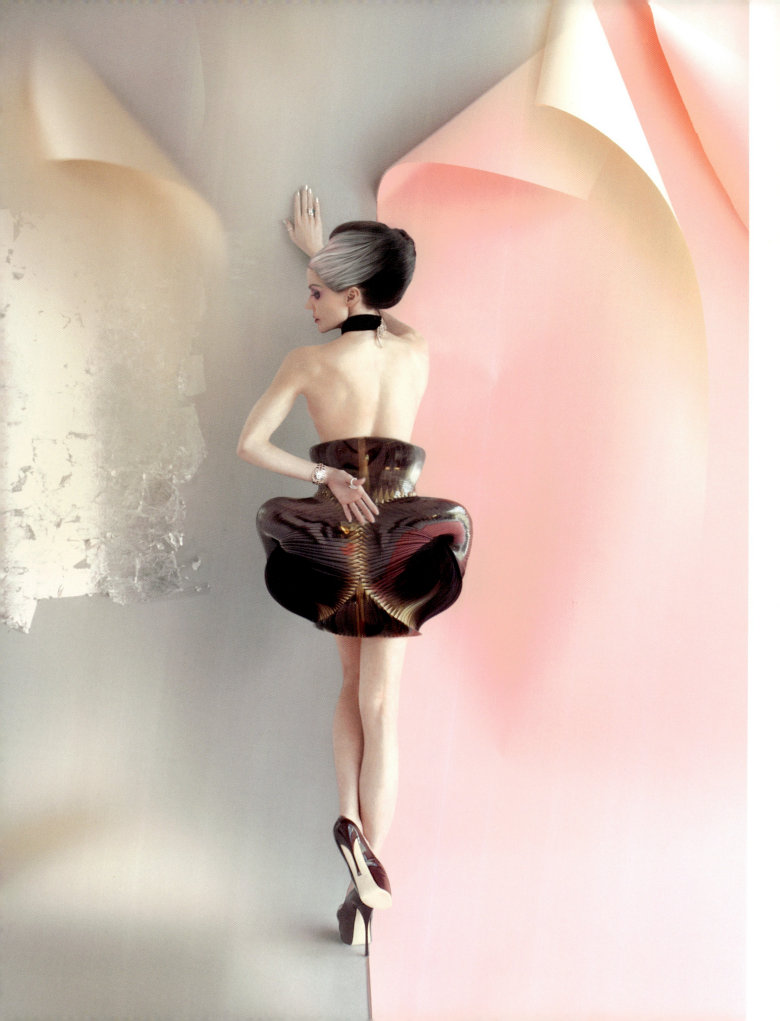

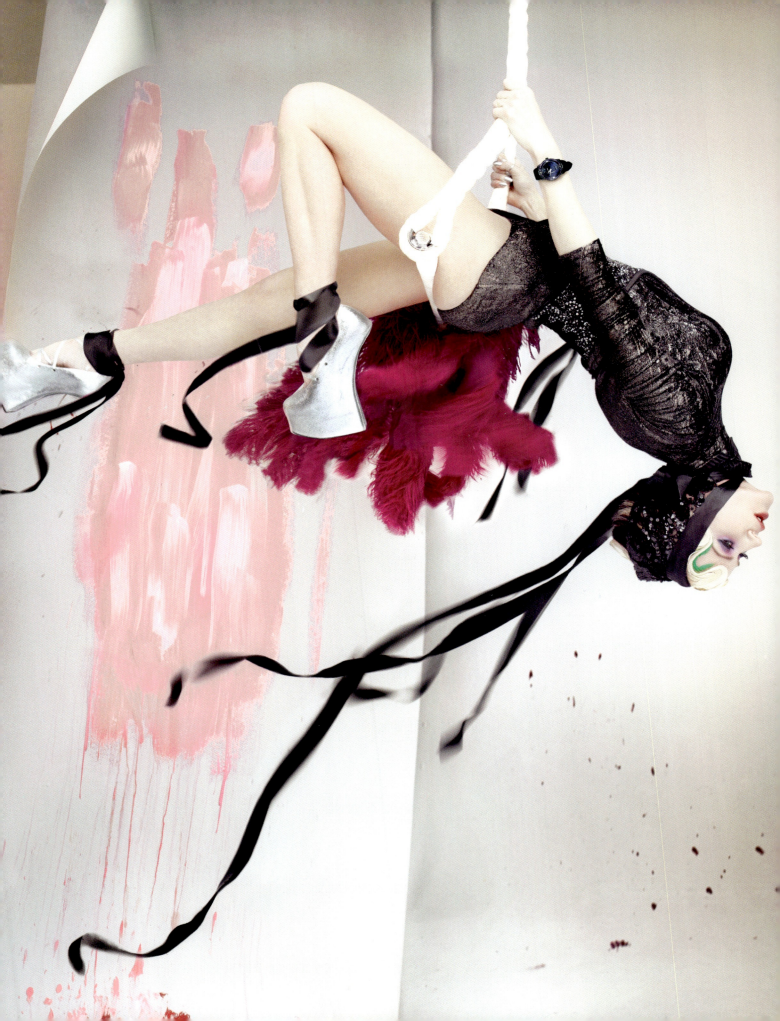

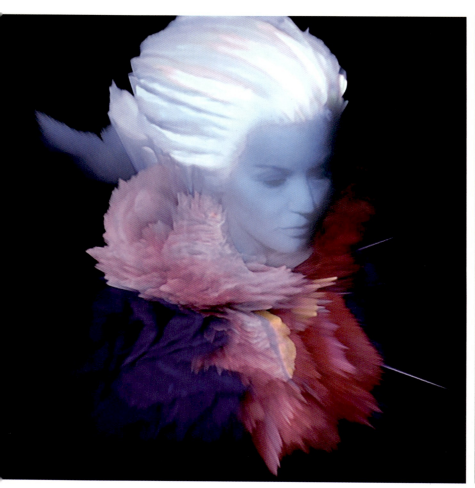
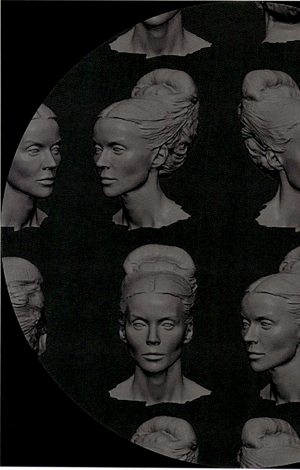

Previous pages: In 2012, Swiss watchmaker Roger Dubuis commissioned Knight to shoot Guinness to celebrate his *Velvet* collection. Guinness wore vintage pieces from her own legendary wardrobe of couture and high fashion. **Above and opposite:** SHOWstudio's ambitious *Visions Couture* series featured fashion films—set to soundtracks recorded by Guinness herself—interactives and 3-D sculptures, which served as the centrepiece of the fashion windows of the flagship Printemps department store in Paris in spring 2012. Guinness was captured wearing pieces from the S/S 2012 collections of designers such as Junya Watanabe and Rick Owens, mixed with garments from her personal wardrobe.

Following pages: Shot in 2015, between the 450th anniversary of Shakespeare's birth in 2014 and the 400th anniversary of his death in 2016, a story for *W* magazine's October issue titled "Hell Is Empty. And All the Devils Are Here," saw Knight re-imagine *The Tempest*. While the play has just one female character, Miranda, Knight cast Guinness as Prospero, a nod to her majestic presence. Here, she wears a vintage Alexander McQueen bodysuit styled by Knight's long-term collaborator Simon Foxton.

Designer **Riccardo Tisci** is a romantic. He talks frequently of love, pride, friendship, and loyalty. These are also the themes that run through his fashion collections. The success of his intimate friendship and working relationship with model **Mariacarla Boscono** is easy to understand. They share much—both are proud Italians, both are dreamers, both thrive on a certain level of intensity. Tisci is most comfortable around women, having grown up with eight sisters. The pair met while Tisci was a student at Central Saint Martins and Boscono was an up-and-coming model. Despite having already booked jobs with established brands, Boscono walked for Tisci in his 1999 student graduate show. She later helped recruit other models to take part in Tisci's off-schedule eponymous shows in 2004. In 2005, Tisci was named creative director of French fashion house Givenchy's womenswear and haute couture lines. He took over menswear direction in 2008. Boscono was a constant presence in his advertising campaigns and catwalk shows. She was the face of his debut campaign for Fall/Winter 2005, shot by Inez van Lamsweerde and Vinoodh Matadin, and appeared in more than twenty others. One of the most touching images, selected for the Spring/Summer 2013 campaign, is a portrait of Boscono cradling her four-month-old daughter, shot by Mert Alas and Marcus Piggott. In 2017, after a twelve-year tenure, Tisci and the House of Givenchy announced their joint decision not to renew their collaboration.

Riccardo Tisci and Mariacarla Boscono

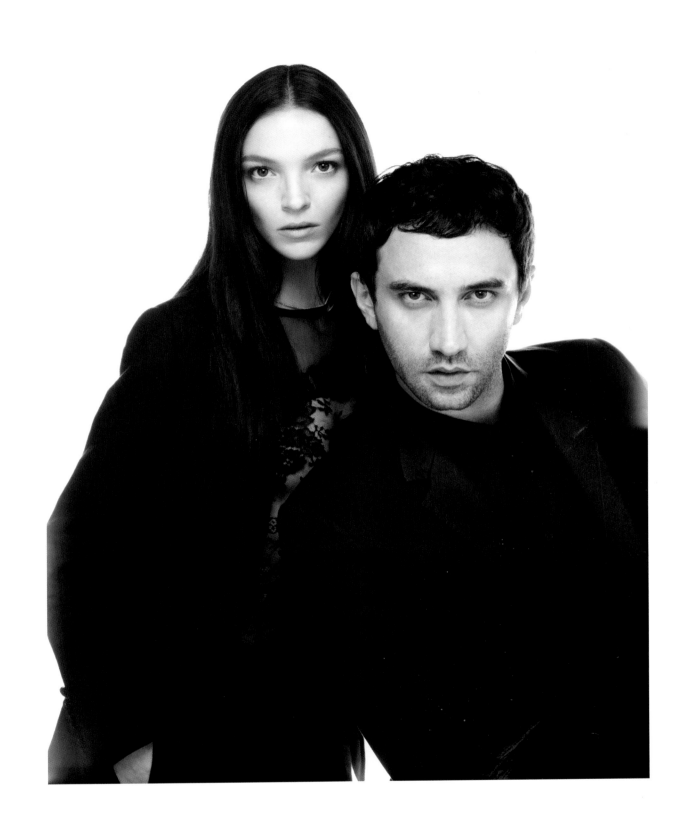

Riccardo Tisci and Mariacarla Boscono shot
by Mert and Marcus in London in 2013.

Riccardo Tisci: I knew about Mariacarla before I met her. She was discovered by Steven Meisel when she was about fourteen, then she went to Tokyo to be an exclusive for Rei Kawakubo. She was a big name. She had very long hair back then. Someone asked her to do a shoot in New York and they wanted her to shave her head. She did, and as a result she lost nearly all her jobs. In Italy, everyone was talking about it. When I was studying at Central Saint Martins, my flatmate, Giovanna, was an assistant to the photographer Sean Ellis. I was always pointing out girls to her—and I was always talking about Mariacarla. One night, my flatmate came home and told me she'd met the Italian model with the shaved head at a casting—she even brought the Polaroid home. When Sean decided to shoot Mariacarla, Giovanna invited her for dinner with us after the shoot. She'd told Mariacarla that I was obsessed with her. So I came home from Saint Martins, and I found Mariacarla in the kitchen. The moment we sat down we started talking and that was that—we clicked immediately.

Mariacarla Boscono: It was love at first sight. We could not spend a day apart from the moment we met. We talk to each other daily, so it's like we never leave each other. Back then, we'd just hang out and take beautiful, major pictures. We'd go out, and then I'd crash at his place.

Tisci: It was like friendship obsession—I decided she would become my muse. After Saint Martins, I was making clothes just for fun, for myself. We used to go to clubs at night—we both loved music—and I used to make Mariacarla wear crazy stuff: high heels and Jamaican fishnet pieces made by me. We wanted people to see what I was doing and provoke a reaction.

Boscono: He was doing these crazy, trashy things. I remember wearing a net shirt—like the net you buy in the market! He had it in every colour and he attached stars and hand-sewed little embellishments in light pink, white, black, and green.

Tisci: Our friendship was so deep that people—even her parents—thought we were a couple because we were together all the time. She was pictured on the invite for my show at Central Saint Martins, and today she's the girl who's done the most Givenchy campaigns in history—alongside Audrey Hepburn.

So she was your muse long before you got to Givenchy.

Tisci: In a way my life changed because my job changed, but my friends and the people who have been there since day one are all still there. I believed in Mariacarla. When Mariacarla came out it was all about the big girls—Claudia Schiffer, Naomi Campbell, Helena Christensen. They were sexy, curvy girls, and she was so skinny. I said to her, "Baby, keep going because you're going to make it. You're so special, you're going to be someone someday."

Boscono: I believed in Riccardo, too. When he was just Riccardo, a kid from a difficult background, I treated him like one of the best designers in the world! Even when no one knew who he was and when

I began working with big houses—with Tom Ford, Karl Lagerfeld, Donatella—for me, he was always Riccardo.

Tisci: What we have surpasses friendship because I love her in the bad and in the good moments. We'll always be there for each other. Some models possess beauty; others give their beauty to us artists. The latter are almost like artists themselves. Mariacarla is one of them. I'm obsessed with casting and I discover a lot of girls. We're always looking for the new Mariacarla—girls who are distinct. We found Lara Stone, Joan Smalls, Saskia de Brauw, Catherine McNeil. They're all different from Mariacarla, but they all have something in common. They have their sensibility, their craziness, and their masculinity, but at the same time the sexuality of Mariacarla. They're all unique, but they're similar because of their intelligence. Many designers and photographers have said that they like what is behind the beauty of Mariacarla. Some people like their girls to be a canvas—so you can change them. Mariacarla comes with baggage—not only beauty. On set, she's present.

Riccardo, when you were at college, did you think you'd want a muse?

Tisci: I never believed in the idea of a muse. I thought it was old-fashioned. But I found one! I would put things on Mariacarla and she would give them new life, partly because she has a strange and interesting style. Her beauty is a strange beauty. I learned to appreciate this very specific energy. What used to be called a muse in the 1950s or 1960s could now be called an identity. Every designer creates their an identity, and often they need someone to draw on and interpret their creations. Ann Demeulemeester has Patti Smith, Dolce & Gabbana have Monica Bellucci, McQueen has Kate Moss. Mariacarla inspired me a lot—the layering, for example, putting the jeans under a cotton lace dress. When I was at Saint Martins I never thought to do that. When I saw Mariacarla do this, it became a part of my identity.

Boscono: I'm often referred to as his muse, but I refer to him as my muse! I'm fascinated by Riccardo. Not with the clothes. We don't sit around and talk about fashion—we talk about life! Holidays, books, people, parties, places we want to go. I think he's a genius, of course, and was born to design. I was so relieved when he got the job at Givenchy because he could finally do what he wanted to do—he could sew and design. I thought, finally he can actually do clothes twenty-four hours a day. Before that, we would be sitting at a restaurant and he would be saying, "Can you wear this? Can you try it on?" I would say, "Oh, God, leave me alone, I'm busy eating!" He's the leader—but I'm a leader, too. Yes, we've had major fights. Sometimes we've even called our mothers to negotiate. We're like brother and sister, lovers, supporters, muses—we're everything.

Tisci: I don't have any secrets from her. If I have to make a decision, or she has to make a big decision, we always call each other. She is family. Not long ago, Mariacarla lost her brother, I would never say

I could replace that, a blood brother, but I was there straight away. I think we connect partly because of our differences. She's younger than me, and she comes from a very specific family, a fantastic family. She grew up in Africa and her parents had money. I come from poverty. I come from tough love. And, I think I inspire Mariacarla because I try to help her keep her feet on the ground. She was very young and she became famous, and I helped her manage that. So many people around her were passive, but I would tell her things to her face. I wasn't scared. Think of it, a young girl travelling the world in first class and lost in the middle of all these people much older than her. I didn't have money because I was a student and I was working in Monsoon and Accessorize in London. During Fashion Week, she would pay for my flight or my train to come to Paris to sleep in her bed and keep her company.

Honesty seems important in your relationship.
Boscono: It is. We used to fight so much when we were younger. Now we're more mature. But I still say things straight to his face, and sometimes maybe I hurt his feelings. Because if he's not going to tell me the truth and I'm not going to tell him the truth, who will?

Riccardo has eight sisters. Do you feel like the ninth?
Boscono: I feel more like a wife. We have the freedom of not being brother and sister—it's the same level of love but with no barriers, because we choose each other. We're not obligated to each other. We grow together, we always come back to each other. So, while I'm happy and proud to walk his show or do the campaign, and while I respect him as one of the biggest designers, it's much more than that.
Tisci: When I started at Givenchy, she was so honest with me. She would come to a fitting and say, "I don't think that part is very good...." We built a world together. Many times, people tried to divide us—they tried to make it difficult for us.

Why do you think they did that?
Tisci: Because it's a big, big present from life, to have somebody next to you in a world that is all about business. We're very lucky. When I started this job, I could have forgotten Mariacarla. I could have used any girl I wanted. But even when she took a break, or when she had things to deal with in her personal life, I was the first one to support her.

Before you did Givenchy, Riccardo, you had your own label. Was Mariacarla important to that as well?
Tisci: She organised my first fashion show in Milan. The company I was working for, Ruffo Research, had gone bankrupt, and I'd gone to India to do my own collection. I was only supposed to do ten or fifteen T-shirts. But probably because of the sadness, I poured myself into it and I made a real collection. Mariacarla was the only person I was in contact with. I came back from India one week before Fashion Week in Milan—I wanted to sell these T-shirts so people didn't think I was completely kicked out of fashion. She came to pick

me up at the airport. We went to her home, it was late in the night, and we started opening my luggage, two or three suitcases full of clothes, and she started trying things on. I was destroyed, emotionally and physically, because I'd travelled so many hours from India. But she said, "No, we have to do a show." She took over. And she was, at that moment, very big. She was in the Chanel and Gucci campaigns. She brought together Karen Elson and Natasha Poly—the big girls of the moment—to do my show for free. She did the invitations, the photocopies—everything. She was the hit girl of the season. She was at ten shows a day. But she gave me the courage. We only had one week to prepare the show. I was so scared. I was so upset, and I said to her, "I don't want to do this, and you can't push me because it will be in my name." So I asked her to leave—it was five o'clock in the morning. I had my shower. I went to bed. In the morning, beep! It was Mariacarla. And we did it. It was the most emotional show of my life—everybody was crying after. It was such a magic night. She pushed me, and if she hadn't, I wouldn't be here today.
Boscono: I went to all the journalists—Carine [Roitfeld], Suzy [Menkes], everyone—and I said, "You've got to come. We're all walking in it. It's underground. It's going to be amazing."

Were there moments when you thought he would be too scared to go through with it?
Boscono: For sure. He was freaking out—he couldn't talk. Also the girls were shocked. They were all backstage looking at me like, what the hell are we doing? We ended up doing our own hair and make-up. We were in a garage. They had laid down stripes and balloons and things, and then the girls just started to have fun. And people wouldn't leave! They were queuing outside. Everyone talked about it for months.

Do you see your role together as reshaping fashion's idea of beauty?
Tisci: I never get impressed with pure beauty from anything—from a painter, a musician, an artist, a model, clothing. I like it always with a twist. I came out in a moment when everything was glamorous. But I was tough. And because of the darkness, the strangeness, my work was difficult to understand. Mariacarla had long hair and completely deconstructed clothes—she was also dark. But I think what she represented, and still represents, is modernity—the beauty of today. Over the last ten years, I've seen so many Mariacarla replicas, but it never works because she's an original. Before us, Italy was represented by Monica Bellucci, sexy clothes, women dancing on top of the tables with men around them and pasta. [laughs] Today, any article in Italy about the new fashion of today mentions me and Mariacarla and our friendship.
Boscono: We took the reference of Italy, but we always made it our own. We show the dark side. I think we proved that there's not just one style of Italian.
Tisci: Yes. My country is Italy. I am Italian. But that doesn't mean everything I do has to be about sex or about food, football or big curves. We all love *la bella*

vita, the *dolce vita* from the 1950s, 1960s, and 1970s. But the reality today is different.

Boscono: Despite our luxurious lives, we still went on underground holidays, or to underground clubs where we met new friends. Sometimes if you're in that designer celebrity bubble, you lose your inspiration.

Tisci: For a long time, fashion, for me, was only for the rich. Meeting Mariacarla made me re-evaluate that. She helped me summon the courage to bring out what I believe in. I was no longer ashamed to believe in darkness. I was no longer ashamed of my childhood, my culture.

Why do you love to be around women?

Tisci: Women have saved my life. If I hadn't had my sisters and my mom, I probably would have become a criminal, or I would have been dead already. Women helped me to be myself.

How do you balance other collaborations with your loyalty to each other?

Tisci: At the beginning, if I used someone else, she would get upset. But she understands that while she's part of my work, she's also deeply part of my private life. There are not many people that can be a part of my private life.

Boscono: After his first year at Givenchy—it was the time that I became blonde—I took a year off. He was in tears. But I think the fear made him stronger. It was almost like horses: when they set free their child—they start by kicking the little horse. It's called tough love.

A lot of collaborative relationships in fashion don't stand the test of time. Why has yours lasted?

Tisci: I'm not scared of her, and she's not scared of me. She was there when I was nobody, and she helped me a lot. She taught me how to be different, how to be more respectful. And if I am really down, I call Mariacarla. If I'm in the shit, I call Mariacarla, because even if she can't find a solution, she can tell me from the real, honest gut what I did wrong.

—

This interview took place in Paris at the Givenchy headquarters on November 30, 2015, with follow-up over the phone on December 2, 2015.

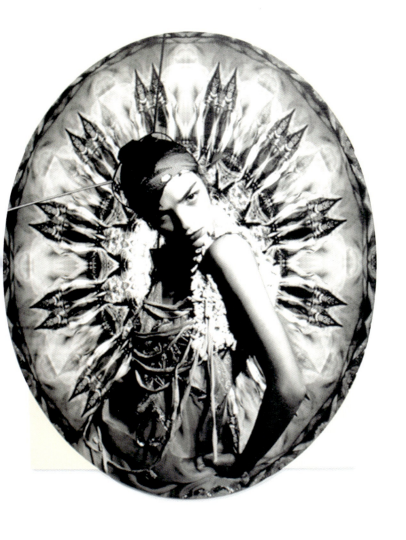

RICCARDO TISCI
CAPSULE COLLECTION

SEPTEMBER 30 2004
7 30 TO 9 30 PM
LA POSTERIA
VIA G SACCHI 7 MILAN

RSVP +39 335 6341857

HAND MADE DRESSES
WORN BY FRIENDS
IN A BORROWED SPACE

Boscono played a pivotal role in Tisci's eponymous collection,
encouraging him to have the confidence to show under his own name and
helping to recruit models to walk and journalists to attend. Here, she appears
on the invitation to his show, held in Milan during the S/S 2005 Fashion Week.

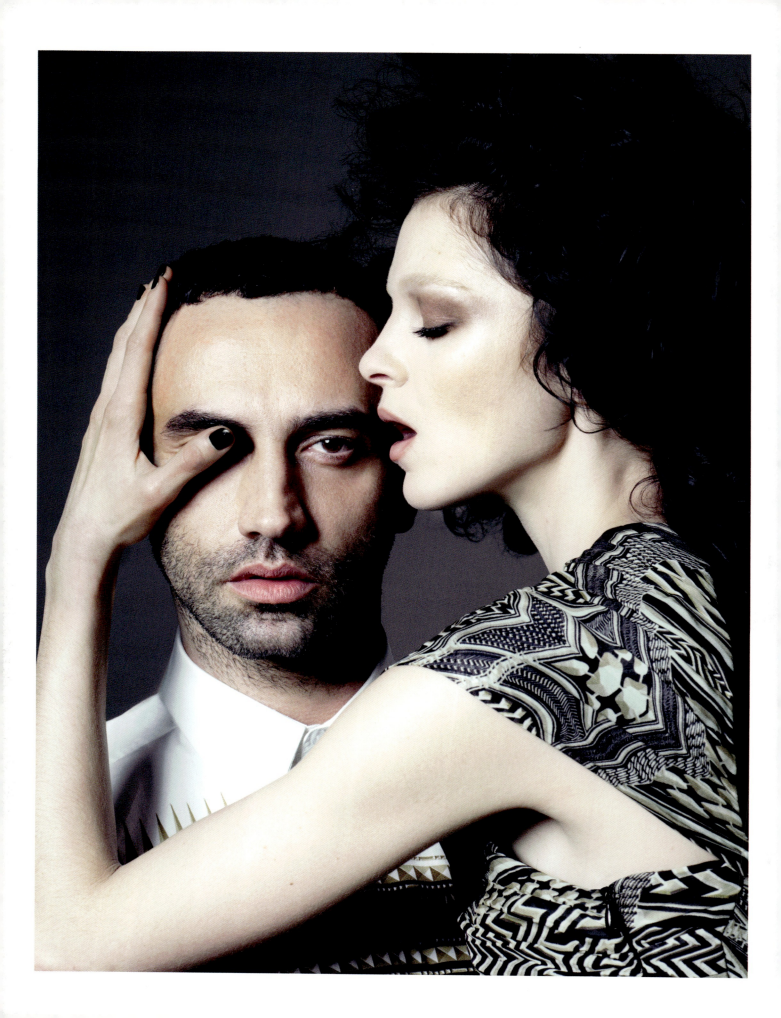

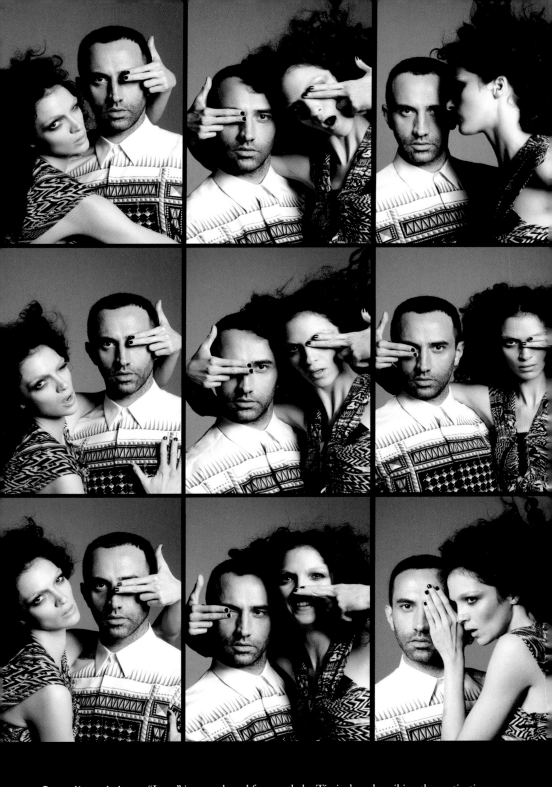

Opposite and above: "Love" is a word used frequently by Tisci when describing the motivations and ideals behind his work. Appropriately, for the cover of *i-D*'s pre-Spring 2010 issue, dubbed "The Lovers of Life Issue," he appeared with Boscono alongside the headline "Love, Sex, Magic." The pair were shot performing *i-D*'s signature wink expression by their frequent collaborators Mert and Marcus, who also captured many of Tisci's Givenchy campaigns.

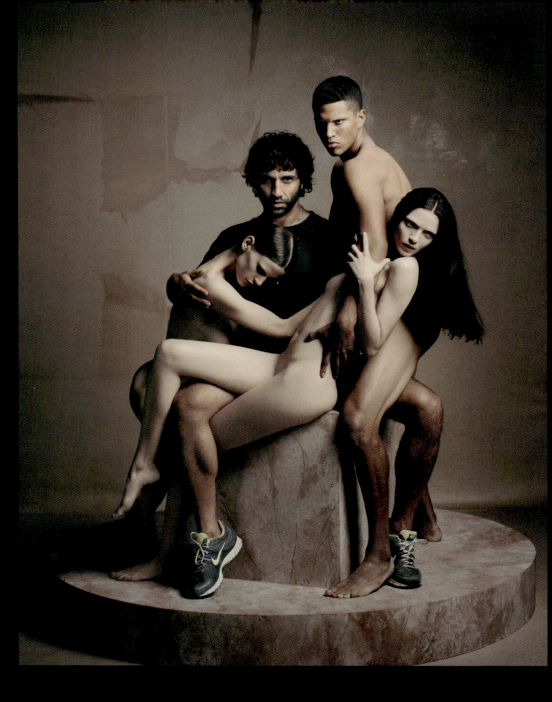

Above: Midway through his Givenchy tenure and having built a reputation as a champion of provocative, sensual beauty and casting diversity, Riccardo Tisci guest art-directed and starred on the cover of *Dazed & Confused*'s twentieth-anniversary issue, for October 2011, shot by Matthew Stone. Boscono lies across his lap supported by other frequent Givenchy faces Chris Moore and Saskia de Brauw. The cover's strapline read "Come Together."
Opposite: For Givenchy's S/S 13 campaign, shot by Mert and Marcus, Tisci asked Boscono to appear cradling her baby daughter, Marialucas Boscono. The campaign highlights the value Tisci—the brother to eight sisters—places on family.

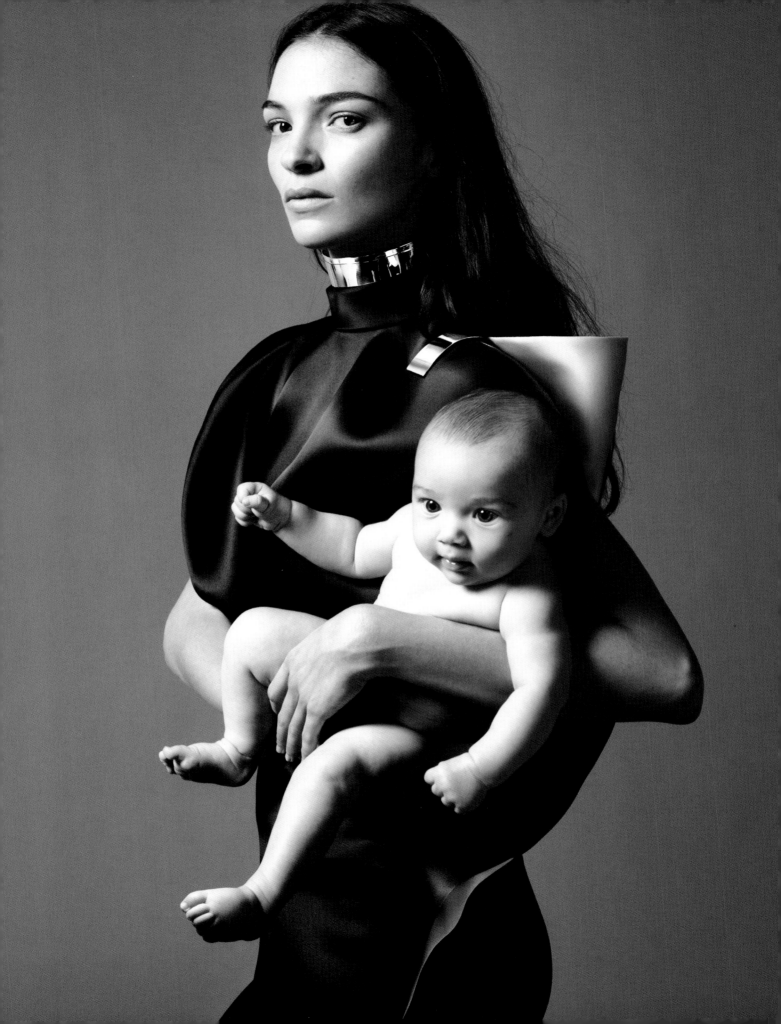

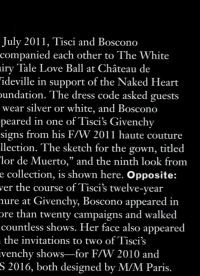

July 2011, Tisci and Boscono
accompanied each other to The White
Fairy Tale Love Ball at Château de
Wideville in support of the Naked Heart
Foundation. The dress code asked guests
to wear silver or white, and Boscono
appeared in one of Tisci's Givenchy
designs from his F/W 2011 haute couture
collection. The sketch for the gown, titled
"Flor de Muerto," and the ninth look from
the collection, is shown here. **Opposite:**
Over the course of Tisci's twelve-year
tenure at Givenchy, Boscono appeared in
more than twenty campaigns and walked
in countless shows. Her face also appeared
on the invitations to two of Tisci's
Givenchy shows—for F/W 2010 and
S/S 2016, both designed by M/M Paris.

Spring Summer 2016
Friday, September 8th, 6:30pm GIVENCHY Hudson River Park's Pier 26
New York City

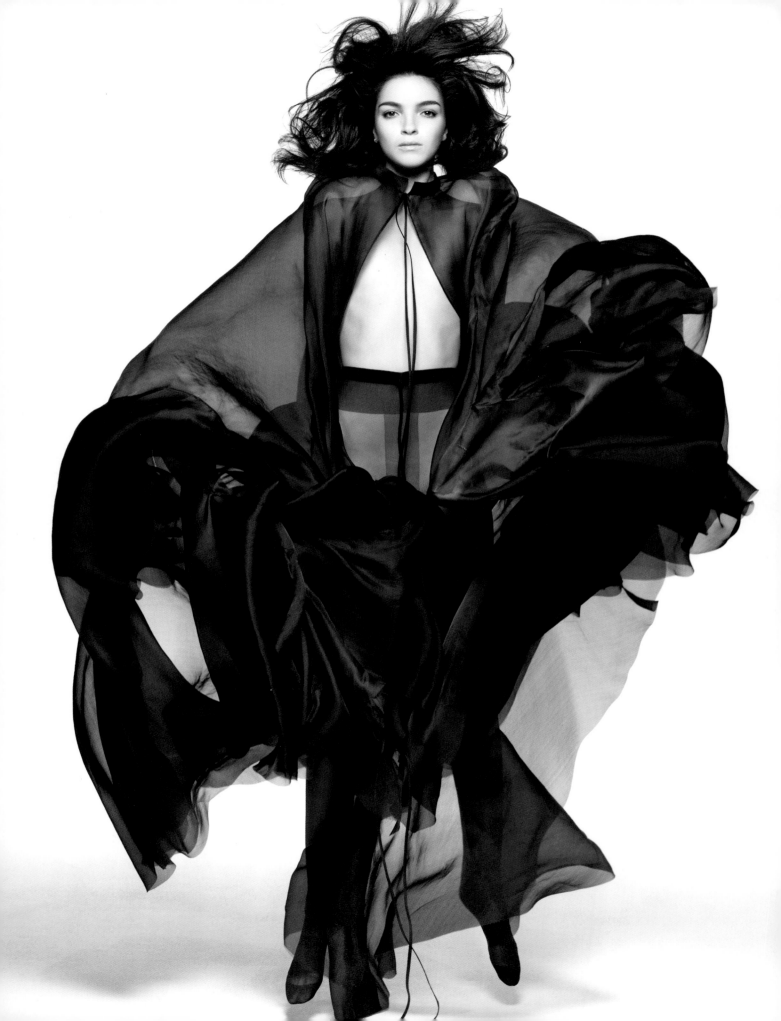

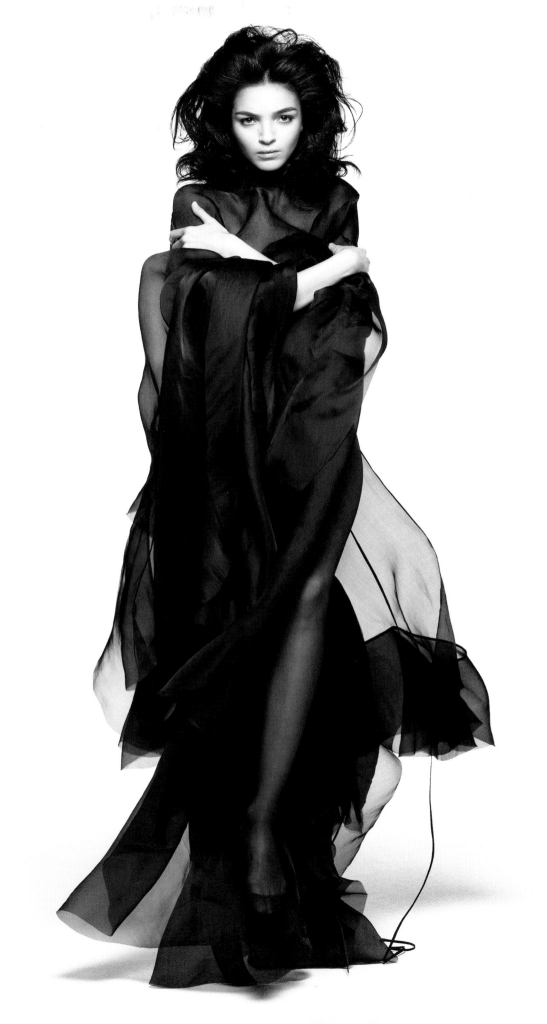

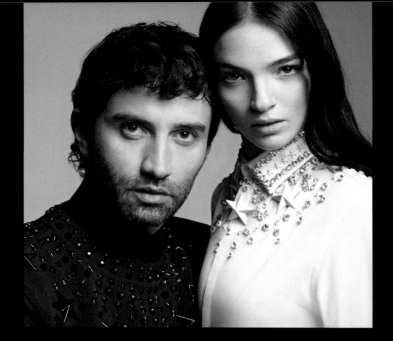

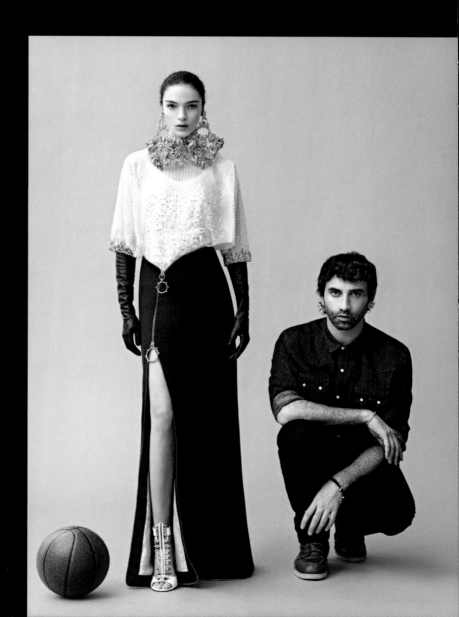

Previous pages: Though later known for campaigns featuring group shots of diverse, eclectic models, Tisci recruited Boscono to appear alone in his debut campaign for Givenchy, shot by Inez and Vinoodh for F/W 2005. **This page:** Tisci and Boscono appear together in official portraits commissioned by the house of Givenchy, shot by Karim Sadli in 2012. **Opposite:** To celebrate ten years at Givenchy, Tisci was shot by Luigi and Iango for the cover of *Vogue* Brazil, October 2015. In an image that paid tribute to "his family of fashionable friends," as the cover read, he appeared in bed with Boscono and other close friend Naomi Campbell.

Few designers have sparked such levels of debate and acclaim in such a short period of time as Northern Ireland–born **Jonathan Anderson** of J.W. Anderson. He met French stylist **Benjamin Bruno**, who trained under Carine Roitfeld at *Vogue* Paris, just two years after graduating from the London College of Fashion with a degree in menswear in 2008. Immediately, his shows began gaining attention amongst the London press. At first his designs were recognised for bringing gender-bending elements and headline-grabbing fetishistic twists into menswear, and later, after the brand branched into womenswear in 2010, he was lauded for his constant pursuit of newness through shrewd recycling. To this day his clothing offers a collage of references and exhibits his skill for simultaneously preempting a trend and nodding to the annals of fashion history. In 2013, Anderson was named creative director of Spanish luxury leather house Loewe and took Bruno with him to this new post. Together, the pair has established a tight team of collaborators, from photographers Jamie Hawkesworth and Steven Meisel, to art directors Michael Amzalag and Mathias Augustyniak of M/M Paris and casting director Ashley Brokaw. Season in, season out, they help shape the J.W. Anderson and Loewe worlds through photographic campaigns and lookbooks that have defined the current language of contemporary fashion image-making. Few young designers can survive the pace of working at two houses, but Anderson thrives under the pressure—at the same rate he produces clothing, he also produces headlines.

Jonathan Anderson and **Benjamin Bruno**

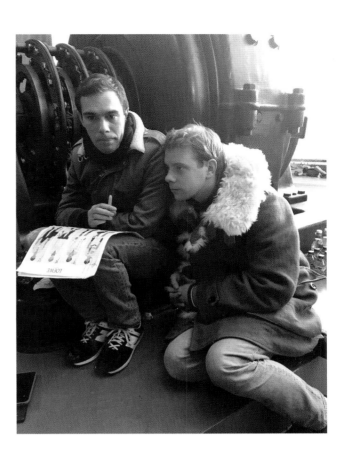

An informal portrait of Anderson and Bruno taken at the Loewe offices in Madrid
during the run-up to the house's F/W 2017 menswear presentation.

How did you first meet?
Jonathan Anderson: We met in Paris in autumn 2010, at the showrooms for the young British designers who show at London Fashion Week.

Accidentally or intentionally?
Benjamin Bruno: Accidentally. I was working at French *Vogue* with Carine Roitfeld and we just visited the showroom for inspiration. It was an act of curiosity. And there he was.
Anderson: There I was. We started working together straight after.

What made you want to work together?
Anderson: Because Ben was very good. [laughs] He was able to help me articulate better. He pushed me. The work felt new.
Bruno: I introduced fashion into you. [laughs] You had the willingness and I had a knowledge that you didn't have. I think he was dreaming of making fashion, and I gave him that fashion.
Anderson: Ben has the fashion and I have the commerciality. What happens in the end is two minds make it a brand. There's no designer. The two of us together make a designer.

So you wouldn't call it a stylist/designer relationship then?
Bruno: No, it's a dialogue.

In the fashion industry, people tend to have fixed roles: you are a designer or a stylist or a photographer. You are usually categorised as a designer, Jonathan, and you as a stylist, Ben.
Anderson: I don't think one can do it like that anymore.
Bruno: Well, I do it for other brands like that. It's a part of my job. But in our case, it's exciting. It's a different creative process—a new way to make fashion.
Anderson: As much as some designers will say they are the designers, really they have design teams. Depending how big the brand is, there could be anywhere from three to sixty-three people working on one collection. There is a lot of manpower behind the scenes. With Loewe and J.W. Anderson, it's the combination of both of us working together that makes it work.

So you couldn't do it on your own without Ben?
Anderson: I don't think anyone could do it like that. Every brand has teams. You need someone you can talk to who is going to tell you the truth, not just on fashion, but on everything. On your own, you would become nearly sterile, because you would never question yourself.
Bruno: I know him as a friend as well, so I always push things for the right reasons. When I look at something, I know if that thing is relevant or if it's not. It's my taste, so obviously it's very subjective. But I always know what is right.

Did you like Jonathan's work before you met him? Were you aware of the previous stuff he had done?

Bruno: No. That day in the showroom was the first time I heard about him. And obviously I was not overwhelmed with it aesthetically, because it was an embryo of fashion then. But there was something honest, a naïve belief in something, and I think that's what's lacking today—there are people who don't believe in anything. So it felt nice that someone was believing in something.

What did you feel he believed in?
Bruno: Just the genuine naïve act of creation. There was a willingness to make something.
Anderson: I went out to make a business. A brand is a world. So, anything can be housed in it. People just need to believe in the brand. The idea was there. The name was there. It just needed someone who was going to be able to go, "Right, that's not good enough. That's not enough."
Bruno: The good thing is that my weakness is your strength. And your weakness is my strength. He's very pragmatic and very business-driven. Jonny is like a global strategist, and I'm more creative.
Anderson: A fashion show is just ten percent—the real thing is brand building.
Bruno: The picture is way, way bigger.
Anderson: Way bigger. Ben's master strength is being able to see the 360 in terms of brand image. He knows how to articulate a fashion image. I think that's one of the hardest things to do, because you need to make an essence of something. If you look at any brand, like Dyson or Apple, they are led by image. At the end of the day, they have a very good function. But in fashion, is it technically about function? The only function is to cover yourself.
Bruno: My background is very classic. I was at *Vogue* for six years. It's the best training, the best academy. I learnt how to make a fashion image. I learnt how to detect a woman's desire for a garment. I learnt about fashion brands in general. So when I came to him, I could style a fashion image, I could style a campaign, I could make a collection. But I knew, as well, who could potentially wear this garment.
Anderson: I think there is a dialogue that needs to be built up. If you're having a conversation with yourself, it becomes loaded with your own baggage. You cannot reject things. The editing process is very difficult. Successful brands are about more than one person. J.W. Anderson became a brand because it was about more than a designer.
Bruno: It's a world now.
Anderson: It's a world now. I know what I'm good at. I can sell a story. I'm very good at marketing something. Ben can feel a trend. I can feel when there's a lull in press. I can feel when we're not getting enough traction for something. At the end of the day, it's actually quite simple—it is about trying to get a flock of birds to go in one direction.
Bruno: And create a universal desire for something.

Would you say you're motivated by trying to cater to others?
Bruno: I think the challenge is within us. What do

I want? What do I feel is right? You need to make yourself excited.

But the name is J.W.Anderson. Does that ever feel wrong when the work is such a balance between the two of you?
Anderson: J.W.Anderson is a brand. It's not me. I don't ever say, "My name is above the door." I don't care about being a star. And I know that Ben doesn't care about being a star. I'm so happy that I can walk down the street or go to a restaurant and no one gives a fuck who I am. The brand will always be bigger than the person. And that's good, because you need distance from it. If you fall into star syndrome, people are scared to propose things to you, and they are scared to question you. And if you cannot be questioned, it never will work.

So you want the brand to be famous, but neither of you want to be famous?
Anderson: Yes.
Bruno: Exactly. I could not have my name on something like that. I'm a backstage person. I love to make my dreams in my corner and that's it.
Anderson: What I admire in Ben is he has the belief in me. But, at the same time, I have the belief in him. And, in a weird way, in this industry, that's really rare. Because, with a lot of designers, it is about the designer. Full stop.
Bruno: And it can be an ego competition.
Anderson: I think we help each other stay extremely grounded. We're not high-flyers. We're not demanding to have doors opened for us. You can't be like that in fashion anymore. It should be about loving the work. It's not loving the glamour, or loving the PR, or loving who wears it. It is about the work. You can't get too close to the glamour, because the minute you start to get too involved in it, your mind just gets screwed.

Are you obsessed with the work?
Bruno: I am obsessed with work. It's much more exciting than life sometimes. [laughs]
Anderson: I think we are very, very, very competitive.

Do you ever get competitive with each other?
Anderson: No. With the rest.
Bruno: Never with each other. I get competitive with myself.
Anderson: We go out to do the best show. That may sound a very arrogant thing to say, but that is how it works. There is so much drive inside this company.
Bruno: It's not about success—it's the drive for precision.
Anderson: I'm hypercritical of myself and of all situations in fashion, because I think you have to question it all.

Jonathan, you have been very open and active in promoting your collaborators and your team: Ben, photographers such as Jamie Hawkesworth and Steven Meisel, art directors such as Michael Amzalag and Mathias Augustyniak from M/M Paris.

Anderson: When you look at the history of really successful fashion companies, they have a photographer and an image, they have a style consultant, they have a designer, and they have an incredible team. And when a business gets very big, they have a very good CEO. Because one man cannot do all that on his own. I want to leave this brand one day. I want to make it a success and be able to leave it and for it to be able to survive and take a different direction. There is going to be a day that our opinion is going to be outdated to the younger person. Loyalty is the most difficult thing to find in fashion. And once you find the people you click with, you need to fight to keep them. You have to struggle. They're not easy relationships to hold on to. It's the dynamic that you're trying to protect.

Do you get jealous when your collaborators work with other people?
Anderson: Of course, in some ways. But then not really, because the formula we have only works with us. When Jamie works outside of the brand it is a different formula; it's not my formula. I'm not emotionally attached to it. When Ben works for a different brand, I'm not emotionally attached to it. Ultimately, it all comes down to trust.
Bruno: It's feeling as well. You achieve something great when you inject feelings into it. So, Jonathan and I are friends. I'm friends with Michael and Mathias. I'm friends with Jamie. With Steven. Each time I work with those people, I give them everything. From the moment you want them on board, or from the moment they want you on board, you want to give it all because it's a trustful act to have been asked to be there. So you don't want to disappoint that person. Life is about being loyal and grateful. And when you build up a creative family, you allow in only the people you consider geniuses. I can't work without feeling. I can't. And I know that's why I get annoyed with Jonathan. It's not a simple work relationship. I know him by heart, and he knows me by heart, so we work like dogs. I'm only attracted by people who deeply move me—people whom I know that I'm not going to be disappointed by and whom I'm not going to disappoint.

But you must frustrate or disappoint each other sometimes. How do you handle that?
Anderson: It does get emotional. Sometimes it's very difficult to work with other people. But as you grow with people, you realise you don't want to be number one, not as an individual. You want the group of people to be number one.
Bruno: But the thing is, we clash so much that we always avoid a real fall-out.

So, you argue a lot?
Anderson: Yes. We have thrown things.
Bruno: But then we love each other the day after.
Anderson: That's the key. Probably if you ask all successful collaborators, the biggest fundamental thing that they all have in common is being able to scream at and cut each other and kiss each other at the same

time. Because you're able to hate and love someone with the same energy. I think, when you look at successful dynamics in fashion or any other field, that's what happens.

Does that friction inform the design?
Bruno: There's nothing more exciting than an awkward, tense situation, because that's where desire starts. Our aesthetic has always been about how you reconcile opposites—how wrong is the new right. In that little gap of uncertainty, you find modernity.
Anderson: That comes from conversations, from feeling like you're going to learn something and see something in a way that you've never seen it before. That's why I get up in the morning. When I'm with Ben, I don't feel like I'm working. And that's vital, because we do ten collections a year, and four advertising campaigns, plus all the other projects. And at Loewe, a full bag line, homeware, blankets, towels, gifts. You need so many ideas. That's why you need to be able to collaborate with people. You can be the most genius designer in the world. You can make the most incredible clothing and come up with the most incredible silhouettes, but if you're unable to collaborate, it will never grow.

Would you say some people mistake delegation for collaboration?
Bruno: Real collaboration is an exchange. Collaboration is not expecting something. It's not about taking. It's about giving.

—

This interview took place at the J.W. Anderson headquarters in Dalston in East London on February 11, 2015.

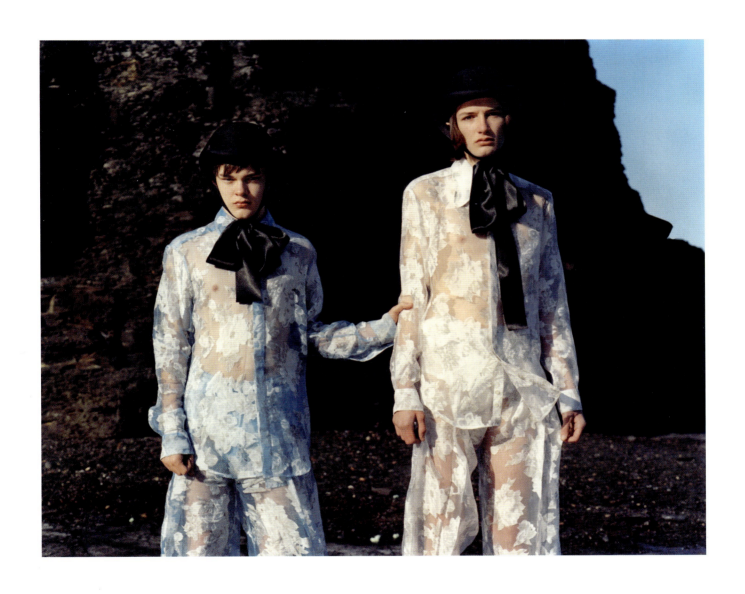

Fashion photography has been central to building up the language of J.W. Anderson and Loewe. For both labels, Anderson and Bruno collaborate with British photographer Jamie Hawkesworth. Bruno and Hawkesworth began working together on magazine projects when the photographer was just a few years out of college. Images such as this, from a story titled "Nancy Boys" in the F/W 2012 issue of *Man About Town* that featured Anderson's S/S 2013 collection, inspired the designer. "When Ben started shooting for *Man About Town*, with Jamie Hawkesworth, it was the newest thing I'd ever seen," he recalls. Explains Bruno, "I said to Jamie, 'It has to be something different.' It had to be, again, a conversation—a different dialogue. I surprised myself initiating a new aesthetic. And this coincided with that aesthetic for J.W. Anderson. So in the end, everything became more global, because it was not just about ready-to-wear. It was about fashion."

SEASONS GREETINGS

Love you could not have done this year with out you

Jonathan xxx

ZSL London Zoo
02/04/14
I Adult
Miss you Sausage
See you soon xx
Benjamin J
272 02/04/14/14:57 4057724 6097889
Admission is subject to the Terms & Conditions of the Zoological Society of London as displayed at each site. The Zoological Society of London (ZSL) is a charity devoted to the worldwide conservation of animals and their habitats. Registered Charity in England & Wales no. 208728.

Above: Correspondence between Anderson and Bruno from 2014. **Left:** Jamie Hawkesworth took this photo of a pram being used to transport cotton candy in the English coastal town of South Shields while shooting a story for *Man About Town* with Bruno. His image was used by Anderson on a sweatshirt as part of his S/S 2013 collection. **Opposite:** Images from the J.W. Anderson F/W 2014 (top) and F/W 2013 (bottom) campaigns by Hawkesworth. **Following pages:** The Loewe F/W 2015 campaign by Steven Meisel. The photographer collaborates frequently with Anderson and Bruno. Together, the three have established a tradition of using productless images from Meisel's archives, including self-portraits, in campaigns for the Spanish house, a nod to Anderson's curatorial approach to fashion design and brand building. **Pages 94–95:** Under Anderson, Loewe has become known for large-scale hardback lookbooks featuring images by Hawkesworth. **Page 94:** The Loewe S/S 2015 collection, worn by Julia Nobis, shot by Hawkesworth. **Page 95:** The Loewe S/S 2015 menswear collection, Anderson's debut for the house, shot by Hawkesworth in Cádiz, Spain.

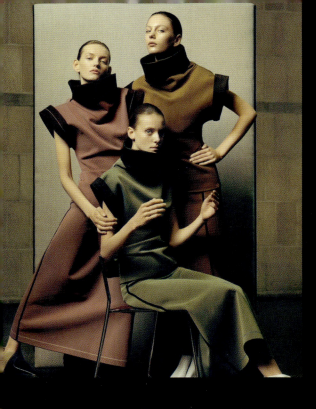
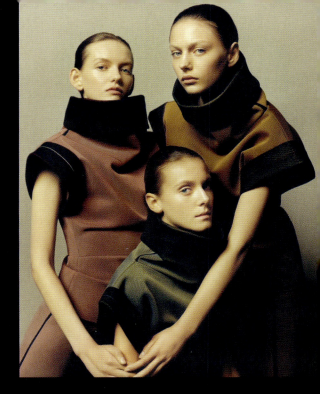
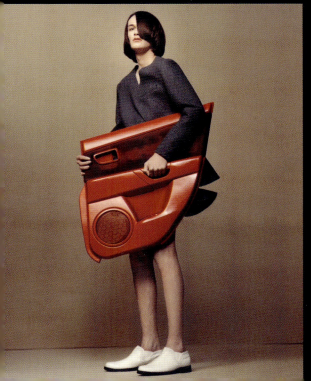

LOEWE

LOEWE

Steven Meisel
Untitled (Self-portrait #2)
2015

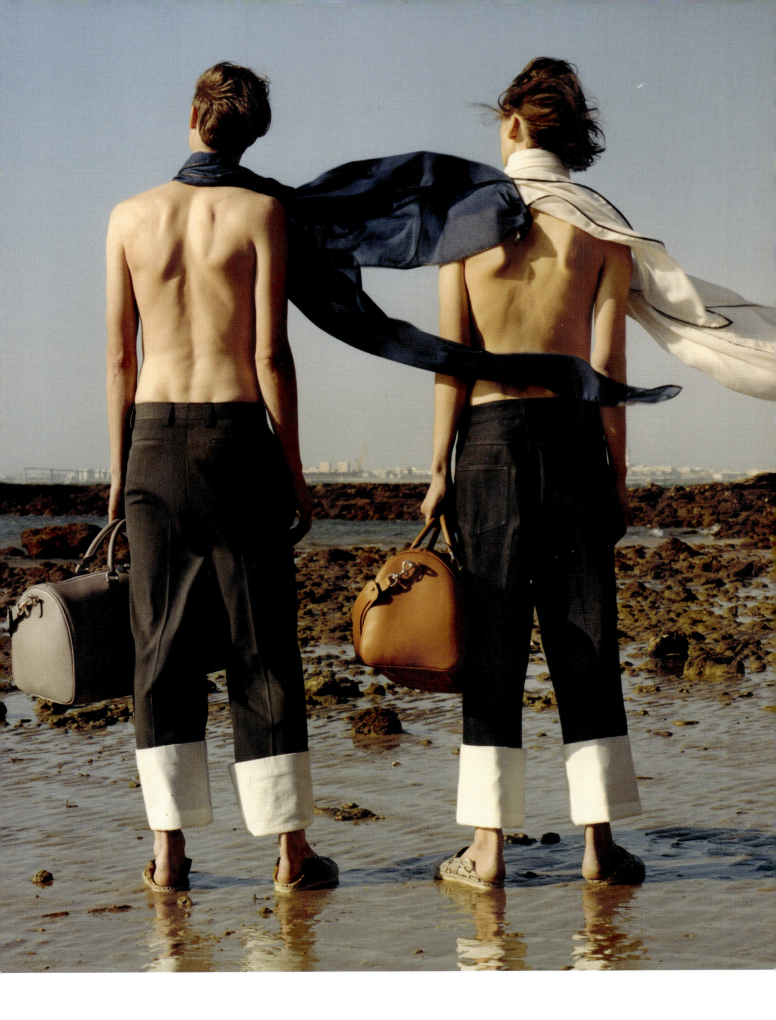

Jeweller **Shaun Leane** smiles when he talks of the late **Alexander McQueen** and his memories of more than seventeen years of friendship. A North London boy, Leane met designer and East London boy McQueen, known as Lee to his friends, in 1990. Through his experimental and often sculptural work on McQueen's celebrated runway shows, which helped establish London's reputation as a city of theatrical, provocative fashion, Leane became known as a fashion jeweller, but the pair were as much confidants as they were work collaborators. They loved to chat and dance in the clubs and bars of Soho, and many of their best ideas—the fierce tusk earrings for *The Hunger*, Spring/Summer 1996; the coiled corset, a huge technical challenge for a jeweller, for *The Overlook*, Fall/Winter 1999; and elaborate vine neckpieces for *Voss*, Spring/Summer 2001—were dreamt up over drinks. McQueen, who served as chief designer at Givenchy from 1996 to 2001, was known as a prolific collaborator, having established close and lengthy working relationships with figures such as stylist Katy England, photographer Nick Knight, and production designer Joseph Bennett. In 2010, McQueen committed suicide. At his funeral, key figures from the fashion industry paid their respects. Most were listed in the order of service by their professional roles. For example, Anna Wintour, who gave an address, was listed as editor-in-chief of American *Vogue*. Leane spoke, but it was telling that despite his celebrated reputation as a jeweller, he was credited simply as a "Friend of Lee's."

Shaun Leane on **Alexander McQueen**

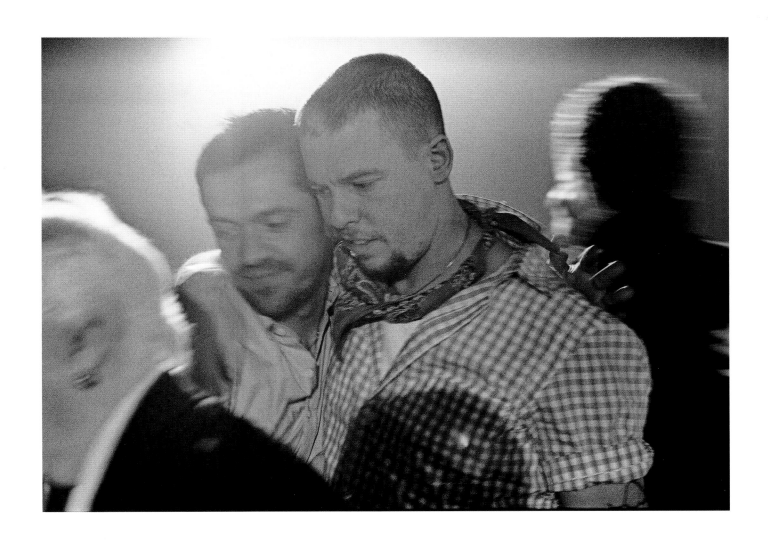

A special moment between Leane and McQueen captured by Ann Ray backstage
at *The Widows of Culloden* show, F/W 2006: "Lee and I had just shown his mum the bird's
nest headdress and eagle headdress that I had made for the show."

You must think of him often.
Shaun Leane: People say, "You must miss him." And I say, "Of course I miss him, but I miss the work, too. I miss the collaboration." We were best friends, and we were great work colleagues. We were exactly the same age. He was an East London boy. I'm a North London boy. Both gay, both quite feisty. Same generation. And my background was traditional goldsmith training— very strict, very classic.

So similar to him, because he trained on Savile Row.
Leane: I was a bit bored with the classic. I think he was bored, too. That's why he branched out and went to Central Saint Martins. He broke the rules and pushed the boundaries. I was so hungry to do that, but I didn't have an outlet or avenue.

How did you first meet?
Leane: We became friends in 1990, through a mutual friend, Simon Ungless. The best friend of my boyfriend at the time was dating Simon, and Simon was on Lee's course. We'd go to The Three Compasses off Old Compton Street and all the bars in Soho. Simon was doing print and textiles, and Lee was doing fashion. I thought they were bonkers, to be totally honest with you.

Why did you think that?
Leane: I was more mainstream. I didn't get fashion at that time. Lee used to come and meet me after work at Hatton Garden. He used to sit on the bench across the road. He'd normally have a can of lager. One time, my bosses weren't there, so I told him to come up and meet me in the atelier. I said, "I've got to finish this piece and then we'll go off." He was a bit blown away, because it was a traditional, beautiful old workshop. I was making a tiara that folded up into a necklace. There were diamonds and gold and, because we did restoration, there were beautiful old pieces everywhere. I showed him some Albert chains. I started showing him pieces and techniques. I think then his brain started ticking. He was already thinking of what I'd be making him for his shows.

Already designing?
Leane: He was already on it. I didn't start working with him until *Highland Rape*, which was Fall/Winter 1995. For that, I made little Victorian chains—he must have remembered the Albert chains I showed him on that first visit—with a T-bar. When he first asked me to work with him, I was daunted, because I was a classically trained goldsmith, not a designer. Also, I was twenty-one years old and had just finished my apprenticeship. I was worried about the money, because I worked with gold and diamonds. I told him he couldn't afford it, and he told me to use silver or brass. I said, "What are you on about? I don't make things in brass!" Then he just said, "It will be fun. I'll pay for the materials, if you'll make them." So I agreed to make them for nothing. At first I just wanted to help my friend. Then I presented them like pieces of jewellery, with anti-oxidising tissue

to protect the silver. I think he thought he was going to get them in a plastic bag. When he unwrapped them, he said, "You didn't need to put them in all this tissue."

Were you happy with the response to Highland Rape*? Some critics said the chains through the skirts looked like tampon strings.*
Leane: I didn't actually see the show. It got mobbed and they had to close the doors. I don't know whether he did it on purpose, but the invite was a photocopy A4 piece of paper—anyone could photocopy it. I was outside with my mother trying to get in. When I saw the pictures, I liked what he'd done. When he first asked me to make the chains, I thought it was a bit boring. But what he did with them—hanging them off the skirts—was brilliant. I never questioned him again.

Never?
Leane: Maybe a couple of times. When he came to me for *The Hunger*, the next show, he wanted chains with a big T-bar that went across the legs. The biggest thing I'd ever made was a tiara. I was a conditioned goldsmith, but he took me out of that box in one fell swoop. "You are a great craftsman—just think big," he said. "Take those skills and use different materials, different tools. You could create anything." No one had ever said that to me.

He gave you a licence to create.
Leane: He would strike while the iron was hot. He'd say, "Maybe you could also make a piece with stag horns?" This was all in a pub. Afterwards, I'd go home but I wouldn't sleep, because I'd start thinking and planning. I'd phone him the next day and say, "I figured it out." I was working full-time, so I did all this in the evenings and the weekends. My bosses were kind enough to let me use the workshop. I got to the point where the pieces I was trying to make were so big that I had to turn to a friend who was a silversmith. I'd use his workshop so I could use the bigger apparatus. I'd find the funniest things to use as tools—old gas bottles, anything. I fell in love with what I made for him then. I was beginning to be me. Early on I made a tusk earring for him. I'd wear one every day and I felt so fierce. The identity for my house was born. It was elegant, refined but powerful.

It must have been strange to go from working behind the scenes to getting credited for shows.
Leane: We didn't reflect too much. It was always about the next show. The day after a show we'd sit down and he'd say, "What's next?" I started to get involved more. I started to suggest things when I did *Dante* [Fall/Winter 1996], which featured the crown of thorns. It was in a church, and I suggested he put nails through the girls' hands. And then he came up with the idea of thorns coming out of the face.

So it became more of a conversation, rather than a commission?
Leane: Exactly. Although when I showed him the

crown of thorns, he looked at it and I could tell he didn't like it. I felt my heart sink. I said, "What's wrong with it?" He said, "It needs more thorns." And I said, "Do you know, I thought that, too." And he said, "If you ever think anything needs more, it needs more. You must, when you make something, be sure, one hundred ten per cent, that it's better than what you thought it would be." Lesson learned.

He never had to say it again?
Leane: Never. He got more than he expected for every show. Literally two days before the show I would turn up with boxes and my screwdrivers. Poor Katy England [McQueen's then stylist] was trying to put the show together, but Lee liked to unveil what we had done. He'd say, "Shaun's here! Shaun's here!" So Sarah Burton would come up, Katy would come, everybody would gather around and I'd pull out these coiled corsets or what-have-you. Lee would call a model's name and shout, "Let's get this on her! Get it on, get it on!"

Such excitement.
Leane: Even talking about it excites me. He was always challenging himself to do something more. And so was I. And so was anyone who worked with him. He was the composer. He knew what Philip Treacy [McQueen's milliner] was doing, what I was doing, what Katy England was doing. He had the big picture.

Do you have favourite pieces?
Leane: The coiled corset and the coiled collars. They were the first things I made in brass. I made the collars first, then, a few shows later, for *The Overlook* [Fall/Winter 1999], Lee said, "Remember the neckpiece you made? Do the whole body." We cast a girl's body to do it. It was like armour, but quite flattering of the female form. We both signed it, and then we had an engraver go over our names and we dated it, like it was a piece of art.

Do you think you were a breath of fresh air for him coming from the world of jewellery? In so many interviews he talks disparagingly about the fashion industry.
Leane: I think so. And we kept each other grounded. We'd be at parties and we'd say, "Should we just go to a fish and chip shop?" We kept it a bit real.

Do you think of him when you design now?
Leane: I'll make a piece for one of my collections and think, "Lee would love that!" Then I know it's a winner. He's embedded in me, because I worked with him for seventeen years.

Some people who worked with him mention that he could be difficult.
Leane: He was quite soft with me. Don't get me wrong, he made me cry many times. We'd fall out. But we loved each other dearly and we had a totally platonic relationship. I think it's relatively rare to get two gay men who are that close and who have a friendship and a work relationship that lasts that long without sex

getting in the way. Also, I worked hard for Lee. He knew that. I was a grafter—I always have been and always will be. Sometimes he would even say, "You need to call it a day." I was his jeweller, and he was very proud of that.

Did he get possessive if you were approached by others?
Leane: He did, but to be honest, I only wanted to work with Lee. That alone was a lot. At one point, I was doing eight shows a year. I was doing McQueen, I was doing Givenchy ready-to-wear and Givenchy haute couture, because he became creative director there.

Do you remember the mood changing as he became more successful and when he won the appointment at Givenchy?
Leane: When he got Givenchy, he was really happy, because he could earn a good wage and grow his own label. But the pressure was huge. I'd turn up at his house after work with some beers and he'd be sitting on the floor, sketching. And there would be drawings all over the floor. A collection of one hundred pieces—he'd have done it all that day. He was a genius. But it was a lot. Lee's shows were art, in my eyes. An artist does a show once a year or maybe once every two years, because it takes so much out of them. Lee was doing one every six months—more.

You don't talk about him with sadness.
Leane: When he passed, I was absolutely devastated. He was my closest friend. When you lose someone close to you, you never get over it. You learn to adapt. So I think about how I had him for nearly twenty years of my life. I created beautiful things with him that will be written about in books forever and will inspire young apprentices and students. It was a joyous, wonderful time, and I have to remember that.

—

This interview took place over drinks in Shoreditch, London, on the evening of October 2, 2014.

Opposite: Leane's personal photographs show him and McQueen holidaying together in Bhutan. "I felt it was when Lee and I were both at our most peaceful," he recalls. The trip turned from a vacation into a research trip, sparking McQueen's acclaimed *The Girl Who Lived in the Tree* collection, F/W 2008. The collection was also inspired by a 600-year-old elm tree in the garden of the designer's Sussex home and centred on a fairy-tale narrative about a girl who descends from a tree to marry a prince and become a queen. **Above:** Sketches by Leane depicting the aluminium and leather skeleton corset from McQueen's *Untitled* show, S/S 1998, and the silver and porcupine quill earrings for *Irere*, S/S 2003.

Brass Soft wire . 6mm

53.' inchs
26.0 FEET
over extra.
3 FEET
30 FEET of 6mm Brass wire.

Ask about Tobe, Circular

T → 120.75 ?

Finger Wax 1 gram
 Silver 10.5 grams
 18" - 15.5 grams.

Left: A reference image of a Kayan woman nursing her baby in Mae Hong Son, Thailand, taken from *National Geographic* and given to Leane by McQueen as inspiration for the coiled neckpiece worn by Alek Wek in the *It's a Jungle Out There* show, F/W 1997. **Above:** Leane's rough initial sketches for the coiled neckpiece, working out proportions and materials.

Above: McQueen was known for being hands-on with fabric. Those who worked in his studio commented on the visceral, even aggressive way he draped and cut cloth. This fabric sample of the coiled neckpiece created by Leane for *It's a Jungle Out There*, F/W 1997, was hurriedly fashioned by McQueen as a way of demonstrating to Leane the shape and style of his vision for the piece. **Opposite:** Björk wears a Leane neckpiece with a bespoke McQueen kimono, inspired by a similar piece from his *La Poupée* show, S/S 1997, on the cover of her 1997 album, *Homogenic*, photographed by another of McQueen's collaborators, Nick Knight.

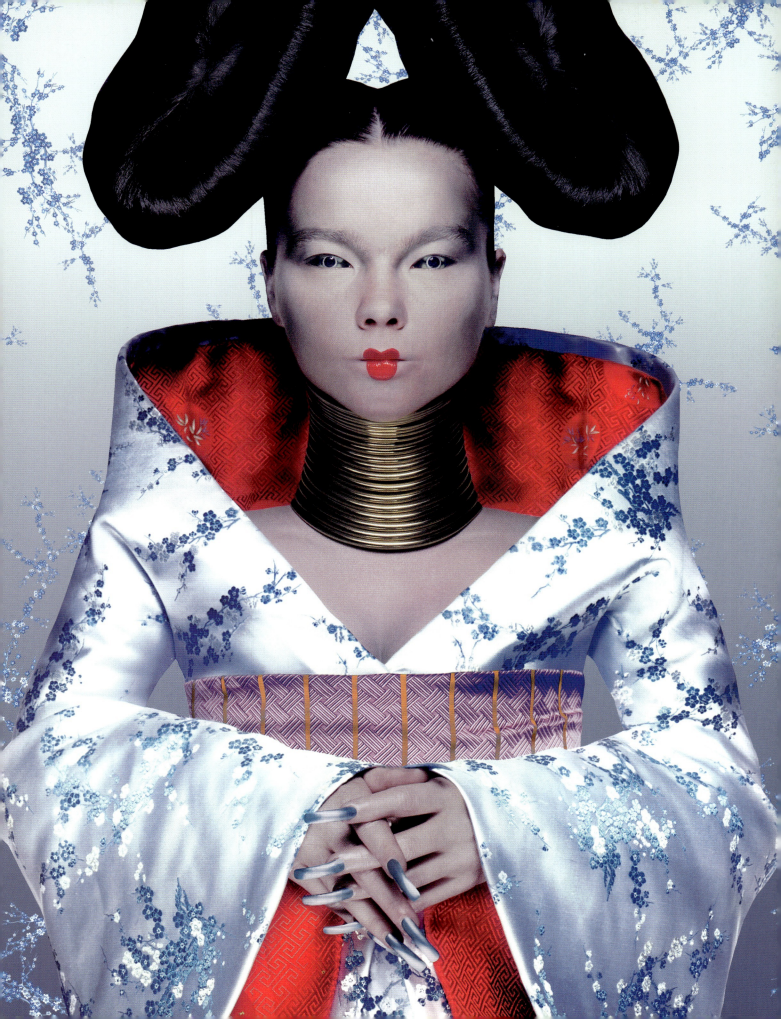

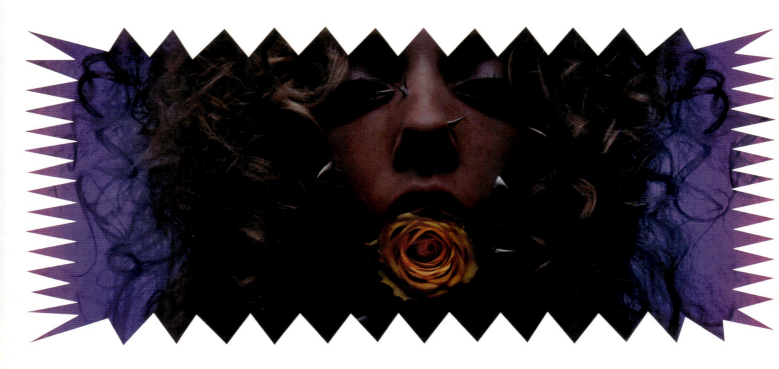

Above: Leane's silver rose thorns for McQueen's *Dante* show, F/W 1996, shot by Nick Knight. "This was one of the first pieces I made for Lee to be photographed by Nick Knight," recalls Leane. "Lee said, 'Remember when you were a kid and you pulled the thorns off a stem of a rose, licked them and stuck them on your face? I want to do that. I want them to look like they're growing from within.'" **Opposite:** Pieces by Leane for *La Poupée*, S/S 1997, shot by Sean Ellis and styled by McQueen's friend and collaborator Isabella Blow in a story titled "The Clinic" for *The Face* in 1997. "This is one of my favourite images. It brings back incredibly fond memories as it embodies the energy of Lee and Isabella, the two most important forces in my life at that time. The idea behind all of the pieces in *La Poupée* was to create fine shards of light. From a distance that's all you would see; only closer would you see the dangerous side of them."

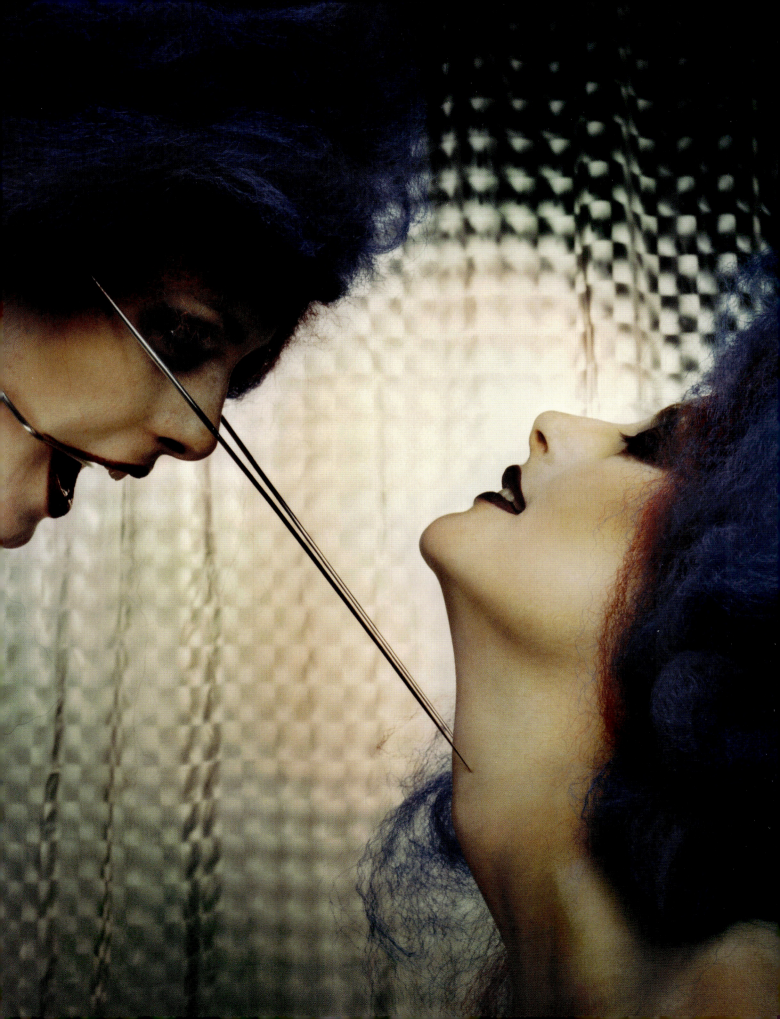

THE OVERLOOK

All work and no play makes Jack a dull boy. All work and no
play makes Jack a dull boy. All work andno play makes Jack
a dull boy. All work and no play mmakes Jack a dull boy. All
v All work and no PLay makes Jack a dull boy. All work and
no play makes Jack a dulllboy. All work and no play makes
Jack a dyll boy. All work and no play makes Jack a dull boy.

All work and no play makes Jack a dull boy. All work and no
play makes Jack a dullboy. All work and no Play m kes Jack
a dull boy. All work and NO play makes Jack a dull boy. All
work and no play makes Jack a dull boy. All work and no play
Makes Jack a dull boy. All work and no play makes Jack a dull
bog. All work and no play makes Jack a dull bot. All work and
no play makes jack a dull boy. All workandno play makes Jack
a dyll boy. All work and no play makes Jack Dull B oy. All
work and no play makes Jack a dull boy.

All work and no play makes Jack a dull boy. All work and no
play makes Jack a dull boy. All work and no play makes Jack
a dull boy. All w+rk and n+ play makes Jack a dull boy. All
work andnoplay makes Jack a dull boy. All work and no play
makes Jack a dullboy. All workand no play makes Jack a dull
boy. All work and no play makes Jack a dyll boy. All work
and no play makes Jack a dull boy. All workand NO PLAY makes
Jacj a dull boy.

All work and no play MAKES JACK a dull boy. All work and no
play makes Jack a dull boy. All work and no play makes Jack a
dull boy. All work and no play makes JACK a dulllboy. All work
and no PLAY makes Jack a dull boy. All work and no play m kes
Jack a dull boy. All work and no play makes Jack a dull boy.
All work and no play makes Jack a Dull boy.All work and no
Play makes Jack a dull boy. All w rk and no play m kes Jack
a dull boy. All work and no play makes Jack a dyll boy. All
work and no play makes Jack a dullboy. All work and no play
makes Jack a dull boy. All work and no play makes Jack a
Dull BOY. All work and no play makesJack adull boy. All work
a no play makes Jack a dull boy. All work and no play makes
Jack a dull boy. All work and no play makes Jack a dull boy.
All work and no play makes Jack a dull boy.

Alexander McQueen The Overlook Autumn/Winter 1999/2000
Tuesday 23 February 1999 8.00pm. The Gatliff Road Warehouse,
Gatliff Road, Victoria SW1.

Name . Seat
Supported by American Express.

Press contact: Janet Fischgrund/Alexander McQueen. T 0171
729 0537, F 0171 256 1618. Buyers contact: Amanda Lewis/
Onward Kashiyama. T 0171 349

McQueen's *The Overlook* show, F/W 1999, featured Leane's elaborated metal corset, which built on the coiled neckpiece shown on p. 105. The piece features 97 handcrafted aluminium coils and has a 15-inch waist. Leane was only able to craft eight coils in a 16-hour day owing to the skill and precision it took to curve, hammer, and polish the aluminium. **This page:** Notes from the catwalk show, which drew inspiration from Stanley Kubrick's 1980 psychological horror film *The Shining*, are shown alongside a Polaroid of Leane and a model in the corset taken by Clive Arrowsmith on set for *The Sunday Times*' "Next Best Thing" feature in March 2002. **Opposite:** Leane and Tim Brightmore can be seen adjusting the coiled corset on McQueen fit model Laura Morgan in this photograph by Chris Moore. It took fifteen minutes to put the piece on and almost as long to remove it.

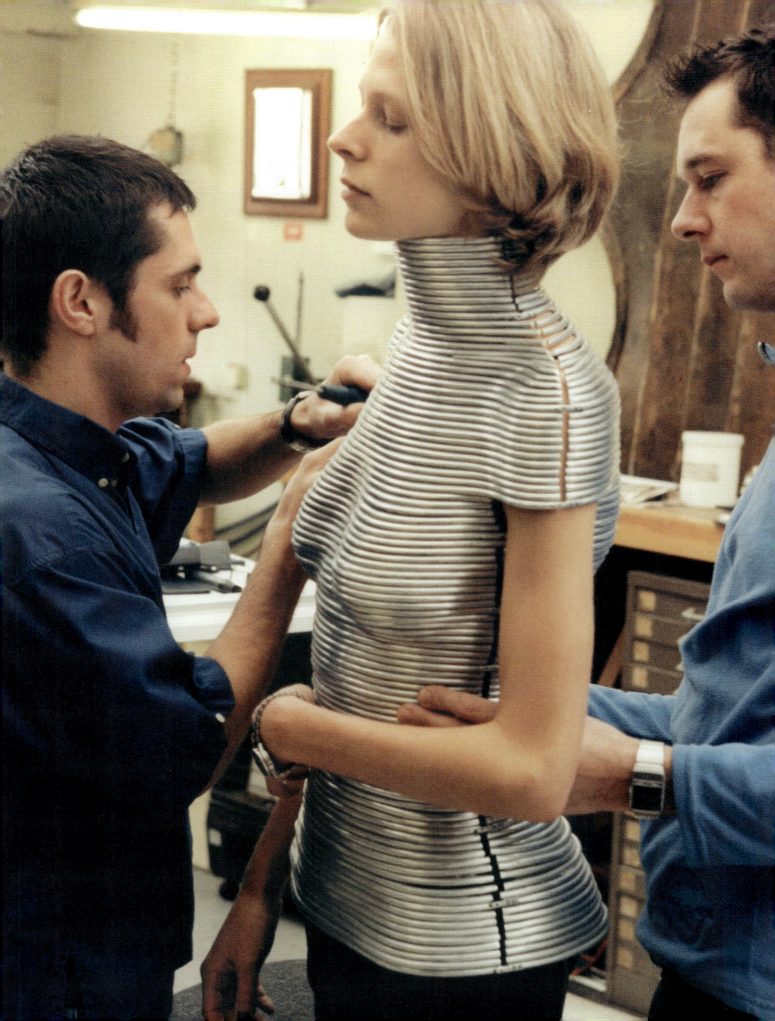

This page, top and left: Two sketches for unmade designs by Leane for McQueen. One depicts McQ logo earrings, the other a complex vine neckpiece, using sea pearls to represent clusters of grapes, which dates back to McQueen's tenure as head designer at Givenchy from 1996 to 2001. "I was always making pieces to tight deadlines, six weeks or less was normal. Lee loved this, but it was impossible to create it in time for the show as I was already working on the McQueen show," recalls Leane. **Bottom, right:** Working drawings and measurements for Isabella Blow's silver tusk anklet. Alongside many of Leane's creations, this piece was used by Blow in her styling work. **Bottom, left:** This 1997 photograph is by Sean Ellis from a story called "Shaft" for *The Face*.

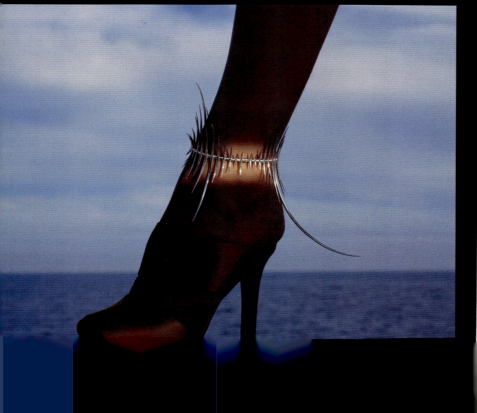

Right: The initial rough sketch for the arm vine crafted by Leane for McQueen's *Dante* collection, F/W 1996—one of the designer's most celebrated shows. **Below:** Donna Trope's image of the piece for *Surface* magazine.

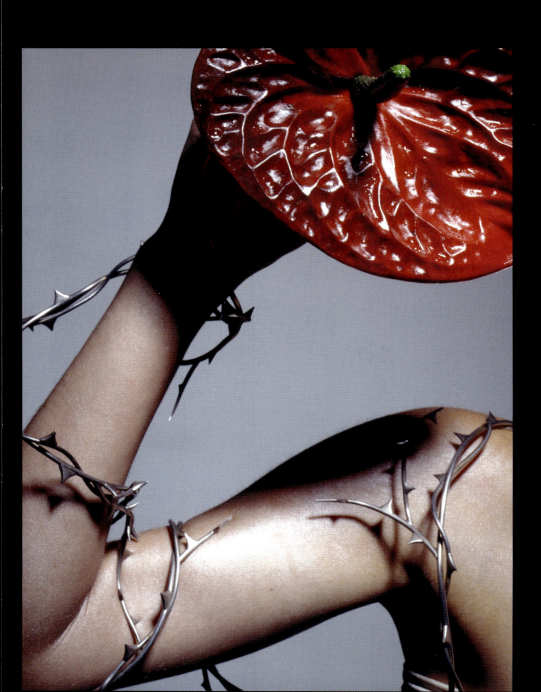

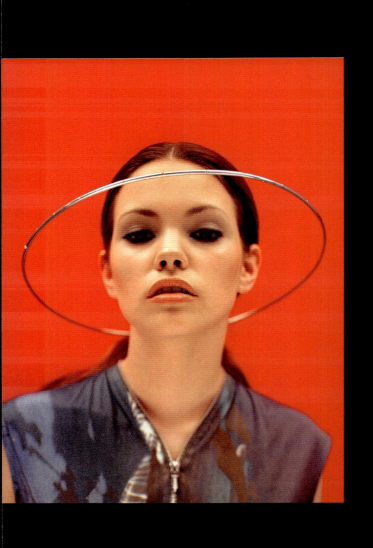
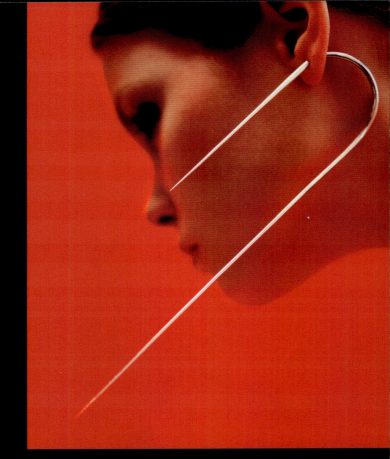
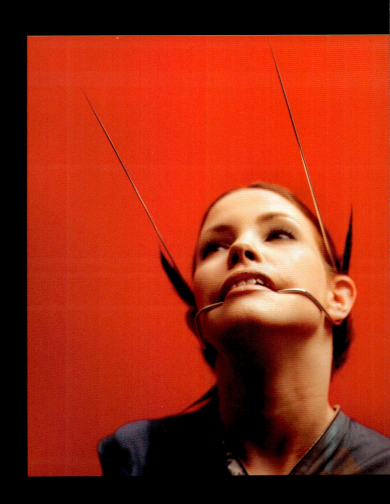

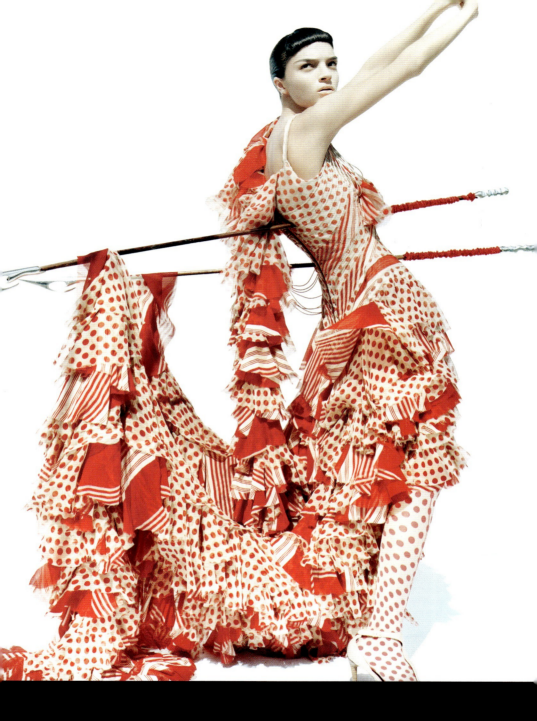

Opposite: Pieces created by Leane for McQueen's *La Poupée* show, S/S 1997, shot by Gavin Fernandes. On the far left image, Leane comments, "I have always thought of this piece as a fallen halo." **Above:** "This was one of the most technically challenging pieces I made for Lee, as I was fighting against gravity," says Leane of the spear dress from *The Dance of the Twisted Bull*, S/S 2002, captured here by Mikael Jansson for *Volume*. "Underneath the dress was a copper corset, created to support both ends of the spear and the entire weight of the train. The ends of the spear were carved in solid silver and inspired by Greek architecture."

Opposite: To celebrate the opening of *Alexander McQueen: Savage Beauty* at the Victoria and Albert Museum in 2015, Nick Knight and stylist Katy England, both friends and collaborators of McQueen, united to celebrate the late designer's groundbreaking work for *AnOther* magazine. On the cover, Stella Lucia modelled an embroidered top, worn by Kate Moss in *Voss*, S/S 2001, with Leane's silver African hoop earrings and tusk mouthpiece, crafted for *Eshu*, F/W 2000. "I have always been interested in cultural differences in body adornment," says Leane. "This mouthpiece was an imagined hunting mask. No such thing exists but I was fascinated by the power and impact of two fine lines. The model appears like a warrior."

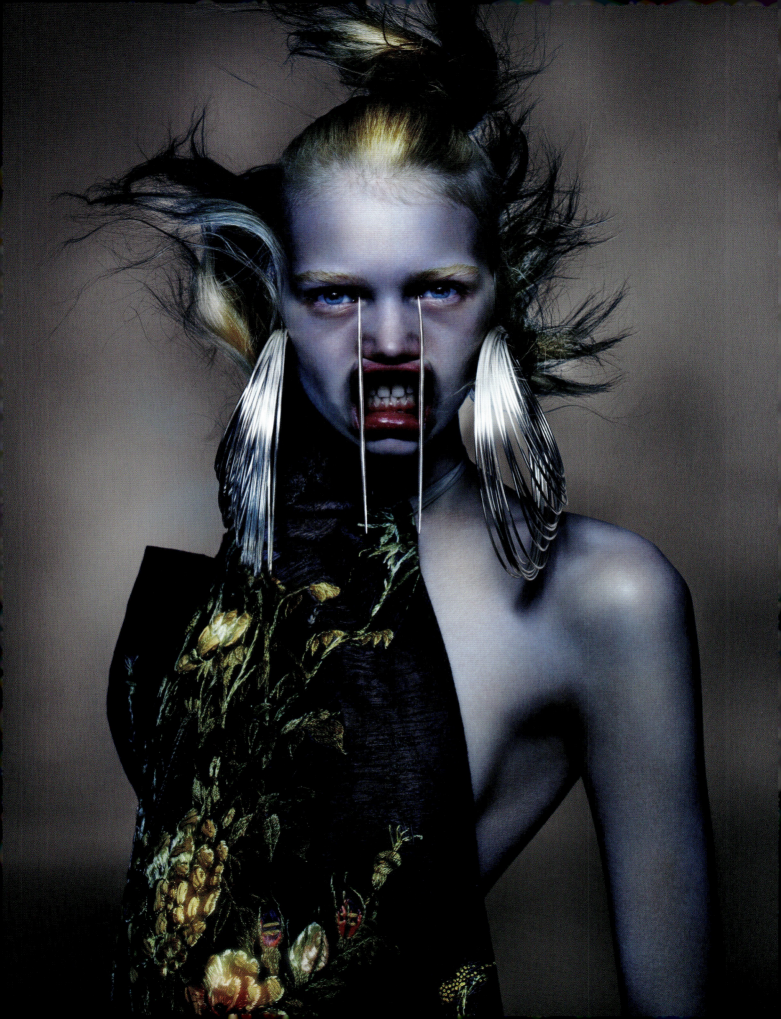

English designer **Kim Jones** and Scottish stylist **Alister Mackie** are two of the most celebrated figures in men's fashion. The former was appointed Men's Artistic Director of luxury French house Louis Vuitton in 2011 and recruited Mackie to consult on the house's collections. Together, they have masterminded runway shows that have set the pace for contemporary menswear. The pair began their collaboration during Jones's three-year stint as creative director of British brand Alfred Dunhill, which began in 2008. Before these positions, Jones ran his own eponymous label, which was styled by Nicola Formichetti, a friend and protégée of Mackie's and then a member Mackie's team at *Dazed & Confused*. Mackie began styling shoots for *Dazed & Confused* in the early nineties after studying at Glasgow School of Art and completing an MA in Fashion at Central Saint Martins, where Jones later also studied. Mackie was recruited to the magazine by stylist Katy England, who continues to collaborate with him to this day. His tendency to work with other stylists is unusual within the fashion industry. In 2005, the Dazed Group launched men's style magazine *Another Man*, naming Mackie the Creative Director. There, he is known for shoots that are romantic, nostalgic, decadent, and focused on capturing a bohemian rebel spirit. By contrast, Jones is celebrated for his sporty aesthetic and elaborate knowledge of streetwear and subculture. The mixture of these two signatures at Louis Vuitton has led to collections that question typical understandings of men's luxury, playing with tradition while making heavy use of Vuitton's access to fine fabrications and craftsmanship. Collaboration is a common theme in the pair's Vuitton collections. Jones's partnerships with art duo Jake and Dinos Chapman won acclaim early on in his Vuitton tenure, while his decision to clash the Parisian heritage of Vuitton with the youthful energy of New York skate-brand Supreme for Fall/Winter 2017 resulted in one of the most discussed and reported fashion collaborations ever.

Kim Jones and **Alister Mackie**

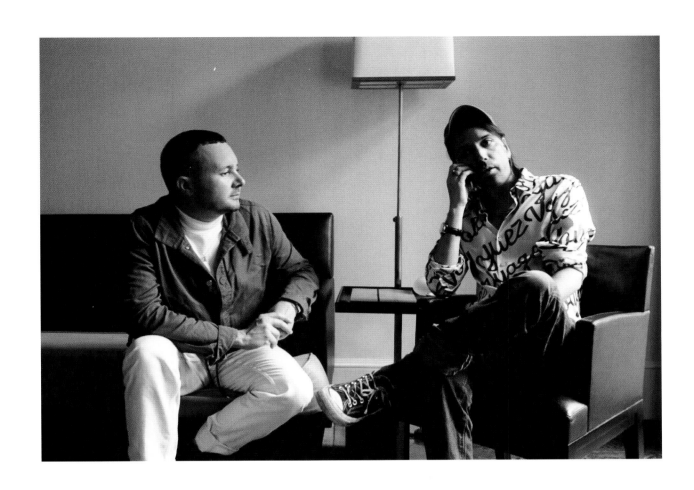

Jones and Mackie, shot in April 2017 at the
Mercer Hotel in New York by Hugo Scott.

Your aesthetics are quite different. Do you think that's why your collaboration is successful?

Kim Jones: We come from different places, and where we meet in the middle is a place that works. Our different perspectives make it strong.

Alister Mackie: Kim's very good because he leaves you the space to do your thing. He always comes up with the themes for the collections, because he's such a great storyteller, but he's not always looking over my shoulder. And we do like the same things. I get excited by a new painting he has, or a piece of vintage clothing he's acquired. That helps. But it's not just about objects; it's about connection.

Jones: If you're collaborating with someone, you have to give them respect. I like to let them say what they think. The shows are when we really have our fun, isn't it, Alister? It's very much an open dialogue. He's not just a stylist—he's a consultant. There's stuff that's Alister, and there's stuff that's me.

Mackie: We've been able to develop our own Vuitton aesthetic, because we've done it over five years now. To be able to invent that is quite a unique thing. It wasn't related to what went before.

Alister, you're from the suburbs in Scotland. Kim, you spent much of your childhood in Africa. Did you both feel like outsiders looking in when it came to fashion?

Mackie: I think you just appreciate everything you get much more.

Jones: I still remember that feeling when you're on a train and you arrive in London—that excitement.

Mackie: I still get that, even when I walk into Soho.

Jones: That feeling of the possibilities, the glamour.

Mackie: Or just going anywhere new and seeing something and not quite knowing what it is, but you know it's going to be exciting. I definitely identify with that feeling of wanting to be where *it* is. I remember being at Glasgow School of Art in Scotland and looking at images in *i-D* and wanting so badly to be in that place where that was happening with those people. I got on an overnight coach to London, with a sleeping-bag, and looked on the notice board at Saint Martins to find somewhere to stay. It was just brilliant. I felt completely free. Our tutor Louise Wilson was a huge figure in both of our lives. She transformed my life, because she got me a bursary and was almost a parental figure for me. I was young. I wasn't well travelled; I hadn't been anywhere at all. And she taught me how to have a critical eye. Her way of teaching was uncompromising. She lives on for me, and for Kim. We remained friends with her through many years—twenty years after I left. She would always come to the Louis Vuitton show. She was another connection between us.

Jones: She was a huge inspiration. That sense of curiosity and possibilities that Alister describes—that's what Louis Vuitton is. It offers these huge possibilities—being in Paris, and what the research can be and how outlandish it can be and the resources you can access. Now we've got a London look on it.

Brits in Paris! Is that London sensibility part of your success?

Jones: I think there's a sensibility in London that works really well in fashion because we're one of the more open societies—somewhere people will feel a lot of things and be excited about a lot of things. It's such an international city.

Mackie: It's historical. People from London have come and done their thing in Paris and broken down that bourgeois theme. I worked at the French house Martine Sitbon when I was young and really absorbed how they approached fashion. They'd be serious about it. Not ironic or mocking at all. It was fascinating to me because I'd come from *Dazed & Confused*, which was about irony and bucking the system.

Do you remember the first time you met?

Jones: It was on the street in 2000 or 2001. I was with Nicola Formichetti. I think we went to Café de Paris. I can't really remember the rest of the evening! It did take a bit of time to win you over.

Mackie: I was really close with Nicola, and they were working together. They were on a roll with Kim's own line, Kim Jones, and they had a dynamic energy together. They were younger than I was and more clubby. It was more sportswear. But Nicola was one of my protégés at the magazine. He'd started to become part of our family, and through that Kim and I got close.

Jones: It did take a while for us to become friendly. He's quite insular, and I'm a bit more gregarious. But we have a very similar sense of humour, which is really important. Now, I can tell if there's something Alister would like or hate. He completely understands me and what works for Vuitton and what doesn't. It's got that synergy now.

Kim, when you were appointed at Vuitton, did you consider other stylists or did you know straight away that you wanted to work with Alister?

Jones: I called him when I got it straight away. "I want you to come work with me." And that was it.

Mackie: It started with a bang. The response was so positive.

Jones: We'd worked together before when I was at Dunhill, and we had a good relationship. The Vuitton team is purely people I trust and like. Alister sees a lot more collections in real life than I do because he's a stylist, so sometimes he'll point out things I'm not aware of because I haven't seen it—a collection looking similar to something recent, or a popular mood. Those things are really important, especially given that there are millions of people watching the show online the moment it happens. The shows are not easy to do, so if you bring someone in to collaborate on them, you have to have that level of trust. And you always have to take the feedback. If you're successful in a place like Vuitton as a designer, they naturally want more from you, so you have to delegate. We're doing—I can't even count!—twelve a collections year, and then there's all the accessories as well. With the big seasonal runway shows, you're putting yourself out there every six

118

months. You're only as good as your last collection.

Mackie: When I first went to see the shows in Paris in 1994, we were a small group. Only a few people cared and were in that inner circle of the fashion audience. Now, it's general mass entertainment. Fashion shows have become more and more of a media event. There are so many more people scrutinizing it. There are more reviewers, and they're more outspoken and more public. Now, everybody's got an opinion. Everybody sees it as soon as it comes out, and everybody's got something to say, and that's great, but we are the ones who actually have to do it. We feel the pressure.

Kim, you must feel that even more acutely because you're the named designer. You're the one taking the bow at the end.

Jones: I hate being put in the prize picture in the end of the show!

Mackie: I am perfectly happy being the behind-the-scenes person. I have the best of both worlds, because I'm working on this elaborate runway presentation, but I don't have to worry about all that stuff that he has to worry about. The production, the sales, the shop opening—stuff like that is not my forte.

Alister, you're very involved in design, which might surprise people who think a stylist just comes in at the last minute and puts the models in the looks.

Mackie: I have done that at other houses, but I started at McQueen, and we always worked like Kim and I do. We had training with Lee—fittings and holding the pins, shaking. The fabrics, the colours, the sketch. It was amazing training. Plus, I studied fashion design at Saint Martins.

Kim, you've collaborated widely on your Louis Vuitton collections, most recently with Supreme for the Fall/Winter 2017 collection, which received a huge amount of press attention. You've also worked with the Christopher Nemeth archive and the Chapman brothers. Why do you bring other voices into the Vuitton world?

Jones: I've always worked like that. You always learn something from people. It's a nice way to be social, too. It's something that I just don't want to think about not doing, be it making books with Pieter Hugo or Alasdair McLellan, or making films, or doing design collaborations. Working this way is probably one of the most modern things you can do. You have to have different worlds coming together. Otherwise it can feel flat. Marc Jacobs does it a lot. He really developed that during his time at Louis Vuitton with his collaborations with Stephen Sprouse and Yayoi Kusama, and I realised it was a part of the culture and that's why I should do it.

Mackie: The way Marc worked with people like Stephen Sprouse was inspiring to both of us. I worked with him for a long time—fifteen years—and his thought process, and the great fetish over the handbags—like with the handcuffs attaching the girl to the bag—stuck in my head. We love to put in touches like that—the monogramed collars, or shirts with the name all over them, or the scarves with the Louis Vuitton name around the necks, like the name is really like strangling them. It's this fetish of branding, but it's such a blockbuster brand. Why not?

Alister, you also are very collaborative. You've worked closely with other stylists, notably Katy England, which is quite rare.

Mackie: It's just something that happened, because I started to work with Katy England when I was still studying at Saint Martins. She encouraged me to go to *Dazed & Confused*. With Katy, it was a really dynamic meeting. I got into it without ever feeling threatened or being competitive. So collaborating has always been easy. I worked with Venetia Scott at Marc Jacobs and I worked with Camille Bidault-Waddington on Marc by Marc Jacobs. Maybe other people would find it hard, but I find it really nice experience.

Does working with someone elevate a bit of the pressure?

Mackie: Absolutely. You can have an idea and you can feel a bit timid about it and you just need someone to say, "That's great. Let's take it and do it in five different ways!" With this Masai stuff we've done—first for Kim's first show [Spring/Summer 2012] and right through to today—that's how it became so big. Because there were two of us springing it back and forth. Now it's such a signature.

Is it hard to see Alister work with other designers?

Jones: Not really. Loyalty to me is really important. If people are not loyal, I tend to not work with them. There's no point, because there's no trust. I'm a bit cutthroat like that. Maybe it's a Virgo thing. But I never doubt Alister's loyalty. I never question his motives.

Why do you think people have responded so well to the work you've done together at Louis Vuitton?

Mackie: It was right for the brief. Taking cult streetwear ideology and making that luxurious makes sense. And Vuitton is about travel, and the travel bug is authentic to Kim. It's real, so people respond to that. What we do isn't radical, but it's right for this place. It's very upbeat, it's not melancholy, it's very dynamic. You could be very poetic and reflective at other houses — that's not what this is about. Louis Vuitton is such a global fast-moving concept. We have to always be going forward.

—

This interview took place across two separate days in Paris; April 15, 2016, at the Louis Vuitton offices on rue du Pont Neuf, and May 11, 2016 on set during the shoot for the pre-collection S/S 2017 lookbook, with follow-up on the phone on February 1, 2017.

For Louis Vuitton S/S 2012, Jones's first collection for the house, he found inspiration in a Masai blanket from his home, a souvenir of his childhood in East Africa. The blue-and-red plaids have reappeared in subsequent Louis Vuitton collections. This image was shot by Jones and Mackie's frequent collaborator Alasdair McLellan and appeared in "A Traveller's Story: Louis Vuitton Special" in *Another Man* magazine, where Mackie serves as creative director. Mackie styled both the show and McLellan's image.

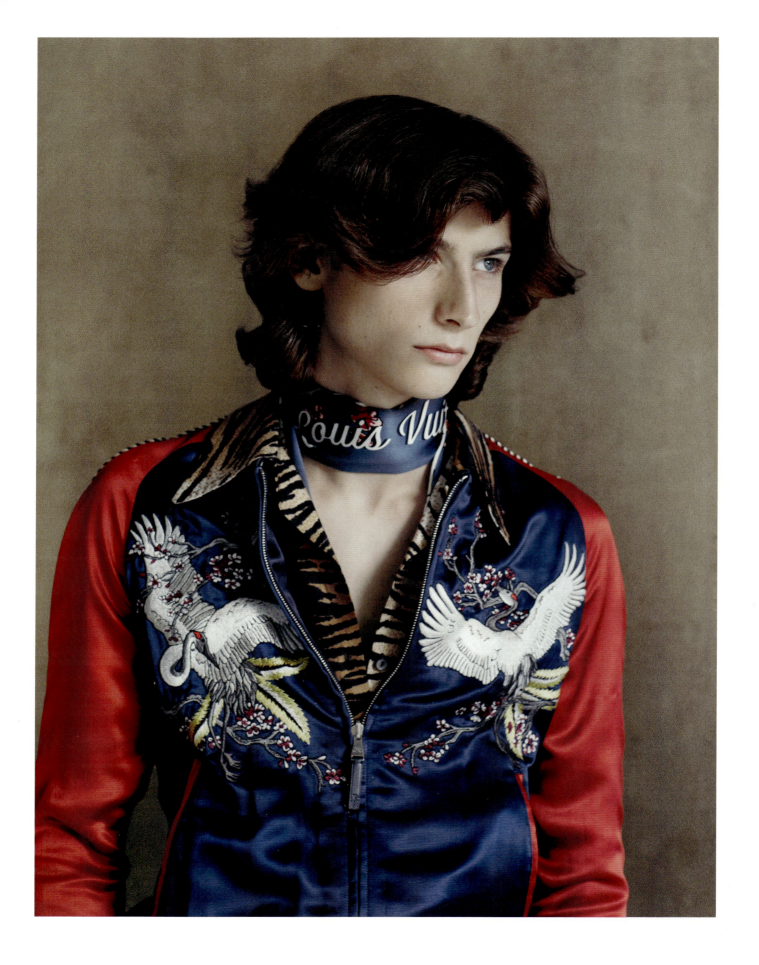

Opposite: Jones's S/S 2016 collection for Louis Vuitton, captured by Julia Hetta for the F/W 2015 issue of *Another Man* under the headline "Grand Tour" in a nod to the travel focus that underpins Louis Vuitton's narrative. Jones crafted vivid satin souvenir jackets with embroidery that referenced various realms, such as Japan, China, and Indonesia. Backstage, he spoke of an interest in how ideas and trends migrate, singling out Japan's adoption of American sportswear styles. The Louis Vuitton slogan neck scarf is an example of what Mackie calls the "fetish of branding." **Above:** Mackie's home in North London is full of pieces from his years working with Louis Vuitton, including gifts and tokens from Jones, collected on the designer's many travels and research trips, and products from key collections worked on by Mackie. A Jean Cocteau drawing, a birthday present from Jones, hangs on Mackie's bedroom wall next to a Louis Vuitton F/W 2013 blanket, made in collaboration with the Chapman brothers, and a bag from Jones's debut collection for the house, S/S 2012. In addition to the clothing of Masai people, one of the key references for the show was the work of photographer, artist, and diarist Peter Beard, who travelled extensively in East Africa. Jones described the collection as "a fictionalised imagining of that period of travel to Africa in the 1960s and 1970s."

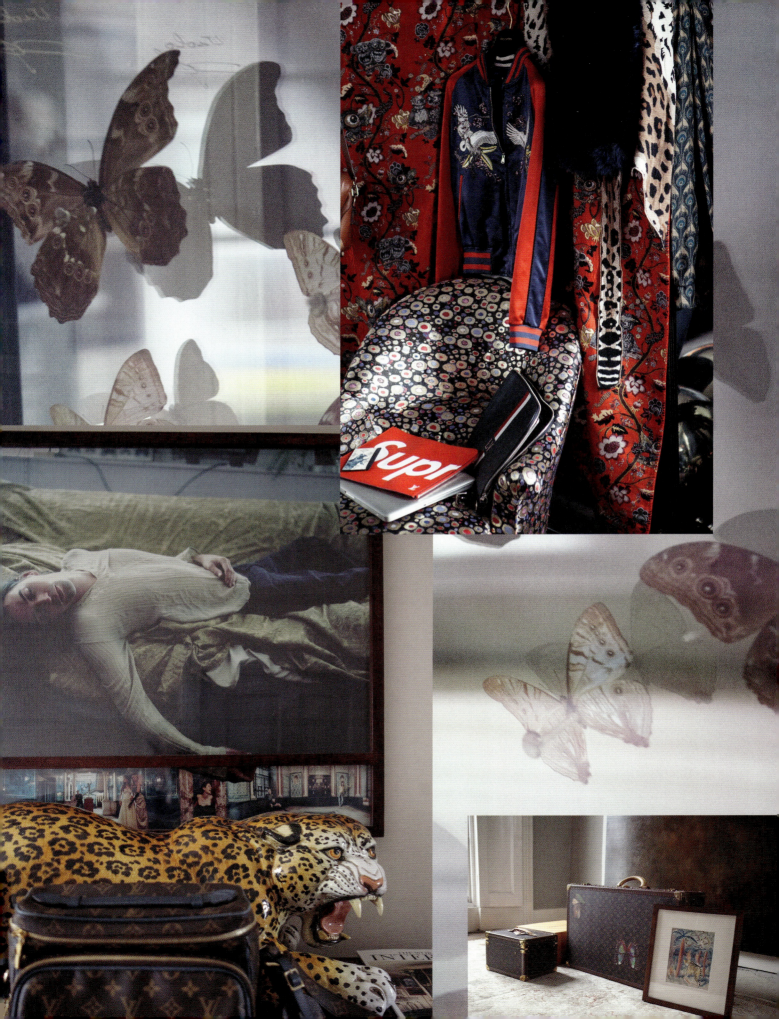

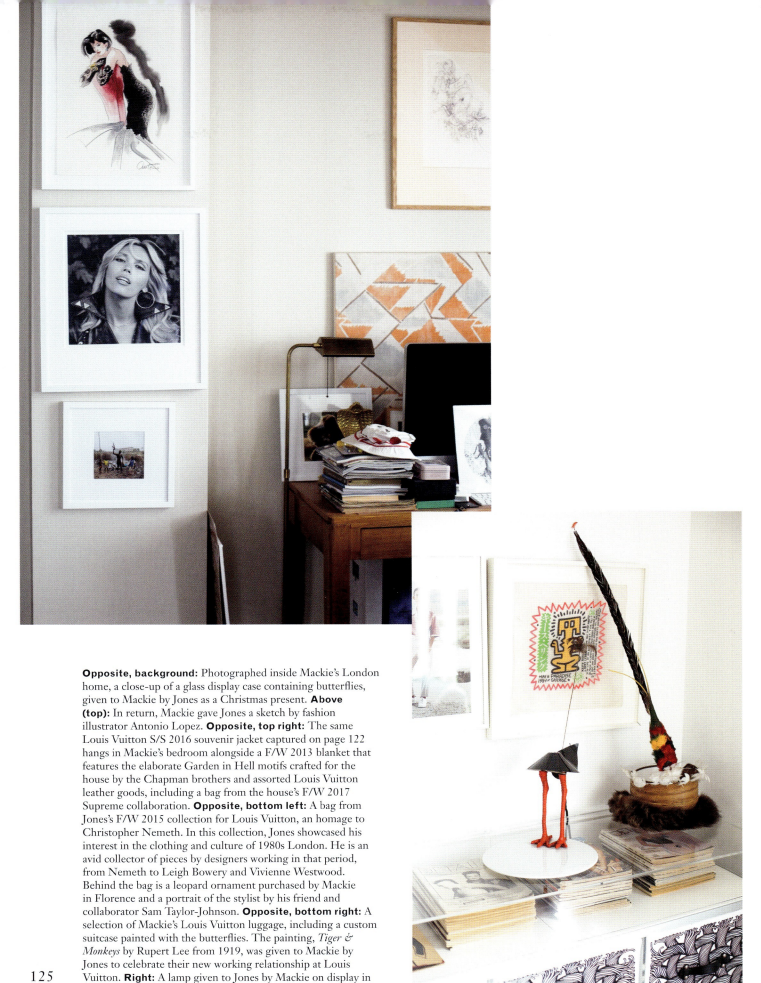

Opposite, background: Photographed inside Mackie's London home, a close-up of a glass display case containing butterflies, given to Mackie by Jones as a Christmas present. **Above (top):** In return, Mackie gave Jones a sketch by fashion illustrator Antonio Lopez. **Opposite, top right:** The same Louis Vuitton S/S 2016 souvenir jacket captured on page 122 hangs in Mackie's bedroom alongside a F/W 2013 blanket that features the elaborate Garden in Hell motifs crafted for the house by the Chapman brothers and assorted Louis Vuitton leather goods, including a bag from the house's F/W 2017 Supreme collaboration. **Opposite, bottom left:** A bag from Jones's F/W 2015 collection for Louis Vuitton, an homage to Christopher Nemeth. In this collection, Jones showcased his interest in the clothing and culture of 1980s London. He is an avid collector of pieces by designers working in that period, from Nemeth to Leigh Bowery and Vivienne Westwood. Behind the bag is a leopard ornament purchased by Mackie in Florence and a portrait of the stylist by his friend and collaborator Sam Taylor-Johnson. **Opposite, bottom right:** A selection of Mackie's Louis Vuitton luggage, including a custom suitcase painted with the butterflies. The painting, *Tiger & Monkeys* by Rupert Lee from 1919, was given to Mackie by Jones to celebrate their new working relationship at Louis Vuitton. **Right:** A lamp given to Jones by Mackie on display in the designer's office in the Louis Vuitton headquarters in Paris.

125

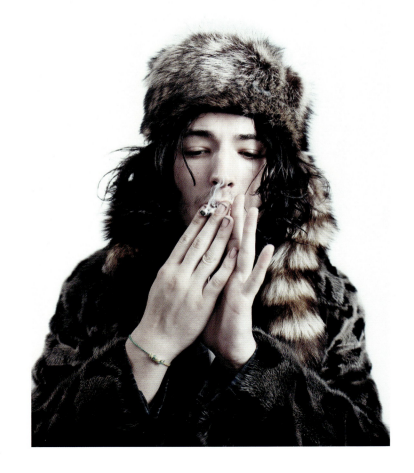

Above: Musician Alex Turner styled by Mackie and photographed by Willy Vanderperre for the S/S 2013 issue of *Another Man*. Turner wears a monogrammed silk tuxedo made for the magazine by Louis Vuitton. **Right:** Actor Ezra Miller shot by Vanderperre for the cover of the F/W 2013 issue of *Another Man* in a fur coat by Louis Vuitton and a racoon hat from Mackie's own clothing archive. **Opposite:** Louis Vuitton's Garden in Hell collaboration with the Chapman brothers is captured by David Sims for the F/W 2013 issue of *Another Man*.

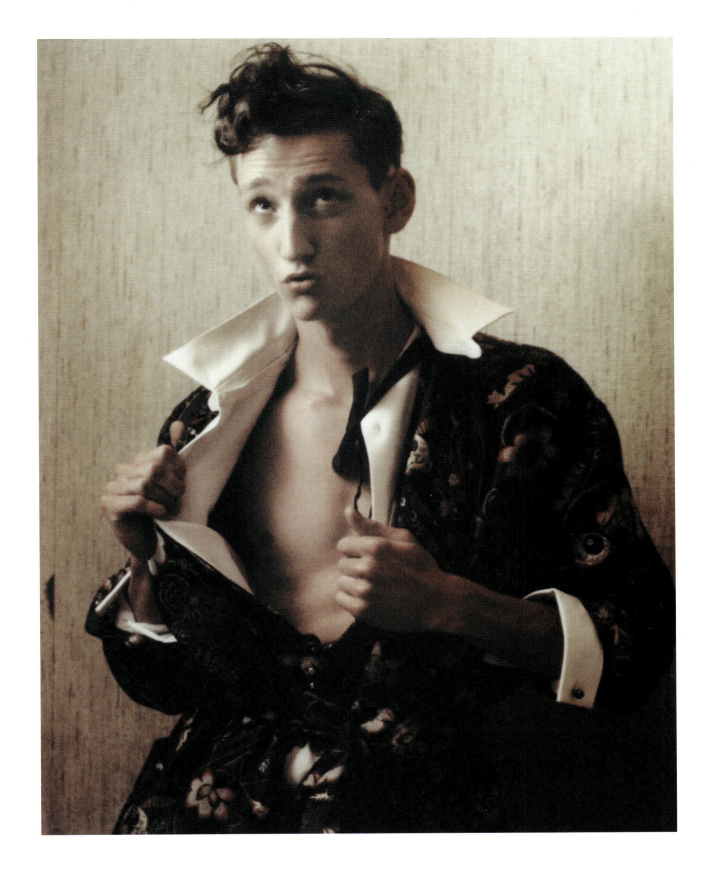

Viktor Horsting and **Rolf Snoeren** enjoy challenging both critics and interviewers. They deliberately invite confusion; inspired by the frequency of comments about how difficult it can be to tell them apart, they began sporting identical glasses. In many ways, as a duo, they are as much a form of artistic output as the collections they show under the Viktor & Rolf name. The similarities extend beyond appearance. Now based in Amsterdam, both were born in small towns in the south of the Netherlands. They graduated from the ArtEZ Institute of the Arts in Arnhem in July 1992, and less than a year later, in April 1993, the results of their first collaboration won the main prize at the Festival International de Mode et de Photographie in Hyères, France. Their first formal presentation was part of a group show at the Musée d'Art Moderne de la Ville de Paris, but since January 1998 they have become known for theatrical and experimental runway shows. In 2015, they announced the end of their ready-to-wear line, two years after they relaunched their couture operation in July 2013, and spoke of a desire to return to their roots as "fashion artists." This desire to defy categorisation and move between different fields is the one consistent line in their varied trajectory— just as they have swayed back and forth between the fashion and art worlds, they have reinvented themselves season upon season, surprising attendees with the eccentricity of their ideas. Models have appeared as walking sleeping beauties, sporting full-length coats crafted from satin eiderdowns and pillows bound to their heads for *Boudoir*, Fall/Winter 2005; as living works of art encased in haute couture dresses made from giant deconstructed picture frames for *Wearable Art*, Fall/Winter 2015; and as human black holes, covered head to toe in soot, for their all-black collection *Black Hole*, Fall/Winter 2001.

Viktor Horsting
and **Rolf Snoeren**

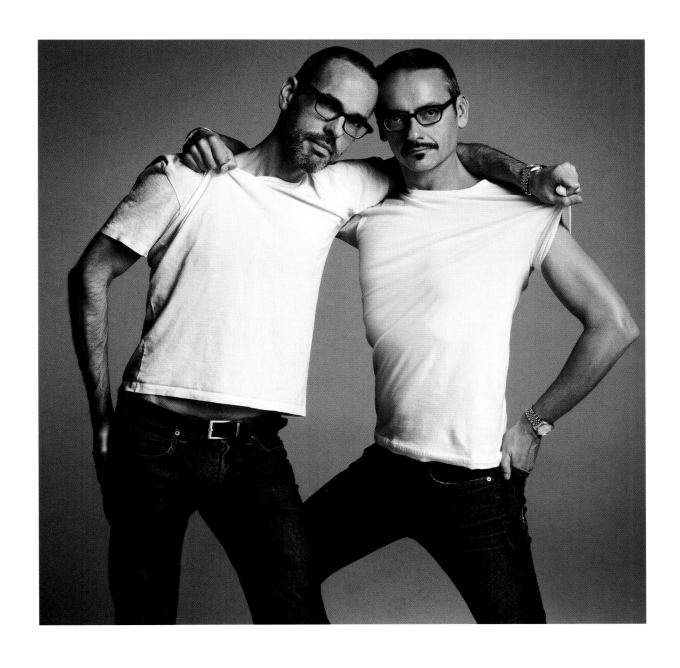

"We noticed that people could never tell us apart," laughs Horsting. The pair enjoy inviting confusion by exaggerating the parallels between their appearances. "We played with it with the same glasses or the same style of dressing," says Snoeren. Evidence of this behaviour is captured in this 2014 portrait by Inez and Vinoodh.

You're almost the exact same age, and you're from pretty much exactly the same place. Are you very similar people?

Rolf Snoeren: In a way. We came together because of our ambition, our drive, our taste, our desire to create something. There are similarities on a very important, deep level.

Viktor Horsting: We're both quite introverted. We both saw our childhoods as quite boring, and I think we developed a similar mechanism for overcoming this boredom: we both loved to draw, loved to read. We were both escaping into the mind, escaping into the world of fantasy.

So, using your imaginations a lot was a formative experience?

Horsting: Yes. The absence of something stimulating can actually be stimulating. It forces you to dive into yourself and to look at yourself and to come up with an alternative self.

What were your ambitions?

Horsting: I knew I wanted to do something creative, and then as soon as I understood what fashion was and that you could be a fashion designer, that's what I wanted to do.

Tell me about your first meeting. You met at art school, right?

Horsting: We met in 1988. We were in the same class. We liked each other's work. We recognized that we had a similar ambition and a similar drive.

What did you like about his work?

Horsting: What could I not like? It was pure creativity.

Was your work similar?

Snoeren: I don't know if it was similar, but we were both more ambitious than many of the people in our class. It was the kind of school where it was frowned upon if you would work too much. They would say to me that I would make the other students sweat because I worked so hard.

Horsting: We didn't decide to work together when we were in school, but when we left school, and we tried to make our way in the world, we were not really sure how to go about it. Working together felt very organic.

Snoeren: We never set out to become a label. We participated in a big design contest [the Festival International de Mode et de Photographie] in 1993 in Hyères in France, and when we won and people just assumed that we were a label, we decided to continue that way and we became one.

In lots of interviews you talk about how you invite people to confuse you and you want to come across as one person rather than two. Why?

Horsting: It's just a part of how we work. It's true that at a certain point we thought it was funny to play with it a little bit, because we noticed that people could never tell us apart.

Snoeren: But only visually. We played with it with the same glasses or the same style of dressing, but in terms of finishing each other's sentences, or what is real…it's just the way we are. Our work is very autobiographical in a way.

You say autobiographical, but you're two people.

Snoeren: Well, we experienced the same things. We've noticed that so many people ask us who does what, what is the vision, what role does each of us take. There is no division. We do everything together. We just sit down and start talking. It's almost coming from one brain. That's what we're saying with the same glasses—to the outside world, we act as one designer.

In fashion, we love to fetishize the individual—the star creative, the genius. There are a lot of collaborative relationships in fashion, but there are not many pairs that operate as one.

Horsting: It's our normal. It's the way we are, the way we work. The way we present ourselves is an extension of that. Even if we play with it sometimes, the root is the reality.

Snoeren: Having to do this on your own would be horrible. It's a gift to be able to do it together.

Do you think you can be more fearless because there are two of you? Are you somehow less exposed?

Horsting: Yes. There is a sense of feeling protected, which also comes from the fact that we discuss everything. We analyse things to death, but that constant conversation is part of the gift.

Do you argue?

Snoeren: Hardly ever.

Horsting: We're not argumentative people. We're conflict-averse.

When you do argue, what do you argue about?

Horsting: Every two or three years or so, I may have a tantrum.

Just you?

Horsting: It doesn't happen so much anymore.

Snoeren: Maybe once every five years.

Horsting: We do not like to shout and be aggressive.

Snoeren: When we don't agree, it just means it's not right. So if we don't agree, it's a signal that we're not there yet.

Rolf, in an interview you said, "Perhaps in the way we treat our work, there are opposites at play." What did you mean by that?

Snoeren: I meant that it's our different assets together that create something magical. We ourselves never really analyse it because it's a mystery and we like to keep it a mystery, but obviously there's some sort of tension.

What kind of people inspire you?
Horsting: Within our team, we tend to gravitate towards people who are open and less introverted. Usually it works well if our team members are more direct.
Snoeren: People like Tilda Swinton who are not introverted whatsoever.

You started the house in 1993. Have you noticed the industry changing since then?
Horsting: Of course we notice it. It sounds very grand that we started the house in 1993, but for two years we mainly performed in the art world. We were not sure about how to enter the fashion system.

If you hadn't met each other do you think you would have felt even more displaced?
Snoeren: We sometimes joke about what we would have done if we hadn't met each other.

Do you think you wouldn't have been successful?
Snoeren: Not much good would have come from it.

What would you be doing now?
Horsting: I don't know. Maybe I wouldn't be a fashion designer.

Is it hard to grow and change when you're so wedded to another person?
Horsting: I like the fact that you use the word "wedded," because in a way it is like a marriage. We both have experienced moments—especially a couple of years ago, when there was a lot of work and we were basically working all the time—where you feel like you forget yourself.
Snoeren: Viktor is my best friend, as well as my business partner. For me it's great to have a best friend with whom you can discuss everything.
Horsting: In that sense, we are our life's work.

You're not a romantic couple. I find it fascinating that it functions that well, but that you go home separately.
Horsting: It just works.
Snoeren: An important thing is accepting each other 100 percent. Whatever happens, there's no judgement.
Horsting: You can't judge, because in the end it is one thing—one body of work, one career.

Some of your shows are very eccentric. Explain to me the process of coming up with those ideas. How do those conversations start?
Snoeren: We call it ping-pong, because we talk a lot. We never work with mood boards. A lot comes from language, so we just start talking about how we feel, about fashion, about whatever we've seen or experienced. The ideas come from talking.
Horsting: We share an office. We travel together. We live in the same city. We see each other constantly. We're texting and emailing always.
Snoeren: We're sending each other hundreds of

messages a day, from waking up to going to bed. Mundane things, by the way, not just work-related. It's all one.
Snoeren: It's all the same.

Do you mind criticism? Is it easier to deal with as a pair?
Snoeren: At a certain point we stopped reading reviews.
Horsting: We started to say, "I don't mind," but we do, and that's one of the reasons we stopped reading reviews—because we'd get down about it.
Snoeren: Sometimes when one of us is feeling bad or feeling angry about something, the other supports him, or we laugh about it. Laughing together is very helpful.

What makes a great creative collaboration?
Horsting: Whatever it is that makes a great collaboration comes naturally to us. It's not just work. It's like Rolf said before—we're best friends.
Snoeren: Has anyone you've interviewed talk about star signs?

No. Do you think that has something to do with it?
Snoeren: Well, whenever we look up information about star signs, it fits.

What signs are you?
Snoeren: Viktor is Gemini, and I'm Sagittarius. Apparently, Sagittarius and Gemini is a match made in heaven.

You never tire of each other?
Snoeren: No.
Horsting: Never.

—

This interview took place over the phone between London and the Viktor & Rolf atelier in Amsterdam on July 28, 2016.

In April 1993, on debuting their first collaborative project, Horsting and Snoeren won the main prize at the Festival International de Mode et de Photographie in Hyères, France. **Below:** Their sketches for this collection. **Right:** This image of one of the looks, shot in Hyères, appeared on the cover of the fourth issue of *Purple Prose*, published the same year. **Opposite:** Devon Aoki shot by Inez and Vinoodh and styled by Nancy Rohde in a custom look by Viktor & Rolf for the cover of issue six of *Self Service*, 1997.

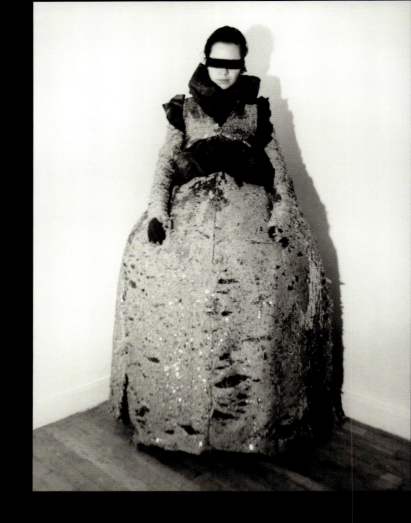

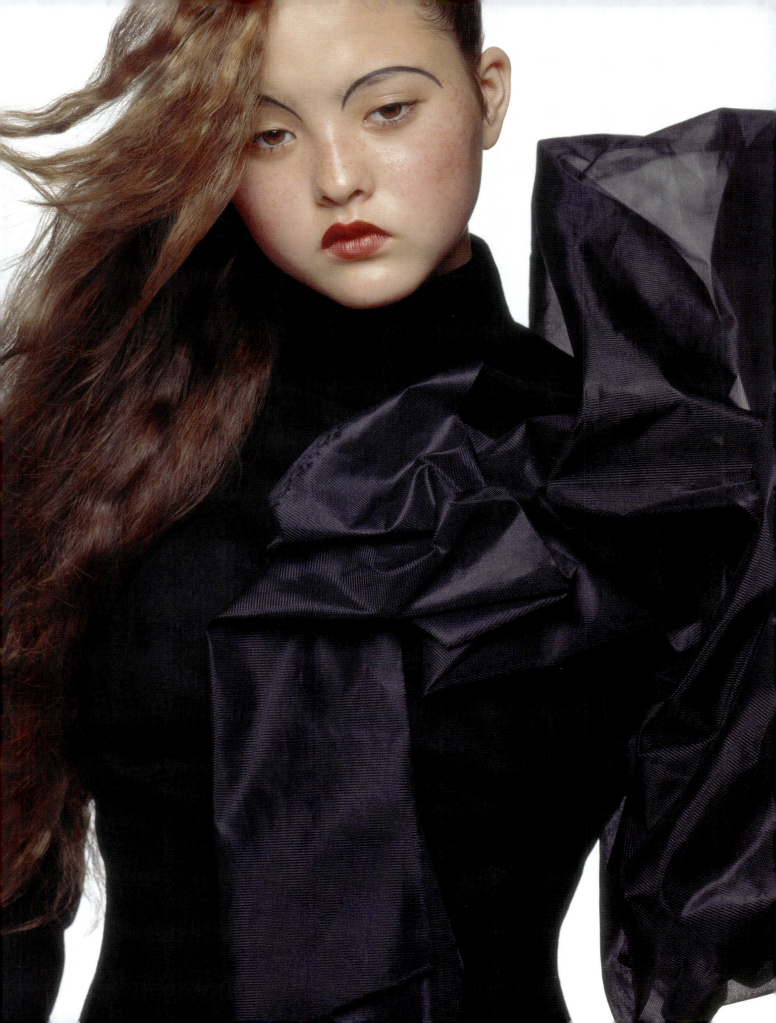

This page, right: This look was the final exit in Viktor & Rolf's acclaimed F/W 2005 show, where the models looked as if they were simultaneously walking and lying in bed. **Opposite, bottom:** The design sketches for the same collection, titled *Bedtime*. **Below:** Sketches for *Flowerbomb*, S/S 2005. **Opposite, top:** Sketches for *Zen Garden*, F/W 2013 haute couture. This show marked the return of Viktor & Rolf to the couture calendar after a thirteen-year absence during which they focused on ready-to-wear. The comeback paid tribute to their label's twentieth anniversary. **Page 138, top:** Sketches for Viktor & Rolf's S/S 1996 collection, *L'Apparence du Vide*. The items in the collection were made entirely from gold fabric that suggested wrapping paper in a criticism of the circus-like atmosphere surrounding the fashion industry and its increasing fascination with the cult of celebrity. **Page 138, middle and bottom:** Sketches for *Atomic Bomb*, F/W 1998 haute couture. **Page 139, top:** Sketches for *Cutting Edge Couture*, S/S 2010, a response to the credit crunch which featured gowns and dresses that had been dramatically hacked. **Page 139, middle and bottom left:** Sketches for *Bonbon*, S/S 2014 haute couture, which featured members of the Dutch National Ballet as models. **Page 139, bottom right:** Sketches for *Red Carpet Dressing*, S/S 2014 haute couture.

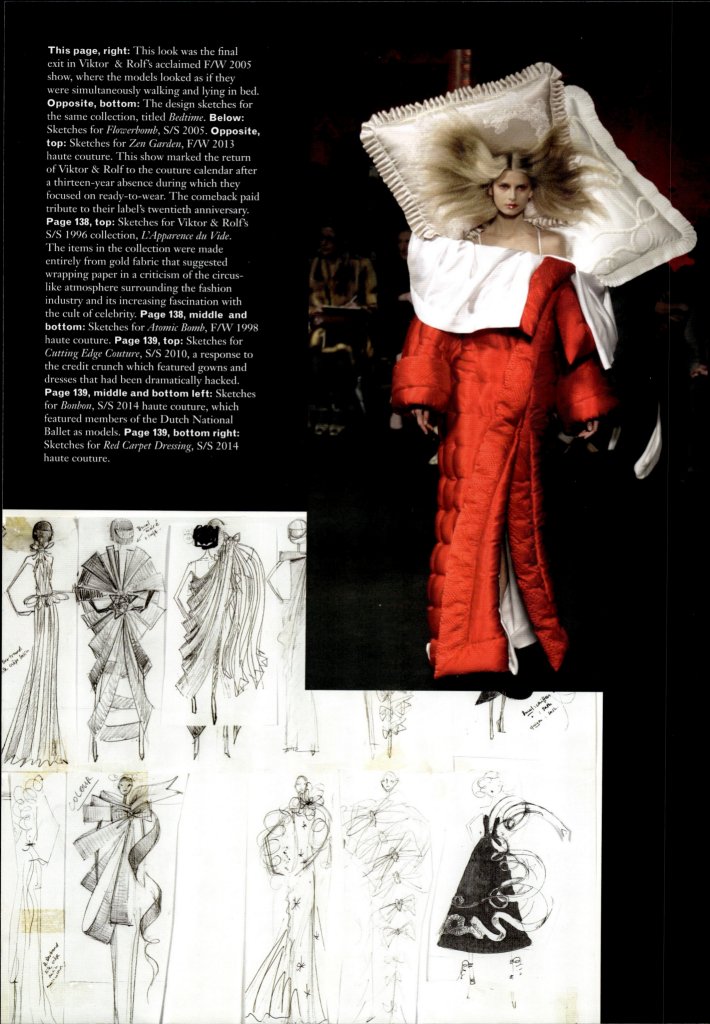

specials F/W 2005/2006.

atoombom ballon slingers nert

slingers
+... regenjas smoking overhemd
 opvulsel-
 illesefaal

LE MEURICE

PARIS

We ~~were~~ ~~~~ romantics

This season we were in the mood for something light and superficial

~~But~~ being diehard romantics and conceptualists, we needed a premise.

228 RUE DE RIVOLI - 75001 PARIS
TEL : +33 (0)1 44 58 10 10 - FAX : +33 (0)1 44 58 10 15
WWW.LEMEURICE.COM - E-MAIL : RESERVATIONS@LEMEURICE.COM

A member of
The Leading Hotels of the World

DORCHESTER GROUP HOTELS

We thou...
ballroom
ice sk...
because
seems
and ea...
at the
it is ext...
ritualism
controlle...
all the
goes into
of things.
the skin...

228 RUE DE R...
TEL : +33 (0)1 44 58 10...
WWW.LEMEURICE.COM - E-M...

A member of
The Leading Hotels of the World

---CE

...nt of
...cing and
...t

appy
 but
...me time
...ely
and
 and
...or it
...e surface
...Even
...s fake.

...5001 PARIS
: +33 (0)1 44 58 10 15
...RVATIONS@LEMEURICE.COM

LE MEURICE

PARIS

that is why
we Areated the
skin as part of
the garment and
worked on
blurring the borders
between them

228 RUE DE RIVOLI - 75001 PARIS
TEL : +33 (0)1 44 58 10 10 - FAX : +33 (0)1 44 58 10 15
WWW.LEMEURICE.COM - E-MAIL : RESERVATIONS@LEMEURICE.COM

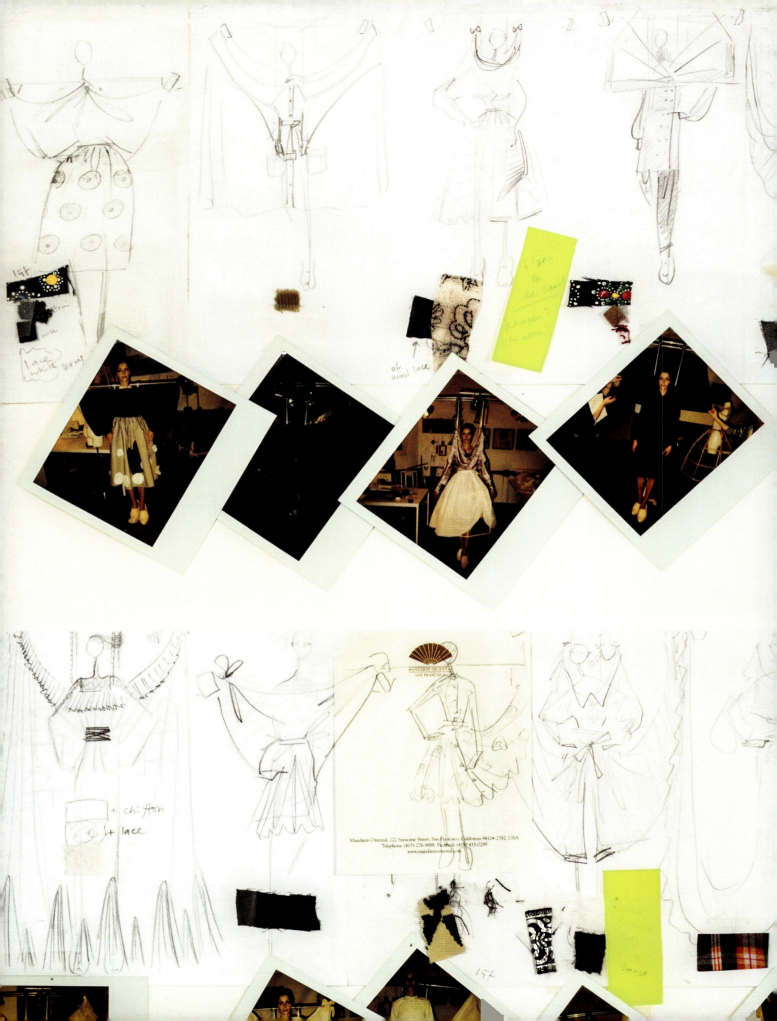

Pages 140–41: Horsting and Snoeren photographed with Shalom Harlow, who wears a look from *Black Hole*, F/W 2001, by Annie Leibovitz for American *Vogue*, September 2001. This image pays tribute to the *Black Hole* show, which featured a collection made entirely in black and saw models, and Horsting and Snoeren themselves, painted soot-black from head to toe. **Pages 142–43:** Notes for *Ballroom*, S/S 2007. The show provided attendees with an elaborate performance: Rufus Wainwright sang "Over the Rainbow," an orchestra performed, and ballroom dancers modelled clothes while guests sipped Champagne under chandeliers. **Opposite:** Sketches and fitting Polaroids for *The Fashion Show*, F/W 2007. As the title suggests, this show toyed with the preparation and production behind a runway show: models appeared supporting steel rigs equipped with tungsten lights and speakers. **Below:** Sketches for the Viktor & Rolf F/W 2008 show, curtly titled *No*. "We love fashion, but it's going so fast. We wanted to say 'No' this season," explained the duo backstage at the time. **Right:** The opening look of the collection.

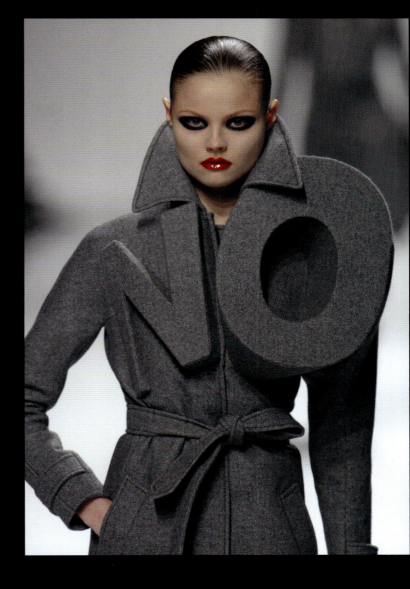

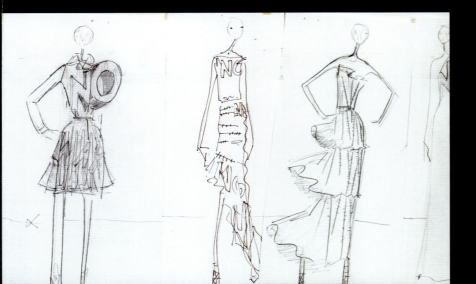

Transcribing an interview with **Jack McCollough** and **Lazaro Hernandez** of New York label Proenza Schouler is tricky. They have similar voices and verbal tics, and they finish each other's sentences—it's hard to tell them apart. Perhaps that's unsurprising given that they have spent over half their lives together as both business and romantic partners. McCollough was born in Tokyo, but grew up in Montclair, New Jersey, then moved to San Francisco to study. Hernandez was raised in the Cuban neighbourhood of Miami. They were born in the same year, 1978. In 1999 both enrolled to do a foundation year at Parsons School of Design in New York, progressing on to the school's fashion course. They began a romantic relationship in their junior year and in their senior year broke protocol by becoming the first students to present their final collection as a collaborative project. They coined the name Proenza Schouler after selling their entire graduate collection to Barneys New York. It is a moniker made by joining their mothers' maiden names— Proenza is from Hernandez's mother, and Schouler from McCollough's. Under this label, and having already found success with buyers, the pair staged their first fashion show for Fall/Winter 2003 in New York.

Jack McCollough and Lazaro Hernandez

Hernandez and McCollough captured by Josie Miner backstage at their
F/W 2005 runway show in New York—their fifth runway presentation,
staged when they were just twenty-six years old.

It's often written that you met at Parsons. But you didn't, you met in a club before you started studying.

Jack McCollough: We did. There's an official version and a not-so-official version.

Lazaro Hernandez: Let's give her the real version.

McCollough: We actually met in a club called Life, right before school started. It was a blurry, very late-night moment.

Hernandez: You don't remember when we first met? [laughs] There was a little a back room; everyone was smoking a joint in there. We ended up sitting next to each other and chatting. We talked about having just moved to New York. I had just moved from Miami.

McCollough: I moved from San Francisco.

Hernandez: We realised we were both starting Parsons in the fall. We left it at "maybe I'll see you there."

So you didn't stay in touch?

Hernandez: A little bit.

McCollough: We exchanged numbers. It was meaningful looking back at it, but at the time, it wasn't so meaningful. He was just a random person.

What was it like when you started school?

McCollough: In foundation year, you're grouped into sections, and you have every single class with those people. We were put into the same section, and, of course, we had that connection before school started. So we immediately became close.

Hernandez: It was before texting, so we would call each other and talk for hours on the phone.

Were you already thinking that you wanted to do fashion?

Hernandez: I was more interested in fashion than he was.

McCollough: I wasn't interested in fashion before. It came out of nowhere. I was into art, life painting, sculpture, and glass-blowing—a bunch of stuff. When I got to New York, I started to explore fashion for the first time. I guess in the back of my head, I always thought it was a more frivolous, superficial world. But then I started learning more about people like Alexander McQueen and Helmut Lang—people who were more like artists than designers. I had no idea that it could be as interesting as it was.

Hernandez: My mom has beauty salons in Miami. When I was growing up, after school, instead of going to sports or doing "boy stuff", which my dad really wanted me to do, I would go to the salon and hang out with her and the women getting their hair and nails done, talking about what they're doing that night and about their outfits. I would come just to look at the magazines. I discovered the world of fashion through *Vogue, Bazaar, Elle, Cosmo.*

McCollough: That's what I wasn't doing.

Hernandez: It was just this foreign, exotic fantasy world to me. I was studying to be a doctor—pre-med. I was always a good student. Science and math were easy for me. But then my heart wasn't in it anymore. My whole family was like, "What's going on with you?"

Secretly, I applied to Parsons. It was the only school I applied to. I left it up to the universe. I thought, if I get accepted, I'm moving to New York and I'm going to do this fashion thing. And if I don't get accepted—given it's such a shot in the dark—I'll just stay in Miami and get married or something!

Have you both always liked to be around other people?

Hernandez: I'm an only child, so I like people.

McCollough: There are seven people in my family—I have two sisters and two brothers—so I was around energy all the time. I'm always looking to disappear and have some peace in my quiet little world.

Did you have similar aesthetics when you met?

McCollough: In the beginning, you were really into sportswear, or that Gucci by Tom Ford moment.

Hernandez: I was really into Marc Jacobs. I liked the American thing. Calvin Klein.

McCollough: McQueen was everything to me. I drew stuff that was completely unwearable. As the years went on, I pulled myself back and maybe at the same time you got a little more experimental.

Were you equally ambitious?

McCollough: We both have the personality that when we do something, we do it all the way.

In interviews you've said that the rest of your classmates didn't like you.

McCollough: We were two years older than everyone else.

Hernandez: When you're twenty and everyone else is eighteen, it feels like a big gap. Fashion school can be a bit like *Clueless* in a lot of ways—all these cliques. The Goth kids are all hanging out in the corner, and then there are the girls who like to shop and have their designer handbags.

McCollough: We were just doing our own thing—really focused. We became tighter and tighter over the years. We were pulling at least two or three all-nighters every week. We were constantly getting each other's opinion and asking each other for advice. And because we were doing that for so long—for three years—our aesthetics started to merge.

Was there a point when you made a formal decision to work together?

McCollough: Probably at the end of junior year. We had to plan over the summer for our senior thesis. And we started to brainstorm about designing a collection together. But no one had ever done that. So we went in and got special permission from Tim Gunn, who was in charge of fashion students at our school at the time. He was new to the department, so he had no preconceived notions of what happened before and what was supposed to happen.

Hernandez: We decided to start our company after our senior collection was a success. We had twice as many looks as any other kid, which just by sheer numbers was impressive.

McCollough: Also, everyone was supposed to sew their own clothes and we sent most of our clothes out to be made, which was technically illegal, but we thought it was kind of silly—most designers aren't sewing their own clothes.

Hernandez: We only had one portfolio, because we had one project between us, and we went for a job interview with Narciso Rodriguez.

McCollough: He was looking for one designer; we were two. It was one salary, one job. We needed two salaries. And I remember walking out of that meeting together down the street—that was the moment we decided we should try and do our own thing.

Neither of you thought of parting ways and taking the job?
Hernandez: A stab in the back! That was never even in question. We pushed each other and it was fun. It was our own little world.

Is delegating hard?
McCollough: With the pre-collection we're happy to delegate more to our team, whereas with the main collection, we do every single thing ourselves. It can be hard to bring other people into that process because we have such a shorthand way of talking.

Hernandez: We still design the whole collection ourselves and fit everything ourselves. On the runway, everything is either mine or his.

Do you sit and sketch together?
McCollough: We're about to go do that. We've got a farm in Massachusetts and we go up there and sketch. We sit at this long table and he's at one end and I'm at the other. And in the end we put our sketches together. We also work a lot with image references and fabrics. We almost storyboard the collection, breaking it down into key ideas—one group will be about this and one group about that. We'll do about ten or so different groups on the wall and then we draw them. We each draw five different groups. Throughout the season, it will all come together and it will somehow become one thing.

How much of the inspiration for collections comes from your own personal stories and passions and how much comes from your relationship with each other?
Hernandez: We've known each other for so long and we spend so much time together that a lot of our experiences are shared experiences at this point. Half of my memory is with him. That's so scary!

McCollough: I do think our collections are very autobiographical in a lot of ways. We're not working at some heritage company where there's this archive and history to pull from. Instead of looking at the past, we're looking more toward our present lives and the future and just pulling from that.

How do you separate professional and personal?
Hernandez: We try not to talk about work outside of work, because we live together. That happened just recently.

McCollough: Fifteen years later. We're slow to burn!

Do you think you could do it without each other?
McCollough: It would look completely different. And there's so much stuff that we take off each other's shoulders—if we were doing everything ourselves we'd go insane. There are some times where one of us is more motivated than the other, too. If I feel a little stuck one season and he's feeling extra motivated he helps to energise me, and vice versa.

Do you argue?
McCollough: Yes. I think arguing is part of the process.

Do you ever look at a collection and see that you weren't clicking as a pair?
McCollough: Occasionally, if it feels disconnected— if there are groups within the show that don't flow in a harmonious way. It's not a mine/his thing. It's ours. It's Proenza Schouler. The tricky part is that it can become double the work if we're working on everything together. Sometimes you are forced to split some things up just to get more done.

Hernandez: It's hard because we've never really worked for anyone else. I was at Michael Kors and he was at Marc Jacobs as interns. But we had no experience other than that. So our process is just this made-up process that's kind of like what our process was when we were in school.

McCollough: We still draw every single look. Our drawings have become more elaborate as the years go on—now they're very OCD. Some designers don't sketch at all, but we even draw the topstitch. I've heard designers say, "I don't touch clothes." We do everything. We have the collection on the wall four months before the show—we know exactly what it's going to look like.

Has your team stayed very consistent over the years?
McCollough: We're not fans of change, which is weird, because our business is so much about change all the time. On a personal level, we enjoy some sort of consistency. Our core group has been here for a long, long time.

You say your process hasn't changed. Has your aesthetic changed?
Hernandez: I think we've gotten better as we've gotten more focused and more adult. The confidence has definitely grown exponentially and the aesthetic has grown up as well. It's very much a reflection of our age group somehow—we design for our peers.

McCollough: I wouldn't want to be the seventy-year-old designing for the twenty-year-old. We're grown up with our girl as we've grown up with each other.

—

This interview took place in New York at the Proenza Schouler offices in downtown Manhattan on November 23, 2014.

Above: McCollough and Hernandez, avid sketchers, meticulously plan their collections through drawings. Top row, left to right: S/S 2014, F/W 2014, F/W 2012; middle row, left to right: S/S 2013, S/S 2013, S/S 2013; bottom row, left to right: F/W 2012, F/W 2014. **Opposite:** Casting and fitting Polaroids from Proenza Schouler's runway shows. McCollough describes how he and Hernandez have "grown up" with their girl. **Page 152:** Model Selena Forrest photographed by Zoë Ghertner for the Proenza Schouler F/W 2016 campaign. **Page 153:** Julia Bergshoeff photographed by Ghertner for the same campaign.

Marina

Diana D.

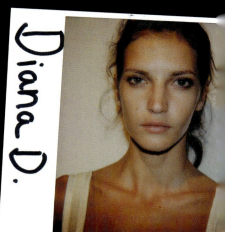

Raquel Z.

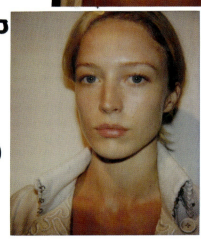

Elise

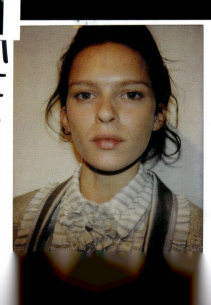

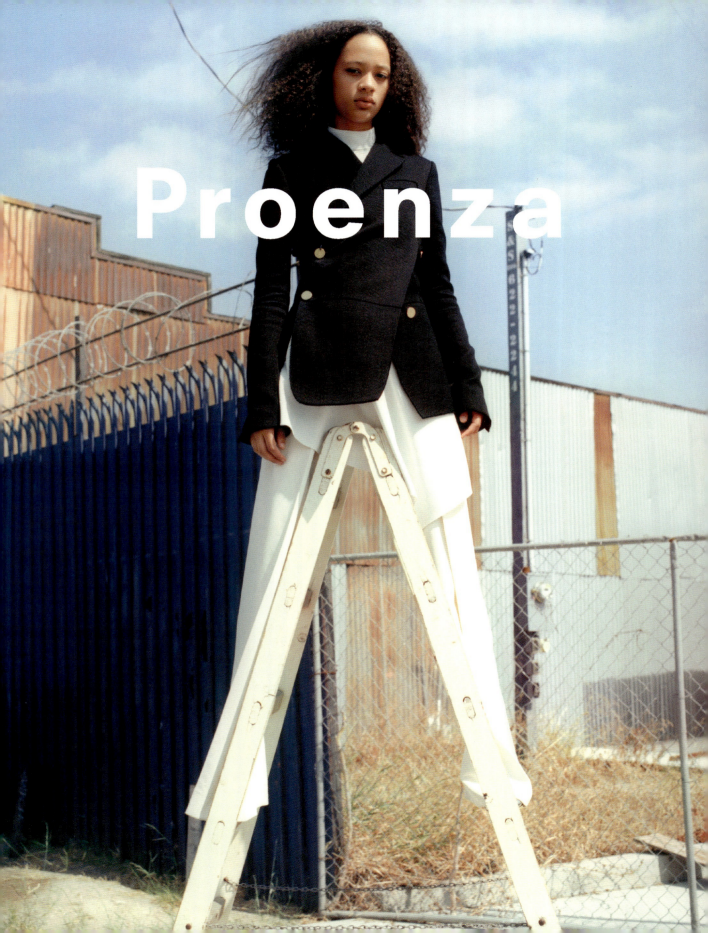

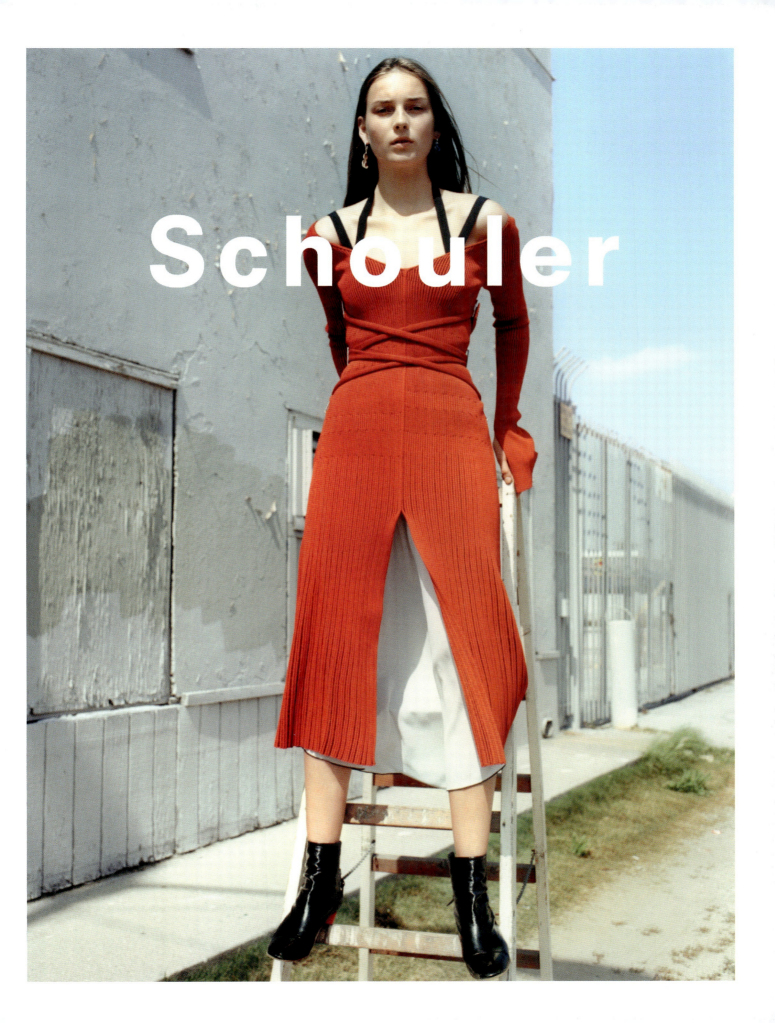

Schouler

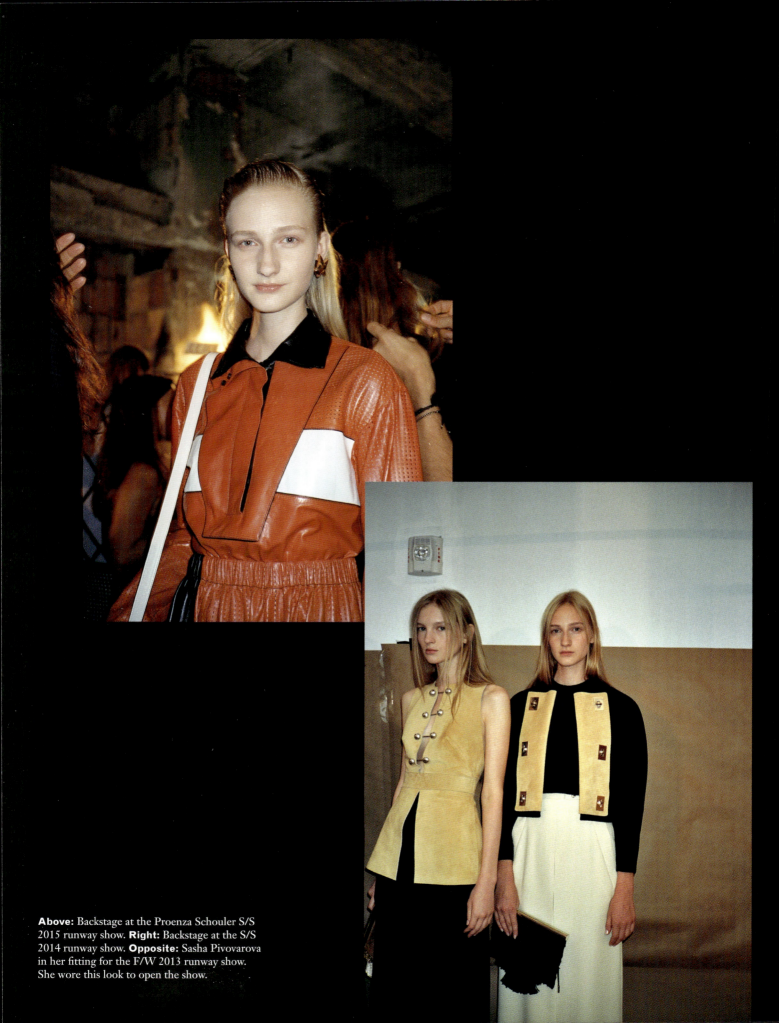

Above: Backstage at the Proenza Schouler S/S 2015 runway show. **Right:** Backstage at the S/S 2014 runway show. **Opposite:** Sasha Pivovarova in her fitting for the F/W 2013 runway show. She wore this look to open the show.

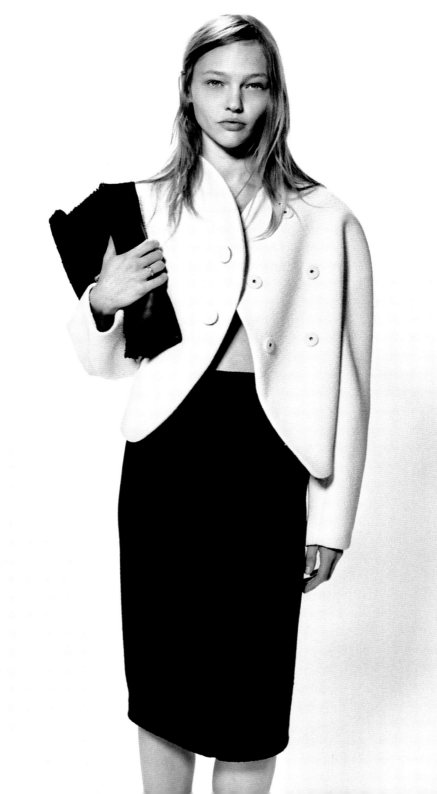

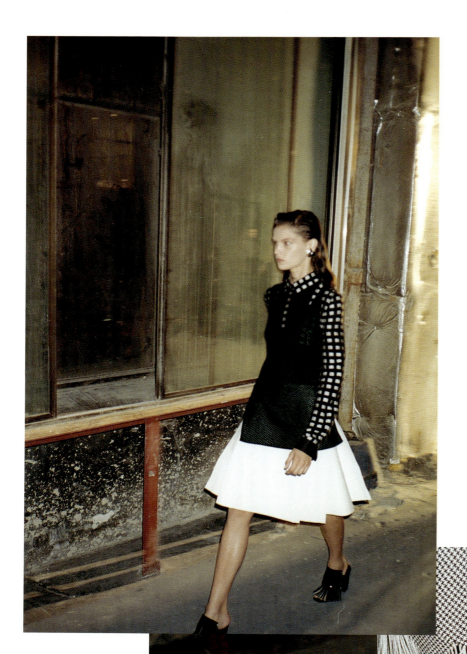

This page, left and below: Backstage at the Proenza Schouler S/S 2015 runway show. **Opposite:** *Hunde No. 6* by Juergen Teller, shot in Göttingen, Germany, in 2013. The image was chosen by McCollough and Hernandez, in collaboration with Proenza Schouler art director, Peter Miles, for posters announcing the opening of the label's New York store in October 2013.

Many duos within this book started as lovers and later became collaborators, but photographic duo **Inez van Lamsweerde** and **Vinoodh Matadin** present a unique example. Just out of college in 1986, they began a working relationship, with van Lamsweerde shooting Matadin's fashion collections for his now defunct Lawina label. Six years later, they began a relationship, which led to a marriage and child. Both hail from Amsterdam in the Netherlands, and they met while studying fashion design at the city's Akademie Vogue. Van Lamsweerde later pursued a master's degree in photography at the Gerrit Rietveld Academie and began her collaboration with Vinoodh. The pair's early work was experimental, with Vinoodh moving from supplying clothing to art direction. Later he added his own photographic eye through a separate camera. Today, the pair continue to shoot with two cameras, capturing distinct views of their subjects. While they got their break with experimental shoots for titles such as *The Face*, which showcased their early adoption of digital photo-editing techniques, they have gone on to work with some of fashion's most classic and iconic brands, from Louis Vuitton to Yves Saint Laurent, and the world's most famous cultural icons, such as Lady Gaga and Björk. Today, they are based in New York and are known throughout the industry simply as Inez & Vinoodh.

Inez van Lamsweerde and Vinoodh Matadin

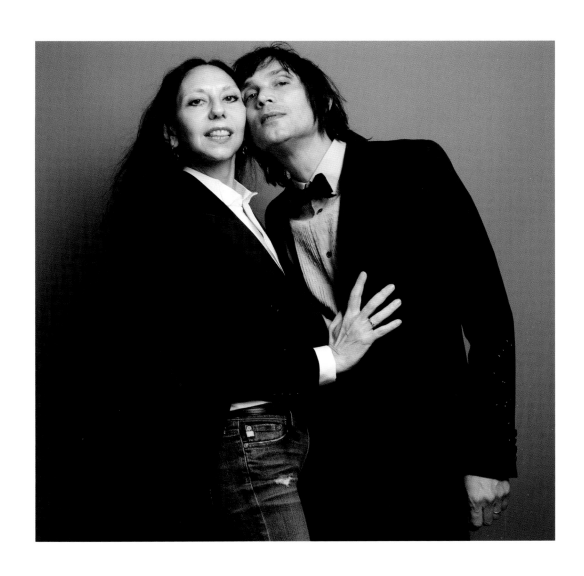

A self-portrait of van Lamsweerde
and Matadin, shot in 2016.

You've said in interviews that all your pictures are like self-portraits. What did you mean by that?

Inez van Lamsweerde: I always wonder if other photographers feel the same. For us, our pictures are so much a projection of the thing you want to be or something you were. You put all this on the person in front of you. Everything feels completely like a reflection of your own state of mind or sense of self. We notice it if we don't have full energy—that's also what you get back from the person in front of you. That's the most beautiful thing about taking pictures of people—the exchange that happens. And it helps to be working together, because you push each other to move things and challenge things.

So when you look at the work does it feel like a joint effort, because of that process of pushing each other?

Vinoodh Matadin: Always. When I look at the work, it's our work—our handwriting.

van Lamsweerde: We are so connected that it doesn't really seem to be possible to see it another way.

Matadin: It's like making a dinner together. And we need either other. Our industry has changed so much. It's much faster now. Nobody can do this tempo alone. You need a team around you to really succeed. There is no fashion designer in the world who can make six different collections in a year, plus six different shows, all by themselves. It's the same for us. Nowadays we have to shoot the campaign, the video, the behind-the-scenes video. In the same eight hours, we used to do three pictures. We didn't plan for it when we started, but we're so lucky that we are two, because otherwise it would be basically impossible.

van Lamsweerde: Before, we used to work for a month on an idea for a campaign. We'd really research. That was the fun part, too—to be able to dive into one thing and dig deep. Then it becomes really your own. When we were starting out, you had to build up prestige. When we were shooting the Yohji [Yamamoto] catalogues, there was no way you could do a campaign for a mass-market brand. That was so low fashion, and Yohji was such high fashion that you couldn't. Whereas now, it doesn't matter anymore. Now, everybody shoots anything. Nothing is high or low anymore.

Matadin: It doesn't matter if you shoot for Yohji or Louis Vuitton or Zara or H&M.

van Lamsweerde: It's all the same. And increasingly, it's all about selling; it's not about creating.

When you shoot, you use two cameras and capture different angles. How do your subjects find that?

van Lamsweerde: We always tell them in the beginning. We explain that they have to focus on me, because I do the front shots.

Matadin: And at one point, they have to look at me.

van Lamsweerde: We'll say, "Look at Vinoodh," when he's at a certain angle where it looks great for them to be on camera with him.

Matadin: The most beautiful example of this is the first time we photographed Tom Cruise. Inez was directly in front of him and he was really focused on her, while I was snooping around taking all the pictures. It gave another side of him that he was not aware of.

van Lamsweerde: Something more introverted or more soft. He completely forgot that Vinoodh was walking around with a camera as well. In all the images I took he was too aware, whereas Vinoodh's shots were so sensitive and softer and sexier. It's a great set-up, because it captures both sides of someone.

How did you come to that set-up? Inez, when you began, you were the one with the photography background. Is that why you are always in the more dominant position, shooting straight on?

van Lamsweerde: We started working together in 1986, when Vinoodh was still designing. After a while he decided to stop that and just focus just on us working together, but not necessarily us taking pictures together—more with him art directing or styling.

Matadin: So it's always been a dialogue.

van Lamsweerde: And then we did a shoot for *Harper's Bazaar* with Charlotte Gainsbourg. There was a new camera out, and our assistant had rented it just to try it out, but I didn't want to use it. And Vinoodh was like, "I'll take it! I'll try it out!" And his pictures were great.

Matadin: It was never really planned. It just grew, even from the first day we started working together. Back then, I did the clothes but they were all based on movies. And we talked about the movies and how to create images. And, in the end, the images were the end result, and they were more important than the clothes.

Do you remember your first impressions of each other?

Matadin: It was the beginning of the last year I was in art school and I was on the ground floor in the first classroom, so everybody who came into the building had to pass our classroom and the door was open. Inez walked into school and the whole class was silent, because she was stunning. She was all in black with black hair. And she had a friend who was behind her all in white. I was fascinated from the first moment she stepped in the building.

van Lamsweerde: We had to draw him as a model. And I remember thinking, oh, he's handsome, but maybe not my type.

Matadin: I was too skinny.

van Lamsweerde: He was too skinny. Then he graduated and started making his own collections and I had moved on to photography. He asked me to do the pictures for his brand and from the moment we started working together, I think we fell in love. But he had a girlfriend, I had a boyfriend, and it just never synchronised. We worked together on and off and had fights and I worked with other people and we each had other partners. Six years later, we met each other on the street, at an ATM, and we went for a coffee and then we were inseparable.

Would you say you had shared obsessions or references?

van Lamsweerde: We liked exactly the same things and were fascinated by the same movies, the same art.

160

Matadin: It all just mixed up. At one point, we started to think, when is it fashion and when is it art? When is it Inez and when is it Vinoodh?

van Lamsweerde: It's the same now. We don't even talk that much about stuff—we understand each other with one word.

Because of your shooting style, I imagine you can always tell who took the final picture.

van Lamsweerde: We do know. But it's never an issue. It's about the process and about the idea and the making of it. In the end there is a picture—whether it's mine or his really doesn't matter.

Matadin: In a funny way, the day is always more important than the end result. Because it's our life, it's what we do every day.

Can you work out in advance whether certain people will lead to an Inez shot or a Vinoodh shot?

Matadin: People react differently. Sometimes people react differently because you're a boy or a girl.

van Lamsweerde: I always think that Vinoodh takes the sexier pictures. His angle and way of looking at a body are different from mine. I look at it like, would I want to look like that? Whereas with him it's, is that exciting or beautiful to me?

Vinoodh, would you say your viewpoint is voyeuristic?

Matadin: I think it's more voyeuristic, yes. I think I'm more of an observer than Inez.

van Lamsweerde: It's also the way he positions himself and the angle. I wouldn't necessarily say that I set out to make the sexiest picture of each woman we photograph. I don't. I am much more about making her the way I would want to be, or as strong as I would want to be, or as vulnerable as I would want to be, or as available, or as unavailable.

Matadin: Like a hero version of yourself, no?

van Lamsweerde: Yes. The good thing is, because of these different viewpoints, you've got two for one. I notice when we are shooting men, I look much more in terms of, is that attractive to me? But I don't look at women that way.

Do you have the same idea of what is beautiful or sexy?

van Lamsweerde: We like something that is different.

Matadin: Not perfect.

van Lamsweerde: Not perfect.

Matadin: Once, somebody asked me, "What kind of photography do you do?" I said, "Well, we take pictures of humans." The moment you credit the sweater it becomes a fashion image.

van Lamsweerde: And when we put someone's name on it, then it's a portrait. And when you credit the make-up, it's a beauty shot. It's up to the context. When we're working with a magazine, a lot of people still say to us, "Don't worry, I'm not going to put a lot of text on your pictures." And we're like, "Put the text!" That's what we like. We like layout. You could have the most random image but when it's been laid out to be this

incredible record cover or magazine spread, it works. In the beginning, in the 1990s, our whole idea was to challenge the context of a magazine and try to subvert from within. We were quite cynical in our approach to fashion and the message it would promote. Cynical about the road to glamour, and having to live this life of the girl in the picture, which you will have if you buy this bag.

Matadin: When we started, we used to not only take the picture, but we did the styling ourselves. We worked on the hair and make-up, we did the layout, the titles, and the graphics. Everything, a full package.

van Lamsweerde: And there were lots more ideas in one image than we would do now. Just because when you're so young you have so many thoughts you want to get out immediately. But then at some point, we realised we should go into the fashion system. We realised we were either playing the game or we should step out of it. And that's when we started working with editors and allowing their different points of view in. It was a big learning curve for us, because in the beginning we thought everything was a joke. We couldn't understand the seriousness of it.

Matadin: The great thing that Inez and I believe is that fashion is always changing. That's why it's called fashion. The rules that were good yesterday don't work today anymore and you have to adapt. We are confident enough that we can tolerate someone else's opinion.

van Lamsweerde: If we were the ones choosing all our pictures ourselves, without an editor's eye or a client's eye or eye on top of it, I think the work would look different. Working with people who have their specific points of view has its benefits. It teaches you things. You learn about people's ideas of beauty and style.

Matadin: We once had dinner with Helmut Newton and his wife, June, and she said, "Eventually, when you do your book, you choose the pictures you really like." She explained that so many pictures he'd done for magazines never ended up in his book. Helmut would say to us, "Never stop doing your own thing." When we met them, I felt, for the first time, like I'd found another couple like us who were working together. They were doing everything together, but Helmut always got the credit. But now it is possible to have two credits.

van Lamsweerde: When we started out, people didn't understand. First of all, my name was too long to put anywhere. Two names—how? What do we credit him as? We'd say, "As a photographer." And that got a lot of resistance. And then at some point it was like, "Okay, but the last names have to go!" They took up so much space.

You storyboard heavily before some of your shoots. Explain to me how you came to work that way.

Matadin: I think it was because of art school. That's how we were trained.

van Lamsweerde: In the beginning, because we worked so much with the computer when creating images, you had to know what you were doing. We did a lot of images where we would shoot the background

separately from the foreground. Or find an image in the stock image bank for the background and then mimic the light for the girl in the foreground. So it would have a lot of technical issues that you had to solve ahead of time—that started the planning process.

Matadin: I remember the first time we shot for *Vogue*, the final result was just one image. It was one of our "merging" images.

van Lamsweerde: And then we went to the office and we saw the drawers of Steven Meisel and Annie Leibovitz and there were thousands of rolls.

Matadin: So many choices. We can't work like that. It's impossible.

van Lamsweerde: By altering the image you've taken, you defy time in a way. For us, that was a very interesting concept. The fact that you could go back and make a different image of something that you had taken.

Matadin: It was almost like you could finally paint in photography. We never started using digital just to retouch people.

van Lamsweerde: It was more conceptual. And it was, and still is, wonderful, to be able to visualise something that is otherwise impossible to capture. You can show a whole other layer of some internal mental state that you probably couldn't get just by taking a picture. It was great to have that and take that to its extreme and then turn around and say, "Wait, but we are photographers and we love pure photography where it's just light and the camera and the person." And that's when we started focusing on all the portraiture in beautiful black and white.

Matadin: Old school. We were trying to take a picture of somebody with no props, basically—no elephants, no motorcycles, no smoke bombs.

Have there been any other turning points, whether personally or professionally, that have changed your work?

van Lamsweerde: Perhaps the birth of our son. I think it's super cliché but it does soften you. In your early twenties, you are fascinated by this romanticised idea of death or horror or blood—stuff you get out of your system. Once our son was born, I think we felt the need to make a different kind of image.

Matadin: You're an example. He will copy anything we do without knowing.

van Lamsweerde: When Charles was a baby, he came to set with us for the first couple of years of his life. People would come in all absorbed with themselves or focused, and they would see Charles and they'd be like, "Oh, but there's a baby!" And then they'd mellow out.

Would you say you are very collaborative people in general?

van Lamsweerde: I don't think either of us is cut out for doing this sort of work alone. You, Vinoodh, are more at ease on your own. Me, after half an hour, even at the hairdresser, I go crazy.

Matadin: We've had a great team of people with us for ten years. We all trust each other more the longer we're together. It's a team effort. It's almost like dancing. Or like being in a band. That one moment, it's just [snaps fingers]. It's there, it's gone. And that was the picture.

Do you ever wonder what life would have been like if you hadn't united? Would you both be taking pictures?

van Lamsweerde: I would probably—but probably not on this level. I don't know if I would have got here by myself. It would be very different. It kind of scares me thinking about it. It would be miserable.

Matadin: Miserable. Definitely.

—

This interview took place over breakfast in van Lamsweerde and Matadin's loft on Manhattan's Lower East Side on October 27, 2015.

Opposite: "Our house is almost like a self-portrait. Every piece of work that hangs here has something to do with our work," says Matadin of the New York loft he shares with van Lamsweerde, their son, Charles, and two labradoodles, Leonardo Moon and Bear River. The couple have lived in the space for more than twenty years and have amassed a collection of objects that includes chairs by Charlotte Perriand and Poul Kjærholm, vintage Moroccan carpets, and artworks by Richard Phillips and Brice Marden. **Above:** The pair's image of Tom Cruise was taken for *W* magazine in 2002 and, to them, encapsulates the benefit of their shooting style, which sees van Lamsweerde shoot from the front, while Matadin circles the subject to capture intimate, unplanned moments.
"It gave another side of him that he was not aware of," says Matadin.

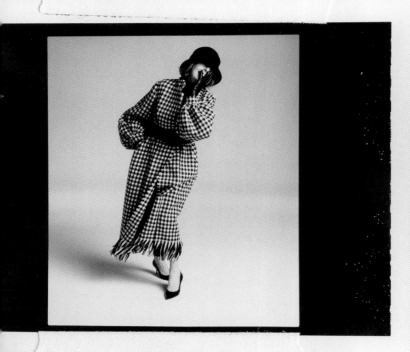

Diane Keaton
LA

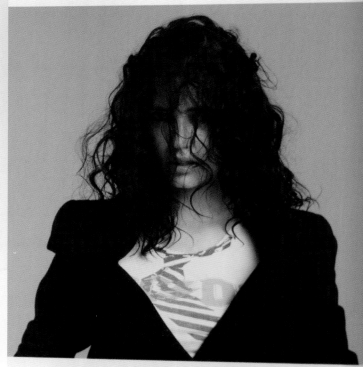

eva green Paris

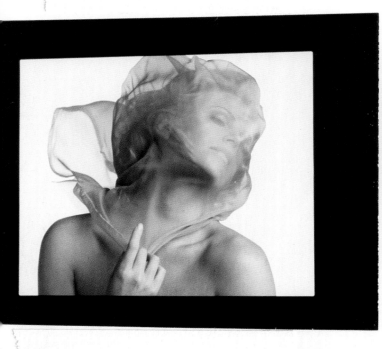

charlize theron
LA

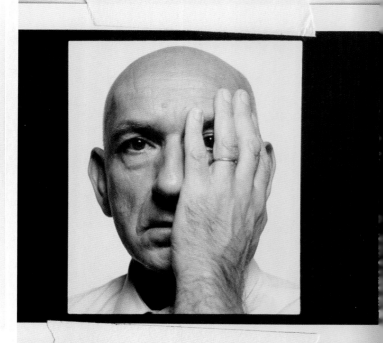

Sir Ben Kingsley
NYC

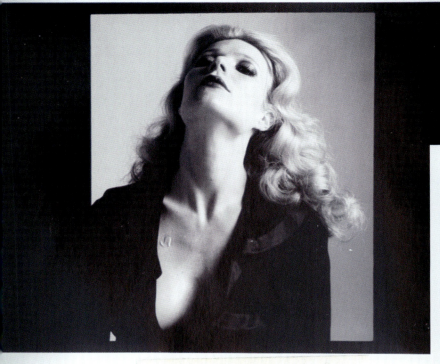

gweneth Paltrow
NYC

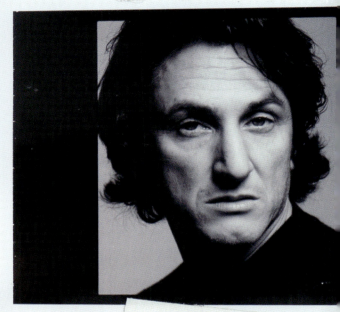

sean penn
SF

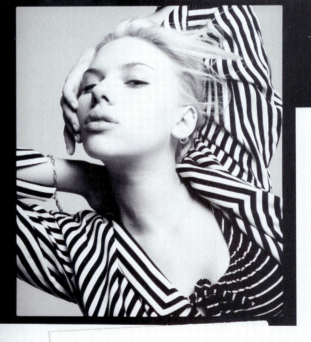

scarlett Johansson
NYC

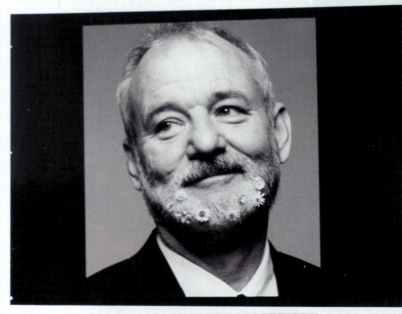

Bill murray

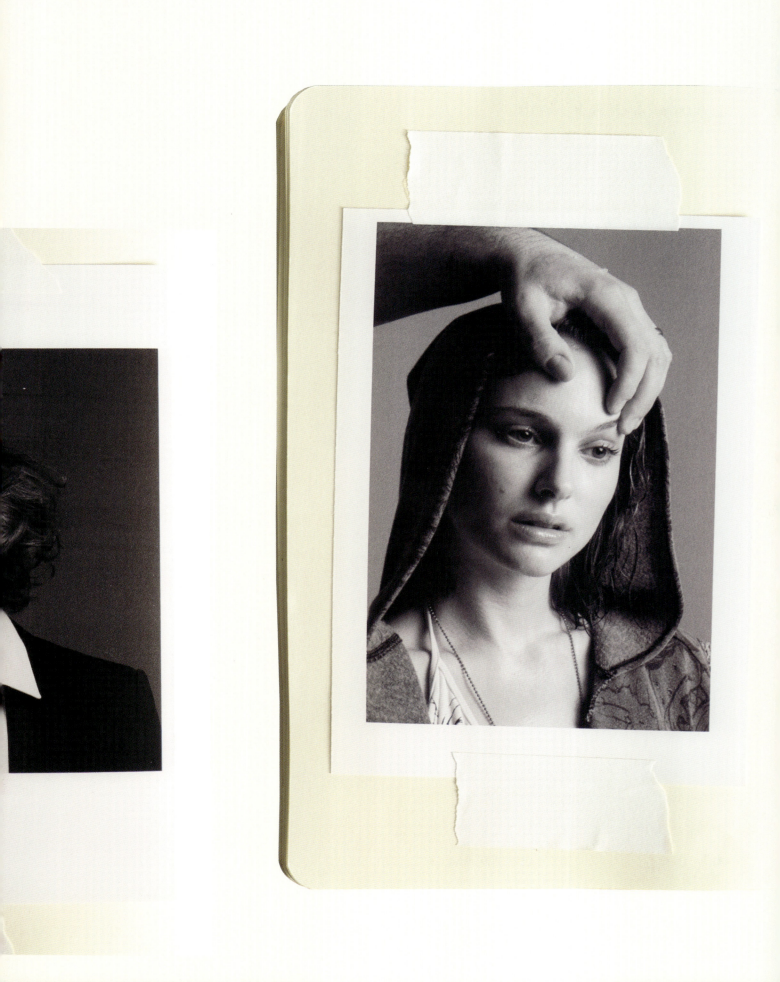

november 24 2004

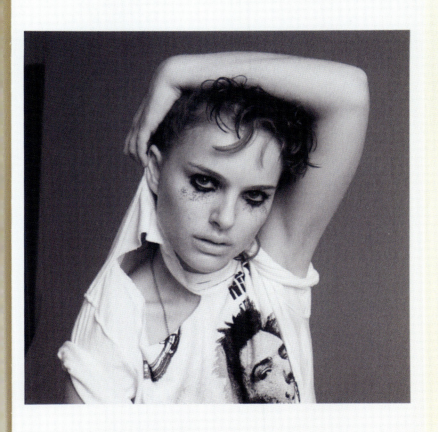

Nathalie Portman New york

in seeking attention as any price she goes
from dead to alive. her drive to be
on stage will always re-
live
her.

look the video is shot in black and white
with hard colored elements and hard drawn
set elements and title cards if feels hand made, dirty
& the speed is up

all black (stage set) on Black
black curtains
black ropes tassels
rough black stage floor
shiny matte leather, denim, velvet, fiberglass, buttons,
stickers, tape

C Dolly from wide to close up of curtain.
 format is square or almost square like ⬜.

L lumapanels + breeze.
 follow spot (stage light) moves around curtain
 + floor (drum roll idea)

a title card appears like in silent movies
but resembles punk flyers from the 80s.
(in kinko photocopier style colors)

D jo ratcliffe designs the cards.
 they appear throughout the video silent movie
 style, all lookig like punk flyers.

the curtain opens (video)

The video opens to a shot of a black
stage with rough black floors; in the
style of an old silent film. The setting
will be modern, but the film will be ed-
ited to look old.

Mi = min avue
S = set
D = Drawing
C = camera
L = light
F = fashion styling
Mu = make up
H = hair

i stand here waiting

D and we find gaga in a cage made
 out of rose vines it's roots are visible.

S She is already on the dish that can spin.
O (flowerpot dish). (multiple sizes)

D the roots of the vines are rooted in black
 earth., insects and nodes may live there too
 she has been in this cage for a LONG time.

cage made
out of roses
like this.

F She wears a skeleton bustier (1900 circus girl style)
 ribcage, pelvis bones etc.

Mu she looks like a dead marilyn
H

She is a performer seeking applause and
will do anything to achieve it.

Pages 164–67: After years of avid experimentation with post-production, van Lamsweerde and Matadin sought to return to a simpler, cleaner form of photography. These Polaroids, stored by the pair in black leather notebooks, were shot during portrait sessions for *The New York Times Magazine* between December 2003 and January 2005. "You can see where we switched over to digital. There are silver Polaroids but then it goes to printouts," comments Matadin.

Opposite and above: Van Lamsweerde and Matadin trace their process of intricately storyboarding their shoots back to their art school training. These pages show the thinking behind Lady Gaga's "Applause" video, shot in 2013. The pair regularly work with musicians such as Gaga and Björk and, despite their planning, like to remain open to feedback from their collaborators. "With the 'Applause' video, it was pretty much all planned out and then, the night before, Gaga comes in with a whole load of other ideas which we loved and wanted to play with. It just all adds something—it all becomes bigger, like you could never imagine it from the beginning," says van Lamsweerde.

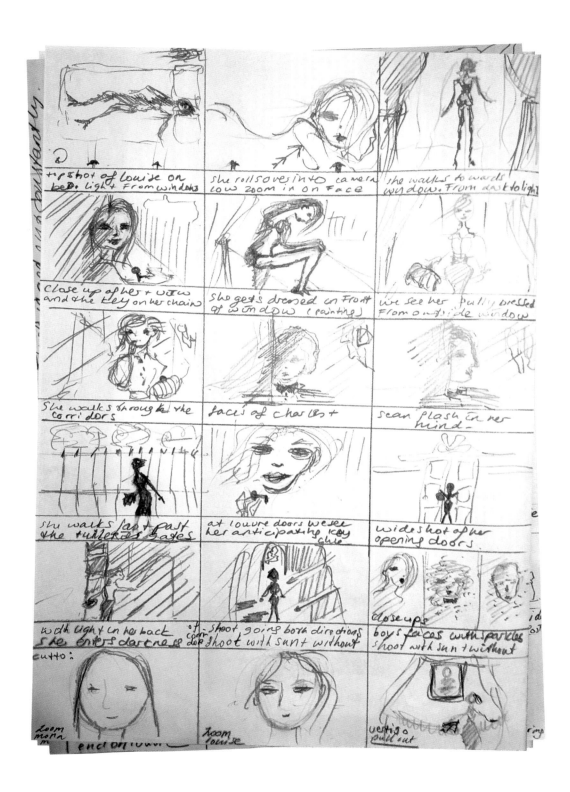

Above: The storyboard for the Louis Vuitton *Invitation au Voyage* campaign film, shot by the pair in 2012. **Opposite and pp. 172–73:** This early work shows the pair's interest in digital manipulation and image alteration, which they describe as offering the ability to "paint in photography." All three images were shot for *The Face* in 1994. **Opposite, top:** "A Two-tone Stretch Satin and Lace Pantsuit by Bertrand Maréchal"; **opposite, below:** "Well Basically Basuco Is Coke Mixed with Kerosene." **Following pages:** "They Gave Me Oxygen."

170

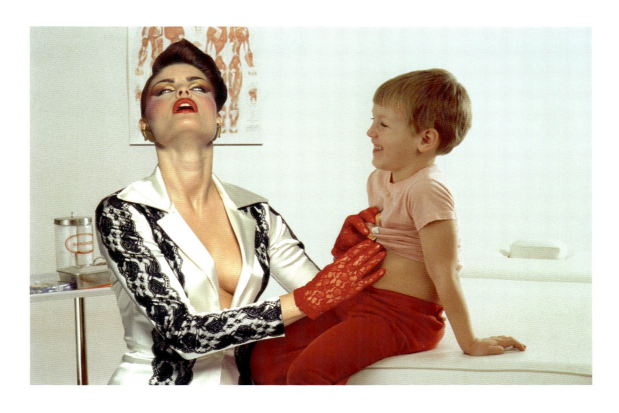

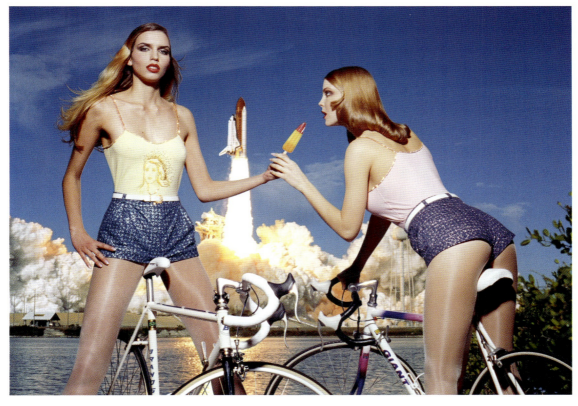

171

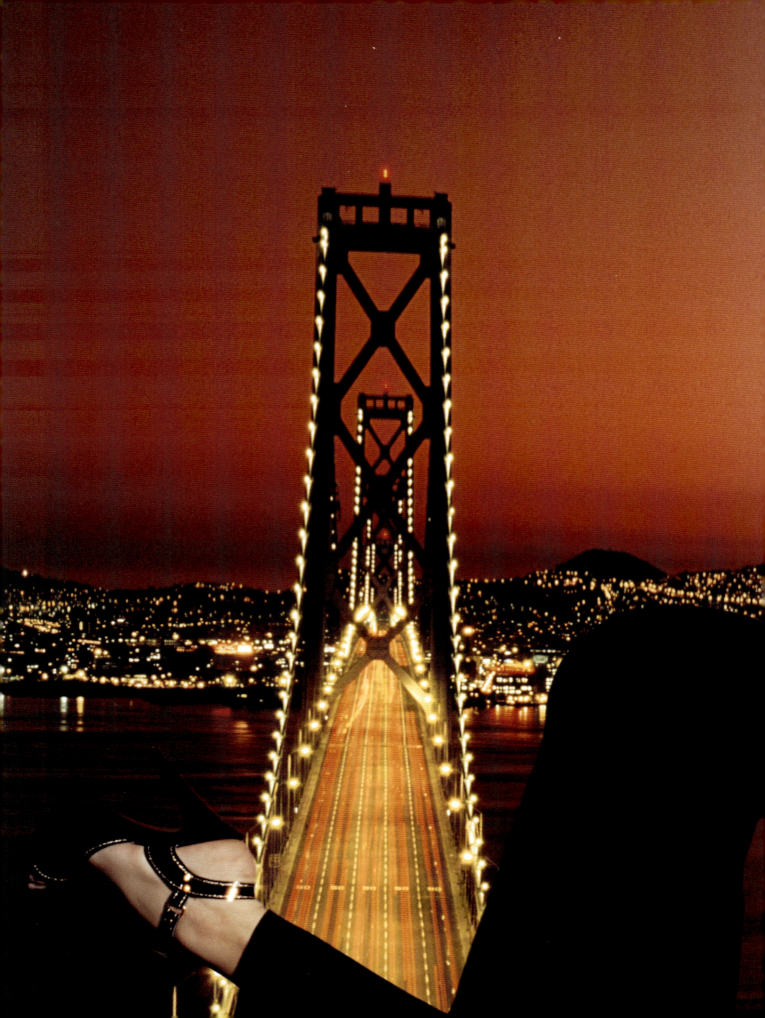

Carol Lim and **Humberto Leon** joke that their success stems from being shopaholics in their youth. One of a number of successful duos working out of New York—a list that includes Laura and Kate Mulleavy of Rodarte, Laura Kim and Fernando Garcia of Monse, and Jack McCollough and Lazaro Hernandez of Proenza Schouler (who feature in this book)—they are notable for coming from a retail background rather than a design background. They were appointed joint creative directors of Kenzo in 2011. The two met at university in California and founded New York–based retailer Opening Ceremony in 2002. Lim serves as CEO, while Leon is creative director, yet their roles remain tightly entwined. The store helped usher in the climate of collaboration that dominates fashion today, thanks to its many partnerships with individuals and brands—often labels previously unavailable to the American market. The pair is known for theatrical, often humorous, fashion shows for both Opening Ceremony and Kenzo. For the former, they collaborated with the New York City Ballet on a Spring/Summer 2016 show that saw dancers performing as models who tripped in their heels. The Spring/Summer 2015 Opening Ceremony show took the form of a play by Spike Jonze and Jonah Hill whose cast members, including Elle Fanning, wore the new collection.

Carol Lim and Humberto Leon

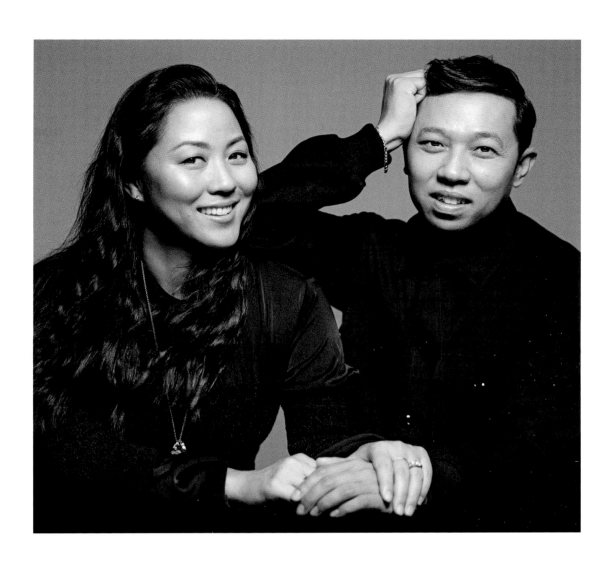

Lim and Leon, photographed by
Inez and Vinoodh in 2016.

Tell me about the first time you met.
Humberto Leon: We met at the University of California, Berkeley. I took a painting class with our mutual friend, Cynthia, and she invited me to go into San Francisco that night to go dancing. It was a weekday. I drove over, and while Cynthia was getting ready, I spent the whole time trying to convince her roommates, Carol being one of them, to come out with us.

So you ended up going out?
Carol Lim: I did. And I always go out, every time he says, "Come on, let's just go."
Leon: I was probably dressed crazy, and I probably had crazy hair. Carol was in pyjamas, with her hair probably in a scrunchie or something.
Lim: I remember the pyjamas. They were Black Watch plaid, an Eddie Bauer flannel set.
Leon: And a cat sweatshirt.
Lim: Yes, I had a cat sweatshirt!
Leon: I was probably in a baby tee, flared black polyester pants with platform loafers, with slightly lesbian-looking hair. I was really into Brit-pop, so really long sideburns, short in the back—a little bit like Kate Gosselin.

So it was a friendship before a working relationship?
Leon: For sure. We were eighteen at the time, so we definitely weren't thinking about work.

How early did the conversations about work start? Did you realise quite quickly that you had mutual interests or shared ambitions?
Lim: From that night on we definitely knew we had not only shared interests, but also a very similar approach to things. We're both very curious. We both grew up in the suburbs of Los Angeles, not far away from each other. Both of us had parents who emigrated to Los Angeles. We had the same cultural references; we were into the same music. I think we had a lot of similar, shared experiences, even though we didn't know each other. And then at Berkeley, all of our experiences were actually shared together: shopping, going to live shows, going to art openings, going to try new food.
Leon: We were good influences on each other in the sense that we respected each other's working boundaries—because there was definitely an inclination in both of us to do really well at school—but also pushed each other to go out and have fun and have other interests. If anything, our school years informed our friendship and what we like in general.

Did you talk about fashion early on?
Leon: I don't think we talked about it. We just liked shopping. We were really interested in dressing up. This was obviously pre-Internet, so we still belonged to the tribe where the way you dressed represented the people you wanted to be around. Carol would be in long sweeping skirts and we would be in faux fur. We would get *dressed* to go to school. There

was this great clan of us that would all do this.
Lim: We'd meet on the steps of the main entryway to Berkeley. You'd see the group instantly. There was no way to get a word in. You were all busy looking at everyone's looks. "Oh you have that that Yak Pak backpack!" and so on. You knew certain brands or pieces, but then you'd see some things you didn't know. We all bonded. But it was an unspoken thing. We didn't say, "Oh, what fashion are you into?" You just knew by looking at the way they dressed.

When did you formally decide to do something together?
Leon: Around 2001, when we decided to open up Opening Ceremony.

You never had conversations about work or fashion until then?
Leon: We had silly, crazy talks in the 1990s, but nothing defined.

Why that moment?
Leon: I had been in corporate fashion for a long time by that point. I had been at the Gap, then I got recruited to go to Burberry. Carol was in finance, and then in 2000, she made the switch into merchandising and buying for Bally. So we both had these midtown corporate fashion jobs. Both were super interesting. They were both going through a rebranding at the time. We would meet up at lunch and talk. We went to Hong Kong to visit our friend Cynthia, the one who introduced us. There were all these great designers there. At that time, in New York, it didn't feel like there was much going on in terms of young designers. Now it's so normal, but in 2002 the idea of "young designers" and shops that catered to them didn't exist. We saw Opening Ceremony as a breeding ground for fun, new, if-you-can-think-it-it-can-be-made ideas. It still is. We approach our retail store as the opposite of a store that has white garments and plastic bags and everything spaced out by two feet. That felt unapproachable. And people just like us who came to the store would have been so intimidated. We set out to create the opposite of that—a warm, fun, shopping experience that is super-inviting to all people.

Tell me about the process from the initial idea to opening the shop.
Leon: It didn't take too long. Our favourite block was Howard Street, so we set out to see if there was anything available there. We found a space and we loved it, and the landlord said we could take it. We knew we needed to come up with some money, so next we put together a business plan to get a loan. It took us a couple of months to get our thoughts down, but we came up with it all, and aside from a cashier desk that turns into a DJ booth, everything turned into what we thought it would be. We didn't get a huge loan, twenty thousand dollars, but at the time that felt like a lot to us. Then 9/11 happened, so times were uncertain. The landlord told us he'd rented the space to a hair stylist,

who actually went on to turn it into a brothel. But he told us about the neighbours, who had a linen business that wasn't doing so well. They were relieved to hand over the lease. So we cleaned out 35 Howard Street. Within six months of opening, the brothel had been busted. We were a bit disappointed, as we could have gotten the original place that we wanted. So seven years later, we told the landlord we'd like it whenever the lease came up. He told us it wouldn't be for another seven years, but we signed it there and then, for seven years later. We ended up getting that space two years ago. That's our men's shop now.

Lim: There was nothing on Howard Street before. It was our store, a little shoe cobbler that isn't there anymore, and then some ladder company. Our street was completely empty and most of the businesses were massage parlours or prostitution rings.

Why was it your place of choice?
Lim: It's such a beautiful street. Crosby Street ends there with the cobblestones, and the architecture is incredible. We loved the feeling of it.
Leon: It's a great little New York block, and with the ladder company there, it felt really authentic. We loved being a destination, because there was nothing happening east of Broadway. Now fast-forward all these years and Rick Owens is taking over the shop where Jil Sander was. There's action happening.

You were part of a big group of friends. Is it chance that you two ended up doing Opening Ceremony together? Could it just as easily have been three of you, or one of you with someone else?
Leon: Probably, but we complement each other. Carol can compensate for every fault I have, and I can compensate for every fault Carol has.

Your team has grown considerably. Are you ever nostalgic for the period where it was just the two of you?
Leon: There's something beautiful about things being small. But things happen for a reason, and you can't really control growth. Also, we grew up as suburban kids, and I think there's something really nice about being able to speak back to the suburban us, and really the only way to do that is to see how we can evolve— how we talk to people. We're as proud of the products we have now as the ones we had in 2002, but they're all a little bit different. I think what we're doing now could possibly speak to our suburban selves, and that's exciting to us. It's a different thing—there's no better or worse, just different.
Lim: We can get nostalgic for moments when we were sitting at the back of the shop laughing hysterically or going, "What are we going to do?," but those moments actually still happen. Sometimes we'll bust out laughing at something that only we would find funny, and everyone's looking at us. We find time for those moments—some things don't change.
Leon: We sit in our office, across from each other, laughing.

Do you think either of you could have done it alone?
Leon: It probably would have been too difficult. We need each other. Without each other, I don't know if the idea would have come up. We probably would still be working for other people.

Do you ever feel the urge to do things separately?
Leon: We even had kids at the same time. Carol got pregnant and then I had a kid and then she had another kid.
Lim: Now we have four girls between us. A little army.

Is it hard to separate professional and personal?
Leon: It helps that we're not a couple. We're just two friends who invited more friends to work with us.
Lim: A lot of people think we're married. At the beginning, we would always be written about as a "cute couple" or "cutest husband and wife duo"! At the beginning of every interview, he'd say, "Just so you know, I'm gay, she's straight, and we're both single."
Leon: We'd laugh, "We're never going to meet anybody!"

You've mentioned your team, and you both seem like very collaborative people.
Lim: Beyond our team, we've collaborated with our friends and people we've met through the store. We have a strong interest in story-telling.

Is that ethos reflected in how you approach Kenzo? In other words, do you see your role as being gatekeepers who are simply a part of the brand's story?
Leon: Kenzo happened partly because people didn't let us in enough before. We worked on so many partnerships before 2012, which was our ten-year anniversary, but it seemed that sometimes people thought we were great for PR, great for making a jazzy product for press. We wanted to sink our teeth into the business. We wanted to take something and give it the biggest turn on its head and make it not only exciting, but profitable and amazing. We owe a lot to Pierre-Yves Roussel and Bernard Arnault, who run the LVMH group, for believing in two people who owned a store and who had never done anything on this scale. They gave us an opportunity to see through what we said we could do. I think it's the ultimate partnership. During all of our years at Opening Ceremony we'd reached out to so many companies and sent sweet emails saying, "We're Carol and Humberto, we know we can make a difference in your company, give us a chance," and they didn't, so this is our way of saying to us, "You know what? We can actually do this."
Lim: We were very purposeful in touching everything, even if only slightly—not just the runway collection, but the advertising, everything digital, the store experience, even what music is playing, what kind of food is being catered at events. We also have our noses in HR and finance and all our contracts. We're in there, cutting and slicing the budget every year. I think that's also the way Kenzō Takada worked. He started a store first.

Now you do two brands, how do you divide responsibility?

Lim: Because we're involved with so much, we had to split tasks and do things separately. We're divided, but we always start the day together, so we can be looped into each other's thought processes. Because we already know each other and how we work, I can guess all the questions he would ask. Because we started out doing everything together, I was able to absorb a lot of Humberto's thinking and he's absorbed a lot of the way that I think. So in some strange way we can each stand in for the other person.

Would you say your work is about finding ways to explore your obsessions?

Leon: We always said we wanted a job where we could travel and shop. The initial idea of Opening Ceremony was to celebrate a new country each year. It's still something we do today. "Global" is definitely a great term that gets thrown around easily. I think we were being global without knowing what global meant. We were excited to go to the outskirts and find that hidden gem, because that's how we, personally, like to shop.

Lim: We're still shopaholics.

Leon: We're basically fans and we look at everything as audience members. So with our shows, we try to think, how can we make ourselves jealous? We want to be sitting in the audience thinking, fuck! How'd they do that? That's amazing! We want to look back in twenty years and say, "That was the car show," or "That was the play at the Met," or "That was our Frank Lloyd Wright collection with the New York City Ballet." We've gotten to work with Jean-Paul Goude and Maurizio Cattelan, with *Toilet Paper* for Kenzo, with Spike Jonze. Afterwards we just think, oh my God, we did it!

Lim: It's about creating a memory in a moment of time so people will remember the whole experience.

What makes a great partnership?

Leon: Open communication and being really honest with each other about how you feel.

Lim: Goals, too. Do you have the same vision for where you want to go? That goal could change, but you need to make sure you talk it through together: "Remember, this is what we thought we wanted. Does it still feel right?"

—

This interview took place on October 26, 2016, at the Opening Ceremony showroom in Little Italy in New York.

Opposite: Inspired by their own shopping passion, in 2002 the pair founded Opening Ceremony as a space to cater to enthusiasts such as themselves. This patch celebrates the first store's founding. They talk of wanting Opening Ceremony to be the opposite of the typical high-fashion shopping experience. "It felt unapproachable. And the other 'us-es' that came to visit that store would be so intimidated," says Leon.

... AND AGAIN

MODERN CAMOUFLAGE

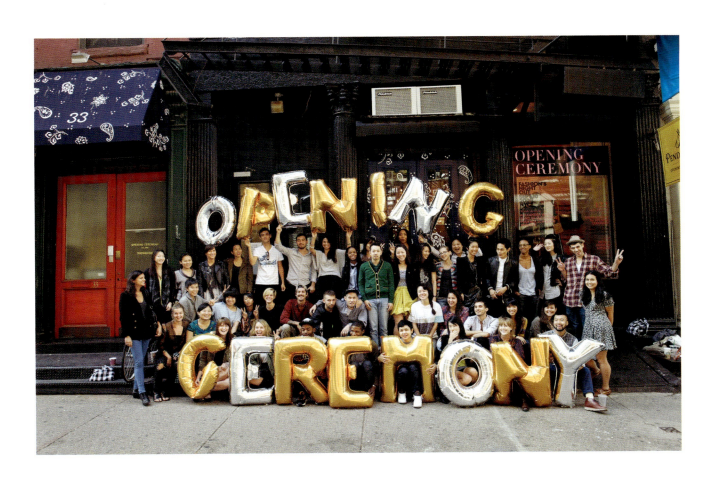

Opposite: Boards featuring photos collected by Lim and Leon and the Opening Ceremony team. Travel is central to the ethos of the store, which celebrates a new country each year. The pair fly to the selected country for research, trying the food and drink, partying, and shopping extensively, then import their finds to their stores. Over the years they have introduced their shoppers to Havaianas flip-flops from Brazil (2003), Acne jeans from Sweden (2006), and Topshop from the UK (2005). **Above:** The Opening Ceremony New York team photographed by Sasha Eisenman in 2010.

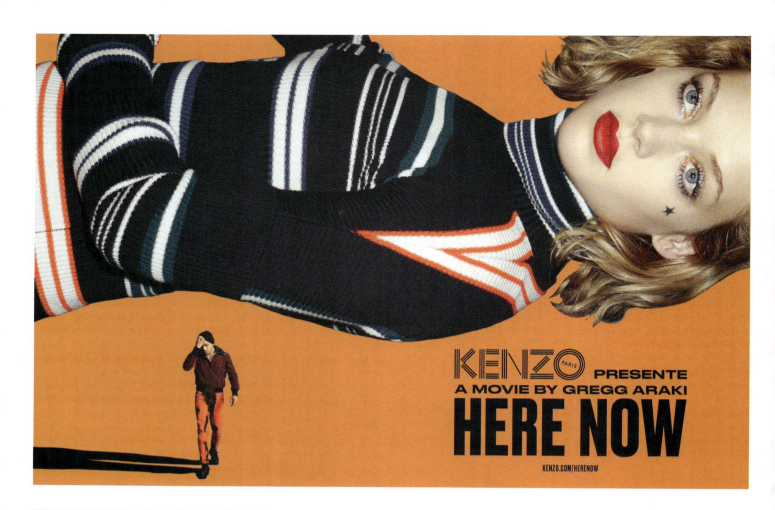

In 2011, Lim and Leon were appointed creative directors of Kenzo, a position they hold alongside their roles at Opening Ceremony. They split their time between New York and Paris. **Pages 182–83:** Kenzo mood boards for the F/W 2017 collections and La Collection Memento N°1. The latter collection was staged at Paris Fashion Week in March 2017. In the wake of combining their menswear and womenswear offerings into a single show in January 2017, the duo launched this new capsule inspired by the Kenzo archives. Kenzō Takada's vivid florals from 1983 proved a particular inspiration. **Opposite, top:** Lim and Leon collaborate widely with individuals from across film, art, and design. For F/W 2015, the duo asked American independent filmmaker Gregg Araki to write and direct an original short featuring the brand's collections. This is the film poster. **Opposite, below:** The Kenzo F/W 2012 campaign by Jean-Paul Goude. **Above:** Lim and Leon have a long-term working relationship with Toilet Paper, which has designed much of their advertising, including the Kenzo F/W 2014 campaign, the source of this image.

Lim and Leon are known for staging their Kenzo shows in unexpected ways, from an open-air event, which saw models cross the Pont Alexandre III in Paris (menswear, S/S 2015) to a catwalk show in department store La Samaritaine (womenswear, F/W 2013). **Above, clockwise from top left:** A selection of invites to their Kenzo shows: S/S 2015 womenswear, S/S 2013 menswear, S/S 2014 womenswear, S/S 2013 womenswear. **Opposite:** An image from the Kenzo F/W 2013 campaign, shot by Pierpaolo Ferrari and featuring Sean O'Pry and Rinko Kikuchi.

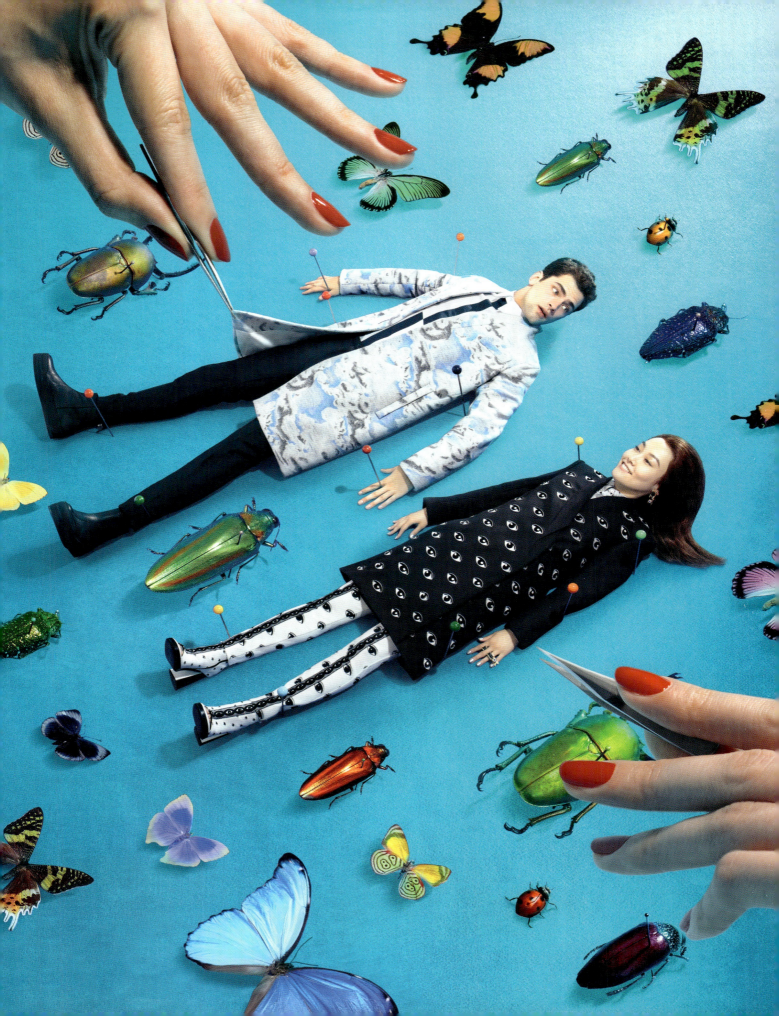

Gareth Pugh and Ruth Hogben are a prime example of a phenomenon Nick Knight and Daphne Guinness discuss in their interview within this book: individuals whose orbits intersect. The designer and the filmmaker met through Knight, with whom Hogben worked from 2005 to early 2009, both as his first photographic assistant and as editor of his fashion film projects. On encountering Pugh's work, Hogben was enthralled by the graphic silhouettes of his clothes and the darkness and complexity of his aesthetic; she deemed his pieces perfect to be shown in motion on film. Just days after leaving her position with Knight, Hogben directed a film for Pugh featuring his Fall/Winter 2009 collection. Pugh broke protocol at Paris Fashion Week by eschewing a catwalk presentation in favour of a film screening to show his collection that season. The reception was highly positive, and Pugh has been credited both as an early champion of the medium of fashion film and as a pioneer in terms of questioning traditional modes of presenting fashion. The pair, who are both based in London, have gone on to work together on numerous film and photographic projects, both for pleasure and to accompany the releases of Pugh's collections and collaborations. To this day, their films regularly premiere online on Knight's fashion platform, SHOWstudio.

Gareth Pugh and Ruth Hogben

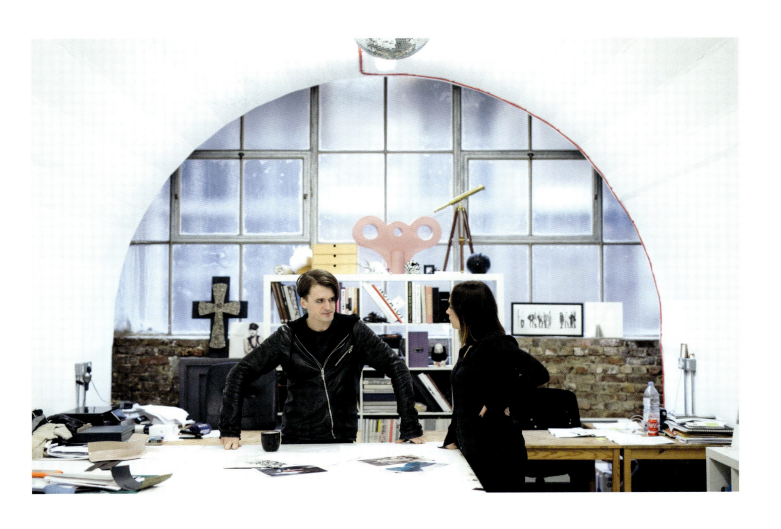

Pugh and Hogben, shot by Rob Stothard in Pugh's
London studio for *The New York Times* in 2016.

Do you remember the first time you met?
Gareth Pugh: It was on a Nick Knight shoot for *Dazed & Confused*. Back then, Ruth was making Nick films. I went to Richmond to Nick's house, and Ruth was working on footage from the shoot. It was a brief meeting.

Ruth Hogben: I think I probably wanted you to come and see the film because it was, for me, a light bulb moment. I spent hours and weeks on it, all in between assisting Nick. So I'd turn up at for work at 7:00 a.m. and then start my normal day at 10:00 a.m. and then stay until 11:00 p.m. I loved it. It was exactly what fashion film should be. Here was this weird designer—a dark, strange man. But fascinating.

Do you remember when you started socialising?
Hogben: I'm not very good at that, mainly because Gareth represented so much stress every time I saw him! Because once we started working together, he used to give me about eight days to do films. No sleep. It was torture!

Pugh: Ruth's relationship with me is like my relationship with Paris. It just represents so much badness!

Hogben: But not really! Because I love working on films. I love the pressure, and I love the stress that we have on the shoot day. That's why we didn't socialise. I took our relationship very seriously. There's no way I would have wanted to mess that up by going out and having dinner, being drunk, and actually knowing anything about his life. He was far too important.

Ruth, do you see your work with Gareth as what established you as a filmmaker?
Hogben: The time that I've been working with Gareth is public. The public listens.

Pugh: I did a lot of growing up with a lot of people watching, right from my degree collection at Saint Martins. People were also watching after you left Nick, when the first film that you worked on was one with me [Fall/Winter 2009], which we did instead of doing a catwalk show.

Hogben: I finished working on Friday with Nick. On Monday, we shot that film.

Pugh: We didn't sleep for five days, because my slot at Paris Fashion Week was the week after. I just couldn't do a show—some of the reason for that was simply production stuff and timings. The intention behind this film wasn't to make a point by doing something different. It was a necessity: How can we still have a presence and present the work, but without having fifty models walking down a runway? I actually lied to the Chambre Syndicale, who run the Paris Fashion Week schedule, by saying I was doing a show, because I wanted to still be on the main schedule. Everybody turned up thinking it was a show. I thought I was going to get in a lot of trouble for that, because, they're very, very strict in Paris.

Was it innovative to do a film instead of a show?
Pugh: It was quite common to have a film as an aside or a catwalk backdrop, but to actually have that as the main thing and nothing else was new. It's not like it was the first fashion film ever made, but I do think we brought it to the forefront. I remember the photographers rushing in when they opened the doors to the space, because at a catwalk show, they're always trying to get the best pitch. They were desperately trying to find the backstage area. But there was nothing there but a screen!

Hogben: Times move. In the last five years, screens are just everywhere—stores, the tube. When I was making films early on, I could feel that coming. But when we did the 2009 video, people didn't show fashion through film. To me, clothes are meant to be seen moving. I actually realised that back when working with Nick in part because of Gareth. I went to see the catwalk show he did at the V&A for their *Fashion in Motion* series in 2007. I'd never seen a show before.

You spent a long time assisting Nick and saw a lot of fashion, but it doesn't sound like a lot of it moved you the way that Gareth's clothes moved you.
Hogben: Not in a filmic sense. When I saw Gareth's clothes moving on that catwalk, it felt like so much for me to get my teeth into. We didn't need a storyline, props, a scene where the girl picks up a phone and has a conversation with a guy. We didn't need any of the normal things that you'd need to pad out a film. Gareth's work is defined and strong enough to lead me.

Pugh: It's about the clothes having some sort of narrative. They have motion embedded in them.

Talk to me about the process of putting together a film.
Hogben: Us meeting just happened, but the films never just happen. Gareth will spend a huge amount of his energy talking to me about fabrics and how things move so I best understand them all. I can remember you just being mesmerised, showing me pieces of material in the studio. So even though the films are shot very quickly and edited very quickly, the process of Gareth involving me in this world is a lot longer. So I'm in his brain, and he's in mine, and he fills me with all the information or the story of everything behind it—the stuff that hasn't worked, stuff that has worked. And then on shoot day, I go and do something with it.

Gareth, after the first season showing a film, how did you make the decision to keep working with fashion film?
Pugh: It was difficult, because working with Ruth on that first film was such a special thing and just seemed to happen—right place, right time, right people. Everything was against us to make it work, but it somehow did. Trying to replicate that is dangerous. Also, I didn't think that I would be satisfied working with somebody else, but I didn't want Ruth to be limited. I didn't want her to be seen as "Gareth's filmmaker." Ruth isn't my possession, and also I knew that I was never going to be able to give Ruth any kind of financial stability. I don't really make money from what I do, and Ruth doesn't, but we enjoy doing it. But

you can't eat magazines, as Judy Blame always says.

Hogben: Finding a great collaborator is hard. You twist my brain and make me see something in a totally different way. We did go on to make lots more films together. Right after we did a piece called *Joie de Vivre* with Raquel Zimmermann. That was my favourite!

Pugh: That wasn't for a show.

Hogben: It wasn't for anything. It was just for me. I'd made some money and I wanted to spend it on Gareth. [laughs]

Pugh: I'd hope we'd never stop working together because we haven't got anything to push, or to sell, or to make money from.

Hogben: But it's not pure freedom, working with Gareth. I'm so sorry, darling, but it's not. He has a lot of rules. Gareth couldn't be the designer that he is—very precise and with all the maths that go into his work—if he just let you do whatever you want. He invites me into his world, which is brilliant, because it's better than my world ever will be. There's nothing about the films that is ever about me or what I want to do or what I see. For me as a filmmaker, that's exactly how it should be. I choose the lens because I've seen the fabric and how it moves. Everything I'm doing is informed by Gareth.

Pugh: I don't roll in a big business kind of way. I don't have loads of people around me. There's nobody telling us what to do, so I make all the decisions and often it comes down to a feeling. With our films, it's not like shareable content or some top or print we want to push.

Hogben: And thinking like that means it's easy to step back and then come back again. We've never asked for a break. Life's just happened, things have happened. But then it feels right again, and I'll feel just as excited and fearless as I did the first time around. Before I was so nervous. I remember when we did the film for Fall/Winter 2011 for Pitti [the Florentine trade show], I had a month to edit that and I freaked out, because I was used to five days and I worried it wouldn't be as good. I worked on it on Christmas Day, even though I had a month. I went slightly insane. "I can't open those presents, because I'm editing!" And when it was screened, it was a beautiful, magical moment. I'm sorry I didn't hug you when you cried, Gareth. I was quite tired!

Ruth, you talked about Gareth inviting you into his world. Gareth, does Ruth make you see your work differently?

Pugh: What came first, the chicken or the egg? A lot of times I see that what Ruth would do with something that I've put in front of her is very different to what I would do, but I think that's where the beauty is, because she's got such a refined eye.

Hogben: Even though, as I said, we didn't socialise from the beginning of the relationship, it's like we've been friends, because there have never really been any inhibitions. I care deeply if he's happy or that he's satisfied. But I don't have any concerns about showing him everything. He sees all of my notes, my work in progress, my shit ideas.

What end goal keeps you coming back together?

Hogben: Well, Gareth does need to communicate his work to an audience.

Pugh: If my work never left the studio, I wouldn't be happy. Creating stuff is one part of the joy of it, but I'm not one of those people who would be satisfied with just doing that. It's not a hand job. It's not a vanity project. It has to be a part of a wider dialogue or a wider conversation. And it has to be shown and it has to be reacted to, whether people like it or not. It has to exist and live in that wider world. I want to have it in a context in which the work is alive.

Isn't the context of the catwalk enough?

Hogben: The dimensions of Gareth's clothes are fantastic. The mathematics of them are so perfect for a film and moving image. And I think that that possibly didn't happen by mistake. You're a very forward-thinking designer who probably isn't satisfied intellectually by doing just one thing.

Pugh: People are in fashion for different reasons, and it's not necessarily top of my list to be commercially successful. Making money is not what keeps me up at night, and it's not what gets me out of bed in the morning. One thing that is so important is not being limited to one thing or a formula.

Hogben: Working together is never easy. We don't comfortably find a direction. We can end up sitting and staring at each other for hours. We have different tastes, which is a good thing. We push each other, but it's not an aggressive goading. I like granny, kitsch, camp stuff. Gareth is the opposite. I spent a lot of time trying to understand Gareth's woman. She's not quite a woman and not quite a man either. I don't quite understand it, but I like it. And that has an effect on the films. People have asked me before why they're not more romantic and sexual. But why does it have to be?

Pugh: Even if it's gold undies, which we have done, it's not sexy.

Hogben: As a female image-maker, that's very interesting for me, especially in this day and age, when there is a lot of sex about. What Gareth's putting into the world is so good—the idea that for something to be powerful it doesn't necessarily mean that the women must be sexually powerful. That's really hard to communicate. He does it very beautifully and very elegantly, but I don't think it's totally easy, because when you think about films, mostly they all come back to sex.

—

This interview took place at Pugh's London studio, then based in East London, on November 21, 2014.

191

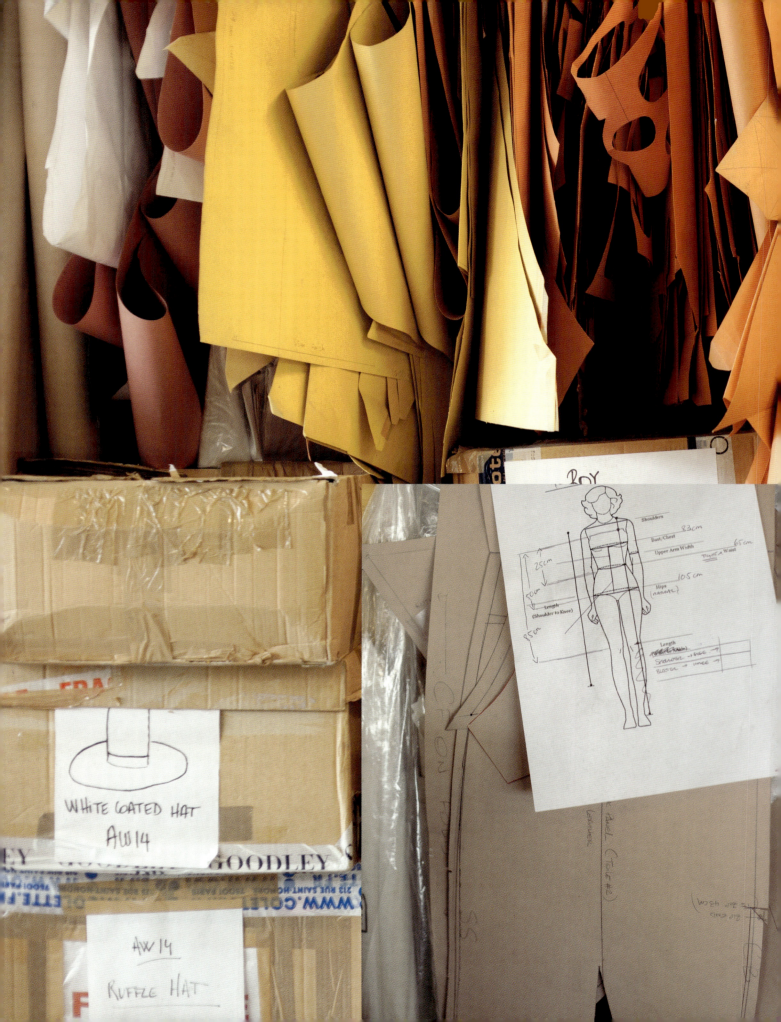

Previous pages (left): Inside Pugh's London studio, patterns from his past collections hang alongside props and garments. Hogben's measurements are kept at hand with patterns for dresses Pugh has made for her; **(right):** For the October 2008 issue of *Dazed & Confused*, Nick Knight photographed model Abbey Lee in pieces from Pugh's F/W 2008 collection. While then serving as Knight's assistant, Hogben worked on the shoot, capturing footage which she turned into a fashion film, *Insensate*, for Knight's platform, SHOWstudio. Pugh and Hogben met on this shoot and she refers to it as a "light bulb moment." A poster of the cover hangs in Pugh's studio. **Above:** Screenshots from Final Cut Pro show Hogben's editing process for a film featuring Pugh's F/W 2015 collection. **Opposite, top left and right:** While Hogben's films for Pugh have an epic, otherworldly feel, often they are made on small budgets using props made in the studio. This model was used for a 2011 film made by Hogben for Pugh for his show as guest designer at the 79th Pitti Immagine trade show held in Florence, Italy. The collection drew inspiration from religious iconography and Florentine opulence and the film was projected onto the ceiling of a fourteenth-century church. "Ruth bought a little projector so you could test the film on our ceiling, so I spent a long time lying on our living room floor," laughs Pugh. **Opposite, bottom:** A model used for Hogben and Pugh's 2014 film, *Proud to Protest*, a response to Russia's repression of the LGBTI community.

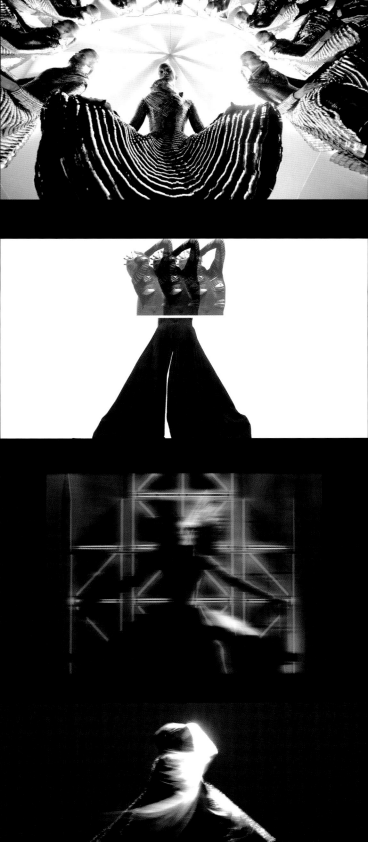

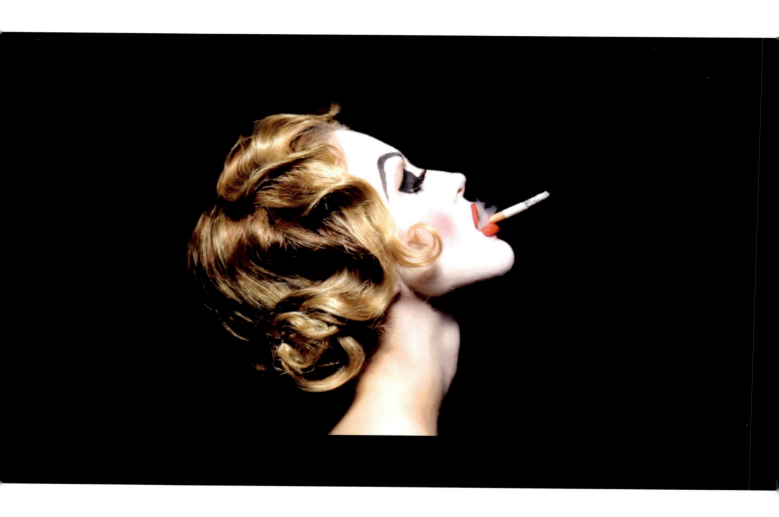

Pages 196–97: Still from Hogben's film for Pugh's S/S 2011 collection starring Kristen McMenamy. For the second time the designer eschewed the catwalk in favour of presenting his work via film at Paris Fashion Week. Pugh took over the Palais Omnisports de Paris-Bercy— a huge sports stadium on the outskirts of Paris—to showcase the film for guests. **Previous pages:** Stills from the pair's many collaborative films. **Page 198, top to bottom:** Two stills from Hogben's S/S 2011 film for Pugh; two stills from her S/S 2012 film. **Page 199, top to bottom:** Hogben's S/S 2011 film for Pugh; Hogben's F/W 2009 film for Pugh; Hogben's S/S 2010 film for Pugh; and another still from Hogben's F/W 2009 film for Pugh, their first formal collaboration.

Opposite: A still from *Joie de Vivre*, Hogben and Pugh's second collaborative film, made simply for the joy of working together. The piece looked to encapsulate the dark glamour and decadence of the Roaring Twenties and featured Pugh's F/W 2010 collection. **Above:** A still from Hogben's *Club Nouveau*, commissioned by Selfridges in 2012 for the Film Project. This film saw Pugh dressed in a *Cabaret*-esque outfit and performing a Liza Minnelli–style chair dance, a tribute to the constant inspiration he takes from performance, theatre, film, and dance.

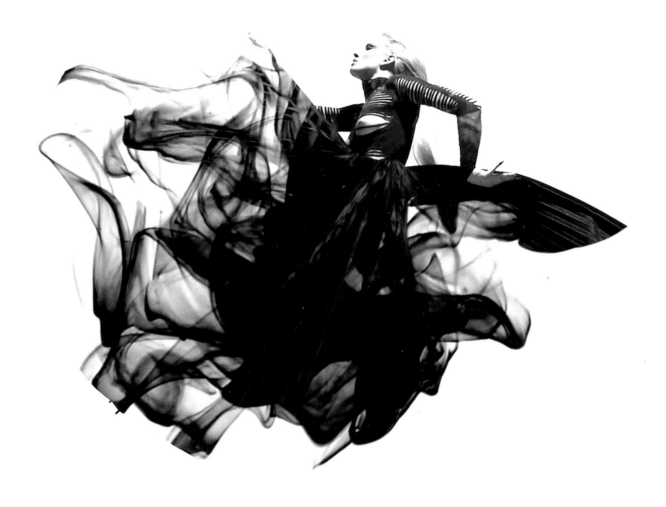

Opposite: More views inside Pugh's London studio. The blue machine in the middle image is a carpet dryer. Hogben jokes that she needs no props or additions to make a film with Pugh, such is the level of movement and narrative embedded in his clothing, but that this one piece of equipment is essential. It is used to blow air onto the garments to create the dynamic, freewheeling movement that is a hallmark of Hogben's films for Pugh. **Above:** Such movement is shown in this still from Pugh's first formal collaboration with Hogben. The film featured Pugh's F/W 2009 collection, and Pugh screened it in lieu of staging a catwalk show at Paris Fashion Week, an unprecedented and risky move. Hogben came from a photography background and approached the film with trepidation. Strikingly, the camera remains largely still throughout the film while the clothes undulate and expand.

Walking into milliner **Philip Treacy**'s studio is a moving experience. **Isabella Blow**'s presence is everywhere—her hat blocks, instantly recognisable owing to the theatrical, audacious shapes and styles of the headwear she favoured, fill the shelves. Pictures of her and notes in her writing litter the mood boards. Her Manolo Blahnik shoes and pink ink bottle are prominently displayed. Blow—a celebrated style icon now, but once a diligent stylist, keen to stake her claim to a successful career in the fashion industry—committed suicide in May 2007, but you get the sense she's still with Treacy every day. The milliner moved to London from his native Ireland in 1988 to study at the Royal College of Art. Blow was instrumental in his success, commissioning him to make her wedding hat for her marriage to Detmar Blow in 1989 and introducing him to her connections within the industry. Such was her faith in Treacy that she invited him to move into her own home in Eaton Square in London as he began to grow his business. She played a similar mentoring role for numerous young designers, notably Alexander McQueen. Blow introduced McQueen and Treacy, and the pair went on to collaborate regularly. At Blow's funeral, held at Gloucester Cathedral where her wedding had taken place eighteen years earlier, her casket was surmounted by a black hat shaped like a seventeenth century sailing ship, which she inspired Philip to make.

Philip Treacy
on Isabella Blow

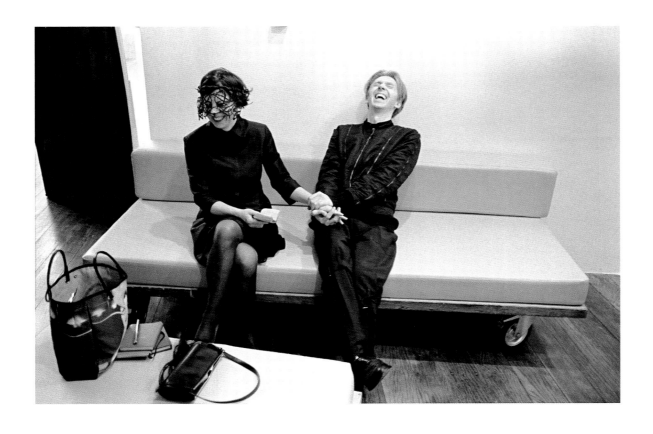

"She was incredibly funny," recalls Treacy of Blow. "We'd laugh and laugh and laugh and laugh." The pair were captured by Kevin Davies on set on a shoot for *Harpers & Queen* in 2002.

Tell me how you first met Isabella. I've heard there was a green hat.

Philip Treacy: It started with a green hat that I made for Michael Roberts, the fashion editor, for a shoot with *Tatler* in 1989. I went to collect it from the art director, and she said, "Oh, you must meet Isabella." Issie walked into the room. She wasn't overly friendly, so I didn't think too much of it, but I remember thinking that she looked completely different to everybody else.

Was she wearing a hat?

Treacy: No, she wasn't, but she was wearing very red lipstick and it was crooked. I noticed, over the years, that people would always say to Isabella, "You have lipstick on your teeth." People would point it out to be nice, but she couldn't have cared less. I remember she was wearing a John Galliano cobweb top and a little bias-cut dress and yellow Manolo Blahnik satin shoes. Everybody else in the office was in navy. She had that very English look about her—she looked really, really English. I know that sounds strange to say, but I've always been interested in those 1920s and 1930s English women who were unusual and extreme. I love how they looked, and she looked like them.

What were you doing at that time?

Treacy: I was twenty-one and I was studying fashion design at the Royal College of Art. I'd just won a competition to design hats for the Harrods hat department, so during the summer holidays after my first year I stayed at college during the day to use the studio to work on my designs. It was just me and the secretary. She was a temp called Helen, and I think she was a bit perplexed by me. Every few days when I came in, she'd say, "This very unusual woman has been on the telephone." And I'd say "Did she leave her name?" She'd say, "No." She kept ringing, but she never left her name. So we'd spend all this time thinking who could it be, because I didn't know very many people. The woman who called kept saying to Helen that she wanted to know what my schedule was like for the next six months. It turned out to be Isabella—she was getting married, and she had decided that I was making her wedding headdress.

Why you?

Treacy: Isabella liked fresh meat. She remained loyal to people, but she very much liked to give people opportunities, which is rare. But Isabella saw it as her duty. She introduced me to Karl Lagerfeld like she was doing him a favour! I always remember when John Galliano lost his backer, she called him up and took him out for lunch, and he said to Isabella, "You're the only person who has done this." She had great humanity. Fashion is not known for its humanity. She was fearless, and fashion is fearful. Fashion people are very concerned about what everybody thinks. Later, I could see how people reacted to her and they treated her differently—like she was "kooky Issie," when really she was the least kooky person I've met. She was completely on the mark and she was very intelligent and her references were better than those of any other fashion people I've come across. She was a brilliant people person, a brilliant communicator. And she made it fun and interesting—she was incredibly funny. Isabella became fashion establishment. But she wasn't always fashion establishment. She was the outsider. People talk about her with adoration and respect now, but they used to laugh at her.

Do you think people didn't understand her? Were they intimidated by her?

Treacy: Both. It's strange, Isabella has become a fashion icon since she died. She didn't feel that when she was alive. I see kids all the time putting things on Instagram—Isabella Blow, Isabella Blow. I look at it and think, Wow, she wouldn't believe that. She really loved young people. When she was alive, people often found her unusual. She actually hated being referred to as eccentric, because eccentric was used for her as a slight putdown. I think possibly her modus operandi would irritate other people in her office, because she wasn't there at nine a.m. She saw fashion in a broader sense than being at an office desk on the telephone to a PR. Isabella was working all the time, but they didn't always get it, because she wasn't chained to a desk. She thought fashion was about visiting Manolo Blahnik to ask his opinion on shoes or going to see Alexander McQueen and speaking to him about a shoot. She was almost a cheerleader, but she didn't cheerlead pointlessly.

Do you think you're the reason she loved hats so much?

Treacy: No, she always loved hats. She said that when she met me, the hats got better. But the magic was that she wore a hat as if she wasn't really wearing a hat at all—she wore them very unselfconsciously and in a completely fearless way. I once made her a mortarboard-style hat for an event, and I asked her how wide she wanted it and she kept gesturing bigger and bigger. So I made it as wide as she wanted, and she couldn't get in the door. She had to walk into the party sideways. In the early days, I would have a sharp intake of breath before we'd walk in somewhere because Isabella looked so reference-less, so new. She wouldn't notice, but the whole restaurant would go silent.

Did her attitude give you confidence?

Treacy: No! I just wished the ground would open up and swallow me because everyone would turn around. And Isabella would tip top, tip top, tip top in her heels across the room and then say to the waiter, "Thank you so much, how wonderful, how kind of you," with all her very good manners. Meanwhile, the whole restaurant was transfixed by this woman in her look. But Isabella wasn't doing it to show off at all. I wish people understood that.

You've told me before that she talked about her hats almost as if they were people, friends.

Treacy: Yes. If she liked a hat, she thought it was fun to take the hat out in the evening. She'd talk about whom the hat met. Or if she met somebody and they

loved the hat, she made them dance in the hat. If you say to most women, "I love your dress," they say, "Oh, really? Do you? This old thing?" Isabella would say, "Isn't it amazing?" She really enjoyed fashion and she saw fashion as something to be adored. She planned her outfit for a month's time if she was going somewhere special. When I say planned it, I mean she would just drive me or Alexander McQueen or whoever was making the dress insane! But in a very sweet way. She'd be calling constantly. "I've been thinking about the veils…" She'd call at seven-thirty in the morning—bright as can be. She'd keep calling throughout the day—just checking in. It was encouragement. It was never instruction. She thought it was really naff to tell me or Alexander what to do. We didn't mind, but she did. But just having her around was like an injection of energy—creative energy. She made you feel great. She was atomic.

Today, there is so much focus on her style and her appearance, rather than her personality or her generosity. People often talk of her as a work of art, an exotic creature.
Treacy: They do, whereas Isabella was no pushover for anybody. Letting her down was not an option. You really had to rise to the mark and rise to the occasion, because she wasn't stupid. Isabella's idea of a hat from me was something that had never been seen before—completely original, new material. Now, that's not easy on a weekly basis. She wasn't forceful about it. She just expected it to be fantastic.

Because she knew you could do it?
Treacy: Yes.

So that made you know you could do it.
Treacy: Yes.

Do you ever feel that since her death the practical and pragmatic support she gave has been overlooked?
Treacy: Of course. Sometimes I am concerned with how people think she was, because actually she was much better than that. It would be great if you could dispel that myth that Isabella was some socialite who bought clothes and hats and wore them to parties. She did, but in a much more interesting way. She wasn't a clotheshorse. The whole muse thing is strange—it's not just a friend who happens to wear something and go out in it. That's not really what she did. She was like a walking, talking ambassador for whatever was taking her fancy at the moment. She liked creative people. She was very knowledgeable about photographers, and as a stylist, she did the most fantastic shoots. She had to fight all the time for what she believed, for all of her career really. Not just for some of it—for all of it. And she was always right in the end and the shoots were always great. And, you know, when I look at *The Sunday Times Style* magazine, where she later worked, I think, God! Isabella believed in dumbing up, not dumbing down. And before, when she was at *Tatler*, all her shoots were so much better than other people's. They would do "ten ways to wear a tartan" or something like

that—tartan ball gowns with 1980s hairstyles and aristo girls in pearls—whereas Isabella would have girls with tarantulas or girls in flying machines. They were all her cronies—all people she collected. She was instrumental in many people's careers at the beginning. And doing that is the most difficult part. A lot of people can come in later on. She always believed. There was a time when Alexander had one champion and I had one champion. Everyone else jumped on the bandwagon afterwards.

Did she become like a mother to you and McQueen?
Treacy: Of course! We were her kids—we belonged to her.

Do you think you would have got to where you are without her?
Treacy: Well, it wouldn't have been as fun without her.

Do you have a favourite hat that you made for her?
Treacy: All her hats are wrapped up in one, really.

How so?
Treacy: Isabella's hats are Isabella's hats, because they're different to everybody else's. They were always the hats that everybody was afraid of. The hats that she loved, that I loved. It was always the un-commercial ones. She wasn't interested in commercial. In later years, after they'd seen her enough or seen images of her, people would come to the shop and think, Well, maybe I could wear that, too. Whereas initially they wouldn't have gone near it at all. No way. Keep it away from me! But Isabella would say, "Give it to me!" So she changed how people see hats.

Your partnership with Isabella has been widely celebrated and discussed—such as with the Design Museum's exhibition When Philip Met Isabella *in 2002. Why do you think people have been so interested in your collaboration?*
Treacy: Maybe because it wasn't about money, or anything financial. It was about friendship and love—it was sincere and authentic. I love making hats and Isabella loved wearing them. I didn't even need to go out with Isabella in the hats—I was happy if the hat went. Isabella used to say to me, in the early years when I didn't understand so much about the industry, that she didn't want us to be a horse and cart act. What she meant was that she wanted me to grow and be successful. She was territorial, but she also wasn't. She wanted the best for me, for us, not the best for her. That's unusual. Sure, she wanted hats and she wanted clothes, but only because she really loved them. That was the biggest compliment I could have been paid. Because she didn't like them—she loved them. But Isabella herself was more interesting than the hats and the clothes. She may not have thought so, but she was much more interesting that any hat or clothes could make her.

—

This interview took place on November 12, 2014, in Treacy's office at his headquarters on Havelock Terrace in South London.

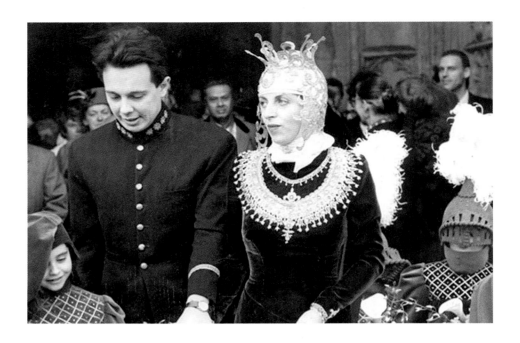

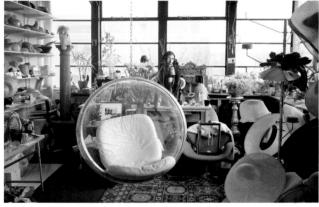

Above, top: Treacy and Blow's collaboration began when he was still a millinery student and she commissioned him to make her wedding hat—a gold lace headdress worn over a flesh-coloured wimple, styled with a purple velvet robe featuring hand-embroidered trompe-l'oeil necklaces. She married Detmar Blow at Gloucester Cathedral in 1989. In 2007, her funeral was held at the same location. **Middle and bottom:** Inside Treacy's London studios are numerous objects that recall Blow's influence. An Eero Aarnio chair hangs in his office, while in the basement, amongst many hatboxes, sits an eighteenth-century Russian gold sleigh. Treacy purchased it from Sotheby's shortly after Blow's death. "She taught me about nice things in life—finer things that I might not have necessarily come across. About it being okay to go to the Ritz or buy something beautiful. She made me buy this chair. That's why it's here! She just said, 'Get it!' And when I saw this sleigh, I just thought, that's mine. It was totally influenced by her."
Opposite: From 1997 to 2001, Blow served as fashion director of *The Sunday Times Style* magazine. This note, alongside various mood boards featuring pictures of Blow, hangs in Treacy's studio.

THE SUNDAY TIMES

1 Pennington Street, London E1 9XW *Telephone: 0171-782 5000 Fax: 0171-782 5658*

Darling Philip,

Enclosed is THE New York
Times article April 4th!
Secondly bad Xerox of Mario
Testino's book.
Thirdly see you May 1st 1999
at Hilles for the weekend.
+ THE Grey Peacock
Beauty as in "Rare Bird!"

Love as always.

Isabella xxx

Registered Office: Times Newspapers Limited, P.O. Box 495, Virginia Street, London E1 9XY
Registered No. 894646 England

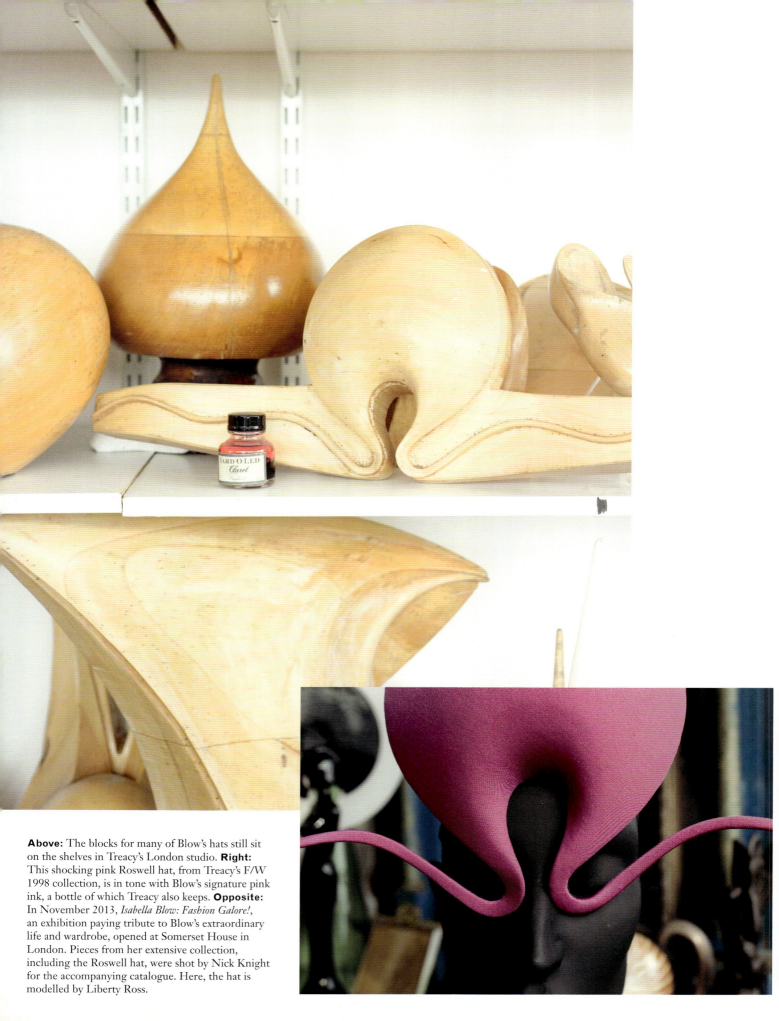

Above: The blocks for many of Blow's hats still sit on the shelves in Treacy's London studio. **Right:** This shocking pink Roswell hat, from Treacy's F/W 1998 collection, is in tone with Blow's signature pink ink, a bottle of which Treacy also keeps. **Opposite:** In November 2013, *Isabella Blow: Fashion Galore!*, an exhibition paying tribute to Blow's extraordinary life and wardrobe, opened at Somerset House in London. Pieces from her extensive collection, including the Roswell hat, were shot by Nick Knight for the accompanying catalogue. Here, the hat is modelled by Liberty Ross.

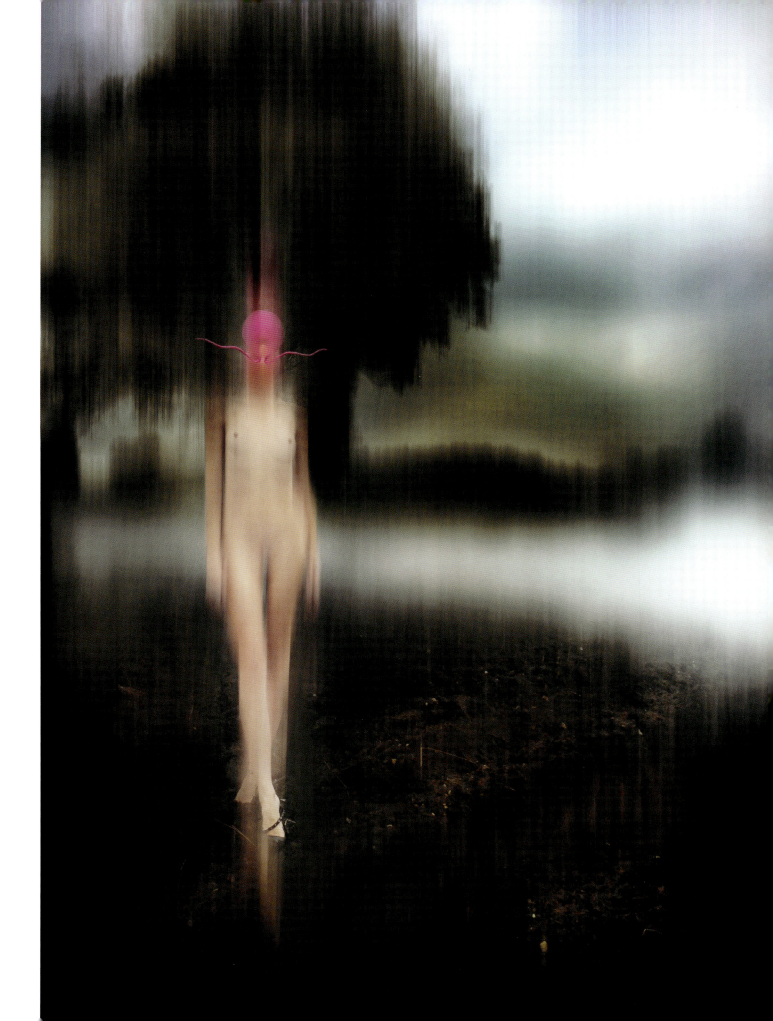

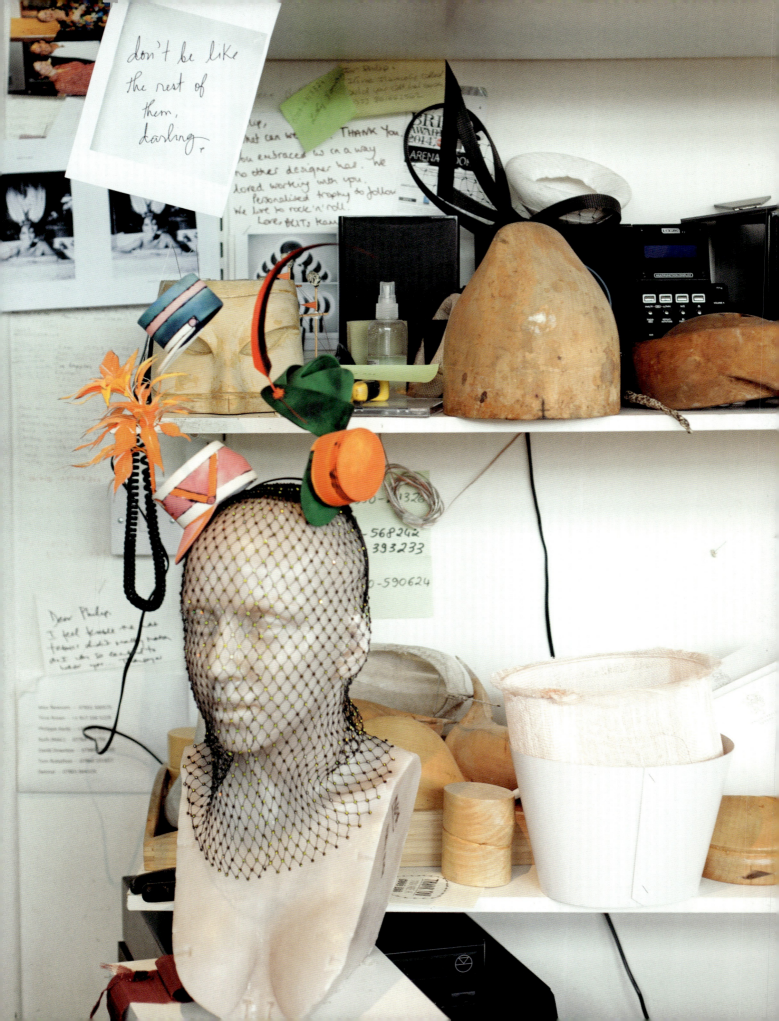

Inside Treacy's studio. **Opposite:** A sketch by Andy Warhol inspired this 2003 hat by Treacy, which turned the artist's 2-D drawings into dancing 3-D hats that move as the wearer walks and gestures. The hat was worn by Blow, with an Alexander McQueen for Givenchy kimono coat, to Royal Ascot, when she and Treacy were invited for lunch by the Duke and Duchess of Devonshire. "Isabella was so excited because we went to the paddock with the Duke to judge the best turned out horse," recalls Treacy. The hat sits on the mannequin used to craft Lady Gaga's Madame Tussauds waxwork. Gaga is a friend and collaborator of Treacy's and regularly takes inspiration from Blow's style. **Right:** *Blow* is spelled out in feathers on this hat, made by Treacy for Blow to wear to the launch of her limited edition MAC Cosmetics lipstick, titled Blow, in 2005. The technique of writing with feathers was specially developed by Treacy. His first piece simply read *Hat* and was worn by Erin O'Connor. **Below:** A pair of Blow's heels by Manolo Blahnik— her favourite shoe designer—sit on a shelf. Blow was known for changing outfits, sometimes multiple times a day. "It was normal to find clothes and shoes left around," recalls Treacy. "Those shoes were left after one of those quick changes. It was not abnormal for Isabella to perform one in the workroom in front of everybody, nude."

Fashion has changed dramatically. Today it's about marketing, and
Isabella didn't understand that—she was only interested in creativity.
The idea of having to go to the launch of a range of socks saddened her
when she'd rather go and visit Marie Antoinette's jewellery or find out
about some incredible material being invented. She had also become ill
with depression and it was very difficult for her friends to get through
to her. Part of the problem was that she had a very black sense of humour.
She could be hilarious about her suicide attempts, so people
didn't know whether to take her seriously or not.

She felt so low before she died that, in a strange way, I'm happy that
her name and life has become bigger than it was when she was alive.
She would have been charmed by that. Some people's personalities become
alive in history, they have light, and she is one of them. Everybody, I imagine,
wants to be remembered in some way once they go and she's getting that in
spades, in exhibitions, books, plays. Isabella, for all her bravado, was low on
self-esteem. She had an air of confidence, but she didn't always believe it.

Today you can see her influence everywhere. She made it possible for
designers like Alexander and me. She invented careers out of thin air for
many people, though not everybody chooses to admit it. She was interested
in every part of culture but people underestimate her because she had
the capacity to look alarming at nine o'clock in the morning.

I think about her, and what she would like, all the time. She's
part of my design psyche because I developed it with her. She's part
of my design life, she's part of me.

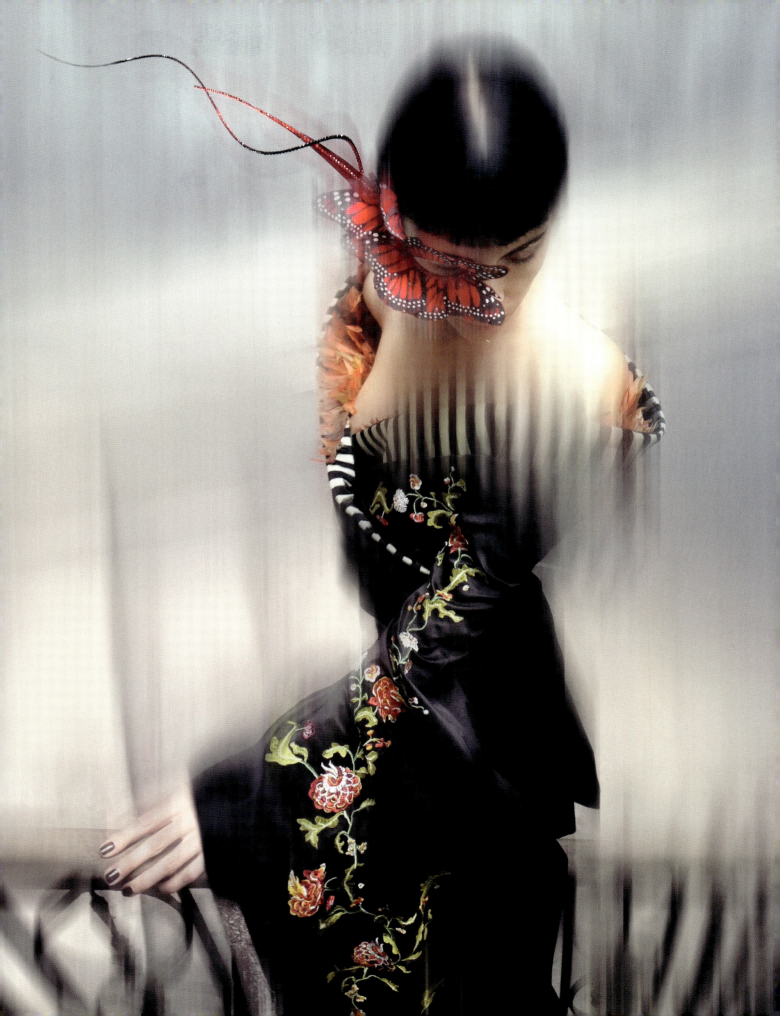

Page 214: A photo of Blow and Treacy with his beloved dog, Mr. Pig, is pinned to Treacy's studio wall. **Page 215:** Another tribute image by Nick Knight from the *Isabella Blow: Fashion Galore!* catalogue. Treacy's red butterfly eye mask, made from feathers and Swarovski crystals, is worn with Blow's Alexander McQueen for Givenchy kimono coat. The look was worn by Blow to the Rainforest Respoke Bespoke Party at Claridge's in October 2006. **Above:** A Polaroid of Blow is pinned on Treacy's studio wall above a rubbing of Marilyn Monroe's grave marker. Blow adored Monroe and once urged Treacy to bid thousands for a pair of her fake eyelashes at auction, which he declined. **Opposite:** Though remembered as a style icon, Blow was first and foremost a highly skilled fashion editor. Many of her shoots are now iconic, celebrated for their rich narratives, intelligent wit, and dark beauty. This story with photographer Sean Ellis was titled "Taste of Arsenic" and appeared in the October 1996 issue of *The Face*. It showcases the work of Blow's two most adored discoveries—McQueen and Treacy.

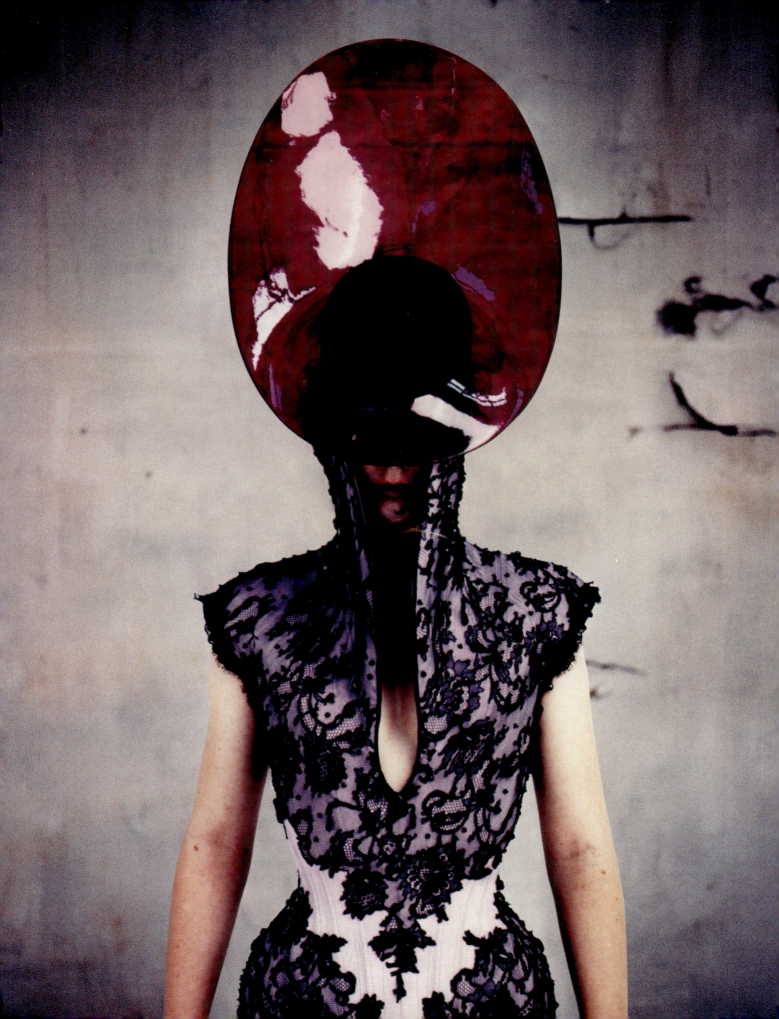

Known simply as Mert & Marcus, photographic duo **Mert Alas** and **Marcus Piggott** are famed for bringing spirit, sensuality, and energy to their photographs. Their subjects are not merely models, but friends and part of an extended family that encompasses stylists, designers, and hair and make-up artists. Evidence of their large network can be seen in this very book, as they have supplied many images not only for this chapter, but for several chapters on other collaborators as well. In an intriguing example of how different duos with the same profession can operate in totally disparate ways, Alas and Piggott share a camera while shooting, passing it back and forth, while Inez van Lamsweerde and Vinoodh Matadin, who are also profiled here, shoot together with separate cameras, taking distinct positions around the subject. Alas is Turkish and Piggott is Welsh, but both were born in 1971. They met at a party in London in 1994 and became a couple. While no longer together romantically, they continue to collaborate, working extensively with magazines, fashion houses, and icons. Their studio is now based in London, but they spent many years living and shooting on Ibiza.

Mert Alas and Marcus Piggott

A self-portrait of Alas and Piggott, shot in London in 2015.

How do you work together on set? I've heard that you share a camera.

Mert Alas: It all starts with the idea. Then we go on to set, and one of us will kick-start the process—the light, the scene, the composition. And then after that we share the camera: he shoots you; I shoot you. It's pretty fluid. While he's doing something, I could be doing the lights for him, and if I'm shooting he will be holding the lights for me. We listen to each other, and that's what makes it beautiful. Marcus tells me, "Wow come to this corner and shoot from this part of the building," and I follow him, because I trust his opinion.

Marcus Piggott: Often we start with the idea of the character—the world she would live in—and then it's just having two sets of eyes looking at that. We have a common objective or goal, so it doesn't really matter who's taking the picture, as long as we get the picture that we're both happy with. Of course, sometimes we get to the point where we're arguing over the camera. He might be shooting from one aspect and I see something, so there's that sense of urgency and frustration of getting it, but in general it's much more of a harmony.

When you see the pictures, is it hard to differentiate who shot what?

Alas: We always fight. "You shot that one. No, I shot that one. No, you shot that one!" But really, we don't look at them like that. We don't dissect it. We look at it in terms of what we managed to do that day and whether it's good enough or not. "I chopped onion, you chopped tomato, and we made a great salad."

Piggott: We were a couple for sixteen years, and he's been my best friend for twenty years now. If we were both out for our own purpose, we would probably be taking pictures ourselves.

You often work with the same models and stylists again and again. Would you say you are very collaborative people?

Alas: We are great believers in team, family, and connection. When you find a connection and create a family, why change it? Something very spectacular needs to happen in order to make me want to work with a stranger. I'm open to it and we do it sometimes, but I feel more secure working with my gang and my team because it feels natural. And if I say "blue," I know what tone of blue they will register in their minds. When I say "red," you might think, "scarlet red," but I actually meant orange-y red; they know that. It's about having a simple language between people. A connection where things are not so much spoken but felt and done is rare.

Is part of the appeal of working as a duo that there's always a person to support you?

Alas: Maybe it is, subconsciously. Looking back, we started by taking photos of each other. And then once we were bored of each other, we started taking photos of our friends. We would have an idea and then call our friend Lula at 2:00 a.m. "Could you please wake up and come to our house? I'll pay the taxi!" She'd come and we'd get her naked and decide what

crazy light to try on her. We did a lot of nudes at the beginning of our career. We didn't start doing fashion photography. In some ways, I do feel the selfish comfort of having someone to rely on. It brings something very spectacular into the day of the shoot, because we have an opportunity to sit back and observe and calculate. So I can watch while Marcus is shooting and sort of review it. When you're shooting by yourself, you don't have that time.

When photographers and designers work alone, they often talk of feeling like they are putting themselves into the work. Working as a duo, do you feel like you're not baring your soul as much?

Piggott: We protect each other. Really, the only opinion that matters to me apart from my own is his. And I think that that knowledge of satisfying not just myself but him pushes us further, even if we disagree. I look to Mert for confirmation that he's satisfied. He looks to me. If we're both satisfied, then we move on.

Alas: We are very strong personalities, and that side of our characters does cause friction We fight a lot and we disagree a lot, but it's all part of the play. And if you like the play, if you like the ending, you play the game, and you go through the tears and the tantrums and the disagreements and all of that.

Are disagreements helpful?

Alas: Conflict is so good, because when you disagree, you have to convince the other party that you are right. And that convincing process is called searching for perfection.

Piggott: We're hard working in that way. We don't feel like we've got it straight away. We keep on searching and searching and searching.

Does that process take place on set? You're known for having a fun atmosphere on shoots.

Piggott: I think our best pictures are always when the energy is very light—when it's fun, when there's music, and when we have laughter.

Alas: You know that thing when the eyes speak, instead of lips? That's it. Fun is a very important part of our life. I go to bed with my work. I wake up with my work. I work at the weekends, sometimes at nights. I'm constantly living this life. So you have a choice—to have fun or not.

Piggott: I think our move to Ibiza helped. I'd always known I didn't want to live in England. I'd lived in France and Italy, and we finally found the dream place. In Ibiza, we were so free. You don't have to request permits a month before. The girls would run naked around the town. No one gave a shit. We lived there eight or nine months out of the year for six years. By the end, we'd shot in every corner. It was not always the easiest place to bring clients to and from. Clothes would go missing in Barcelona, but they'd always turn up the next day! We'd panic. "The wigs have gone missing!" "Grace Coddington's clothes are gone!" But it would always turn out fine.

Alas: Early on, we were really obsessive. Obviously the

wings of ambition and perfection add to the obsession to make something look more amazing. But when you grow up a little bit more, you digest all that crap. You're a little more confident and you know your game a bit better, and that relaxes you ever so slightly, and then you start thinking, "OK let's put on a Madonna song and just jump around in the studio." How boring it would be if we just went to the studio and everyone was serious, and I was sitting down with the tripod and the camera, just clicking my life away? I would never do that. I would rather be a pop star!

Tell me more about that process of growing up.
Alas: It's about understanding the light more. Understanding what we like more. Understanding what I thought I liked but I'm not really that into. Learning my tools, my dance floor, my dancing shoes, my friends around me—all of these things mean growing up. We grew up together from being reckless, irresponsible, fun, crazy club kids to being in a place where we could express ourselves. Coming to that point with someone through the stages of hardship—because we didn't start as rich kids—is very bonding.
Piggott: I'm here today because I have had this relationship. I think the two of us together pushed each other so much, especially in those few years when you're doing things on a shoestring—when there's no money, when you're building sets, when you're cooking the food for everyone to eat on set, when it's either you pay rent or do a shoot and you choose to do a shoot.
Alas: And through it all, you become more confident. I used to work for weeks to prepare myself for shoots mentally, creatively. I used to do sketches and drawings. Now, sometimes I can just wake up and go to a shoot and start from that moment. And that is sort of growing up, you know? Getting comfortable with your mind, and getting comfortable with your spontaneous creative power. Ninety per cent of our photos that I love the most are the ones that I haven't prepared for.

The accidents?
Piggott: The mistakes are often the ones that get picked in the end. I go onto location and it's supposed to be beautiful sunshine, and it's actually foggy, but that fog transforms the whole mood of the shoot and actually that's perfect. You have to be flexible.
Alas: The reason you like those accident pictures more is because they really were not existent anywhere. They're totally new—just pure bursts of creative lightning. There's no preparation for it, no idea for it— we don't know what the hell we're doing but we're doing it! An example is our shot where she's running down the road naked. We were shooting in my house in Spain using plain backgrounds, and suddenly I just told her, "Take your clothes off and just *run*. You're going to look great, I promise."

Marcus, when you first met you asked Mert out. Do you remember your first impressions of each other?
Piggott: We were at a party and there was a girl who was hitting on me. She asked us both if we wanted a

drink, and we said yes. She went out of the room to get them, and I'd kissed him by the time she came back. I found his number through a friend of mine, and then we were inseparable.
Alas: He was very tanned; he had these very piercing blue eyes. He was really handsome. I must have drunk far too many drinks that night, because I woke up and I couldn't really remember it. The next day my friend told me I was talking to a beautiful guy. "Really? Was I? Who was he?" At that very moment, my phone rang and he said, "This is Marcus. Should we go out?"
Piggott: We met because we both went to this party outside London, so I think it's destiny and fate, isn't it? I can't imagine if we hadn't met each other. And I wonder what it was that really attracted me, initially, to him. I don't really know what that was.

How did it develop into a creative partnership?
Piggott: Mert studied music and is classically trained. I studied graphics and photography. It was probably six months into the relationship before we started working together. He came on board as a stylist and make-up artist. But then he had such great ideas, and after one of the very first tests we did we knew it was something that worked.
Alas: The beginning of our romantic partnership has got a lot to do with it, because we talked so much. When you're young, what do you like doing? We liked making love and having fun and talking and talking and talking. I remember going to sleep thinking, "God, I said so many things that I didn't know I knew!"

Did you always feel like you were looking for that connection with someone?
Alas: I've always liked to have a partner-in-crime. I was an only child, so I always sought to have someone to share with or play with.
Piggott: I come from a family of five children, so in that sense we're very different as people. But in other ways we're quite similar. His father was in the RAF, my father, too. My mother and his mother have a lot of personal style. So we each remember being a child and looking up to this stylish woman.

Was there a power imbalance because Marcus knew so much more about photography?
Piggott: That period was quite short. In terms of the ideas and creativity and the energy on set, we were very equal straight away.
Alas: I remember going to a second-hand shop and finding an encyclopaedic series of twelve books about making good photography: night photography, nude photography, speed photography. I was trying to educate myself. And I used to say to him, "You know what? You can't do it that way because you have to do the shutter speed like this," and Marcus would be like, "Oooh! How did you learn that?"

Is it hard for people on set with you—your assistants or stylists—to deal with your closeness?
Piggott: My friends used to say, "How can you work

and live together?" For me, it just got better every day. We were lucky, because travelling with your partner meant you were always at home, in a way. Now, we're family. Holidays, houses, dogs—we have everything together.

Alas: When we first shot Kate Moss in the 1990s, she apparently went back to her agent and said, "I'm never doing that again! I didn't know where to look! One says, 'Get up.' One says, 'Get down.' One says, 'Smile.' One says, 'Cry.' I'm never going through that again!" But of course she did.

Did comments like Kate's ever make you consider trying two cameras?
Piggott: I actually I think it's more confusing for the subject. It becomes like paparazzi, a bit of a frenzy.

You're no longer a couple romantically. How did that affect your working relationship?
Alas: We had a baby, in the form of our work, so we had to be mature about how we resolved the problems. I'm very emotional and so is Marcus, so at first it was tricky, but somehow we got past that stage. In the end, the only thing that was different was that we weren't sleeping in the same bed. Everything else is pretty much the same. Whenever he has a partner, they have to go through me first. And same thing for me! We'll probably get married when we're old and live together again one day.
Piggott: We never stopped loving what we did. We never stopped loving each other, it just got to a point where we couldn't be together anymore. But as Mert says, our work was like our children, so our relationship ended but our love was still there. We split up in the studio, but the next day we still went back. I come from a big Irish-Catholic Welsh family. My grandparents were married their whole lives, and my parents are still married. I think that's what life is about. And I found that with Mert. We're still partners, just not boyfriends. And I know that when we're seventy or eighty, we'll be the ones still together.

So, you never thought about splitting creatively as well?
Alas: No. It was bigger than that. I didn't spend fifteen years with someone for that. Work has really helped us. It was like therapy. We had to be gentle with each other.

You must have separate obsessions or interests. How do you work those into the images and combine them?
Alas: Our images reflect one of our, or both of our, fetishes, dreams, memories, admiration. We like the same kind of characters, which is a very good starting point. We also like the same kind of stories. Sometimes we allow each other to self-satisfy—to take the lead, or have the say. We are strong people, so I have to sometimes let Marcus feel special, and he has to do the same thing to me—that's really what a good relationship is.
Piggott: We do like the same type of woman. She's assertive, she's strong, she's sexually charged.

She's not just a beauty. There's a personality behind that beauty, too.

I would say that your imagery is very varied.
Alas: I don't like consistency. I think the only consistency I like is good work.
Piggott: I look at a lot of work we've done, and I hate it. Now that's a pain in the ass, but also it means I'm always striving to do something better.

Is there a secret to successful collaboration?
Alas: First of all you have to have a partner that you respect. Then, you have to have someone that you connect with, and connection is so hard to define. It means liking the same things, enjoying the same things, crying for the same things. There's often something invisible that joins you that allows you to be able to do that. And that's why it's so rare to have a long relationship or a long artistic relationship—it's hard to find someone who thinks like you.
Piggott: It's also knowing that when you stop, you still appreciate that person. When you're not talking about work, it's about still finding intellectual excitement there.

Do you ever look at people who work on their own, particularly image-makers, and wonder how they do it?
Alas: Thinking back, everybody I always ever truly admired had someone with them. Helmut Newton had June. He's the greatest photographer of our time, for me. I do think it's a very big responsibility to go and express yourself. I feel like you need someone— someone to inspire you, to trigger you, to spark an idea. Unless you're a very programmed and planned person, which, when you think about it, is not really the definition of an artist. I think the greatest people always have someone else there, because they have no time to program.

What are you more proud of—the work or the relationship?
Piggott: The relationship, of course. Because without that, all of this wouldn't have happened. This is just the fruits of our time together.

—

This interview took place in Mert Alas and Marcus Piggott's North London studio on two separate days, July 29, 2015, and October 14, 2015.

Early experiments by Alas and Piggott from circa 2000. **Above:** A working Polaroid from a session for *Dazed & Confused*. **Below:** A working Polaroid from a shoot with Björk for *The Face*, 2000. "Consistency of a style? How boring that would be! Doing one technique for the rest of my life? I would have stopped by now. For us it's like tales. One day we do sex. One day we do portraits. One day we do animals. I like having a repertoire of different things—different styles, different lighting, different people," says Alas.

Alas and Piggott met in London
in 1994. "We started by taking
photos of each other. And then
once we were bored of each
other, we started taking photos
of our friends," says Alas. These
personal Polaroids (this page of
Alas, opposite page of Piggott)
were shot a few years after they
met, from about 1998 to 2000.
Following pages: Kate Moss,
shot in London in 2009 for
Love magazine.

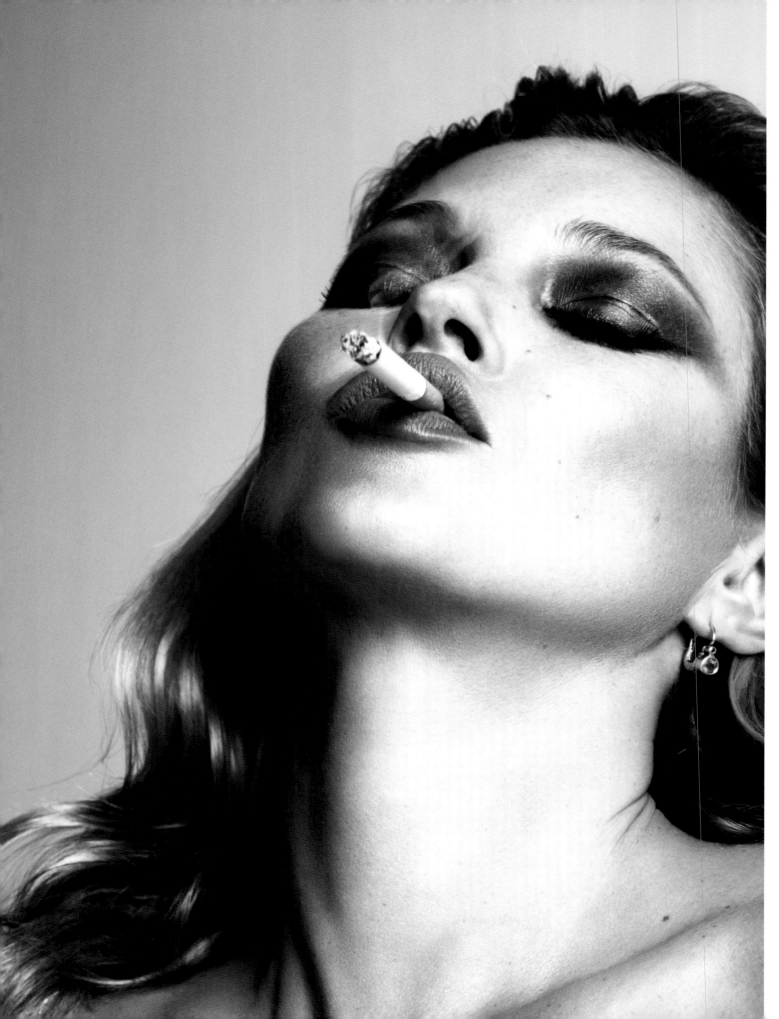

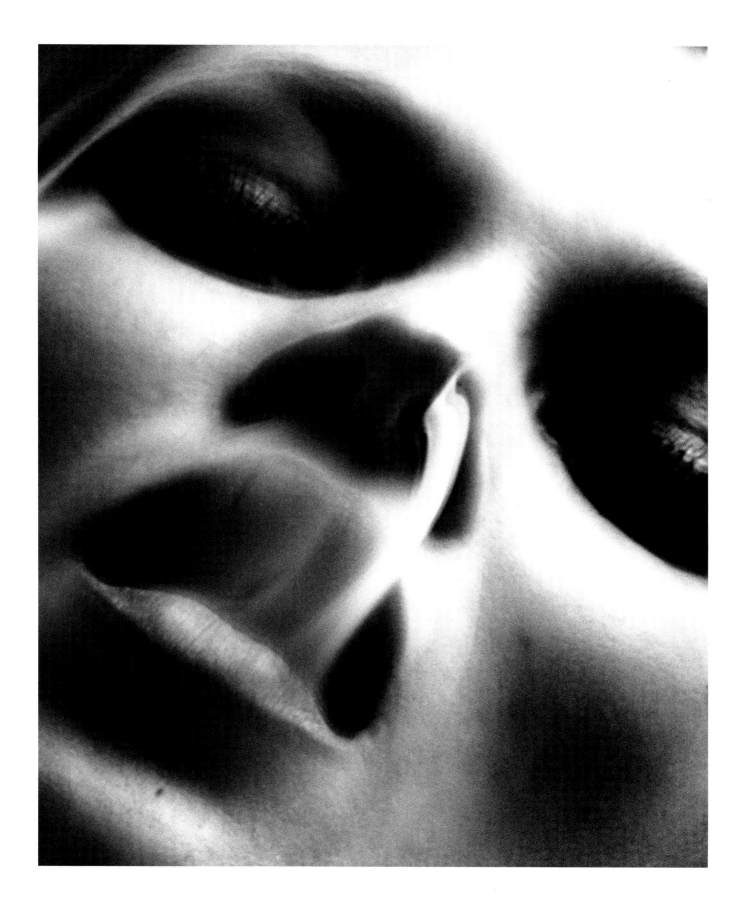

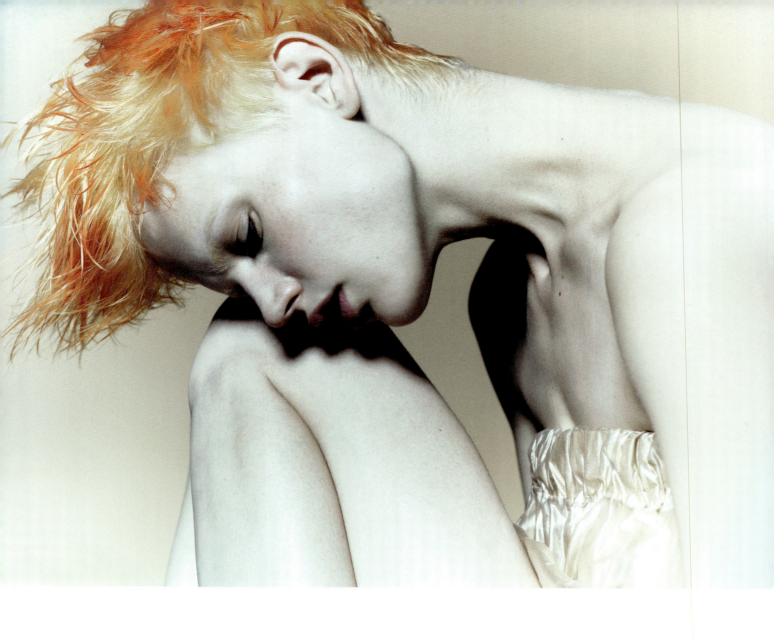

Above and opposite: Saskia de Brauw shot by Alas and Piggott in London in 2012 for *Love* magazine. The pair regularly collaborate with the title and have worked with its founder, Katie Grand, for some twenty years. In 1997, when she was fashion director at *Dazed & Confused*, she was the first editor to publish their work. "We are great believers in team, family, and connection. When you find a connection and create a family, why change it?" says Alas.

Above: Working Polaroids from *Big* magazine, 1999. The top image features Gisele Bündchen. **Opposite:** Missy Rayder shot in 2005 for *Pop* magazine in Ibiza, where Alas and Piggott lived for many years. Alas and Piggott are open to change on their shoots. They comment that accidents and unplanned moments often give way to the best images and cite this image, taken on Ibiza, as an example. "Suddenly I just told her, 'Take your clothes off and just *run*. You're going to look great, I promise,'" recalls Alas.

Opposite, top to bottom: Working Polaroid from
Dazed & Confused, circa 2000; working Polaroid from *Numéro*, circa
2000; working Polaroid from the Louis Vuitton S/S 2002 campaign.
Above: Working Polaroid from *Dazed & Confused*, circa 2000.

Above: Suvi Koponen shot in London in 2012 for *Vogue Paris*.
Opposite: Saskia de Brauw shot in London in 2012 for *Love* magazine. "We do like the same type of woman. She's assertive, she's strong, she's sexually charged. She's not just a beauty. There's a personality behind that beauty, too," says Piggott.

Page 236, top to bottom: Working Polaroid from 1999 for *Visionaire's Millennium*
issue "The Bible"; working Polaroid from a shoot for Levi's jeans, circa 1999;
working Polaroid from a 1999 *Big* magazine shoot featuring Gisele Bündchen.
Page 237, top to bottom: Working Polaroid for Levi's jeans, circa 1999; working Polaroid
from 1998 for the *Visionaire* issue "Fantasy"; working Polaroid for Levi's jeans, circa 1999.

Above: Working Polaroids from *The Face*, 2000, and *Dazed & Confused*, circa 1999.
Opposite: More Polaroids, circa 2000. **Following pages:** Guinevere van Seenus and Angus Whitehead shot in London in 2011 for a *Love* magazine story titled "What Lies Beneath." Piggott says, "Fashion is ever evolving and changing and, as artists, you have to do the same to survive. It's like a playground. One day I'm playing with glamour, the next day with grunge. It keeps me entertained."

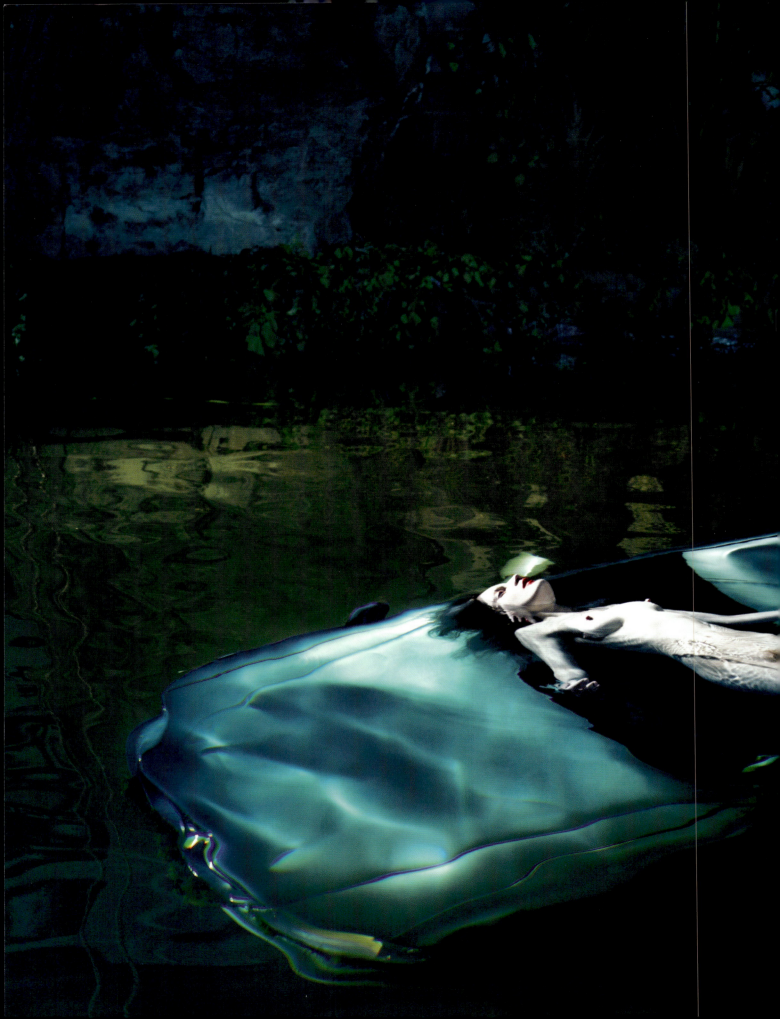

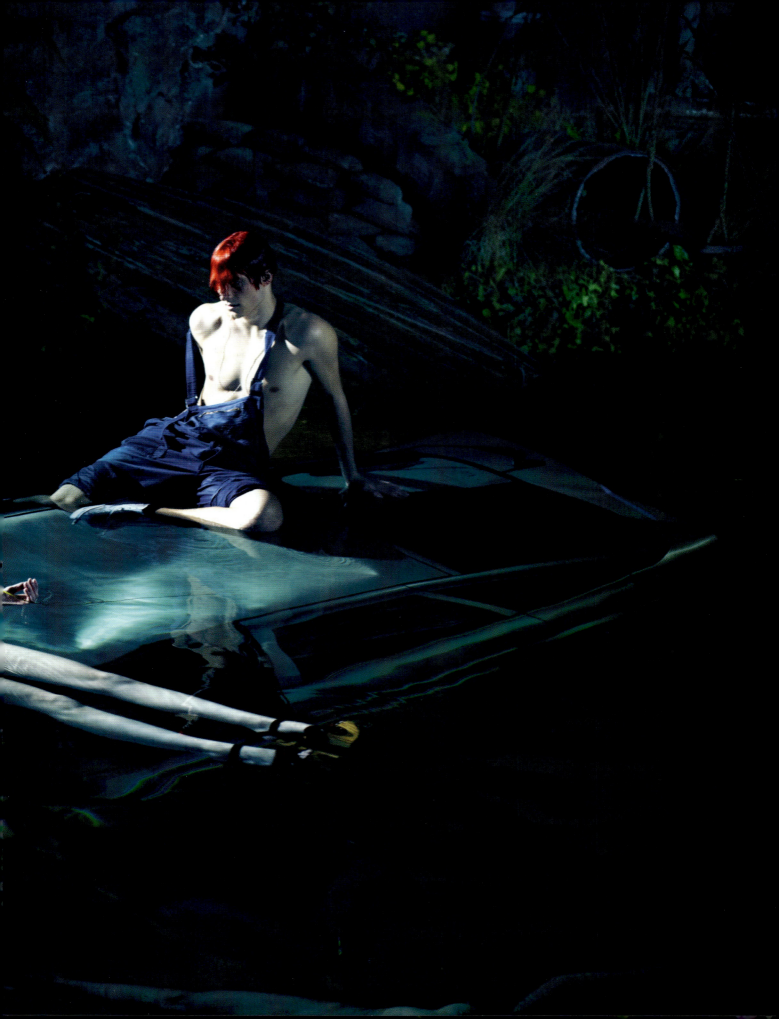

American designer **Thom Browne** began his business in 2001 with five suits and a small by-appointment-only shop. Since launching his ready-to-wear collection in 2003, he has grown to be both one of fashion's most respected businessmen and one of its most experimental showmen. His theatrical and highly choreographed runway events blur the line between performance pieces and catwalk presentations. His collaboration with British milliner **Stephen Jones** plays a central role in these moments of spectacle. The duo's working relationship began in late 2013, when they met to discuss collaborating on Browne's Fall/Winter 2014 show. That show featured elaborate, oversized hats by Jones that represented a range of animals, from elephants to rabbits. Since then, Jones has worked on Browne's men's and women's collections, crafting everything from straw boaters with gaps for models' hair to protrude in high vertical plaits to intricate mourning veils. Jones is no stranger to collaboration with designers. He has worked for many years as the milliner for Dior, initially with John Galliano, and later with Raf Simons and Maria Grazia Chiuri. He also works regularly with Comme des Garçons.

Thom Browne and **Stephen Jones**

Browne has a very specific eye when it comes to dress. When Jones posed with
him for this portrait, taken by Max Vadukul for the September 2015 issue of *Town & Country*
and featuring a range of models, alongside Browne's design director, Daniel Roseberry,
in Thom Browne attire, he broke with tradition by being the first of Browne's employees
to wear brightly coloured socks with one of his suits. "I tortured him," laughs Browne. Says
Jones, "He joked, 'One thing's got to go: either you or the socks.' So when I'm meeting
with Thom I always do have a wardrobe crisis about socks."

You met through Thom's partner, Andrew Bolton, curator of the Metropolitan Museum of Art's Costume Institute. Thom, why did you ask him to introduce you to Stephen?

Thom Browne: Usually, I try to stay outside of what's going on in fashion, because sometimes it can contribute to my feeling insecure. But there are icons in the world of fashion—people who are the best at certain things. If you want to do something, you might as well do it with those people. In the world of hats, that person is Stephen. I was very lucky Andrew knew him, because if I'd just picked up the phone without any introduction, maybe we wouldn't have started this.

Stephen Jones: But we did!

Browne: I remember that nervous first meeting. I remember how open Stephen was.

Jones: When we first met, it was about the big questions: Do we understand each other's design language? Are we going to be able to communicate? We don't live in the same continent, so if we couldn't communicate, it wouldn't work. There was a little bit of chat, but really it was straight to it.

Browne: It immediately became apparent that we would work well together, in part because I have very sophomoric ideas. For the most part I don't come from a very intellectual point of view. I don't like to reference things. I don't like to know what's happened in the past. I just go off of instinct. And it's a perfect collaboration, I think, because you, Stephen, know so much about everything, a bit like Andrew. I always reference the elephant hat we did for Fall/Winter 2014. Andrew has the elephant on his wall in his office. I have the bear and the reindeer in my home, because they're such amazing objects. We both do things that are not just for the world of fashion, but for the world. It transcends fashion.

Is there an element of wanting to make things readable, or even delightful, to someone who's not from a fashion audience?

Jones: That's also the point of hats. They have to communicate to people; they have to be eye candy. I don't know everything about everything at all, believe me! But I do remember on the second day of our first meeting he said, "How is it you know so much about so many different things?" I said, "I don't." And he said, "We're Americans. We know about Freddy Krueger!"

Browne: My references are Bugs Bunny and the Flintstones, and Stephen's are Proust and Sartre.

Jones: I love Bugs Bunny, too.

Would you say you're similar, even though you have different references?

Browne: I like to approach design from a conceptual point of view and so does Stephen. Of course, you realise that in the world of fashion you have to ground it in reality so you can actually survive as a business. We both understand that balance.

Stephen, I would say you're a very collaborative person, based on your work with John Galliano and Rei Kawakubo. Thom, would you say you're also collaborative?

Browne: I only want to collaborate with somebody that's worth collaborating with, so it's definitely not something I do a lot. With Stephen, there is an unspoken understanding of each other. It's almost like a relationship—it works because we get along very well, we respect each other. Stephen knows what I do and I know what Stephen does.

Jones: I think on a visual level, what I do goes with what Thom does. There's a very nice balance when it comes to tailoring and hats. It's that sense of discipline, and authenticity in how it's made, which goes with the flippancy of what's in a hat. A hat tends to go better with a tailored shoulder, or a pair of trousers, even on a girl, because it needs that visual balance.

Thom, did hats always interest you?

Browne: Not at all. The collection with the animals is really where it all began. Initially I'd thought of doing masks, but then it evolved. All of a sudden there was a zoo in the studio! That season was specific and particular, but then the experience was so amazing that every season now is a chance to work together. It initiated a whole new world that I never even thought I would be interested in. And that speaks to the importance of the collaboration.

How do the discussions start? Does Thom's concept for the show always come first?

Jones: Whether it's hats or make-up or set, it's all an extension of the same thing. Interestingly, most designers don't come and see me, whereas Thom always comes to London to discuss the show. All the people who are working with me see that he comes, and see that he's that interested, and see that he's that concerned, so every little stitch they're putting in, they're thinking, that guy took the trouble to come to us. I know it's really important to Thom that he runs a happy ship. And that feeling gets put into the hat, too.

Browne: I design from head to toe, so I like to be involved from head to toe.

Jones: Each hat is designed specifically for each outfit. It's not just one great shape that's going to go with look one, five, twelve, and twenty-five. It's couture.

Browne: This is why it drives me crazy in the showroom when they're selling. I think, why can't you tell the store that this jacket and this hat and this skirt don't mean as much if they're not all together! It's so important for people to see the full thing, the full idea. When they're cheated of that one piece of the puzzle, it's doing it a disservice.

Jones: It relates to how people actually dress. When I see people in my shop, they come in with an outfit, and then you're making a hat to balance it. That's the same as what Thom and I are doing together. Working with Thom takes a lot of my time and mental power. It's sort of a full-time job. Because it's not just about making these things. It's about how often it's there in your head. And Thom is there in my head every day.

Many of the hats you've done are a bit tongue-in-cheek. Are

244

you consciously trying to make things that are playful, maybe a bit naughty?

Jones: I think fashion, particularly millinery, is there to cheer you up and make you feel good. Hats can put you and other people in a good mood. They're great if they're optimistic.

Browne: Humour has always been a part of what I do. If everything is serious it becomes really boring. You have to throw something light hearted in there that makes it not so perfect, because there's nothing worse than seeing fashion that's taking itself too seriously.

Jones: And humour communicates much better than seriousness. You get through to people if you make them smile much more than if you make them furrow their brows.

Browne: I don't want ever to put something in front of somebody that is just jerry-rigged together for shock value. We never do anything just for effect. There has to be something really conceptual and beautiful behind it. For example, at one point I made a three-legged trouser. It took me so long to figure out how to make it, and it was as beautifully made as a two-legged trouser. It was very seriously thought out and very seriously made. So it's funny, but serious in its own way, too.

Jones: I could do serious hats, but it would feel phony—not true to myself. I see that seriousness in fashion sometimes as an easy way of making something appear authoritative, when actually it is just a beige skirt.

You mentioned communication before. Tell me more about how you discuss and shape the work—the back and forth.

Jones: Thom is very decisive. He doesn't waste words. He will offer a very clear, simple idea. I'll do research from those initial words. Probably ninety per cent of it will be wrong, but maybe there'll be one image or one piece of fabric or one idea that is right, which can then be developed. And then we have a big meeting when Thom comes straight in off the plane with a big pile of drawings and notes, and I sit and sketch. "That can go with that, and that can go with that, and that can go with that!" Or, "I don't like that and that, but I really like that." Often, there's a slight eureka moment when we're talking. Thom will say, "How about…?" and I'll say, "What do you mean, like this?" and I'll draw what he's talking about.

Browne: We're very honest with each other, too, which is important to a good relationship. A lot of ideas come from the conversation, and we leave ourselves open to being able to evolve along the way, as opposed to being so stuck with one idea.

Jones: I try to come to it with a really open mind— to come to it mentally with a blank sheet of paper. I wouldn't suggest things I've done before. I think that would be insulting, and it's not really interesting. I want to do something new! That's the fun thing. I would never have made any of our pieces by myself anyway. Full stop.

Thom, you once wanted to be an actor. Do you two share that interest in theatre and performance?

Browne: I love the entertainment element of what I do. I like to put the ideas in front of people within the context of some type of story—something fantastical and out of the ordinary. I love my shows probably more than anyone else does.

Jones: It's all a story. A plain white cotton handkerchief is a story. And hats are really about telling a story. It's all about the symbolism that either you understand or you don't understand. That's the trade we're in—telling a story with clothes.

It does seem that you see fashion, and the power of fashion, very similarly.

Browne: And that's why it works so well. Because we know why we're doing it. Tennis balls on top of a girl's head…

Jones: …a shuttlecock.

You just said, "We know why we're doing it," and before you said, "I love my shows probably more than anyone else does." I get the sense that you don't mind if people get it or like it, as long as you two know what the show or the hat is about.

Browne: If we like it, that's all we care about.

Jones: I do it for me, but I do it for him, too.

Do you think people understand your collaborations?

Browne: Probably not. But that makes it even better. We're supposed to be doing things that make people think more. It makes it more important when some people get it and some people don't get it, as opposed to people kinda getting it. We live in a world nowadays where there is so much that is brought down to everybody's level, whereas we always try to bring people up. I remember when I was in school, I had a teacher that said, "You should dress for mass like you're going to see the Queen." And it's an amazing idea! You should elevate everything you do to a level that is similar to Brooke Astor—always dressed up! We try to elevate people to whatever level we're at! Though maybe we're at some sub, lower level and we're actually bringing them down to our level!

Jones: Your clothes are very much about dressing up. It's always about turning the volume up, but in a very discreet way.

The rules of dress seem to interest both of you.

Browne: Yes. But those rules become so boring when you get bogged down by them.

Jones: The world out there is completely unaware of many of these rules. What hat is appropriate to go with an afternoon dress in New York, in May, is a world apart from most people's awareness. But that's fascinating to me. There's a photograph of Thom's father that I love. It shows him getting off of a plane and being appropriately dressed for travel. That's one of those things that we put in the cocktail of all of the different design elements that we approach together— appropriateness.

Browne: It's our responsibility to know those rules well. Because when you do, you can play with them, and interpret them differently, and show people

things in a way that makes those rules not so boring anymore. There's a time and a place for showing things differently, but then there are times when you really need to embrace the beauty of rules and tradition.

Jones: Use it as an inspiration, but then move on and do something new.

So, is the goal to challenge yourselves and challenge each other, or is it to challenge other people, or is it both?

Browne: Both.

Jones: Both. Is it a pleasurable experience as well? That's really important, because if it's not going to be a good experience…

Browne: Why do it? It'd be such a drag. But it's so much fun. It is so much fun.

Jones: It is. I always approach our meetings with excitement and a little bit of trepidation, too. That's the thing about fashion—it keeps you on your toes, because you do it for six months and then you've got to think of a whole new thing. But it's really amazing how that combination of a suit and a hat can be taken to so many different places and so many different looks. We've only scratched the surface.

Browne: There is definitely something we could do every season. That's what the challenge of design is—every season you have to put those ideas in front of people. I know that we will always be able to do something worthwhile.

Jones: And it might not always be the same, but for the time being, it's great. You take each day as it comes, in a funny way.

It's like fashion isn't it? Meaning it's always changing.

Browne: I want more to evolve, as opposed to change. From the beginning of your career to the end, you should see a beautiful evolution of how it's all built upon one original idea, and that's why it's so important to start from a strong original idea.

Jones: Anna Piaggi once said to me, about my work and my hats, "You're giving it an accent. You always give things a particular flavour!" That's why my exhibition at MoMu in Antwerp was called *Stephen Jones & the Accent of Fashion*. Thom constructs this work, and I give it an acute accent. Thom, you have super-strong handwriting. It's so identifiable. It's so you, and cannot be copied by anybody else. And I just give it a little accent.

Browne: That's nice. Thank you.

——

This interview took place in Paris at La Réserve hotel on October 5, 2015.

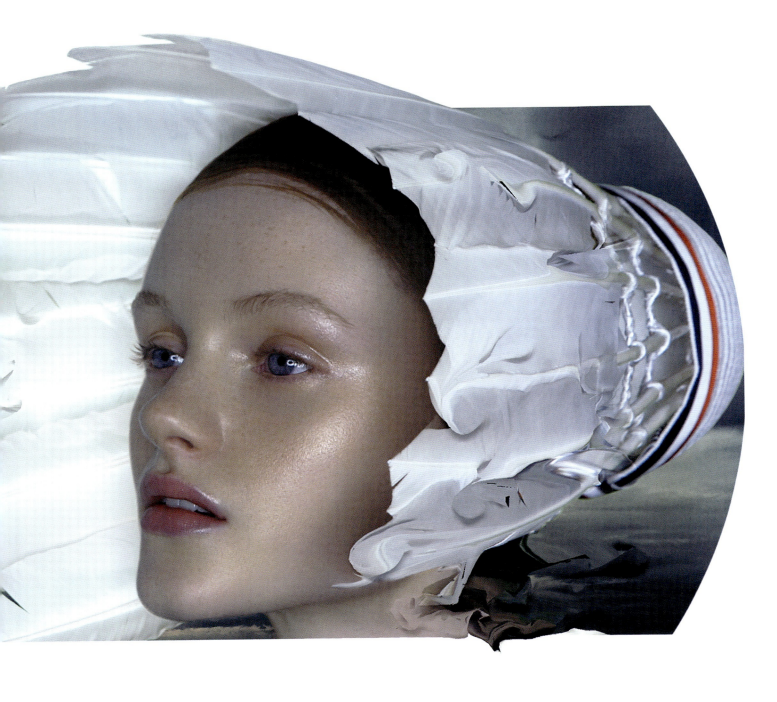

The headwear created by Jones for Browne is theatrical, amusing, and unexpected. Over the years of their collaboration, they have created headpieces in the shapes of cats, dogs, and birds (S/S 2017), as well as hats that reinterpret and echo the models' outfits, from bucket hats decorated with panels to suggest minisuit jackets to oversized straw, crin, and metal pieces designed to look like dresses, both for S/S 2015. **Above:** This shuttlecock hat, complete with Browne's signature red, white, and blue branding, also comes from the S/S 2015 womenswear show, which played on typical summer pursuits. Weeks after the show, the hat was shot by Nick Knight, a long-time friend of Jones, on model Emma Laird for a bonnet-themed story for *V* magazine's winter 2014–15 issue.

3cm

Rabbit

③

9cm

= 30cm

8cm

27cm.

.23cm
wide.

6cm

Browne and Jones began their collaboration with Browne's F/W 2014 menswear show, themed *Animals and Hunters*. Using the same grey wool selected for the garments, Jones crafted headwear in the shape of a range of creatures, including elephants, bears, rabbits, and deer. Some featured wire frames, used to create large masks, while others played on traditional hats—a top hat with fox ears, a baseball cap with antlers. **Opposite, right,** and **following page:** Jones's original sketches for the designs. **Opposite, bottom:** The second look from the show, captured backstage, features a rabbit hat worn with a short suit. **Below:** Jones adjusts another piece for the show, this one shaped like an elephant. **Following page, bottom:** Models line up backstage.

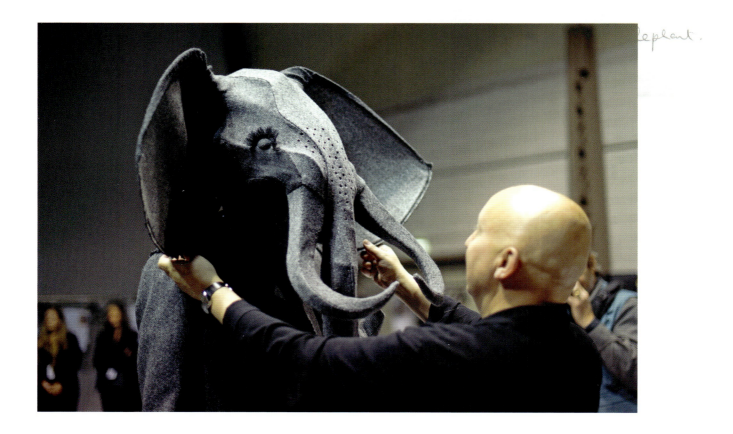

9326

9327

9328

FRAYED EDGE ON
PEAK

BACK PANEL
9340

FRONT PANEL

9326

9328

inside flap
9340

UPPER AND
UNDER
9327

ANTLERS

FRAYED
EDGE

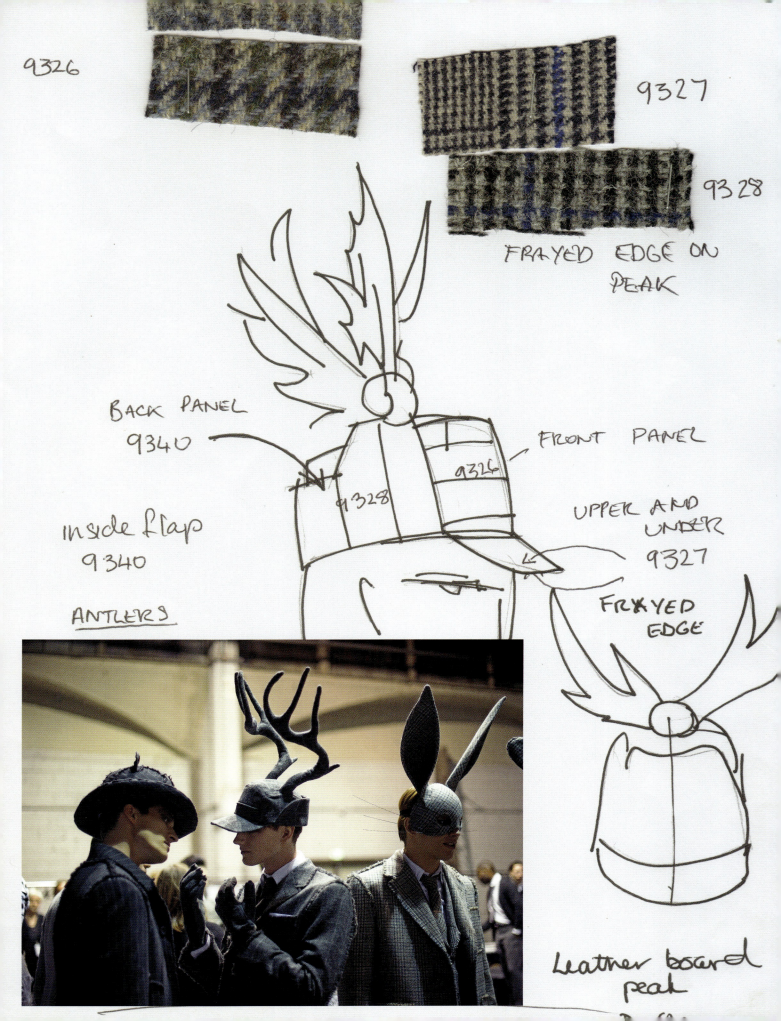

Leather board
peak

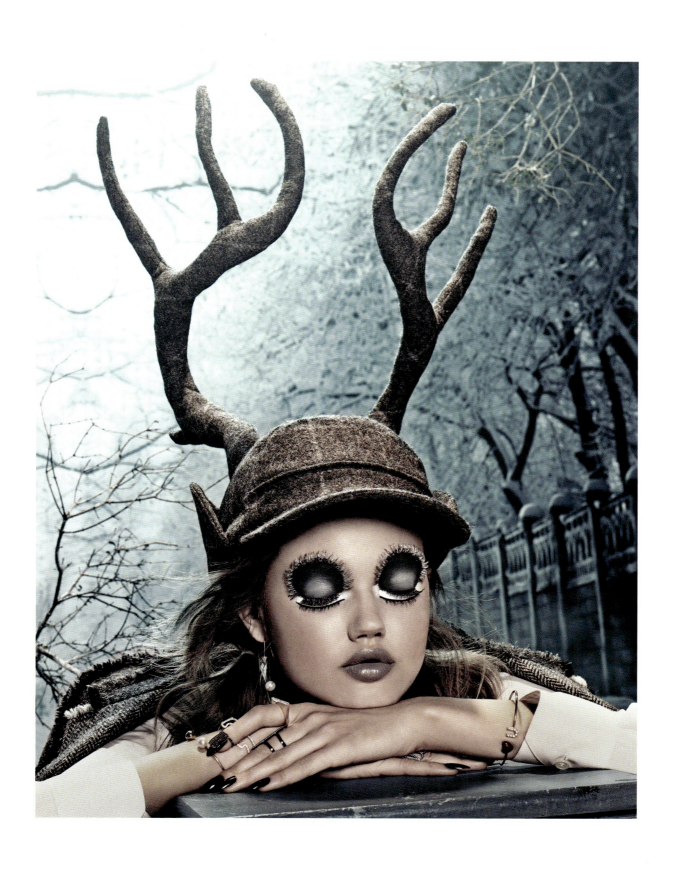

Above: Model Lindsey Wixson shot by Giampaolo Sgura in a hat from Jones and Browne's debut collaboration for F/W 2014 for the September 2014 issue of Japanese *Vogue*.

Jones thinks of his hats as adding an "accent" to Browne's collections, a term coined by his late friend and collaborator Anna Piaggi. His pieces complement the complex, theatrical themes dreamed up by Browne. **Below:** Browne's Japan-themed menswear show, S/S 2016, saw some suit-clad models walk around a teahouse while others, resembling scarecrows in kimonos, stood perfectly still like props. **Right:** For the S/S 2016 womenswear show, Jones created this playful twist on the traditional boater, rendered topless to allow models' plaits, styled by Jimmy Paul, to stand tall. **Opposite, top and bottom:** Browne's partner, Andrew Bolton, is curator of the Costume Institute at the Metropolitan Museum of Art in New York, where the exhibition *Death Becomes Her: A Century of Mourning Attire* opened in October 2014. The title and theme captivated Browne, who refused to see the exhibition while working on his F/W 2015 mourning-themed menswear and womenswear shows to avoid preconceptions or limitations on his imagination. Jones did large amounts of research for the shows: "How mourning appears in different cultures, the symbolism of it, and the beauty—always those extraordinary images of mourning. For example, there's a very famous one of the Queen, the Queen Mother, and Queen Mary, when they're wearing long crepe veils, which we both thought was a very beautiful image."

Browne's name is synonymous with tailoring and therefore formal dressing. Rules, regulations, and traditions fascinate him. **Opposite and below:** The designer curated the S/S 2016 issue of *A Magazine Curated By*, a title that works with a different designer on each new release. Jones contributed these visuals, made in collaboration with embroidery masters Lesage, which feature archival photographs of Black Ascot. The event occurred in 1910 because King Edward VII, an avid race goer, had died just weeks before. All attendees wore full mourning dress. Jones showed the images to Browne ahead of his F/W 2015 mourning-themed shows. "Since the very start of my life in millinery, these amazing photographs have been a constant source of inspiration. The drama, the silhouettes, the hats!" wrote Jones in the magazine. **Opposite:** Countess Wedell and the Earl of Portarlington. **Below:** Baroness Rosencrantz and Mrs. Frank Mackey. **Right:** In this photograph, Thom Browne's father, an attorney, descends the steps of an aeroplane. Every day he wore a suit, usually from Brooks Brothers, and he is a constant source of inspiration to Browne. Jones, who is intrigued by the notion of "being appropriately dressed for travel," counts the photo as one of his favourites. The image, he explains, is "one of those things that we put in the cocktail of all of the different design elements that we approach together—appropriateness."

Designers **Katie Hillier** and **Luella Bartley** look and sound similar. They are warm, animated, and artfully dishevelled. Both are Brits; though the former hails from Greater London, while the latter is from Stratford-upon-Avon. They launched their joint label, Hillier Bartley, some fifteen years after they first started collaborating. Back in 1999, Hillier was still a student, while Bartley had just launched her line Luella after years working as a journalist. Celebrated for championing a twisted vision of girliness that revered teenagehood and insouciant tomboy spirit, Luella debuted with a collection titled *Daddy, I Want a Pony*, followed by shows such as *Daddy, Who Were The Clash?*, *Dial F for Fluoro*, and *Cowboys and Indians at Glastonbury*. On the advice of the label's stylist, Katie Grand, Hillier was recruited to create accessories. Her work has been cited as a catalyst for the "it bag" phenomenon of the 2000s. By the time Luella closed in 2009, Hillier had won a reputation for having the best eye in the industry for accessories. She has consulted for labels such as Giles Deacon, Stella McCartney, and Victoria Beckham. In 2003, Hillier became a creative consultant in the accessories department of Marc by Marc Jacobs, Marc Jacobs's diffusion line. A decade later, in May 2013, she was appointed creative director of the label and invited Bartley to serve as women's ready-to-wear design director. Despite positive reviews, the label shut down in March 2015. Behind the scenes, the pair had spent years plotting Hillier Bartley, which was announced to the press just a few weeks after the Marc by Marc Jacobs closure and was described by Hillier at the time as "a reflection of us, of what we want to wear." Both have continued to lend their eyes to other labels and brands, with Bartley joining the Calvin Klein Jeans team as head of global design under the label's chief creative officer, Raf Simons, in February 2017.

Katie Hillier and **Luella Bartley**

Bartley and Hillier, shot by Bartley's partner, fashion photographer
David Sims, for the September 2015 issue of American *Vogue* for a piece
announcing the launch of the Hillier Bartley line.

I've read that you met through the stylist Katie Grand.
Luella Bartley: She instigated the meeting. It happened how most relationships started in the early 1990s—because of a very spontaneous emotional reaction.
Katie Hillier: She was teaching me at the University of Westminster. I made her a little crocodile key ring for her birthday.
Bartley: Based on that crocodile, Katie Grand thought we should meet, because we had a similar aesthetic. I'd started the Luella label. It was literally just me and a pattern cutter in my house. I needed someone to help me.
Hillier: Katie Grand was styling the show, and she thought I should meet you because you needed trinkets. So we met to talk about that, and in the end you offered me a job.
Bartley: We went to a pub on Flood Street, just off the King's Road, and had some drinks. Then we got quite excited, and then we went to the ribbon shop.
Hillier: To V V Rouleaux.
Bartley: And then we got more excited and I offered you a job—all on the same day. It's the same thing as with Katie Grand—I moved in with her a day after I first met her. It was the excitement of that period.
Hillier: It was very spontaneous and different.
Bartley: Also you didn't worry about setting up a business. You didn't consign yourself to work financially. And I think you can see that in the work from that time—so many collections are very chaotic and creative.

Would you say you're very similar?
Hillier: We're very different, but I think we're very compassionate…
Bartley: …for each other's faults. We definitely have complementary skills. And we share the same references, the same history. We're exactly the same age.
Hillier: Actually, we're not the same age, because you're a year older than I am, thanks very much! But we're both Taurus, and our birthdays are two days apart.
Bartley: I do think generational experiences are really important. It really was a friendship before a business partnership, partly because all relationships back then were based on an emotional reaction as opposed to a professional one.

Would you say you had similar upbringings?
Hillier: Mine was very suburban—parents still together and letting me do absolutely whatever I wanted to do as long as I was happy. Always supporting me.
Bartley: Mine was much more chaotic, slightly bohemian, slightly weird. But I would say we both had similar experiences in different ways, because we both went to raves…
Hillier: …we were both a bit rebellious.

You have had breaks from working together, such as in the years between Luella closing and working on Marc

by Marc Jacobs. Did you still collaborate?
Bartley: We've come together, we've been apart, we've crossed over, we've come together again. We've both had different enriching life experiences, and we've both drawn on each other's lives. If you can share each other's experiences, the work has more breadth, because there are two minds and two sets of ideas.
Hillier: Really, I've always worked with Luella, or at least I feel like I have done in some way. Even during the gaps, when the relationship was more of a friendship, we stayed in touch. Not every week, but whenever we spoke to each other it was kind of like it had only been the other day that we had spoken. After Luella closed, and she'd had a break for a while, I wanted her to come and look at the bags that I'd been working on, and I wanted to get my friend back into doing things for herself.
Bartley: It's quite hard getting back into the work-place, no matter what industry you're in. Katie was really there supporting me and working out how or what I could do or we could do. That's the ultimate kind of friendship: you've dropped off the radar and someone who's in it helps get you back.

You are the only pair of women in this book. I have found that there are not that many instances in fashion where two women publicly collaborate constantly.
Bartley: Female relationships, if you can make them work, are the most incredible friendships, but they're more complicated, partly because women are more complicated.
Hillier: But I don't think ours is complicated.
Bartley: I don't think ours is complicated at all, but I think we're quite laid back, and we're not competitive. I don't feel any competition.
Hillier: No, me neither.
Bartley: I feel great when you're happy and feel sad when you're sad. In fashion a duo is so strong, if you can get it right. Maybe your non-competitiveness rubs off. You're very, very supportive. You are quite a giver.
Hillier: And we're only children. Also, my background in fashion was always about helping other people out. I didn't start working in design until I started working with Luella. Prior to that, I worked with Katie Grand. I was basically her production assistant, so it was always about helping everyone else, making sure that the shoots were organised properly and everyone had the right things that they needed. And I learned a lot about collaborating from Katie, because those shoots were always collaborative. The photographer and the stylist were coming up with an idea and working together. That left an impression on me.
Bartley: My path was different. I was working as a writer, and it was a conscious decision to stop writing and to design, because all my friends were working with each other, and I was lonely.

Does being a natural collaborator make you more willing to work behind the scenes?
Hillier: I've never ever really had a burning desire to be in the spotlight, which is why the Marc by Marc

258

Jacobs job was intense for me. The spotlight was one of the only things that almost stopped me saying yes at the time. Also, I didn't want to do that job without Luella. I knew I couldn't do it without her, which is why I pressured her to do it with me! It was really good for us, but it was definitely an eye-opener to what it's like to do something on that scale versus what it's like to do this. With Hillier Bartley we like to do things in a way that keeps us quite under the radar. We've done a label in exactly the way we want to do a label.

Would you say the way you have built Hillier Bartley is a reaction to your experiences working for a big business?
Bartley: You need to have done it every way to make an informed decision about how you want to work. If you work at a smaller company, you're always thinking, I wish I had a massive conglomerate behind me, but you don't learn until you've done it all. Then you can truly understand how you want to work and what you're willing to sacrifice and what you're not willing to sacrifice. It's not that we want to shun big business or anything like that. It's just that we want to be very sure about everything we're doing. It's about control.

Has your design aesthetic changed as a result?
Bartley: Marc was brilliant. It was so exciting, and I was in awe of the idea of having a voice—especially for that youthful age group—and doing something that was positive and strong. I think we both really got worked up, and that was exciting. Luella was also very girly. It was more of a sort of theoretical idea of a perverse girliness.
Hillier: Before, it was about feisty tomboys, and at Hillier Bartley, it's between femininity and masculinity.
Bartley: It was really nice to exercise a bit of that, and then come back and have a growing-up period and start to think about who we were as people and women and what we wanted to feel like or look like.

Has your work always been informed by your sense of what it means to be a woman?
Bartley: There's a certain rebelliousness to it. It's not about a certain idea of femininity. I think that is very important—femininity can encompass so much. It's really sexy, but it's really covered up, and really masculine. You can take on a colourful character and be sort of rakish, louche—things that only existed for men before. It always felt so incredible to see young girls feeling really empowered by it. It sounds a bit hackneyed now, but it doesn't make it any less important.
Hillier: When we started this, we just wanted to do exactly what we want, and what we feel is right. There's this creative pathway that you can go down sometimes where you can choose to be a bit blinkered and not look at what's going on around you because you're supporting each other. Often you might have a really great idea and if you're on your own, you can talk yourself out of it, whereas if you're together you can get excited about it.
Bartley: You're definitely braver when there are two

of you, because you can share the shit if it doesn't work out! And you can give each other freedom. Katie does a lot of a consultancy, so when she's away I'll base myself full-time here. And that could change, I could do something else—you can have freedom as a pair.

Do you feel less exposed, as if you're not baring your soul in the same way you would if working on your own?
Bartley: That's it. These collections feel like baring my soul more than anything I've ever done, because Luella felt ironic. Marc felt like it was for someone else. But this is a very personal project. It's purely who I would like to be, which is quite a statement.
Hillier: It's easier sharing it. Not that it needs to be easy.
Bartley: Also, this is not about world domination. We're seeing repercussions from how commercial the industry has become. People are burning out. But then there are our contemporaries, like Phoebe [Philo], like Stella [McCartney], who have very clear boundaries about home life and work life and being able to be a woman in the industry and making that an advantage as opposed to a disadvantage The industry has become a better place for it. There are still dark, misogynist things going on, but I think the most inspiring thing for women to do is approach things in different ways. We're questioning everything. For example, we don't do a catwalk show. I don't know if I like the way shows are now: huge amounts of money, putting it on girls that wouldn't necessarily wear it. One day, we might decide that we're going to do a show, but at least we'll have questioned it and why we're doing it.
Hillier: That's one thing that I find really inspiring about working with Luella: she will question those things rather than going down the same path as everyone else. It's not just about the product that we're creating—it's about us building something together, so that in the next five years we'll have a voice like we did with Marc, but in a very different way. And we don't necessarily know exactly what it is right now. We don't just want it to be the same kind of fashion business that everybody else is going into.
Bartley: Because even the success doesn't look that great.
Hillier: No.
Bartley: You look up to where you think you want to be, and suddenly you're like, I don't know if I want to be there! So you have to create it how you want it to be, and it's good doing that as a pair. On your own, saying, "I'm not going to go down the trodden path," would feel slightly scary. You would feel very alone.

—
This interview took place on December 10, 2015, at the Hillier Bartley studios on Arnold Circus in East London.

This page, right: New York graffiti: This "Katie + Luella" sign appeared mysteriously on Lafayette Street between Bleecker and Bond Streets during the preparation for the first show that Hillier and Bartley staged for Marc by Marc Jacobs for F/W 2014. Hillier, who photographed the happy surprise, says, "It was on our walk to and from the office and our hotel! It was awesome!" **Below:** An early Polaroid of Bartley with a similarly cheerful tone, shot by John Akehurst. **Opposite:** It was a beaded key ring made by Hillier for Katie Grand that first connected the pair. Appropriately, the first items Hillier made for Bartley, who at the time was running her Luella label, were beaded belts with ribbon fringing. They appeared in the S/S 2001 show, an ode to the 1980s, which featured The Go-Go's on the soundtrack. Similar styles appeared a year later in the S/S 2002 show, which paid tribute to the American West, and was soundtracked by "Sweet Home Alabama" by Lynyrd Skynyrd and "Get Ur Freak On" by Missy Elliott.

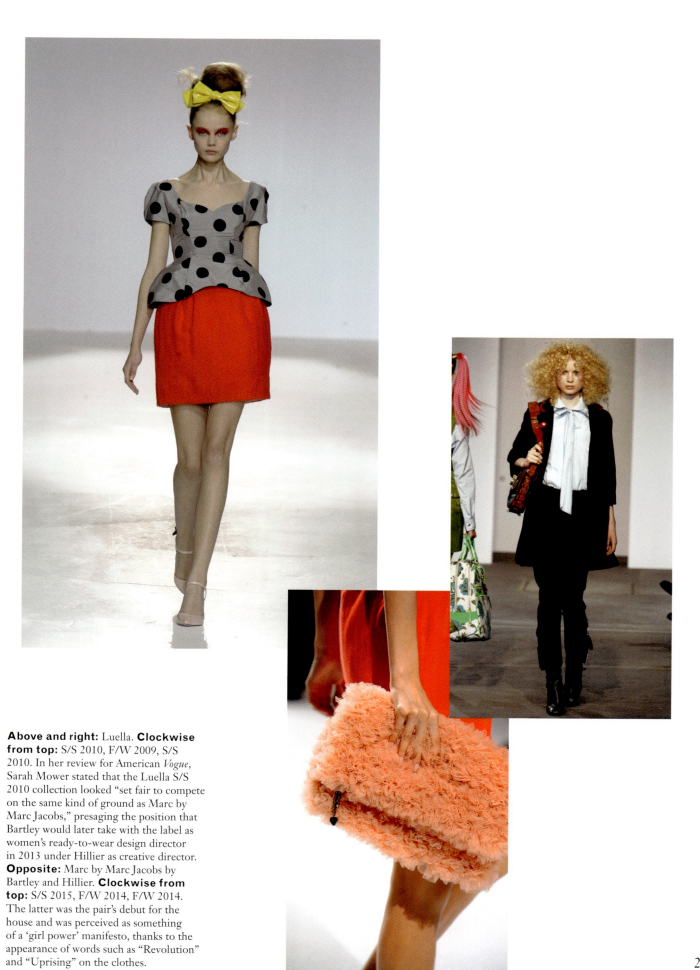

Above and right: Luella. **Clockwise from top:** S/S 2010, F/W 2009, S/S 2010. In her review for American *Vogue*, Sarah Mower stated that the Luella S/S 2010 collection looked "set fair to compete on the same kind of ground as Marc by Marc Jacobs," presaging the position that Bartley would later take with the label as women's ready-to-wear design director in 2013 under Hillier as creative director.
Opposite: Marc by Marc Jacobs by Bartley and Hillier. **Clockwise from top:** S/S 2015, F/W 2014, F/W 2014. The latter was the pair's debut for the house and was perceived as something of a 'girl power' manifesto, thanks to the appearance of words such as "Revolution" and "Uprising" on the clothes.

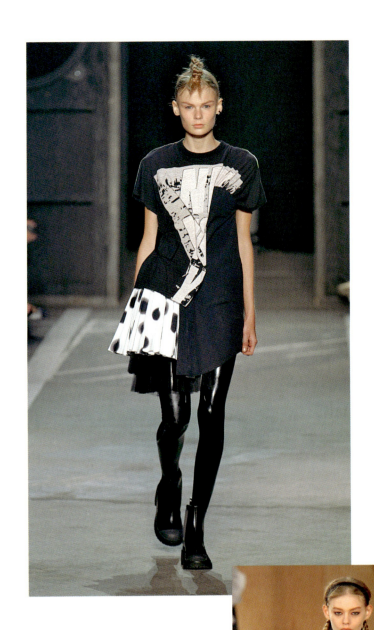

SOLIDARITY

"There was a lot going on in America: anti-women, anti-abortion. We made subjects out of what was happening and put this really cool feisty girl on the catwalk. Maybe some people were uncomfortable, but I loved it." **Above:** The invitation to Hillier and Bartley's F/W 2015 show for Marc by Marc Jacobs held at New York Fashion Week. **Right and opposite:** The Marc by Marc Jacobs F/W 2014 campaign, featuring Vivien Huba shot by David Sims. Hillier and Bartley used social media to cast the campaign, asking members of the public to post photos of themselves with the hashtag #CastMeMarc. Over 70,000 entries were narrowed down to thirty finalists and nine eventual campaign faces. They were shot by Sims and styled by Katie Grand, who first introduced Bartley and Hillier to each other back in the 1990s.

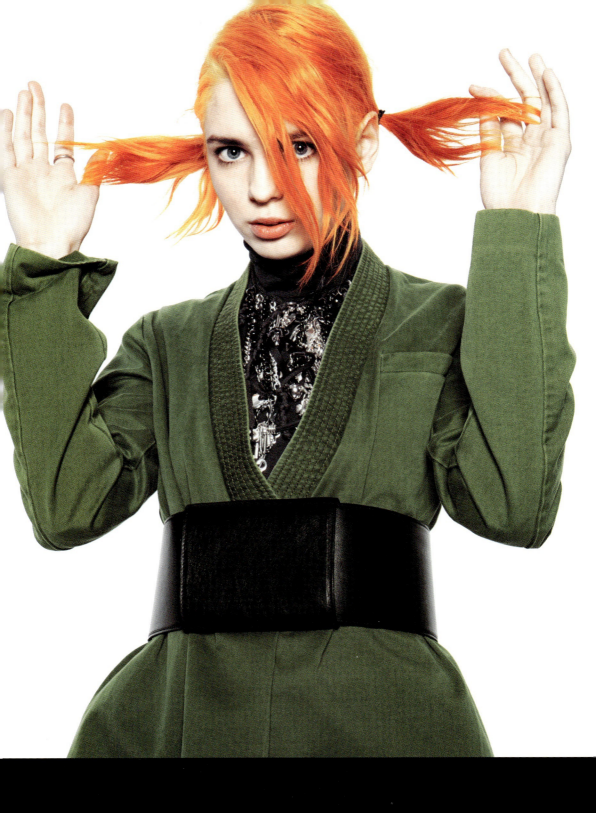

Hillier Bartley, launched in March 2015, is the culmination of the pair's years
of collaborating and is, in part, a reaction to previous positions they have held.
"We're just going to do exactly what we want to do," says Hillier. **Opposite:** Shot
by David Sims, who has worked with the pair consistently on imagery across their
various projects, the debut advert for Hillier Bartley featured Aida Becheanu.
Above: The Hillier Bartley S/S 2016 campaign, also shot by Sims and featuring
Becheanu again alongside Tom Fletcher. Becheanu models regularly for Hillier
Bartley and inspires the pair with her personal style.

hillier
bartley

Style Code :

Style Name:

Fabric:

Season:

Date Last Amended:

Sampling / Production:

Master / Copy:

Pattern cutter:

Sketch

On paper, **Iris Van Herpen** and **Philip Beesley** are worlds apart—she is a fashion designer based in Amsterdam in The Netherlands, he is an architect working out of Toronto in Canada. She is celebrated as one of fashion's true pioneers and forward-thinkers, combining handcraft techniques with pioneering technologies such as 3-D printing in her dressmaking. His work is of a totally different scale, often encompassing public buildings. Yet both share a fascination with the interplay between technology and aesthetics, and the potentials and promises of new materials to improve human experience. Their connection started long before they officially met, when Van Herpen, fascinated by Beesley's work, paid tribute to his ideas and design approach in her *Hybrid Holism* show, Fall/Winter 2012. On seeing the designs, Beesley made contact, starting a fluid collaboration that is defined more by constant conversation and sharing of research and discoveries, rather than by key outcomes or public-facing moments. That said, the duo have won acclaim in the fashion industry for their pioneering collaborative pieces, which were debuted as part of Van Herpen's *Voltage* collection, Spring/Summer 2013 at Paris Fashion Week. Dresses came with outer-layers formed of complex, flexible meshwork structures and translucent frond components, envisaged through extensive dialogue between the pair's studios. Their investigations into resilient hybrid fabrics have run throughout Van Herpen's subsequent collections, including *Wilderness Embodied*, Fall/Winter 2013, *Magnetic Motion*, Spring/Summer 2015, and *Hacking Infinity*, Fall/Winter 2015. Though almost permanently far apart, each is a constant presence in the other's studio and mind.

Iris Van Herpen and **Philip Beesley**

Although Van Herpen is based in the Netherlands and Beesley is in
Canada, the pair stay in constant communication, exchanging ideas and
new materials regularly. Here, they are pictured during one of their
face-to-face planning sessions in Beesley's studio.

How did you come across each other and who made the first attempt at connection?

Iris Van Herpen: I saw Philip's work online and it blew my mind. At that point, I didn't think about collaborating together, because obviously our work—our "real jobs"—is very different. But I dedicated a collection, *Hybrid Holism* [Fall/Winter 2012], to his work. I didn't do it to make contact with Philip. I was just completely fascinated by his work. I showed the collection in Paris, and Philip saw it online somewhere and then emailed me—that was the very start of it. Philip travels a lot, so soon after he came by my atelier, and then we could not stop.

Philip Beesley: I was absolutely struck by how after five minutes of curling up with teas in the big overstuffed chairs overlooking the harbour on the first day we met, I felt that I was your friend. It just started flowing in the loveliest way. And perhaps the springboard of the past work harmonised to give that sense of a mutual history.

Van Herpen: At first glance, the scale of your work is completely different to mine. So before I knew you, I just didn't see a way of merging our processes together. But when we met in Amsterdam, it was obvious that there was a link in the way we thought and how we see textures and materials. We come to completely different end results, but we come to them in a very similar way.

Beesley: I would agree. It was a surprise, and it still strikes me quite acutely. Because from one point of view, our roads are very, very different. And the formal structures and rituals and social appearances of the disciplines are very different. And yet there is this point of remarkably intimate interception. The harmonies and rich dissonances and fertile associations keep bubbling back. It's having a very striking effect on a full range of scales for me.

Van Herpen: Me too.

Iris, when you were working on the collection about Philip's work, did you not think to contact him?

Van Herpen: Not at that moment. Before I worked with Philip, I mostly did practical collaborations. For example, say an architect draws a 3-D model for me. That's a very practical collaboration. You know what to expect from each other and what you're going to do. But with Philip, I could not have imagined what we do today. Ours is not a thought-out collaboration in the traditional sense. There's no goal from the beginning. It's about mutual sharing and interest and fascination.

And Philip, how did you feel when you saw the collection that paid tribute to your work?

Beesley: I do remember a sense of astonished delight. It's a wonderful compliment. I also remember a bemused affection and a curiosity, because the words used in describing your work, Iris, were quite sensitively framed. I remember feeling, this could be a kindred spirit. And perhaps there is no greater pleasure than such a thought. It made me intensely curious and very hungry for a dialogue. At that point, it was still conditioned by the distance. The Atlantic Ocean makes a very distinct gulf.

Many pairs explain that part of the beauty of working with someone is that you see things you wouldn't otherwise see and that pushes your creativity forward. Would you say that's the case?

Van Herpen: Definitely. Philip opened up my eyes up to the way different materials can work together—to the way you can connect softer and more rigid materials and so on. Now, when I find out about a texture or a material, I send it over, and the other way round. And it just goes forward and backward very naturally. That's really different to how I was used to collaborating.

Philip, were your peers surprised you were working with a fashion person? Did you surprise yourself?

Beesley: I confess that I am quite an acutely shy person and I have a bit of a monastic bent. I feel very, very removed from social spheres. This relationship has encouraged me to take some striking risks. One of those is to be more social—to connect with the social sphere that is the bubbling gathering that happens immediately after runway situations. There's this remarkable festival of interconnection—a climax of social interchange. There are two other types of risks. One is technical. That is the chance to have precise conversations about the manipulation and tuning of a particular material and combinations of components when making textile structures that intersect with the most sensitive realms of the body. That led to new design thoughts—thoughts that materials can be manipulated for pursuing fragility and pursuing a very deliberately precarious charged state. The other realm of encouraging risk has been a kind of design method in which I have discovered that my body can be a map of my understanding and my judgement. I've learnt very directly from you, Iris—as we speak and explore a possible conjunction of, let's say, a way a fabric can work, I not only imagine it at scale, around my body, but I also am acting it out in the way my muscles and face and even just basic posture move. A little tilt in my shoulder, for example.

Would you say you are similar people?

Beesley: We are both quite curious people, and we also each have a thoroughly pragmatic side.

Van Herpen: How you come to a material or a textile is very hands-on. And I think that it's really by trying things out and having something in your hands that you find what it needs to get better and better and better. At some point, I start moulaging on the doll with the materials. I always need to play with it before we know if it's correct. That's not something the eye can do. It has to be tested. I wouldn't be able to design my work just by drawing, or just by thinking of something. The feeling is a big part of our collaboration. We revisit a lot of textures and materials or pick them up later on with a different technique. It's not about setting a goal in our heads for that material and that design. It's much more free and chaotic. And I am very happy to find that mutually chaotic friend in life.

When did you first decide to work on something together?

Van Herpen: The first collection we worked on together was *Voltage* [Spring/Summer 2013]. We made three dresses together. After our first meeting, we started sharing materials and structures, and later we communicated a lot by post and by email and by Skype. Our first collaboration was complete in about two months, which was very fast. My whole family worked on it at Christmas! It's always a continuous process, and the shows are a part of it, but not the end point. We try to finish something before a show, but if it doesn't work, we just go on with the development and work it out for another. It's a very open process.

Beesley: The question of goal setting is interesting: How does a conversation like this get organised? We're both surrounded by structures that pull us— the opening of the runway show or the exhibition or the installation. In fashion, you may have six months. That's very different from architecture, where three or four years is not a long time.

Van Herpen: It helps to have a time frame. Often it's about knowing when to push something back to the next show so you can keep on developing it and have a bit more time on it.

Beesley: One could argue that if things are sufficiently fertile, then waiting is important. A farmer would leave a field fallow, or perhaps even chop down some weeds.

Van Herpen: You are very good at getting things going. I am a little bit quicker to say "I'm not sure if this is realistic." It's a good balance.

There must be something you are trying to achieve. Is it related to recognition and how other people view the work?

Van Herpen: I try to achieve a personal goal. I try to challenge myself to go into techniques and materials that I have no idea how to handle. That's why it's so great to be challenged by Philip and his way of thinking. With some techniques and materials we've used, I'm quite sure I wouldn't have solved the questions or difficulties myself.

Beesley: The sheer craft and structure of the material or the scale of an intensely embroidered organisation of cellular textiles means that a tremendous amount of thoughtful planning and management forms a kind of cradle around us. It is spoken and articulated in part by itself and in part by our colleagues. I rather enjoy being carried by that. Then the work condenses and takes form and acquires coherence and clarity—a singing quality. That's a rather different working model than something where you start from a concept and then you build it out. It's a very punctuated, hiccuping, almost convulsive series of multiple cycles.

Do you hope your work will push others into working collaboratively?

Van Herpen: Inspiring others is not a goal, but it's beautiful when it happens. Collaboration can help fashion to move forward because sometimes it's so isolated. Sometimes it seems that it's not going anywhere. I think it's very beautiful when it's more interactive with the world around us.

Beesley: The ability to orchestrate quite complex structures and forms and materials in ways that are very rich and very fertile is tremendously enabling. Orchestrating new technologies in ways that increasingly resemble living systems is something that needs to be shared. And it's tremendously encouraging to see some of the innovations that are being developed. There is even a sense of responsibility to share that material.

Would you say your overall working practices have been influenced by the relationship?

Beesley: I would. I love the sense of something being built on intimate exchanges of craft and technology and physical actions, but also the memories of our childhoods and the hope of what comes in the future. It's the feeling of being in a deep forest. The whole field of human experiences can weave together in striking ways.

Van Herpen: In good collaborations, your character is being improved in the right way. For certain things, I have to be alone. Loneliness is a part of the beauty of work, and I need it. But for other things, it's really great to have another opinion, or a different view to push it further. If the characters fit well together, you get other things out of the work than you would if you did it alone.

Beesley: When you describe it that way, Iris, I think of how we have tremendous harmonisations but also periods of productive dissonance and disarticulation. Perhaps that's created by the distance that naturally frames our work—the periods of separation. The affinity that you were just speaking of reminded me of when we visited the Everglades and saw that extraordinary ancient crocodile. I started thinking personally about spiny extensions out of the body and thermally expanded diagrid crystal spikes of acrylic that would be like a halo radiating outward. You took the sample, when we were together, and you turned it inside out. And I remember the shock and surprise of those points all of a sudden riding on the skin and this whole pore field on the outside instead. It was a completely different way of seeing the material—a perfect example of turning things upside-down.

Have there been other occasions when your working relationship has been particularly fruitful?

Van Herpen: All of them.

Beesley: We often go through an exquisite tuning of a material where we do trial after trial and it just isn't working yet, but we're very hopeful. For example, we may try to figure out how to coat polyurethane to achieve iridescence without it being kitsch. Sometimes it's just about conversation; sometimes it's about raising the temperature five degrees.

Van Herpen: Most of the materials and structures that we work on together are a combination of handwork and some technology, like laser cutting or moulding. And I think a lot of what we are doing is about finding the balance between the two. What works

well for what, and how can we improve the way we make it? How can we make it faster? How can we make it more durable, or maybe softer?

Beesley: Often simply hand-adjusting or stretching something can be completely effective. In fact, the combination of a very generous range of primitive and raw gestures together with extremely surgical, fine operations turns out to be a very happy way to work.

Is there ever a tension over ownership?

Beesley: Interweaving is welcome. Perhaps there are resonances with certain economies like the open-source movement or Creative Commons licencing. Being many people and interconnecting is just a fundamental way of living. It seems far more interesting, in any event, than focusing on the cut and the boundary. Of course, it takes sensitivity and respect, but it can allow for a really delicious sense of exploration.

Van Herpen: Exactly. So, when are you moving to Amsterdam?

Beesley: I thought we had an agreement about Toronto.

—

This interview took place over a three-way Skype call between London, Amsterdam, and Toronto on April 5, 2016.

Above: After discovering Beesley's work but before making contact with him, Van Herpen paid tribute to his approach in her *Hybrid Holism* show, F/W 2012, which included this look. Van Herpen specifically referenced Beesley's *Hylozoic Ground* project, which considers how a future city could operate as a living being. This chimes with Van Herpen's belief that, "design, art, architecture and even fashion will be radically changed: they will not constantly be newly made and after discarded, but they will become human creations that are partly alive and therefore able to change and able to improve constantly," as laid out in her show notes for that season. **Opposite:** Van Herpen regularly collaborates with technical specialists and innovators from other disciplines. This 3-D printed dress from that collection was made in collaboration with architect Julia Koerner and Materialise using mammoth stereolithography, a new technique that builds the piece slice by slice from bottom to top in a vessel of polymer that hardens when struck by a laser beam. **Page 276:** The working process: material samples created by Beesley and Van Herpen are subject to experiment in the studio. **Page 277:** Van Herpen's *Magnetic Motion* collection, S/S 2015, shown at Paris Fashion Week, explored the interplay of magnetic forces. Beesley contributed ten dresses to the collection, which saw polymer, crystal, and leather components combined into interlinking 3-D fabric structures. This dress, look nine from the collection, was photographed by Mathieu César.

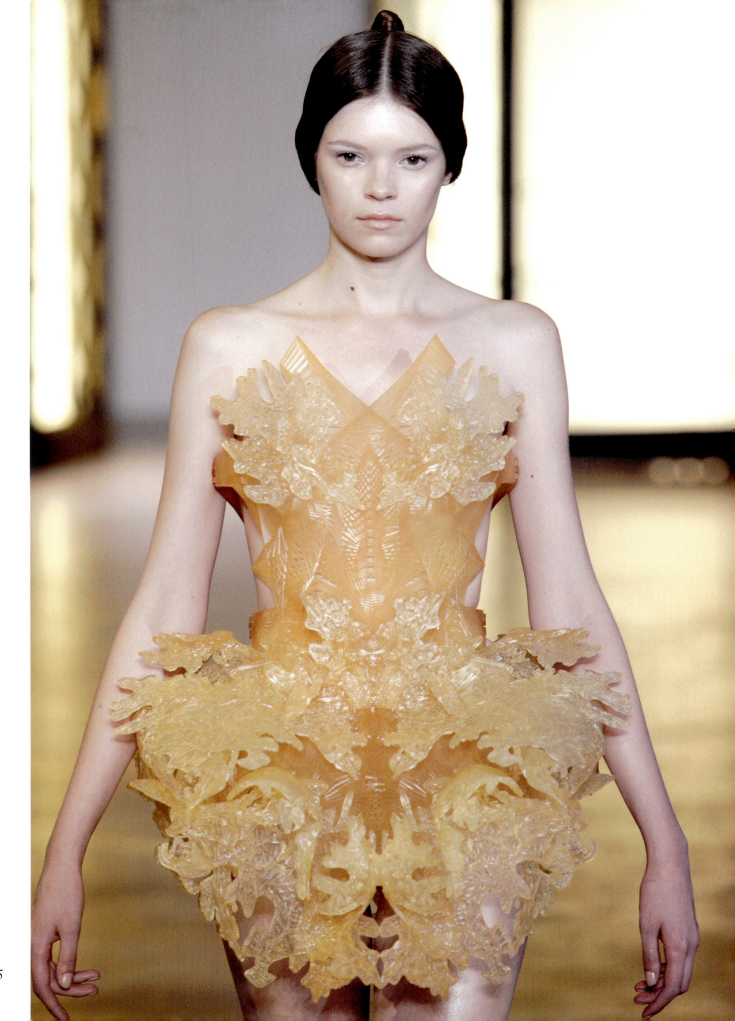

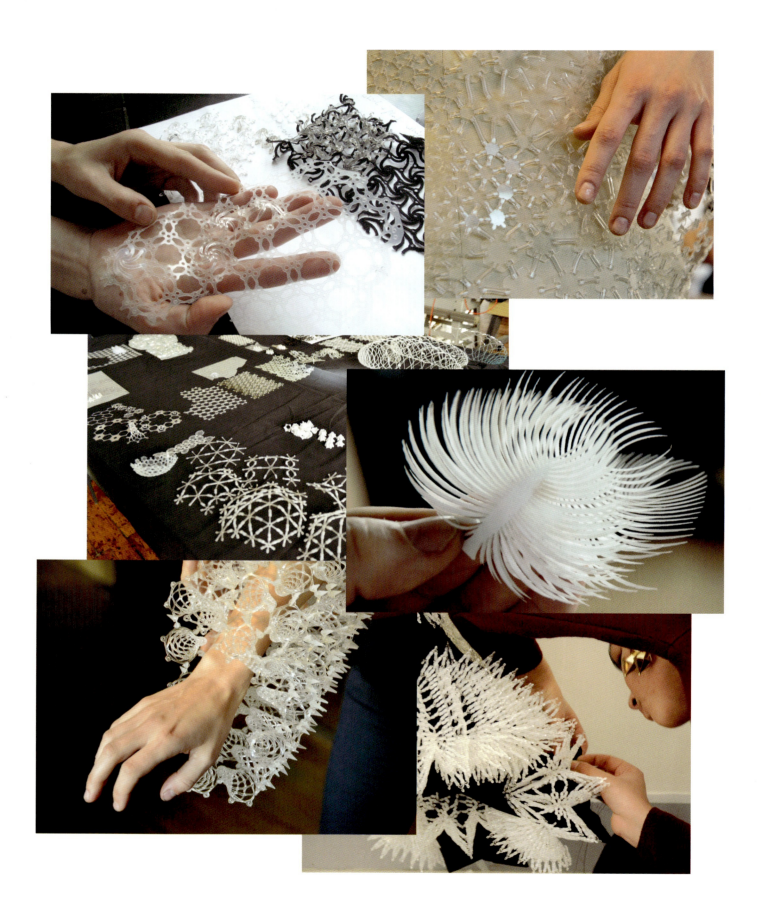

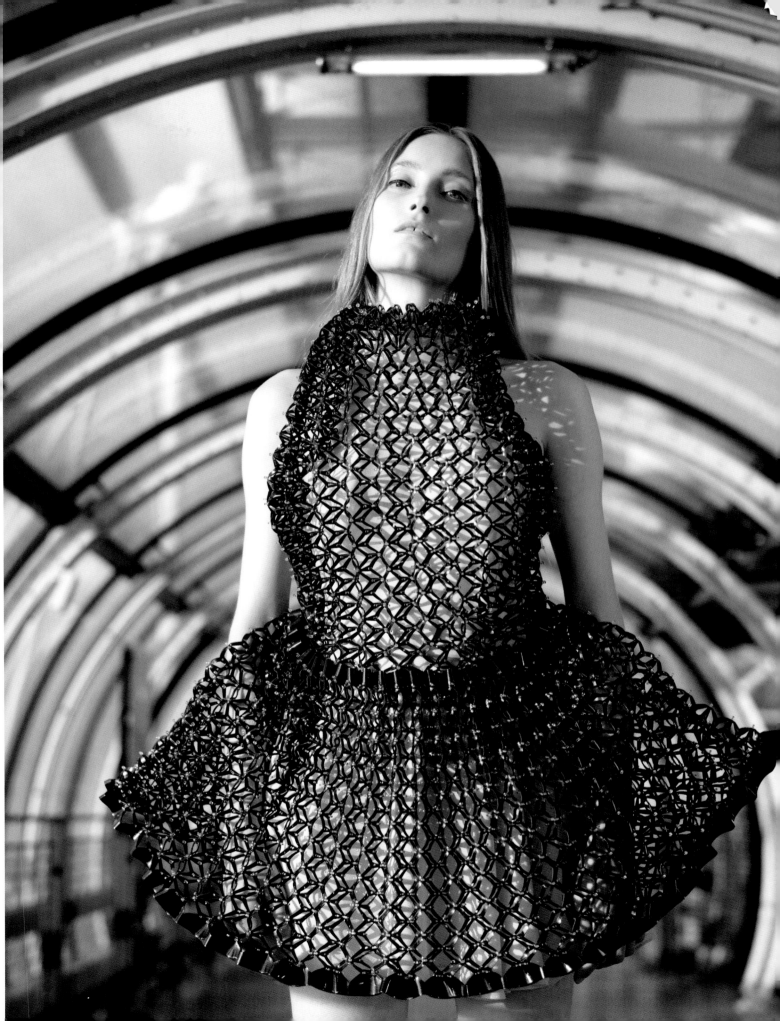

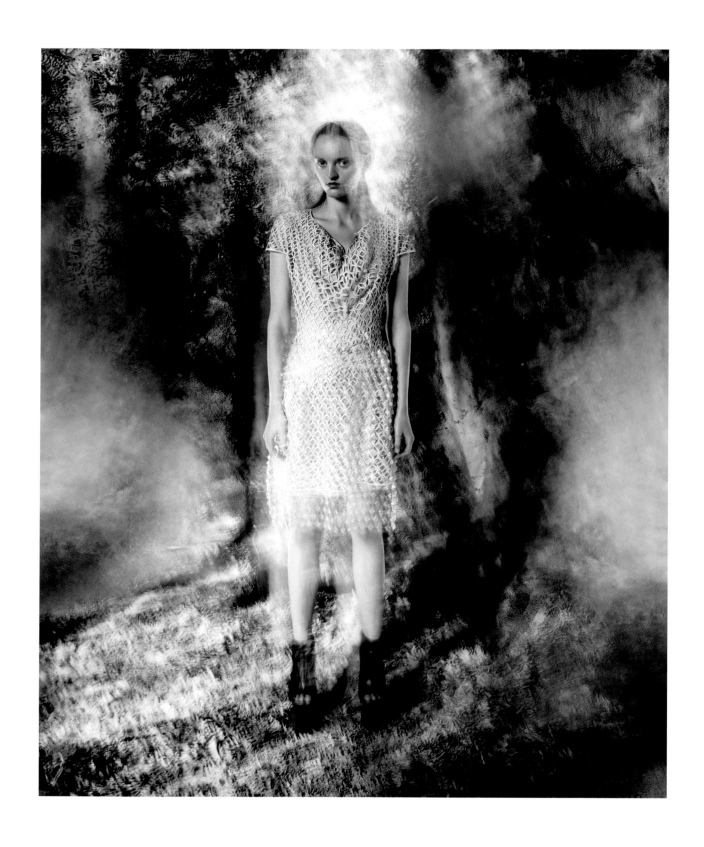

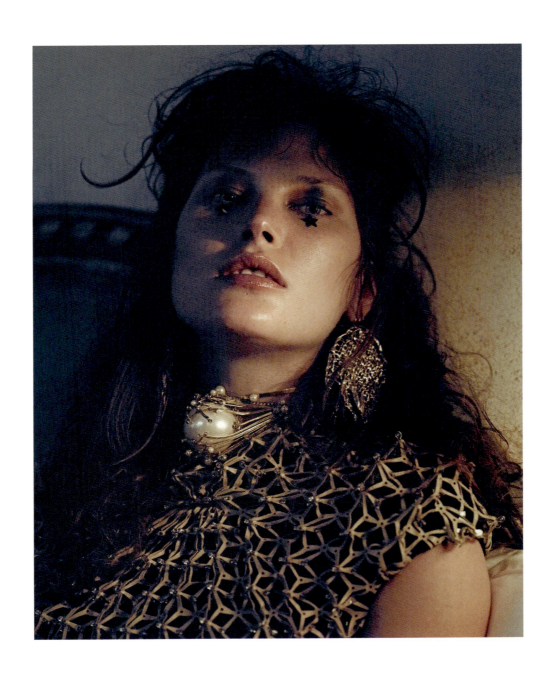

Opposite: A look from Van Herpen's *Quaquaversal* collection, S/S 2016, shot by Warren Du Preez and Nick Thornton Jones. **Above:** Catherine McNeil wears look ten from the *Magnetic Motion* collection, S/S 2015, in this image for *Zoo* magazine by Bryan Adams.

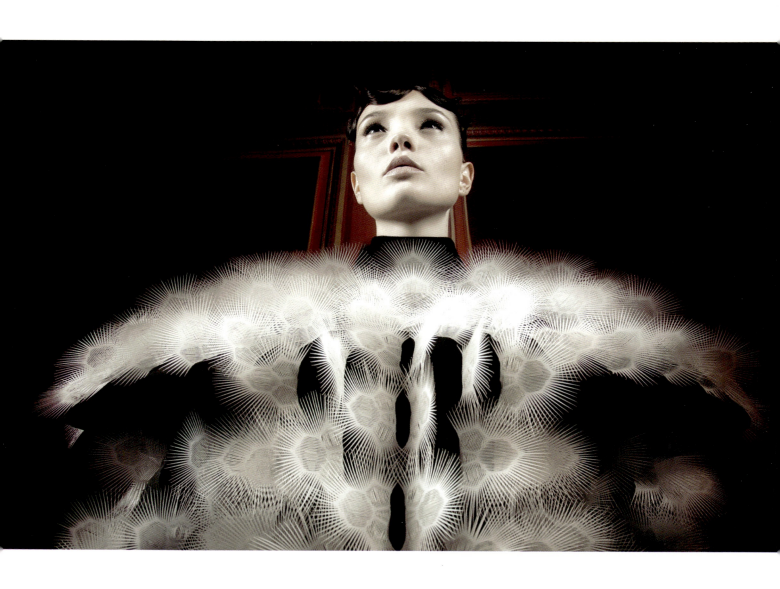

Above: A dress from *Voltage*, S/S 2013, the fourth collection Van Herpen presented at Paris Couture Week as a guest member of the Chambre Syndicale de la Haute Couture and the first to incorporate her collaborations with Beesley. The architect helped develop finely detailed flexible meshwork structures and translucent frond components, which formed the outer layers of three intricate dresses, including this one. **Opposite, top:** Van Herpen makes adjustments.
Opposite, bottom: Material samples hang in Beesley's studio.

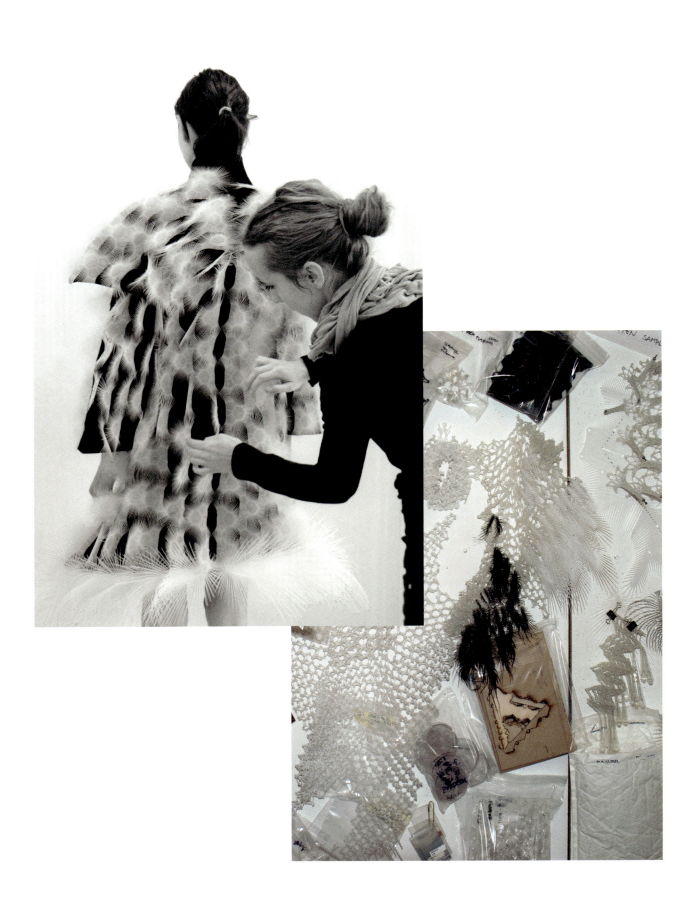

Opposite: Ellen Von Unwerth photographed one of three dresses from Beesley and Van Herpen's first collaboration, part of the designer's *Voltage* collection, S/S 2013, for *Numéro China*'s May 2013 issue.

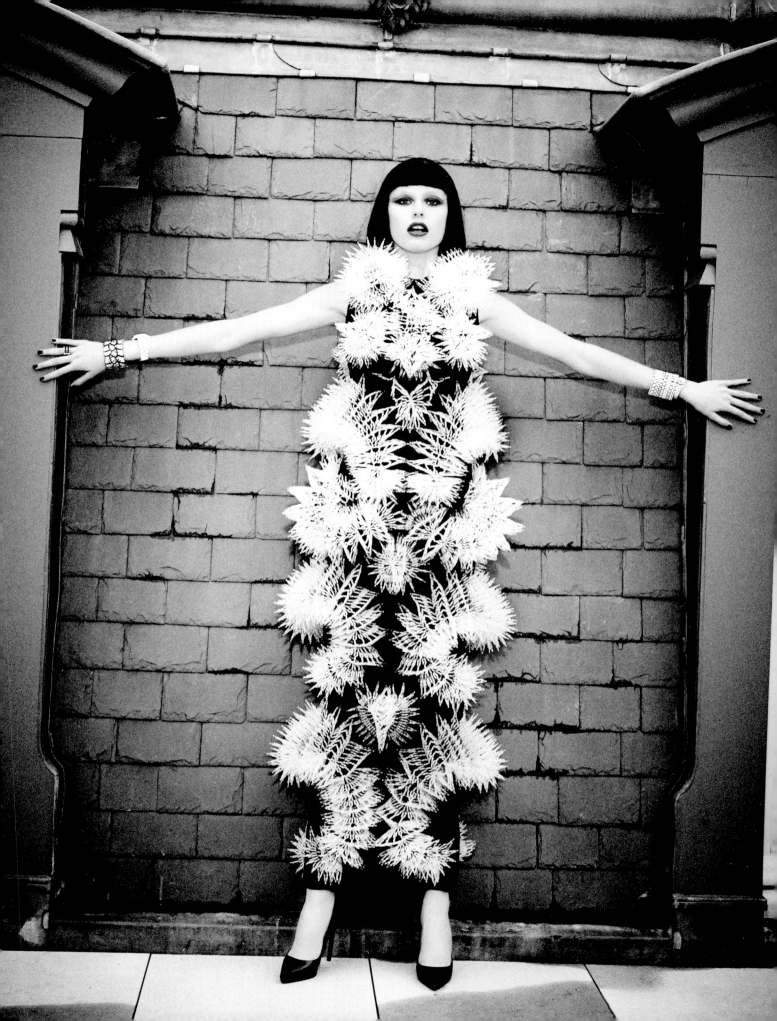

Vivienne Westwood and **Andreas Kronthaler** are both husband and wife and colleagues. To many, their union was a surprising one, in part due to the fact that she was twice his age when they met in 1988. Austrian Kronthaler was studying fashion at the University of Applied Arts Vienna when Westwood arrived to teach a class. Nearly thirty years later, they have proved naysayers wrong, continuing to enjoy a vibrant professional and personal relationship. Kronthaler joined Westwood in London a year after their first meeting, and the designs that had so impressed her when he was a student were swiftly incorporated into her collections. Kronthaler crafted numerous sunwheel dresses from large wheels of fabric for her *Cut, Slash & Pull* show, Spring/Summer 1991. For many years, Kronthaler's role within the Vivienne Westwood company was sizable yet largely unpublicised, with Westwood taking centre stage. Today, she dedicates much of her time and resources to her Climate Revolution campaign, using her fame and platform to address issues ranging from fracking to the destruction of the rainforests. While Westwood continues to design her company's mainline, named Vivienne Westwood, in 2014, she declared that climate change, rather than fashion, had become her key priority. Kronthaler's role has grown concurrently, and in February 2016, after streamlining her business to just two lines, Westwood renamed her Gold Label "Andreas Kronthaler for Vivienne Westwood," highlighting the significance of his leadership as creative director. Westwood is no stranger to collaboration with a romantic partner—her union with Malcolm McLaren resulted in the iconic King's Road boutique Sex (also known as Seditionaries and Let It Rock), which has been credited for providing the impetus for London's punk movement. After Westwood and McLaren split, and following a difficult and short early marriage, Westwood intended never to wed again. Yet in 1993, Westwood and Kronthaler married. Over the course of their union, they have regularly appeared in their own advertising campaigns, demonstrating their mutual eccentricity, flair, and passion for each other.

Vivienne Westwood and Andreas Kronthaler

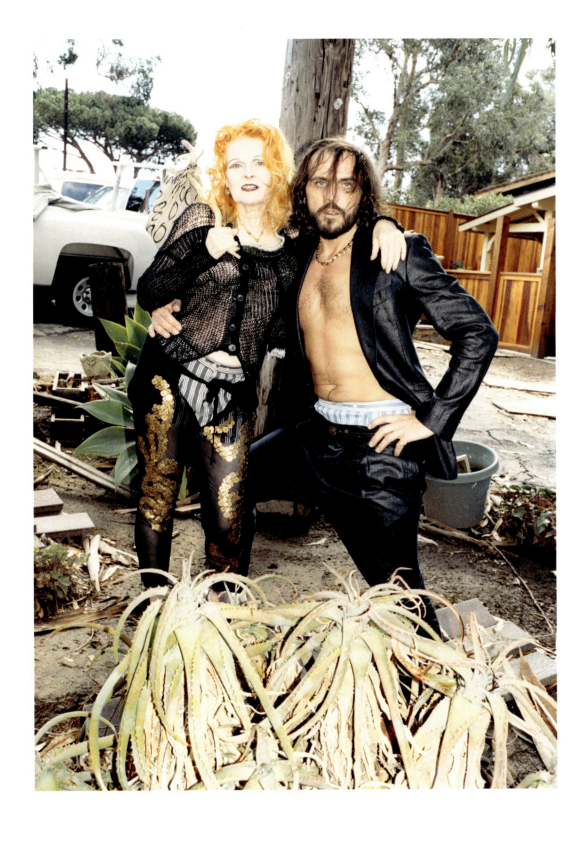

Westwood and Kronthaler photographed by their long-term collaborator Juergen Teller for the S/S 2009 Vivienne Westwood campaign. The campaign also featured the pair's friend Pamela Anderson and was shot in and around Anderson's trailer in Malibu. This campaign marked Westwood's fourth season collaborating with Teller.

Vivienne, when you and Andreas met he was a student in a class you were teaching. Tell me about your earliest interactions.

Vivienne Westwood: One of the first things he showed me was a dress made out of great circles of fabric—the circle dress. The model had to climb a ladder because the dress was so long. I was teaching the students about fashion history, and that dress made me understand something I hadn't before. I realised that during the Renaissance people also cut dresses like that. There's all this volume on the floor that occurs when you put on belts and pull up the fabric. It's like the foam of the sea around your feet. It's like they wanted to look like Greek statues. I only saw that after Andreas showed me that dress.

Andreas Kronthaler: I was so young when I met her, twenty-three years old, and she taught me such a lot. I was always very fascinated by a wide range of things and I think that must have drawn her towards me. I was interested in history and she was very obviously one of the first designers to take from the past. I did that as well. Over all these years, we've looked at so many different epochs together. Through that, I've started to really love and appreciate Englishness, whereas back then I was such a Francophile.

Did it feel like a eureka moment?

Kronthaler: Yes. These things happen sometimes in life—special moments—and this was one of them. I thought, my God, this person is really putting into words things that I was thinking about. Before her, I didn't know how to say or do it. After that key moment, you do know what to do—you instinctively go for it. It's a bit like falling in love.

Did you think you were falling in love with her?

Kronthaler: She looked very, very chic. I'd never seen anything like her before, probably not even after. It's still a high point. She had on a wonderful, wonderful argyle twinset, with matching leggings and a beautiful handmade kilt in a huge plaid, which she got woven in Scotland. And she had this hair in curls, little golden slithers, and she had a little clutch bag made out of wooden beads, like something you would keep your crayons in. And I just thought, my God, amazing. I remember one time, she asked all the students to make something in papier-mâché. Don't ask me why. I made a cow. I started quite well, and then I got myself into a mess. I was painting her, with white and black, and I gave her these big eyes and I had all this paint everywhere. I still work like that! Vivienne looked at it and asked why I made a cow and I said I thought that they look lovely and they have lovely eyes. And she laughed. And in my very difficult English, I had to explain to her that while some people called women cows as an insult—you know, "stupid cow"—you can also call them "cow-eyed" to suggest beauty. It's the ultimate compliment. In Greek, the goddesses were cow-eyed. I grew up on a farm. Horses, they never look at you. They're difficult. Cows, you can look into.

Westwood: He seemed so bemused that I'd asked him why he did a cow. His answer was "because it's the most beautiful creature in the world." And I was supposed to know that somehow. He looked at me, with his blue eyes and his big lashes, like those he'd painted on the cow, and he just stared and said that.

How quickly did you realise that you wanted to stay together and travel back to England and work together?

Kronthaler: We liked each other right from the beginning. When it's like that, you're in a bit of a dream. I was extremely happy at that time, because at last I was doing what I wanted to do and that was fashion. Because where I came from, I hadn't known how to get to it. And all I could think of was to be a goldsmith, because it was something to do with making the body beautiful. As the next step, I went to Vienna to the Academy of Fine Arts, and I enrolled to be an industrial designer, making coffeepots and things people need. It still didn't do it for me, but then I found this fashion thing and it all began from there.

Westwood: I was always looking for him when I went in, because he was just outstanding. I've taught a lot—for thirteen years in Berlin. And out of all those students, you never feel you should give anybody a hundred marks out of a hundred. But Andreas was completely off the scale. It's nothing to do with a hundred. It's way beyond. I'd never seen anything like that before. When that woman went up the stepladder, I realised his ideas were too big for him. And, I think, one of the things that really was very good for Andreas was coming to work with me, because I'm very literal. I pinned him down to the concepts.

Kronthaler: You really did pin me down. If I go on and on and on, I lose myself.

Westwood: When we do a collection, if we didn't have a deadline, he would never stop.

Do you think you're quite different as people?

Westwood: I think so. Incredibly.

Kronthaler: Certainly. The only thing that connects us is the sheer brilliance of our intelligence! [laughs]

Westwood: Andreas is an original thinker. He really is. You know when you see a painting, you don't need words to understand the vision that is in it? It's just communicated to you. Every painting is a vision of somebody who lived at a different point in time, as an individual with a different vision from everybody else's. Andreas understands that. He gets things by direct experience, not words. He just gets painting and he gets music. So we'll walk down the street and I'll say, "When exactly was that building built, would you say, Andreas?" And he'll tell me straight away, exactly to the year, because he understands the qualities of things. But he can't be bothered to speak about it and tell you about it usually. There's a wise saying: Those who speak don't know; those who know don't speak. But whenever he does finally tell you, maybe because he's Austrian and German-speaking, his language is so alive. He's using words that somehow I wouldn't ever think of using to describe what it is. He's absolutely brilliant. I learn so much from him.

Vivienne, you are incredibly dedicated to so many causes. Do you demand similarly high levels of commitment from him?

Westwood: I think it's the other way around. I'm very happy to stop doing something. Andreas is never happy to stop. When something's perfect, as perfect as he'll ever get it, that's still not good enough. He goes right over every other possibility before he's happy.

Whereas you can walk away?

Westwood: When I know it's okay, I don't have to think about what else I could have done that might be better.

With the many political, social and environmental issues you spend such energy championing, you don't feel like you could easily give things up?

Kronthaler: You certainly don't let go, Vivienne. I did know her mother very well and I think she's quite like her. She was a very, very outspoken and straightforward lady. That's what Vivienne is, too. She's very truthful and she speaks her mind. I think it's more unusual in this day and age, when people hardly do that. I do make compromises, but she doesn't. I don't know if she's ever made a compromise in her life. At least not willingly.

Westwood: Well, no. But, let me put it this way: I am desperate. I think that we face mass extinction of the human race and destruction of this wonderful planet. And I do understand that this is the fault of our politicians, who are in league with the banks and the monopolies. It's a triad. They keep this information from the public as much as they can, because they want to continue to wreck the place. So we really have to fight. I'm always thinking about how you can communicate these things to people, and often the only way you can get your point over is if you do have access to the media, which I do. So do I never stop? Well, no, I've got that fire.

Kronthaler: When she started becoming this big environmentalist and campaigner, I was quite irritated, to be honest. There she was, this older person, who found another thing beyond fashion. She found a platform again and built it up and worked very, very hard. I was probably jealous, like a child who hasn't got his playing partner anymore. I sometimes feel alone, but I think she must feel the same in her field. Nowadays, I've made peace with that, and I actually support it wherever I can. I'm there for her and she's there for me, and in the end, even when she's off busy, I still don't do anything without her benediction. But she's somebody who is not satisfied with just making clothes. She wants to do more and, I think, one day when you speak about her, her legacy will be not just the clothes. I'm less that person trying to change the world. I believe in making clothes and that they are really important and essential to us and I feel worthwhile in what I'm doing. I feel like a farmer who milks a cow and who gives you milk. I'm making something we need for our life.

Vivienne, do you like working with other people?

Westwood: I much prefer to work on my own. It's so much more rewarding and easy. But you do need people to bounce off.

Was it hard when you invited Andreas to join you and work so closely with you?

Westwood: It is difficult to work with Andreas. It is more difficult than working on your own, definitely. But I think the results of working together show our true forces. The whole is better than the sum of two parts.

Kronthaler: I do think you're nothing and nobody alone. I really do. It's the same in any field. Whether you're with a woman or gay, I think it is always nicer, better, stronger to be in a relationship—whatever relationship it is. People are programmed this way. There are exceptions, of course—loners or people who do certain work where you need to be completely on your own. But some of them go mad, crazy, because it's very, very draining, because who is putting something back in? You need that.

Andreas, would you agree that you are difficult?

Kronthaler: I'm very tiring. I'm bossy, apparently, and I like to get my way. I can get very, very angry. I have great passion. And she has it, too, but it's so much more enclosed and hidden and contained. I can explode quite easily. But I don't keep grudges at all. Hardly.

Westwood: We work in different ways. We tend to start working separately. Andreas usually chooses the fabrics first and gets together a pre-selection, because I'm busy doing my Climate Revolution and Vivienne Westwood line at the moment. So he'll get me in to make near-final decisions to his line. When working with anyone, I do believe that having to delegate is very difficult. If you have the time to do everything yourself, wonderful. We expanded, so I'm not going to do what I want to do, which is sit on the machine and make all my samples. I have so many other things to do that I couldn't spare the time. I'd love to do it small again, actually, so then I could do that.

Kronthaler: It's not terribly planned, the way we work together. We divide the work differently each day.

Do you make an effort to have a separate relationship outside of work?

Westwood: We don't spend much time together in a way. Andreas goes out more than I do.

Kronthaler: I haven't been out for ten years!

Westwood: I stay in reading. We go for walks on the common. I've only recently started to do that with him.

When you got married you didn't tell people. Why?

Westwood: We didn't. My mother read about it in the paper. We only got married because Austria wasn't in the European market. We were travelling so much for work and it always felt touch-and-go whether Andreas would be allowed back in the country and that was really nerve-racking. I'd be through customs, waiting, and they'd still be talking to him. So I said to Andreas, "It's so difficult to get permission to work in England. There's only one way that you'll be able to stay here, Andreas, and that is that we have to find somebody for

you to marry, I'm afraid." And he said to me, "Vivienne, I'd have to marry you then."

What did you say?
Westwood: I thought, oh well, yes, it is possible. I'm not married to anybody else! We didn't say anything mostly because everybody knew he was in the company, and they didn't really know that we were having a love affair. Except they did. The girl who did the jewellery used to say, "Oh, they're in love." But, I didn't want anybody to know, probably because I was older as well—twenty-five years older.
Kronthaler: We had to go to the Home Office for interviews a few times.
Westwood: To prove that we really had a relationship and it wasn't just one of those fake marriages.
Kronthaler: They asked some good questions.
Westwood: He has got a good memory about things he did last week and everything. Me, I couldn't tell you what I did last week. They were asking me questions about our relationship and he got his answers right. But when they said things like, "What did you do at Christmas?" I just invented things. But I didn't know I was inventing them. Maybe it happened to me five years earlier with somebody else or something. But at one point, they said to him, "Have you got any cats?" And he said, "Oh yes, I've got a whole wardrobe full of them." He thought they said hats.

Did things feel different after you got married?
Westwood: They did, because I didn't want to get married. After my first marriage to Mr. Westwood, I'd been with Malcolm [McLaren] for thirteen years and I didn't want to get married to him—even though I was completely loyal. It felt like if you get married that's a vote for the system that we live under, and I don't like the system we live under. Before Andreas, I spent nine years on my own and I loved it. I didn't want to get together with another man, not really. But Andreas and I were very attracted to each other. We were always together whenever we could be. Andreas is a very affectionate person. He's like an animal. He likes having somebody with him. He likes to sleep with somebody. Somehow getting married really made a difference to me this time. It didn't make a difference the first time. And suddenly I just took this vow about "until death us do part" completely to heart. I like the Chinese proverb: If a horse is yours, it will always come back!

Has your relationship changed over the years?
Kronthaler: For me it's just like it's always been.
Westwood: I've got used to living with Andreas. I loved living on my own, and now, after a long time, I think I like living with him as much as living on my own. I'm used to him, and I would miss him.
Kronthaler: I'm very pleasant, Vivienne.
Westwood: He's wonderful.

So you think you're a good husband?
Kronthaler: Yes. I look after everything and I'm very

cosy. I'm very easy-going, aren't I?
Westwood: Very. And I am.
Kronthaler: You are a nightmare. You're lazy.
Westwood: He loves cleaning. I've never used my Hoover or my washing machine yet. He washes everything far too much.
Kronthaler: I love it.
Westwood: If Andreas is in a bad mood, he'll clean. And when we work together, he has to clear the table. Everything has to be precise and organised—the piece of paper, the pencil.

Do you think people thought you would be together for as long as you've been together?
Westwood: We don't care what people think.
Kronthaler: I remember you then and me now, and it's just the same. Of course, you were a bit younger or looked a bit different or whatever. But you were the same person then that you are today and I liked you as you were then as much as I like you as you are now. Your energy is still astonishing. I've always liked older people.
Westwood: I know you do.
Kronthaler: I was fascinated by them. Not that I didn't like my age group or something, but I just got more from them. Simple as that.

Andreas, what do you think you would have done with your life if you hadn't met Vivienne?
Kronthaler: I really like old things. I still love them. I would probably be an antiques dealer. My mother used to deal in them, and I grew up in the middle of them. Finding them, looking after them, repairing or restoring them. I would have quite liked that.

What makes a great relationship?
Westwood: A relationship should be based on friendship. I remember somebody telling me that when I was younger and I just thought, you know, stupid people, with that rubbish. But now I see that that is so important.
Kronthaler: I think that what is so inspiring about life is how you've got this opportunity to be with people who you like and admire and are friends with. And with those people, you take from each other, always.

—

This interview took place at the Vivienne Westwood studios in South London on April 17, 2015.

A tiny torn fragment of an envelope, used by Westwood for sketching. Westwood is
a committed environmentalist. In her efforts to save paper, she regularly draws and
writes on any scraps of paper she can find, even receipts.

Sketches and boards photographed in Westwood and Kronthaler's studio in Battersea, London. **This page, right:** Westwood regularly uses her collections to spotlight her fight against climate change. Here, garments from past collections are stored in the Vivienne Westwood archive. **Below, left:** Light pours into Kronthaler's office in the studio, which is filled with reference books on diverse topics. **Below, right and opposite:** Kronthaler first collaborated with Westwood on her *Cut, Slash & Pull* show, S/S 1991, crafting sunwheel dresses from large wheels of fabric, similar to ones that had impressed her when she taught him fashion design at University of Applied Arts Vienna. Here, records of the collection are stored in the Westwood headquarters.

END ECOCIDE SS15
SAVE THE RAINFOREST AW 14/15
EVERYTHING IS CONNECTED SS14

SAVE THE ARCTIC AW 13/14
CLIMATE REVOLUTION SS13
LONDON AW 12/13

Spring/Summer
1991
**Cut, Slash and
Pull**

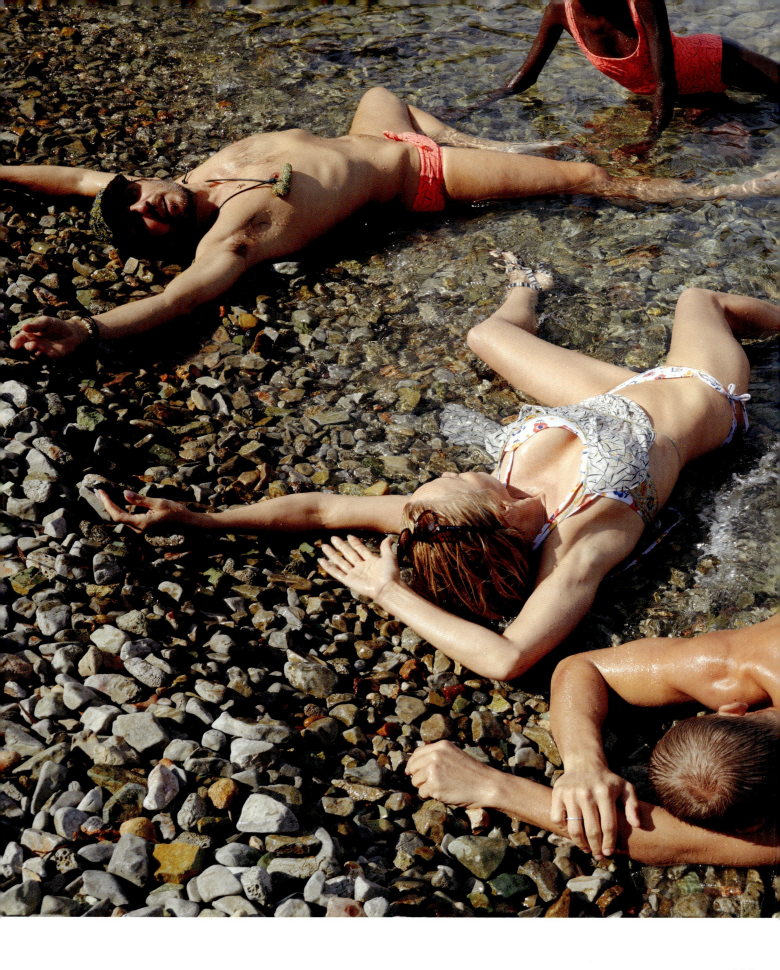

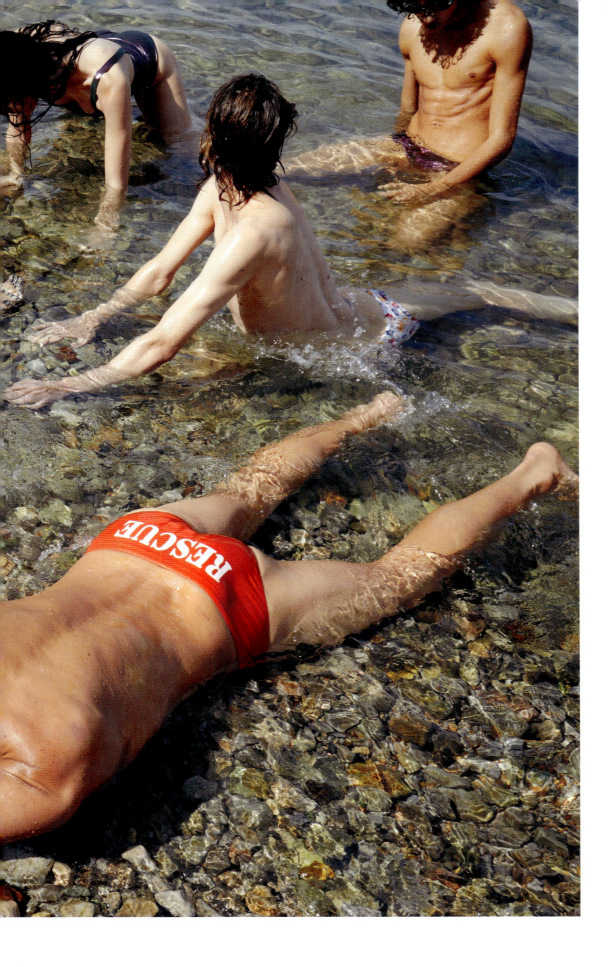

CLIM
TATE

Dry clean?

FOOTWEAR
FOOTWEAR
ABCDCS
GENESIS
EDITH HEAD
ATLAS
Matisse Cut-outs
Matisse Jazz

Greek Erotica

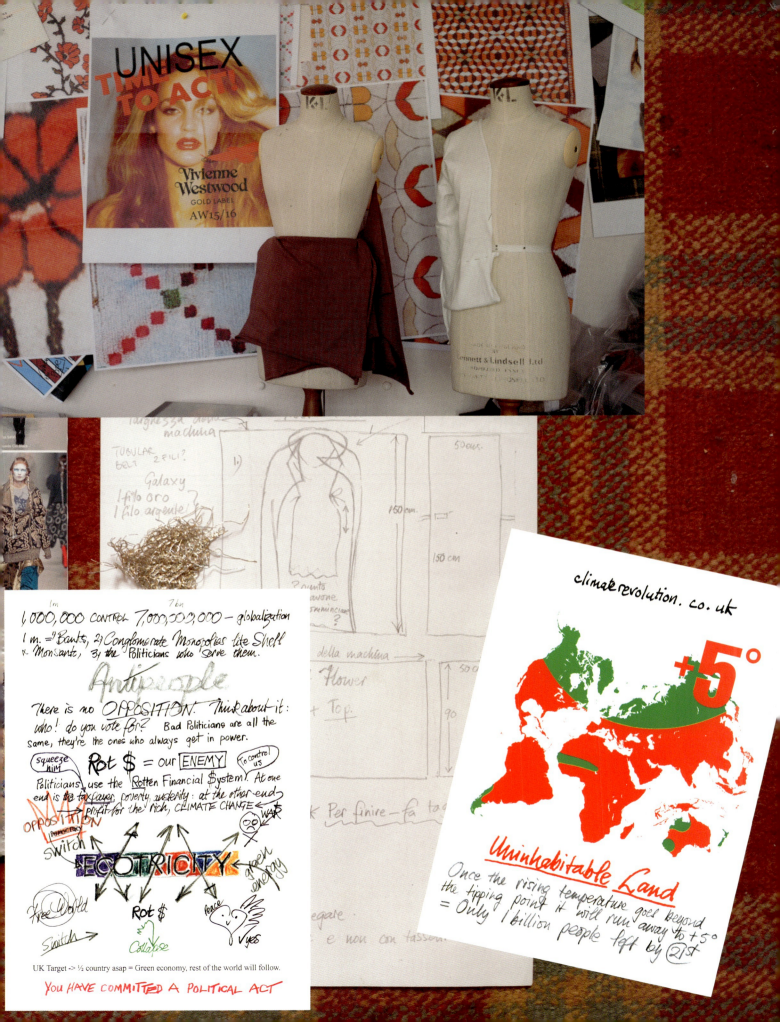

UNISEX
Vivienne Westwood
GOLD LABEL
AW15/16

climate revolution. co. uk

+5°

Uninhabitable Land
Once the rising temperature goes beyond the tipping point it will run away to +5° = Only 1 billion people left by 21st

1,000,000 control 7,000,000,000 - globalization
1 m. = 1) Banks, 2) Conglomerate Monopolies like Shell & Monsanto, 3) the Politicians who serve them.

Antipeople

There is no OPPOSITION. Think about it: who! do you vote for? Bad Politicians are all the same, they're the ones who always get in power.

squeeze him Rot $ = our ENEMY to control us

Politicians use the Rotten Financial $ystem. At one end is the taxpayer, poverty, austerity; at the other end profit for the rich, CLIMATE CHANGE — WAR

OPPOSITION DEMOCRACY
switch

ECOTRICITY green energy

Free World Rot $ peace Yes
Switch Collapse

UK Target -> ½ country asap = Green economy, rest of the world will follow.

You HAVE COMMITTED A POLITICAL ACT

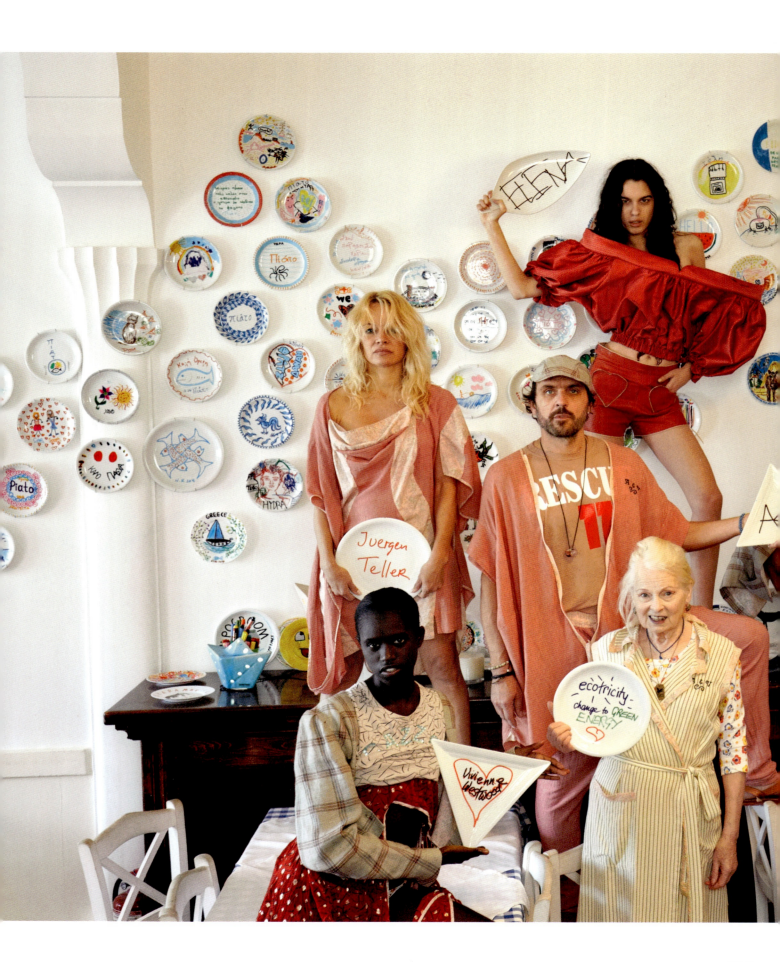

296

Pages 292–93: The Vivienne Westwood S/S 2017 campaign was photographed by Juergen Teller in Hydra, Greece, where he has a house. It nodded to the *Europa* title of the show, which referenced the Mediterranean. "Inspiration for the campaign always comes from the idea of the collection first. There is a trust between us and we explore and work quite freely," he said at the time of this collaboration with Westwood and Kronthaler. The latter has a particular fondness for the sea and the Mediterranean way of life. "I love the light. I love women wearing hardly anything—going to the market in their bikinis. Lunch with friends. A bowl of spaghetti. Things are simple. But at the same time it makes you think— thousands and thousands of migrants moving across it every day—using the sea as a passage. Is it a coincidence that I'm thinking of Europe? I am not a particularly political person but I want the collection to be part of where I am, where we are," he said at the time. **Previous pages:** More shots from inside Westwood and Kronthaler's London studio, alongside shots of the pair and their collection taken backstage at their F/W 2015 show in Paris, and handwritten text and graphics created by Vivienne Westwood for her Climate Revolution initiative. **This page:** Another of Teller's images for the S/S 2017 *Europa* campaign, featuring Kronthaler and Westwood alongside models and their friend and collaborator Pamela Anderson.

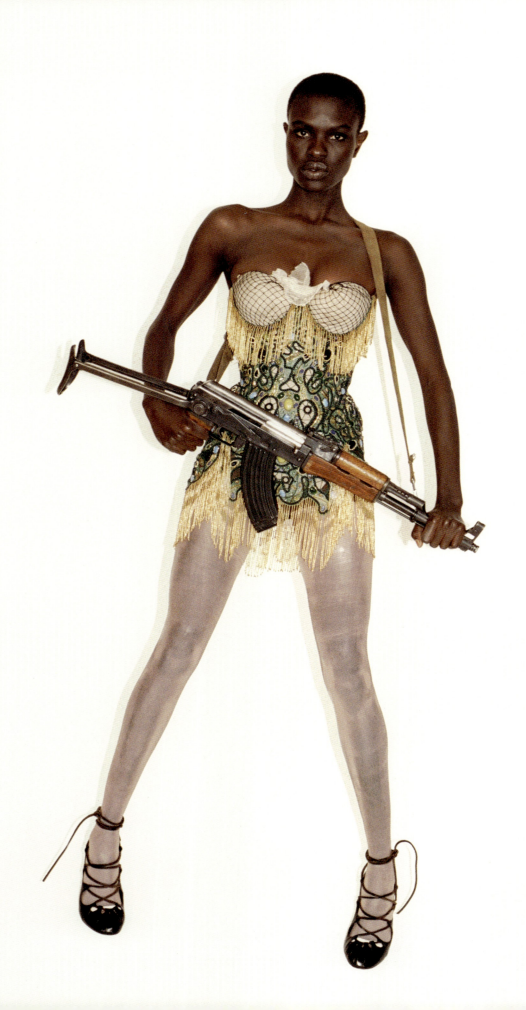

Opposite: The Vivienne Westwood S/S 2008 campaign, shot by Juergen Teller and featuring Ajuma Nasenyana. **Above:** Westwood eats a banana in another image from her S/S 2008 campaign.

Above: "Not Charity, Just Work" is the key message of The Vivienne Westwood Ethical Fashion Initiative. Westwood's F/W 2011 campaign saw the designer photographed by Juergen Teller in Nairobi, Kenya, alongside bags created as part of this initiative. They have been produced since 2010 in collaboration with the Ethical Fashion Initiative of the International Trade Centre— a joint body of the United Nations and the World Trade Organisation—which currently supports the work of thousands of female microproducers from marginalized African communities, providing an income for some of the poorest people in the world. For Westwood's bags, local artisans make use of recycled canvas, reused roadside banners, unused leather off-cuts, and metal collected from discarded padlocks and car pieces. **Opposite:** For their S/S 2016 campaign, *Mirror the World*, also shot by Teller, Westwood and Kronthaler focused on both the beauty and decay of Venice, using their images to highlight the problems caused by mass tourism and climate change. Images, like this of Kronthaler, were captured around the city's alleys, canals, shipyards, and palazzos. "If we can't save Venice, how do we save the world?" asked Westwood.

Acknowledgments

This book is dedicated to Nick and Charlotte Knight—an irrepressible duo. Thank you for all the opportunities.

This is a book about collaboration, and appropriately it certainly wouldn't have happened without the collaboration of a range of brilliant people. Thanks to my agent, Gordon Wise, for the encouragement and advice. To Giulia Di Filippo and Charles Miers of Rizzoli, for taking a chance on the idea and helping so supportively to shape it into this book. To Ray O'Meara and Thomas Swann, for your brilliant eyes and for putting up with my pedantic nature. To Beth Mingay for your tenacity in securing the best photographs. To Andrew Smith, for your enthusiasm, endless reliability, and wonderful images. To Barbora Kozusnikova and Christina Cacouris, for your help in handling the hours upon hours of recordings—you are transcription queens. To the wonderful team at SHOWstudio, who have gone out of their way to provide help and input. To the many, many agents, studio managers, and press teams who helped chivvy and chase to secure the material that makes this book so special. And of course, to all of those featured, for your incredible generosity in sharing your stories and digging deep into your archives—this is really your book not mine.

Special thanks also to my family. And finally, to my friends, the most wonderful people in the world and the best collaborators—you know who you are. And to Rob Nowill—because it's you.

Photography credits

Marc Jacobs & Katie Grand
Pages 15, 29 (bottom), 30–31 © David Sims. Page 19 ALFRED/SIPA/REX/Shutterstock. Pages 20–21, 24–28, 34–35 © Mert and Marcus. Pages 22–23 © David Hughes. Page 32 (top) Jamie McCarthy/Getty Images; Ephemera courtesy of Marc Jacobs. Page 33 © David Urbanke.

Rick Owens & Michèle Lamy
Page 37 © Danielle Levitt. Pages 41, 42 BG, 44–45, 48 BG, 50 © OWENSCORP. Page 42 BG, 43 © Benoit Barnay. Page 46 FG © Matthieu Bredon-Huger. Pages 46 BG, 47, 48 BG, 49, 51 © Adrien Dirand.

Nick Knight & Daphne Guinness
Pages 53–67 © Nick Knight and SHOWstudio. Page 60 Ephemera courtesy of Daphne Guinness.

Riccardo Tisci & Mariacarla Boscono
Pages 69, 74–75, 77 © Mert and Marcus. Page 73 © MACSIOTTI. Page 76 © Matthew Stone. Page 78 Pascal Le Segretain/Getty Images. Page 79 © M/M. Pages 80–81 © Inez and Vinoodh. Page 82 © Karim Sadli at Art+Commerce. Page 83 © Luigi and Iango.

Jonathan Anderson & Benjamin Bruno
Page 85 Courtesy of Benjamin Bruno. Pages 89, 90 (bottom left), 91, 94–95 © Jamie Hawkesworth. Page 90 (top) Courtesy of Jonathan Anderson and Benjamin Bruno. Pages 92–93 © Steven Meisel at Art+Commerce.

Shaune Leane on Alexander McQueen
Page 97 © Ann Ray. Pages 100–104, 108–9, Courtesy of Shaun Leane. Page 105–6, 115 © Nick Knight. Page 107 © Sean Ellis at Kayte Ellis Agency. Page 110 All drawings Courtesy of Shaun Leane; BR © Sean Ellis at Kayte Ellis Agency. Page 111 (right) Courtesy of Shaun Leane; (left) © Donna Trope. Page 112 © Gavin Fernandes. Page 113 © Mikael Jansson.

Kim Jones & Alister Mackie
Page 117 © Hugo Scott. Pages 120–21, 126 © Alasdair McLellan. Page 122 © Julia Hetta. Pages 123–24 © Jon Emmony. Page 125 © Romain Mayoussier. Page 127 © Peter Lindbergh. Page 128 © Willy Vanderperre. Page 129 © David Sims.

Viktor Horsting & Rolf Snoeren
Pages 131, 135 © Inez and Vinoodh. Pages 134 (bottom), 136 (bottom), 137–39, 142–44, 145 (bottom) Courtesy of Viktor and Rolf. Page 134 (top) Courtesy of Purple Prose. Page 136 (top) REX/Shutterstock. Pages 140–41 © Annie Leibovitz. Page 145 (top) Courtesy of firstVIEW.com.

Jack McCollough & Lazaro Hernandez
Pages 147, 154, 156 © Josie Miner. Pages 150–51 Courtesy of Jack McCollough and Lazaro Hernandez. Pages 152–53 © Zoë Ghertner. Page 157 © Juergen Teller, All rights reserved.

Inez van Lamsweerde & Vinoodh Matadin
Pages 159–73 © Inez and Vinoodh.

Carol Lim & Humberto Leon
Page 175 © Inez and Vinoodh. Page 179 Courtesy of Opening Ceremony. Page 180 Lim-Leon personal collections, courtesy of Opening Ceremony. Page 181 © Sasha Eisenman. Pages 182–83 Courtesy of Kenzo. Page 184 (top) © Gregg Araki, (bottom) © Jean Paul Goude. Pages 185, 187 © TOILETPAPER. Page 186 Courtesy of Kenzo and Lim-Leon personal collections.

Gareth Pugh & Ruth Hogben
Page 189 © Rob Stothard. Pages 192–93, 195, 202 © Andrew Smith. Pages 194,196–201, 203 © Ruth Hogben.

Philip Treacy on Isabella Blow
Page 205 © Kevin Davies. Page 208 (top) Photograph first published in *The Cheltenham Echo*; (bottom left and right) © Andrew Smith. Pages 209, 214 Courtesy of Philip Treacy. Pages 210, 212–13, 216 © Andrew Smith. Pages 211, 215 © Nick Knight. Page 217 © Sean Ellis at Kayte Ellis Agency

Mert Alas & Marcus Piggott
Pages 219, 223–41 All Images © Mert Alas and Marcus Piggott.

Thom Browne & Stephen Jones
Page 243 © Max Vadukul/AUGUST. Pages 246–47 © Nick Knight. Pages 248–50 Sketches courtesy of Stephen Jones. Page 248 (bottom) © Mathieu Lebreton. Pages 249–50 (bottom) © Liam Goslett. Page 251 © Giampaolo Sgura © 2017 Condé Nast Japan. All rights reserved. Page 252 All images © Pamela Berkovic. Page 253 (top right) © Dan and Corina Lecca; (bottom left) © Pamela Berkovic. Pages 254 and 255 (bottom) Courtesy of *A Magazine*. Page 255 (top) Courtesy of Thom Browne.

Katie Hillier & Luella Bartley
Pages 257, 264 (right), 265–67 © David Sims. Pages 260–61, 269 Courtesy of Katie Hillier and Luella Bartley. Page 262 (top and middle) © Giovanni Giannoni/Penske Media/REX/Shutterstock; (bottom) Courtesy of firstVIEW.com. Page 263 Clockwise from top left: Victor VIRGILE/Gamma-Rapho via Getty Images, Giovanni Giannoni/Penske Media/REX/Shutterstock, Antonio de Moraes Barros Filho/FilmMagic. Page 268 © Zora Sicher.

Iris Van Herpen & Philip Beesley
Page 271 Portrait of Iris Van Herpen and Philip Beesley in studio. Pages 274–75 © M. Zoeter. Pages 276, 280–81 Courtesy of Iris Van Herpen. Page 277 © Mathieu César. Page 278 © Warren Du Preez & Nick Thornton Jones. Page 279 © Bryan Adams. Page 283 © Ellen von Unwerth.

Vivienne Westwood & Andreas Kronthaler
Pages 285, 292–93, 296–301 © Juergen Teller, All rights reserved. Pages 289, 290–91, 294–95 Courtesy of Vivienne Westwood, photography by Andrew Smith.

First published in the United States of America in 2017 by
Rizzoli International Publications Inc.
300 Park Avenue South, New York, NY 10010
www.rizzoliusa.com

Publication © 2017 Rizzoli International Publications, Inc.
Text © 2017 Lou Stoppard
Foreword © 2017 Andrew Bolton

2017 2018 2019 2020 / 10 9 8 7 6 5 4 3 2 1

Distributed in the U.S. trade by Random House, New York.
Printed in China

ISBN: 978-0-8478-4880-5
Library of Congress Control Number: 2017935107

Front cover:
Isabella Blow and Philip Treacy photographed by Kevin Davies in 2002.
Shaun Leane and Alexander McQueen photographed by Ann Ray in 2006.

Daphne Guinness

JW Anderson

Macy

Stephen Jones